THE ULTIMATE VISUAL HISTORY

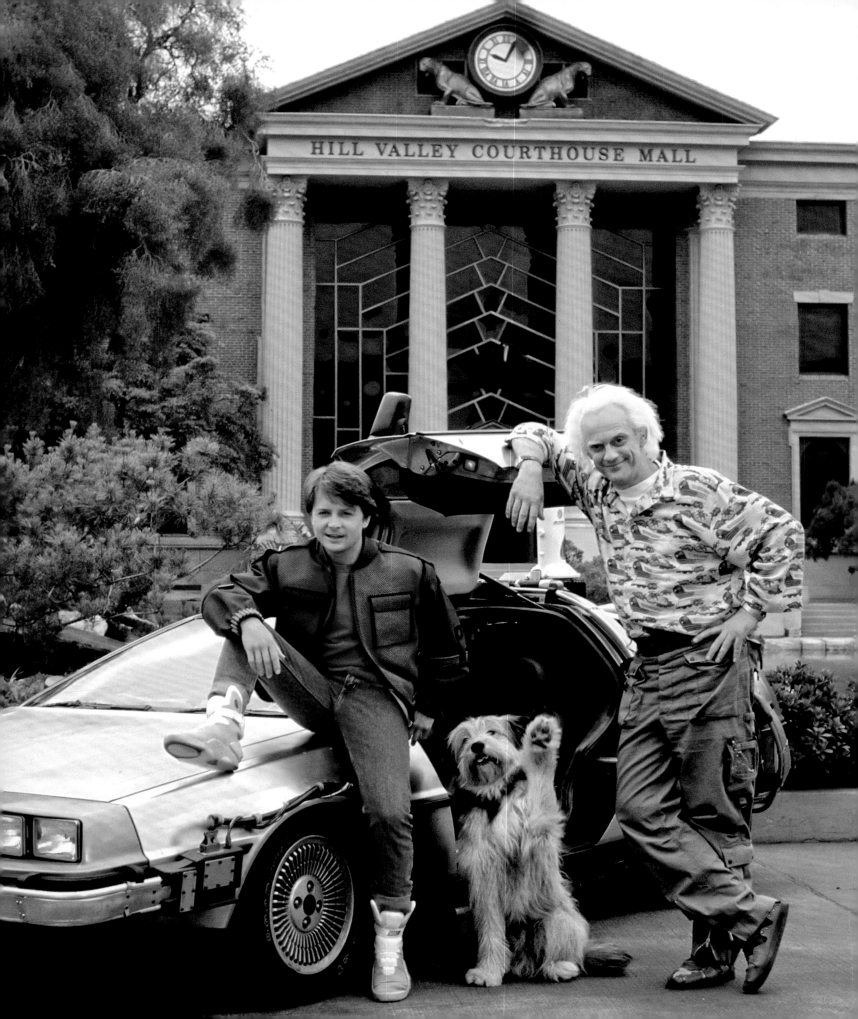

THE ULTIMATE VISUAL HISTORY

WRITTEN BY **MICHAEL KLASTORIN** WITH **RANDAL ATAMANIUK**

FOREWORD BY **MICHAEL J. FOX** PREFACE BY **CHRISTOPHER LLOYD**

INTRODUCTION BY **BOB GALE** AFTERWORD BY **ROBERT ZEMECKIS**

HARPER DESIGN

An Imprint of HarperCollins Publishers

An Insight Editions Book

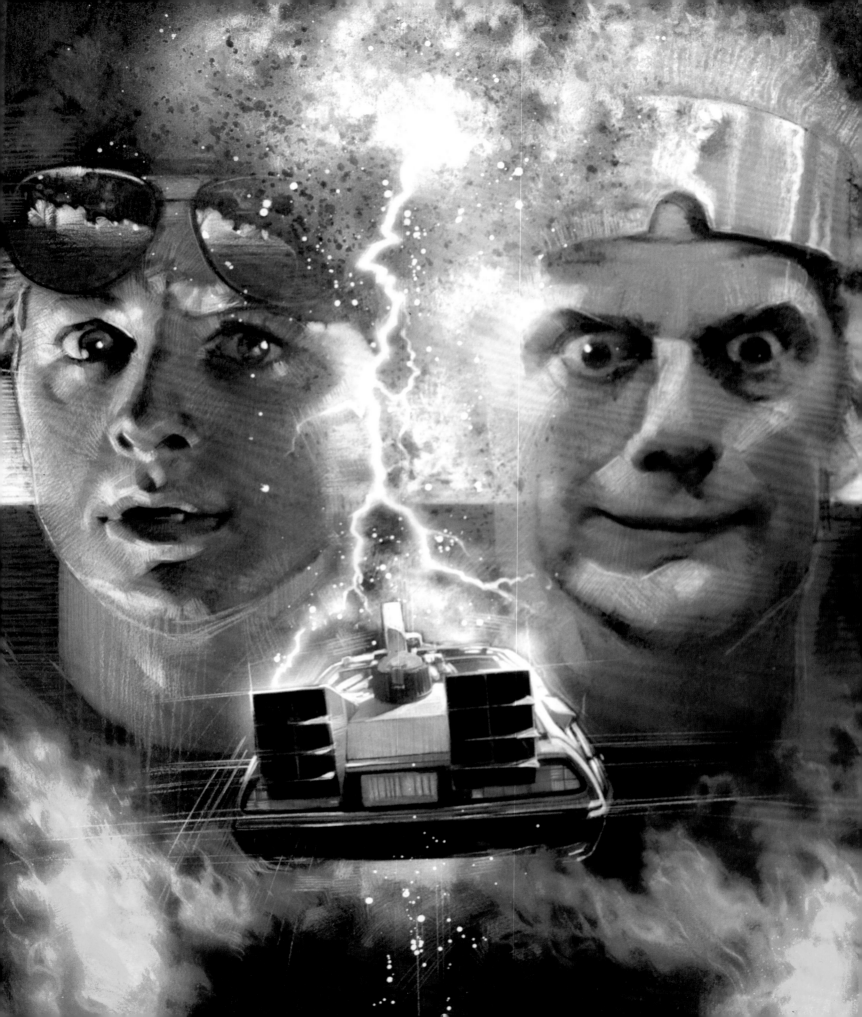

CONTENTS

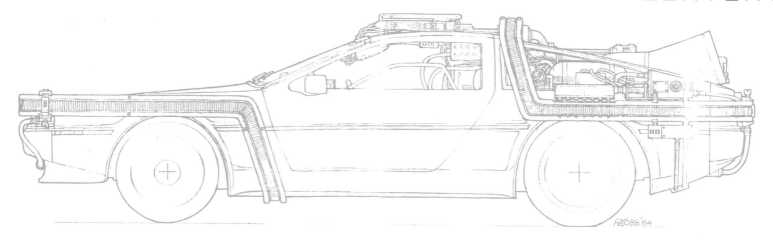

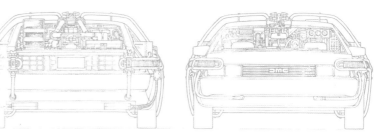

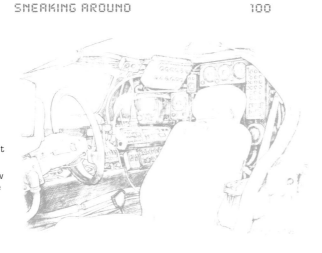

THIS PAGE DeLorean concept drawings by Ron Cobb.

OPPOSITE One of artist Drew Struzan's concepts for the *Back to the Future Part II* movie poster.

FOREWORD

WOW. OCTOBER 21, 2015. We made it. Even if you're a casual Back to the Future fan (and I've never met one of those), you realize the significance of that date; that's the day Doc and Marty travel to in the future. Look around: Did the film get it right? Flying cars, not so much, but Marty's receding hairline looks painfully familiar.

People actually ask me if I resent going through life so closely identified with Marty and the Back to the Future trilogy. I assume they're referring to the fact that some folks will still point at me in crowded restaurants and exclaim "McFly, you Irish bug . . . where'd you park your DeLorean?" Annoying, huh? Are you freaking kidding me? Hell, no. I am forever grateful that Bob Zemeckis, Bob Gale, and Steven Spielberg chose me to ride along with Chris Lloyd in the DeLorean. I am even more grateful that so many took this long, strange trip with us.

I have to admit that a lot of you know more about Back to the Future than I do. Seriously, I've heard Back to the Future fans reel off factoids regarding flux capacitors, the space-time continuum, and all matters temporal and existential, and I respond with slack-faced ignorance. I was there at the time, although I was working two jobs and it all became a blur. I was too busy to take notes.

Lucky for me and for Back to the Future fans everywhere, someone was writing this stuff down. My friend Michael Klastorin, who was the production publicist on the two Back to the Future sequels, not only has his own set of notes but also had access to daily production reports, design sketches, storyboards, and every official photograph taken for the entire trilogy. The result is this amazing book—a must for any wannabe Hill Valley resident. It's an exhaustive, forensic breakdown: the who, where, why, and when of what went down. Even I find this stuff fascinating and revelatory. Did you know that they shot the first five weeks of *Back to the Future* with another actor in the lead role? Get outta town.

Since Doc and Marty didn't travel any further into the future than 2015, there are no more specific dates to look forward to, so I encourage you to read this book now. Or just stand there and feel the weight of it in your hands. Heavy!

Michael J. Fox

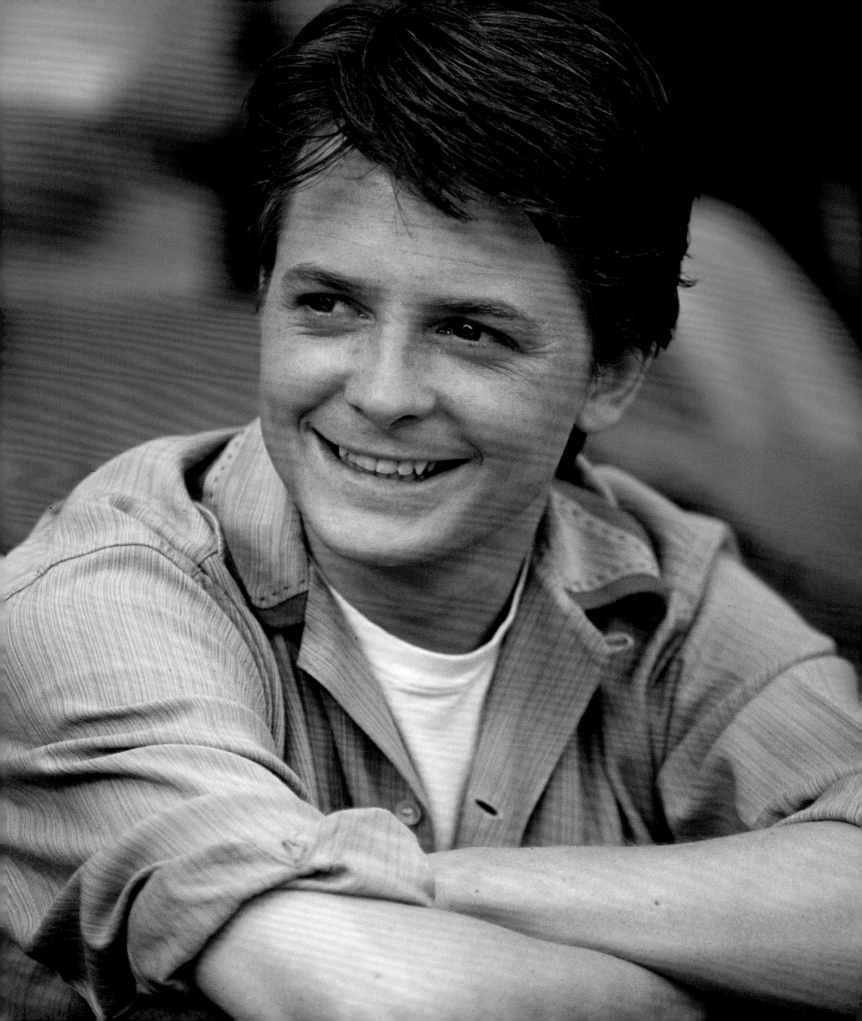

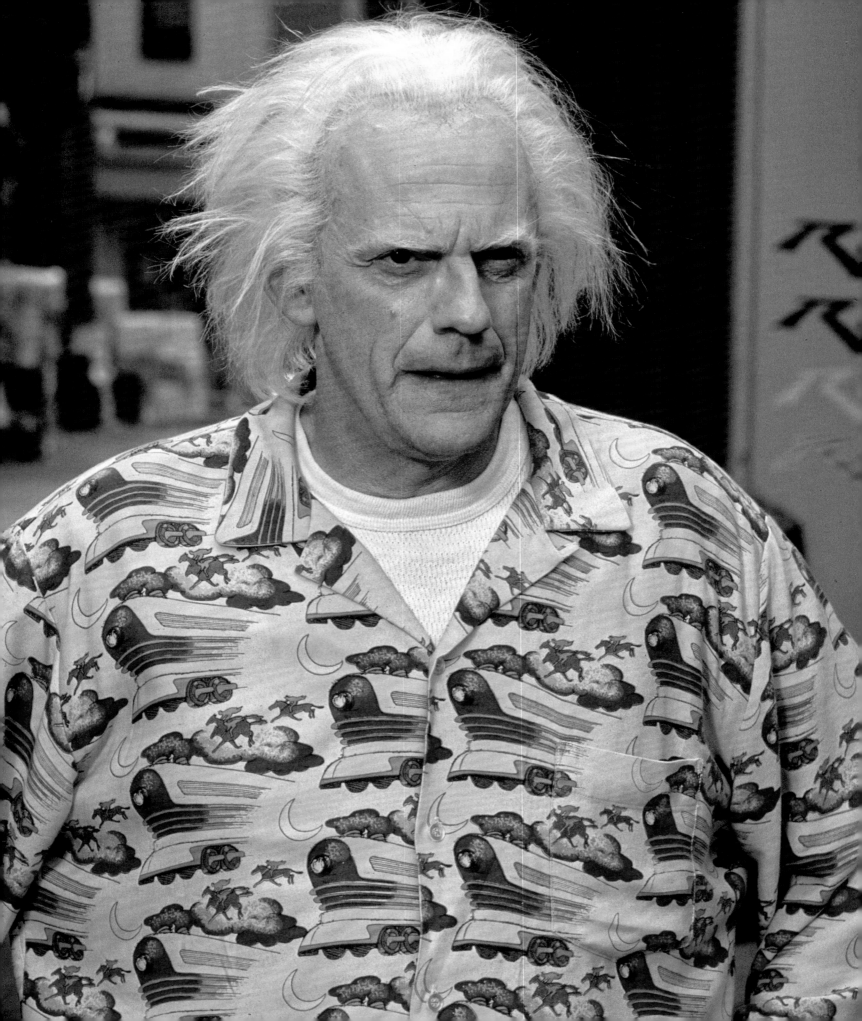

I'M NOT A WRITER. Actually, I'm not even sure if I've ever *played* a writer. But I know that one rule of writing is to grab the reader with something interesting right away. So here's a grabber:

After I read *Back to the Future* the first time, I threw the script in the trash.

I know what you're thinking—"Great Scott!" You'll find the story of why I retrieved that script later in this book, so I won't tell it here. But I often wonder how my life and career would have turned out if I hadn't retrieved it. What if I hadn't rethought that decision? What if I hadn't taken the meeting with Bob Zemeckis and gotten a sense of the wacky movie he intended to make? What if I hadn't said "yes"?

One thing is certain. I wouldn't be writing this preface! You might be reading something by Jeff Goldblum or John Lithgow. I probably wouldn't have been cast as Judge Doom in Zemeckis's *Who Framed Roger Rabbit* or have been cast in a lot of other films. I wouldn't have gone to a lot of great parties at Bob Gale's house. Who knows, I might have gone back to the theater and chucked my entire film career—it was actually something I was considering at the time. Quite an alternate time line, and one I'm blessed to not be living in.

We all think about those "what if" sort of things. What if I'd said "yes" instead of "no"? What if I'd gone to school in Illinois instead of Texas? What if I had married Pat instead of Adrian? It doesn't matter who you are, how old you are, or what country you live in. There are times you lie in bed at night and replay the decisions you made that day, and wonder, what if . . . ?

To me, that's one of the reasons that the Back to the Future movies are so compelling. They not only ask those questions, they answer them. The trilogy presents alternate time lines, and we actually get to see the results. We see what happens if George stands up to Biff. We see what happens if Biff marries Lorraine. We see what happens to Marty's future if he crashes into that Rolls-Royce. And we see what happens when Doc rescues Clara. (I get to kiss Mary Steenburgen!)

Making a movie is all about making decisions. The writer has to decide what to put on the page. The director has to decide where to put the camera and who can best play a part. The actor has to decide how to deliver the lines. The studio has to decide how much money they'll spend. Some of these decisions have little impact. These movies would have been just as good if I'd been named "Doc Greene" instead of Doc Brown, or if Marty's hoverboard had been purple instead of pink. Other decisions have the power to alter the space-time continuum. What if Bob Zemeckis hadn't been bold enough to replace Eric Stoltz with Michael J. Fox? I doubt this book would even exist.

What if? Two words that can fire up the imagination and send us into worlds of endless possibilities. That's the power of film, and the power of Back to the Future.

Christopher Lloyd

Christopher Lloyd

INTRODUCTION

GOOD THINGS TAKE TIME. THIS BOOK TOOK TWENTY-FIVE YEARS.

It's true. In Spring 1990, when Bob Zemeckis and I were in postproduction on *Back to the Future Part III*, we thought there should be a big coffee-table book about the trilogy, with photos, artwork, and a look behind the scenes at how we made these movies. And even then, we knew that Michael Klastorin was the perfect guy to write it. Michael had been our unit publicist on the sequels, and his unusual duty was to *minimize* publicity. You see, we wanted certain aspects of the sequels to remain secret, and we didn't want hordes of visitors showing up while we were shooting. Michael comported himself admirably. He was—and remains—smart, knowledgeable, funny, and a damned good writer. And, most important, he *wanted* to write this book. Unfortunately, back then, nobody in the US publishing business thought our trilogy warranted such a volume.

Luckily, Michael never gave up on his dream to do this book and do it right. In 2009, with our twenty-fifth anniversary just a year away, Michael again pitched the project. Once again, no takers. According to the studio, the interest in these types of books was evaporating. But five years later, with our even more important thirtieth anniversary on the horizon, Michael went back to pitching the book. And what had become increasingly clear in those five years was that the kids who had grown up watching our movies were now in positions of power throughout society. They were decision makers in various fields. And their love for Back to the Future had only increased over the decades. Many of them were parents, and they were sharing their love for the movies with their kids, and (to paraphrase Marty McFly) their kids loved them, too. Enter Robbie Schmidt at Insight Editions. She got it, she too wanted to share the love, and she pulled the trigger. Thank you, Robbie!

Of course, nothing ever gets done as quickly as we'd like, so when the contracts were finally signed, Michael realized there just weren't enough hours in the day to get the book completed for October 21, 2015, the date of the future sequences of *Back to the Future Part II*. So he got some help in the person of Randal Atamaniuk. I had met Randal at several BTTF events and knew him as one of our überfans. He definitely had the passion to be part of this, and the writing ability as well.

Because Bob Zemeckis and I wanted this to be *the* book, we gave Michael and Randal unprecedented access to our old files, papers, memos, scripts, artwork, and material, which we hadn't looked at in decades. We dug up things we'd forgotten about, most of which had never been seen by the public. Universal and ILM gave them access to their archives, and you'll see photos that have never before been published. There is a *ton* of great stuff in here!

We contacted everyone with whom we were still in touch from the trilogy (a long list, I'm happy to say), told them the project had our blessing, and urged them to do an interview. The response was overwhelming. Michael and Randal got scores of interviews, stories, and eyewitness accounts.

Now, any police officer or trained memory expert will tell you that eyewitness testimony is the most unreliable testimony there is. And twenty-five or thirty years after the fact, it's even more unreliable. That's not surprising. We are all the heroes of our own life stories, and we all want to look good. As we tell

OPPOSITE Bob Gale with Lea Thompson on the set of *Back to the Future Part II*.

BELOW On the set of *Back to the Future Part III*, Bob Gale (second from left) consults with Robert Zemeckis, Steve Starkey, and Neil Canton.

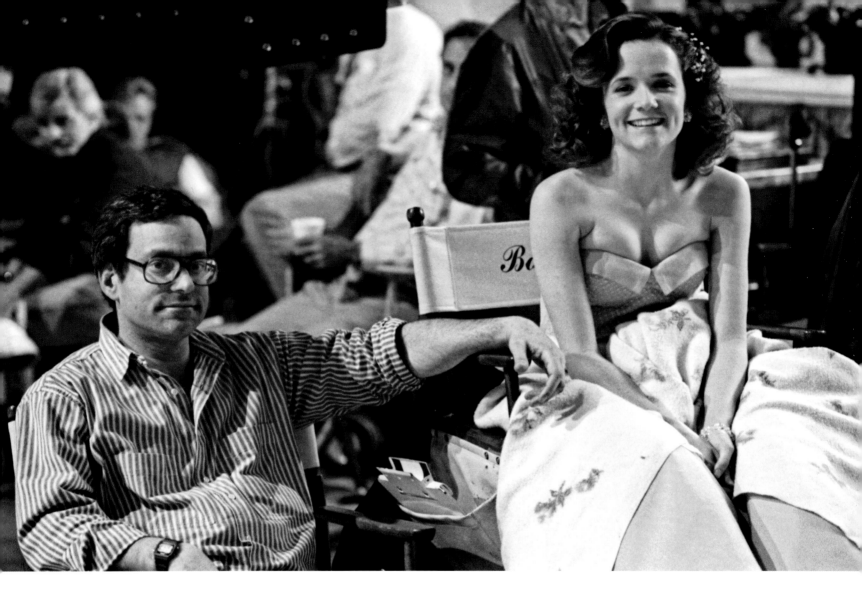

and retell our stories, we embellish here and there, sometimes putting ourselves front and center into incidents in which we may have only been bystanders. I'm guilty too—in the course of locating material for this book, I found an old memo I wrote that contradicted the way I'd been telling a story for years.

Luckily, the authors had access to multiple memory streams and lots of documents to guide them through the morass of uncertainty. Nevertheless, there were conflicting versions of events that couldn't be resolved. Nor was there room to include every great anecdote and every great image. So although this may not be a perfect history, as Bob Zemeckis would say on the set after yelling "cut" and completing a take: "It's perfect enough." And until we have a real time machine to do ultimate fact-checking, or an expanded four-hundred-page version, I'm certain this book will remain "perfect enough" for a long time to come.

As the saying goes, "Success has many parents, while failure is an orphan." So prepare to go back in time and meet a whole lot of proud parents.

Bob Gale

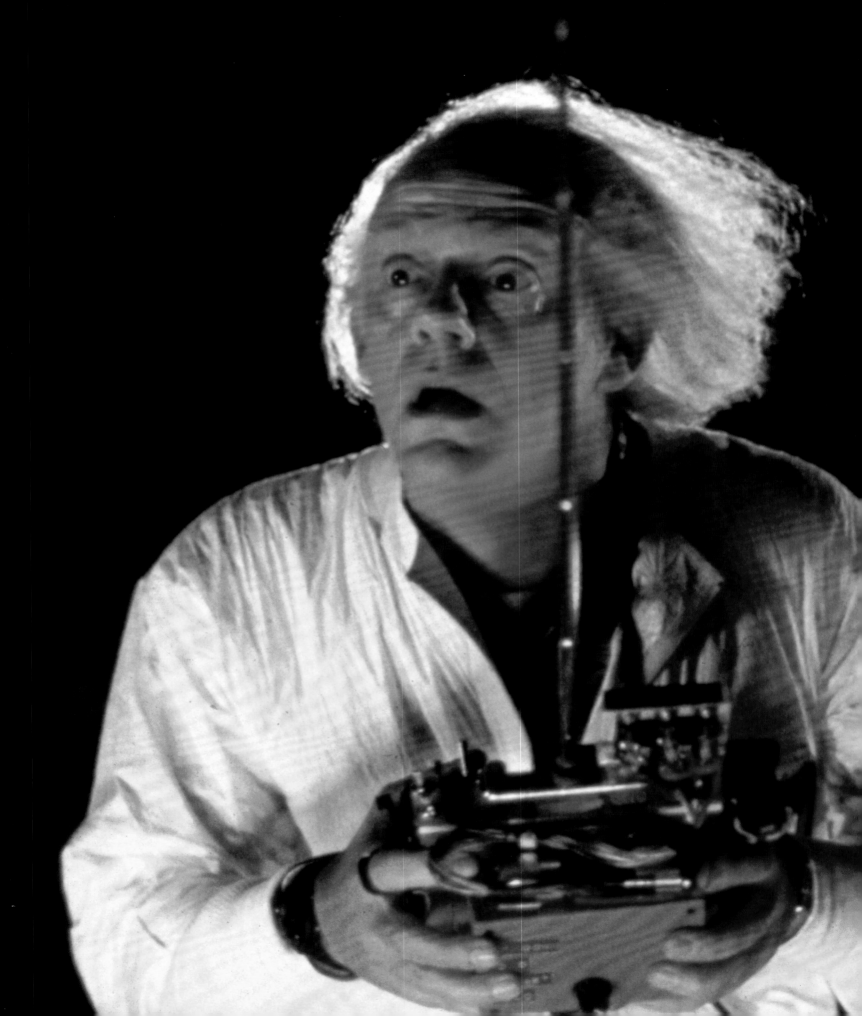

PART ONE

THERE WERE ONLY around ten college juniors among the forty-seven pupils—mostly graduate students—in the USC Cinema 290 class of September 1971. Among them were two youths from the Midwest. Robert Zemeckis, a native of Chicago, had spent his freshman and sophomore years at Northern Illinois University. His class-mate Bob Gale, born and bred in St. Louis, had come to USC after his freshman year at Tulane. The two became fast friends and quickly discov-ered a shared love of movies. "Not film," stresses Bob Gale, "but *movies*—we didn't want to make art films or documentaries. We wanted to make big Hollywood movies."

As they went through the two-year film program, they quickly established their goals. They didn't want to work their way up from the bottom of the industry as apprentices or production

ABOVE Robert Zemeckis (left) and Bob Gale (center) with Kurt Russell on the set of *Used Cars* in 1979.

OPPOSITE Zemeckis behind the camera on *I Wanna Hold Your Hand* in 1977.

assistants. They wanted to start at the top. Says Gale, "Bob Zemeckis wanted to be a director, and I wanted to be a writer, so we thought: Let's finish school and go make a movie."

Their first official collaboration came in their senior year when Gale told Zemeckis an idea he had for a low budget horror movie: "It was a vampire movie called *Bordello of Blood*. Bob loved it, and said we should start writing it immediately, which we did." Immediately after graduation, they made numerous attempts to produce the project to no avail. (It was eventually produced in 1996 as a feature film under the *Tales from the Crypt* banner.)

Concurrently, Zemeckis made a contact that would shape the future of the team. Steven Spielberg had previously visited USC and screened his first feature, *The Sugarland Express*, for the film students. Zemeckis and Gale were totally taken with the film but more amazed that "he had done this huge production, and he wasn't much older than we were. He was like us," says Gale.

Zemeckis had won one of the very first Academy Awards® for student films with *A Field of Honor*, the story of a man recovering from PTSD who is besieged by a chain of events that seriously (and comically) hampers his road to recovery. The film featured riots, shoot-outs, and an out-of-control careening bus, all accompanied by the classic Elmer Bernstein score from *The Great Escape*.

With his film under his arm, Zemeckis headed to the Universal Pictures lot and walked straight into the office of Steven Spielberg.

Spielberg watched the short and was very impressed. While he could offer no immediate help to the aspiring director, he did invite Zemeckis to stay in touch.

Zemeckis and Gale's next encounter with Spielberg would begin their professional relation-ship. They had gotten their break via writer / director John Milius, another USC alumnus. "In the first half of 1975, we used our USC connection as a way to meet him and ask if he'd read a spec script we had written," explains Gale. "He read it, liked it, and decided to do for us what Francis Ford Coppola had done for him in hiring him to write *Apocalypse Now* when he'd just gotten out of USC. He asked if we had any ideas, and we told him we wanted to do a comedy about the L.A. air raid of 1942." Milius was aware of that incident and hired the duo to write the World War II comedy *1941*, their first paid job. Milius related the plot to Spielberg, who then asked to read it. Shortly thereafter, he committed to direct.

"After that," says Gale, "whenever we wrote a script, Steven would ask, 'What are you guys working on? Let me read it when you're done.'" "We took everything to him," adds Zemeckis. "Why not? We had Steven Spielberg's ear." Spielberg's enthusiasm for their writing led to Zemeckis's directorial debut for Universal Pictures: *I Wanna Hold Your Hand*, a comedy scripted by the duo about a group of fanatical teenagers trying to meet the Beatles during their first trip to New York. Spielberg served as executive producer on that film and—alongside Milius—on their next: Columbia Pictures' irreverent comedy *Used Cars*.

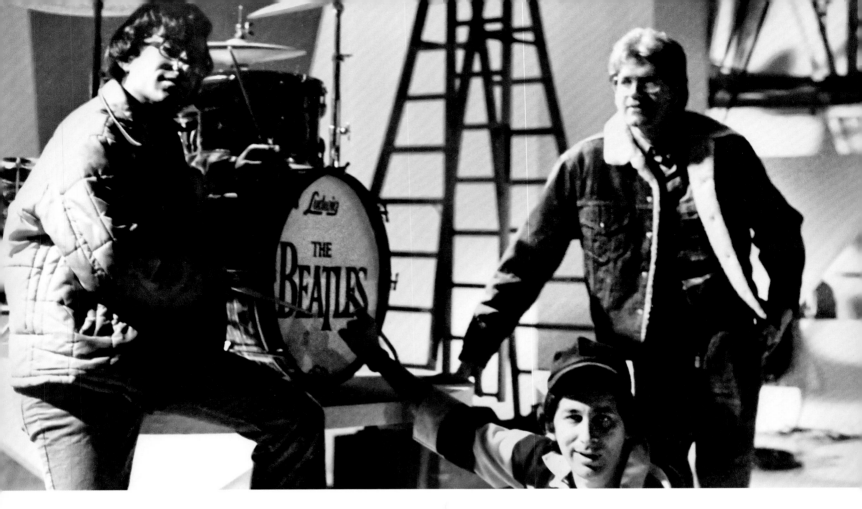

BACK TO THE BEGINNING

AS EARLY AS 1975, Zemeckis and Gale had toyed with the concept for a time-travel movie. Relates Zemeckis, "We kicked around the idea that if you went into the past and changed something, the present you returned to would be how they envisioned the future in the time you just came back from." Adds Gale, "We got talking about the General Motors Futurama exhibit at the 1964 World's Fair and the Norman Bel Geddes future that was depicted at the 1939 World's Fair. Why didn't we ever get the future we were promised? So we thought it would be cool to make a movie where that actually became the future. And I got a title in my head: 'Professor Brown Visits the Future.' No story, just a title. We didn't come up with the hook until much later."

That "hook" was found in the summer of 1980 when, on a promotional tour for *Used Cars*, Bob Gale had the occasion to stop at his parents' home in St. Louis. As he leafed through his father's high school yearbook, he stopped to wonder if he and his father would be friends if they had met in high school.

Gale shared the notion with Zemeckis who felt it was exactly what they had been looking for. They didn't want to do a film that involved a major historical event or figure of the time. They wanted to do a time-travel story where the audience didn't have to know anything about history to enjoy it. "We put all the history you need to know in the first ten minutes of the story," says Gale. Given the new premise, they could explore a more personal story with far more comedic implications. "When you were a kid, did your father or mother ever tell you all the tough things they did as a kid?," mused Zemeckis. "Walking twelve miles to school through the snow and doing their homework on a shovel? Wouldn't it be really interesting to go back and see if they really *did* walk through those blizzards?"

After taking a few weeks to construct their basic outline, Zemeckis and Gale met with the head of Columbia Pictures, for whom they had just made *Used Cars*. "We went to Frank Price and said, 'Modern-day kid finds a time machine, goes back, and meets his parents.' He said 'Sold.' We sold the pitch in literally thirty seconds," recounts Zemeckis.

Approximately six months later, on February 24, 1981, they delivered their first draft screenplay.

INETEEN *Forty*

CLASS OF JUNE, 1940

OFFICERS

MARK GALE - - - - - - - - *President*

THE FIRST AND SECOND DRAFTS

THE FIRST DRAFT of *Back to the Future* contained many of the set pieces audiences would come to know and love, but, as with the development of most scripts, there were a number of refinements made over the course of the process.

When first introduced, Marty McFly is more streetwise: he and "Professor" Brown run a video-pirating business from the third floor of an abandoned movie theater. "We wanted to show that Marty was an operator, anti-establishment, a rebel, and a huge contrast to his father, George," says Gale. "Video piracy was still new in 1981, with prerecorded movies retailing for $70 in stores." For Brown, the extra income was a way to fund his experiments and to pay for the care and feeding of his pet organ-grinder monkey, Shemp.

In the initial draft, Brown is obsessed with finding the chemical ingredient to fuel his latest invention: a power converter that turns radiation into energy. He's got the radiation part covered, having "borrowed" some plutonium from a California power plant. But it's Marty who stumbles on the crucial ingredient Brown has been searching for: Coca-Cola, which Marty accidentally spills into the device.

After the professor reveals the time machine to Marty and sends Shemp two minutes into the future, Marty comes up with the idea of going back to the immediate past with some racing results to make an easy buck by placing surefire bets. Brown refuses, so, while the scientist isn't looking, Marty makes an adjustment to the machine from "future" to "past." Then, agents of the Nuclear Regulatory Agency, tracking the stolen plutonium, burst in on the second experiment, shoot the professor, and cause the machine to send Marty much further into the past.

Now stranded in 1952, Marty finds the younger Professor Brown's address but, while walking by the future McFly home, he encounters his seventeen-year-old mother, Eileen. Having passed out from sensory overload, he is awakened by Brown, who was called by Eileen's mother after she found the professor's number in Marty's pocket.

Marty proves to the professor that he is indeed a time traveler by revealing the power source necessary to make the prototype time machine functional. But in 1952, there is no easily accessible source of radiation.

It's not until the halfway point of the first draft that Marty encounters the young versions of his father, George, and bully Biff Tannen at the high school. (In 1982, Biff is a security guard at the local country club who makes weak-willed George's life miserable.) In short order, Marty accidentally beguiles Eileen and derails his parents' destiny. After Brown explains the possible consequences of his actions, Marty must find a way to get them back together.

It was in this draft that Zemeckis and Gale created one of the most memorable sequences of the movie: the skateboard chase. "We wanted to come up with some '80s things that Marty could 'invent' in the '50s," explains Gale. "Rock 'n' roll and skateboards were the ones that worked best."

The writers also created a situation in which Marty withheld vital information from the professor in order to stay in 1952 and pursue his musical opportunities by inventing rock 'n' roll. It's at this point in the script that Marty realizes his actions will not only endanger his own existence but adversely affect the people he loves. As a result, he gives up on his fame-grabbing scheme.

02

FADE IN:

EXT. OUTER SPACE

The MOTHER SHIP rises above Devil's Tower and sails off into space to the strains of John Williams. In a moment we realize that we're watching the end titles of "Close Encounters", and then we

PULL BACK TO REVEAL

that the image is on a TV monitor...as we continue PULLING BACK, we discover a bank of video equipment, and "Close Encounters" is being pirated, from 3/4" cassette to VHS and Beta.

INT. VIDEO WORK AREA - LABORATORY - DAY

The video pirate operating this equipment is MARTY McFLY, 17, a good looking kid who has an air of confidence just shy of cockiness. He's wearing a silver Porsche jacket, and like most typical modern day kids, not a stitch of his clothing is without some brand name or form of advertising. He's looking at an ad for a guitar amp in ROLLING STONE.

With the movie over, Marty shuts down the equipment, ejects the cassettes, and writes on them, "Close Encounters, Original Edition."

He puts the master tape back in a drawer, and we catch a glimpse of a few other titles---"Empire Strikes Back," "Stir Crazy," "Superman II."

MARTY

packs up his cassettes with his school books and takes us into ANOTHER PART OF THE LABORATORY. The lab is a huge room, and workbenches are all over, covered with chemical and electronic equipment. The place is old and dusty and has the air of a mad scientist lab of the 50's.

An ELDERLY MAN is hunched over an experiment on one side of the lab. Marty calls to him.

 MARTY
 Professor Brown! It's almost
 8:30---I'm outta here!

 PROF. BROWN
 Ssshhhh!

PROFESSOR EMMETT BROWN, late 60's, is tinkering with a device that looks like a Solar Cell, positioning it under a skylight to catch the sun's rays. He is eccentric, moody, but basically kindly. And very involved in his work.

 CONTINUED

02

OPPOSITE TOP LEFT Bob Gale, Steven Spielberg, and Robert Zemeckis during the filming of *I Wanna Hold Your Hand* in 1978.

OPPOSITE BOTTOM LEFT The photo that started it all: the high school yearbook of Mark Gale (father of Bob Gale).

ABOVE The first page of the original draft of the *Back to the Future* script.

17

As in the final film, this script includes Marty's plan for George to "rescue" Eileen, although in this instance their first kiss was to be at the "Springtime in Paris" high school dance to the strains of "Turn Back the Hands of Time." The complication of Biff's arrival and George defeating the bully with a punch also appear in this draft, as well as Marty's performance of "Johnny B. Goode."

The final act differs the most from the *Back to the Future* that fans know and love. This finale details an elaborate plan to harness the radiation of an atomic bomb in order to trigger the time machine and return Marty to 1982 via a time chamber built into a lead-lined refrigerator. Using knowledge that Marty had learned from a 1982 class about nuclear testing, the duo travels to Nevada's atomic testing grounds where Marty has to overcome last-minute complications in the form of an attack by the US Army to get home.

Back in the present, Marty emerges from the refrigerator, buried under desert sands, and is met by Brown in his Aero-Mobile (a flying car), an invention made possible by his advance knowledge of the Coca-Cola power source. Marty soon sees additional ramifications of his trip to the past. The left hook that George used to fell Biff has led him to become middleweight boxing champion of the world. George is also happily married to Eileen. Professor Brown's other inventions have become a mainstay in a society that now resembles the future

20

CONTINUED

 PROF. BROWN
 Get behind the shield! I'm about
 to release radiation!

Marty hurries behind the shield.

Professor Brown pulls the rope ever so slightly.

The Power Converter is activated! The low frequency hum of vacuum tubes becomes more intense---the frequency begins to rise, accompanied by the crackle of static electricity!

Shemp looks around, curious about all of these sounds...the sounds grow in intensity...tension builds...and at exactly 9:00, Professor Brown releases the rope. At that moment, a high frequency tone is emitted, accompanied by a FOCUSED BEAM OF BLINDING RED LIGHT---like a spotlight--- which hits Shemp!

Shemp disappears! And the top half of the stool disappears with him, leaving the lower halves of the legs (which were not hit by the beam) to topple to the floor!

Air rushes through the lab to fill the vacuum that was created by Shemp's disappearance!

The sound of the equipment dies down, and a stunned Marty McFly steps out from behind the shield.

 MARTY
 Jesus!! Professor, you just dis-
 integrated Shemp!

 PROF. BROWN
 No, Marty. Shemp's molecular
 structure is completely intact.

 MARTY
 Then where is he?

 PROF. BROWN
 The appropriate question to ask
 is when is he. You see, Shemp has
 just become the world's first time
 traveller. I've sent Shemp into the
 future---two minutes into future, to
 be exact.

 MARTY
 The future? What are you talking
 about? Where's Shemp??

 PROF. BROWN
 Shemp is right here in this room
 ...two minutes from now. And at
 exactly 9:02, we'll catch up to
 him.

 CONTINUED

21

CONTINUED

 MARTY
 Now hold on a minute, Professor.
 Hold the phone! Are you trying
 to tell me that this---all of this
 here---that this is---it's a---a---

 PROF. BROWN
 A time machine.

Marty has to sit down to take this one in.

 PROF. BROWN
 I always knew it would work. I knew
 it would work when I built it 33 years ago.
 But I was never able to harness enough
 power to test it. Power is the key.
 Massive amounts of energy to accelerate
 matter to the speed of light while creating
 an intense gravitational field. But
 generating that kind of energy has never
 been possible...until the discovery of the
 formula for my power converter.

Professor Brown pours a bottle of Coca-Cola into the Power Converter.

 MARTY
 You mean it's Coke? Coke is the formula
 you've been looking for all these years?

 PROF. BROWN
 Precisely. Shemp, in his simplistic
 wisdom, poured some in the Power Converter
 this afternoon...and Eureka!

Brown takes on the characteristics of a tour guide as he explains the machine.

 PROF. BROWN
 The Power Converter, now operating at peak
 efficiency, channels energy into the Flux
 Capacitor, which releases several jigowatts
 in a fraction of a millisecond. Electron
 acceleration takes place here...and the
 result is the temporal displacement beam you
 saw a few moments ago. The entire process
 is triggered when I release the rope.

 MARTY
 I thought that Power Converter thing operated
 on solar energy. There's no sun.

 CONTINUED

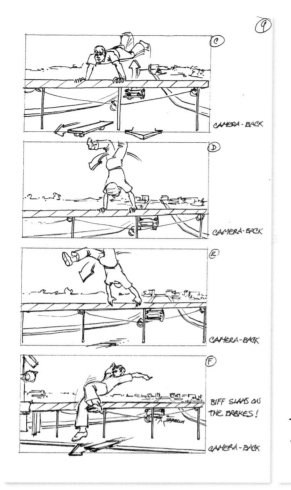

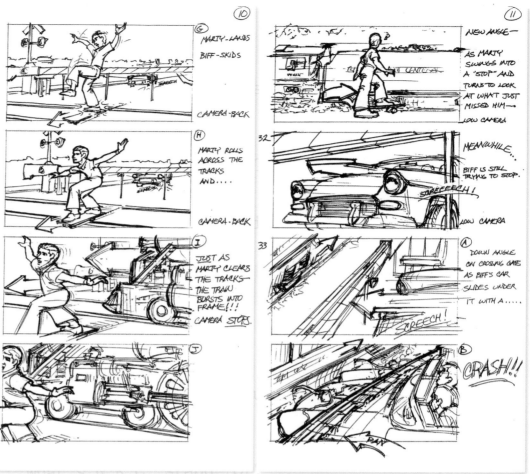

envisioned in those world's fairs that so fascinated Zemeckis and Gale. And, since rock 'n' roll was never invented, everybody does the mambo.

The Columbia Pictures studio execs read the draft and gave the team notes. Combined with some new ideas of their own, Gale and Zemeckis completed their second draft, dated April 7, 1981, some six weeks after their original submission.

In this draft, Marty is still a video pirate. Shemp has evolved into a chimpanzee, and it's the primate who unwittingly pours the Coca-Cola into the power converter, sparking it to life.

Biff Tannen is now the "bad cop" of the town, shaking Marty down for copies of pirated movies.

At home, Marty's mother has undergone a name change to Mary Ellen, and Marty now has a brother, Dave, and an unnamed sister. "Dave was someone Marty could complain to about their parents," says Gale, "but in subsequent drafts, we put that info into new scenes with Marty's girlfriend, Suzy [who would later be renamed Jennifer]."

Marty is still a musician, and when his band is rejected for the school dance, he talks about his dream to play at his school just once before he graduates. He no longer pursues the idea of inventing rock 'n' roll in the past. "We realized the audience would already know his plan was doomed to fail,"

says Gale. "So in this draft we gave him a dream that he could actually fulfill."

When he gets to 1952, Marty interrupts a young Biff from making unwanted advances on a young woman in a parked car, and the girl escapes his clutches. She turns out to be Mary Ellen Gaines (or MEG), Marty's future mom, and she's completely taken with her rescuer.

It's in this draft that Zemeckis and Gale introduce the device that sees Marty's siblings fading from a photograph following his inadvertent meddling with the space-time continuum. Marty still invents the skateboard but gets away from Biff by zipping in front of an oncoming locomotive. Biff crashes into the lowering crossing gate, and the train rips off his car bumper.

The second draft basically mirrors the first from this point on with only minor changes in the nuclear test site finale.

Back in the present, Brown again arrives right on time to meet Marty in the Aero-Mobile. At home, bad cop Biff Tannen is now the good cop. As Marty goes to the window, he sees the city skyline, but it's like no skyline he's ever seen. "What do you think?" asks Brown. "It's not exactly the way we pictured the future in 1952, is it?" Replies Marty, "No, but I think I'm gonna like it here!"

OPPOSITE Script pages show the scene from the second draft in which Professor Brown sends his pet chimp, Shemp, two minutes into the future.

ABOVE Storyboards by Andrew Probert depicting the original finale of the skateboard chase.

INTERMISSION

AFTER THEIR SUBMISSION of the second draft, Gale and Zemeckis didn't get additional revision notes from the studio. Instead, they got word from Columbia's Frank Price that the studio was dropping the project.

According to Gale, the studio felt the script was "too soft . . . more fit to be a Disney movie."

Zemeckis and Gale were hesitant to actually take the project to Disney, so they submitted it to every other studio in town. Much of the feedback they received was the same as from Columbia. Not enough edge. After double-digit rejections, they reluctantly submitted it to "the Mouse House." But in the early 1980s, Disney was still firmly rooted in wholesome, family entertainment and deemed that a film that featured a mother falling in love with her son, no matter what the circumstances, was far too risqué to be made under the Disney brand.

Even Universal Pictures, which would later produce all three *Back to the Future* films, passed. A year later, Zemeckis and Gale hired a new agent who sent the script around town again. They got back a note from Universal executive Ned Tanen that read, "We didn't like it the first time. Pass." By Gale's count, the script received more than forty rejections.

Despite these setbacks, there was one filmmaker who loved *Back to the Future* and had the clout to move it into production. Steven Spielberg had been a supporter since reading the first draft and, after Columbia dropped the project, he was ready to throw his weight behind Zemeckis and Gale as the executive producer.

Executive producer Frank Marshall remembers the excitement at Spielberg's production company, Amblin Entertainment, when they first saw the script: "We had just formed Amblin—[Kathleen Kennedy] and Steven and I—and we were looking for projects. We read *Back to the Future*, and it was fantastic. It was a really satisfying popcorn movie: unique, clever, and different. That's what we were trying to do; we didn't want to do the same old movies."

Despite Spielberg's enthusiasm and eagerness to take on the project, Zemeckis and Gale said no. "He had godfathered us as executive producer on *I Wanna Hold Your Hand* and *Used Cars*, and neither were successful at the box office," explains Zemeckis. "I literally had this conversation with him where I said, 'Steven, I love that you love this movie, but if you produce it and it's a flop, my career is over.' He nodded his head and said, 'You're probably right.' I told him I had to go and establish myself as my own entity. I can't have [him] be the guy who gets all my movies made. And he totally understood that, because he's savvy in the business. He knew what was going on."

In spite of their gracious rejection, Spielberg assured Gale and Zemeckis he was still willing to lend his support if they changed their minds.

With no other prospects in sight, the duo pushed forward on other opportunities. They wrote and then began to prep a gangster movie set in the '20s for ABC films, but, after five weeks, the studio pulled the plug. Zemeckis was particularly depressed. He wanted to direct and didn't want to keep going through the process of more development and script treatments. He told Gale that he intended to take the next decent script he was offered.

That offer came from actor/producer Michael Douglas, who had been a big fan of *Used Cars* and thought Zemeckis would be the perfect choice to direct *Romancing the Stone*. "He told me, 'I want a guy who can bring this sensibility, this kind of humor, this kind of energy to this movie,'" recalls Zemeckis.

On March 30, 1984, *Romancing the Stone* swung into theaters to rousing box office numbers and critical acclaim that rightfully identified Zemeckis as a key player in the success of the film. With an estimated budget of $10 million, it went on to gross more than $85 million worldwide.

Robert Zemeckis had his first bona fide hit and suddenly found himself besieged with numerous offers to direct other projects. But he never had any doubts about what would be his next film: "I had this ability to do any movie I basically wanted to do. I wanted to do *Back to the Future*."

Zemeckis and Gale sat down to strategize their next move. They reviewed all their options and came to the same decision. "We looked at each other and said, 'The right thing to do is to bring it to the guy who was the only fan of it.' I called Steven Spielberg and said, 'I want to make *Back to the Future*, and I want you to produce it. He said 'Great. Let's make it for Sid [Sheinberg at Universal].' And that was it."

"I thought *Back to the Future* was one of the most original things I had ever read," says Spielberg, "and felt the best place for the movie would be Universal and with Sid Sheinberg, the head of the studio and the man who broke me into the business. I was able to easily set it up there—much credit going to Bob Zemeckis and the success he was enjoying with *Romancing the Stone*, because in the heartbeat of a hit, he had become bankable."

In his capacity as studio president, Sheinberg rarely oversaw the development and production of the studio's slate of films. With one exception: If it was a Steven Spielberg project, Sheinberg would personally take charge. The relationship between the two men went back many years, as it was Sheinberg who helped shepherd Spielberg's first blockbuster hit, *Jaws*, to the big screen.

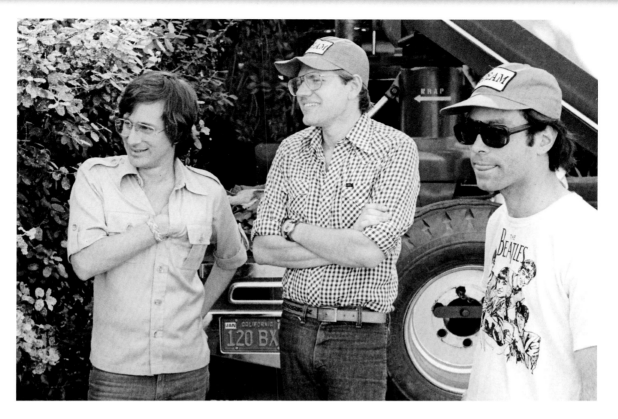

Sheinberg had not been privy to Universal's previous rejections of the script and immediately went over the second draft to give the filmmakers his notes.

His first request was nonnegotiable. "Sid was vehement that Marty could not be a video pirate," reveals Gale. "Frank Price over at Columbia had no problem with it, but Sid said he would not make a film where the lead character was a video pirate." Likewise, they had to come up with a new power source for the time machine other than Coca-Cola, which, at the time, was the owner of Columbia Pictures. While the project was at Columbia, it might have been a clever tie-in, but with the move to Universal, the beverage went flat.

Sheinberg also suggested that "professor" was far too formal a title for the character, so Zemeckis and Gale changed it to "Doctor" Brown, to which Sheinberg replied that people would confuse him with the Doctor Brown brand of cream soda that was extremely popular at the time. They shortened it to "Doc."

Both Zemeckis and Gale also remember Sheinberg requesting they change Doc's pet from a chimpanzee to a dog. Says Gale, "He was adamant we could not have a chimp in the movie. He said, 'Movies with chimps don't make any money.' I mentioned the Clint Eastwood movies *Every Which Way But Loose* and *Any Which Way You Can*, and he looked at me and said, 'That, sir, was an orangutan.' I couldn't argue with him."

Thirty years later, Sheinberg doesn't recall that conversation but offers his own take on the change: "I would have said 'Change it to a dog' with it having nothing to do with money. I am, second only to my wife, the biggest dog lover. I wouldn't advocate dogs for any reason other than Americans and most other people just love dogs." He also allows that it's very possible he did ask Zemeckis and Gale to change the name of Marty's mother from Mary Ellen to Lorraine, after his wife, actress Lorraine Gary.

Sheinberg would have other very strong suggestions as the film neared production, but, at this juncture, he sent Zemeckis and Gale off to write their third draft of the script. "We just really wrote the shit out of it and improved it," says Zemeckis.

The biggest change beyond Sheinberg's suggestions was the form the time machine would take. "That was all Bob Zemeckis's idea," explains Gale. "Originally, the time chamber was carried around on the back of a pickup truck. Bob realized there were a lot of production logistics to move it around, and he thought it would make more sense to have it in a car."

With the decision to make the time machine mobile, the two quickly fixed upon the car of their cinematic dreams—the DeLorean. John DeLorean had formed the DeLorean Motor Company in 1974, and it was his vision to create a safe, reliable, and affordable sports car that would last for twenty-five years or more. Apart from making the time machine easier to move around, its sleek, futuristic design allowed the writers to have even more fun with it in the film, particularly when devising the scene in which the DeLorean is mistaken by Farmer Peabody and his family as an invading spaceship.

The DeLorean made its debut in the third draft, dated July 11, 1984, which closely resembles the final script that would go into production.

THE THIRD DRAFT

FOLLOWING SID SHEINBERG'S DIRECTIVE, in this draft Marty is no longer a video pirate. He's a normal seventeen-year-old high schooler whose passion is music. School disciplinarian Mr. Strickland also appears for the first time, reprimanding Marty for being a slacker just like his father, George.

At the audition for the YMCA dance, Marty reveals his true acumen with the guitar, but when it's time to perform for the committee, his Achilles heel is revealed. Marty suffers from a paralyzing case of stage fright! "This was a reasonable idea," says Gale, "but it begged the question, if Marty has stage fright, why does he want to perform rock 'n' roll in the first place?"

The McFly family unit is now complete, with parents George and Lorraine and siblings Dave, Linda, and Marty. Explains Gale, "In the third draft, we realized it was better to show the dysfunctional McFlys all living at home, so that at the end, we could see that they, too, had improved."

For the first time, the writers also revealed the name of the town in which the story takes place: Elmdale, Missouri. "We imagined Marty's town as sort of a *Leave It to Beaver* Mayfield place in the Midwest—also because Bob Zemeckis and I are Midwesterners," says Gale. "We also envisioned shooting it somewhere outside of California, so in this third draft, made it Missouri. Once we decided we were shooting in California, we made it California in the story. After all, there comes a time when you have to put something on the license plates! This would, of course, be changed to Hill Valley in the fourth and final version of the script. "Hill Valley is an oxymoron," continues Gale, "but not many people get it. They tend to think of it as a play on Mill Valley in Marin County."

In this draft, Biff Tannen is no longer a cop, but George's work supervisor. "In the first two drafts, Marty has the conflict with Biff in 1985, so we needed to give Biff a job where he could both be an asshole and interact with Marty," says Gale. "When we wrote the third draft, we realized that was a mistake, and that in 1985, Biff and George should be in conflict in the same relationship they would have in 1955."

The mall at which Marty meets Doc (and his Saint Bernard, Einstein) in the early hours of the morning is the "Three Pines Mall," where the scientist reveals the time-traveling DeLorean. The plutonium that powers the car has now been taken from "a terrorist group that shall remain nameless."

After Marty sees Doc get shot by terrorists, he escapes to 1955 and crashes into the barn at the Peabody farm, but curiously, there are no pine trees to be found, much less three of them. Unlike the previous versions in which Marty met George and Biff in the high school, the scene now occurs in a very familiar manner at Lou's Cafe / malt shop.

Marty follows his future father, who falls out of a tree into the path of an oncoming car. Marty pushes George out of the way only to be hit himself. Marty awakens in Lorraine's bed, and his future mother assumes his name to be Calvin Klein, due to the logo on his underwear.

Marty finds Doc's house and tries to convince Doc that he's from the future with the aid of his driver's license, 1985 currency, and the photo of him, Dave, and Linda, but it's his knowledge of how Doc came up with the idea for the flux capacitance unit (as it is named in this version of the script) that does the trick.

Doc comes up with the idea to harness the power of the nuclear blast to send Marty home, and at this point, they discover the photograph is fading.

Marty's attempts to get Lorraine and George together are similar to earlier drafts of the script, encompassing the cafeteria, malt shop, and skateboard chase. When Marty returns to the malt shop, Lorraine is waiting for him and asks him to the dance. He turns her down, but when he relates the story to Doc, the scientist is insistent Marty accept the invitation and then figure out a way to get her and George to interact at the dance. Marty calls her back, but Lorraine has already accepted another offer . . . from Biff Tannen!

Late that night, it is Biff who receives a visit from Marty dressed as "Darth Vader from the planet Vulcan." He orders the terrified bully to cancel his date with Lorraine and to await the arrival of the *Millennium Falcon* some eighty miles out of town on the night of the dance.

Marty outlines his plan for George to "rescue" Lorraine at the dance, and George talks about being scared. Marty admits he suffers from stage fright, and to give George further confidence, he claims to have overcome it by sheer determination.

As detailed in the earlier drafts, the plan moves forward, but Biff, having been tipped off to Marty's deception, shows up unexpectedly. From there, the story proceeds as in previous drafts up to the point when Marty has to fill in for the injured Marvin Moon (as the bandleader is known in the third draft). His stage fright plagues him, and he sees George looking at him with disappointment and disillusionment. Gritting his teeth, Marty takes a deep breath and plays like he's never played before. All is restored.

In the Nevada desert, Marty tries to tell Doc about the inventor being shot, but he won't listen, so Marty writes a letter that he slips in Doc's pocket. When Doc tears it up, Marty gets the idea of returning to 1985 early enough to warn his friend.

Hearkening back to the first draft, the Army brass spot Marty driving into the blast area. This time

OPPOSITE Andrew Probert's storyboards for the original A-Bomb test site finale.

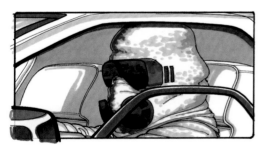

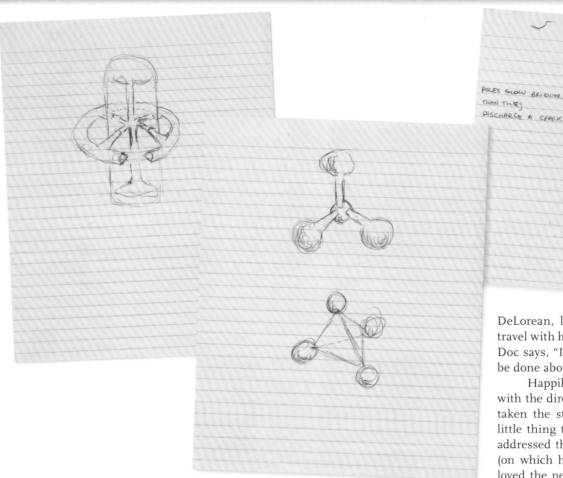

they don't fire at him. They just drop the bomb early. Marty arrives back in 1985 but is still in Nevada, 1,435 miles from Elmdale.

Driving like a maniac, Marty arrives three minutes before the shooting and runs out of gas. As in the final version of the film, Marty runs the last stretch to the mall only to watch the terrorists shoot Doc again. Doc opens his eyes to reveal the bulletproof vest and the Scotch-taped letter.

The next morning, Marty awakens to his new, improved family. George is a successful businessman and Biff's employer. The concept of the futuristic world that Marty returns to is gone. "This was an early idea that Bob Z. and I loved, but no one else did," explains Gale. "Almost unanimously, people who read those drafts didn't like the idea that Marty ends up in a world very different than the one he left, which was also very different than the real 1982." This also led to the change in George McFly's altered present. No longer would he be the former middleweight champion of the world. "George as a boxing champ was the literal extrapolation of the punch he delivers to Biff," says Gale. "But it was a bit silly and certainly didn't work when we decided not to change 1985 to 'Professor Brown's world.' So in the third draft, we basically had George and Biff switch jobs, with George as Biff's boss, although we never said what George does."

As Marty prepares to get in his new Z-28 to take Suzy Parker to the lake, Doc appears in the DeLorean, beseeching him to get in the car and travel with him to the future. When Marty asks why, Doc says, "It's your kids, Marty. Something's gotta be done about your kids!"

Happily, Sheinberg was more than satisfied with the direction in which Zemeckis and Gale had taken the story in the third draft. There was one little thing that still bothered him, though, and he addressed the issue in a memo to Steven Spielberg (on which he also copied Zemeckis and Gale). He loved the new script but found the title *Back to the Future* "less than wonderful."

In retrospect, the former studio head acknowledges, "I really missed the point of *Back to the Future*. I kept saying, 'This title makes no sense. You can't go back to the future. The part that doesn't make sense is that he doesn't really go back to the future.'" Sheinberg's point was that Marty wasn't really going to the future of 1985 but returning to the present day. What he did understand was the strength of the screenplay. "That picture is written like a Swiss watch. You can sit and watch that picture five or six times and try to catch the magician that is doing his magic, and you can't. It's a masterpiece of legerdemain."

His feelings about the title notwithstanding, based on the strength of their latest draft, Sheinberg gave them what every filmmaker dreams of—the green light. *Back to the Future* was on its way to production!

OPPOSITE The memo from Sid Sheinberg to Steven Spielberg requesting a title change for *Back to the Future*. Spielberg replied with his own memo thanking Sheinberg for the humorous note, and the subject was never raised again.

ABOVE AND BOTTOM RIGHT Early sketches of potential flux capacitors by Bob Gale.

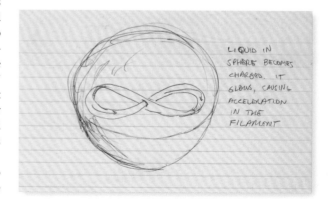

DATE	October 17, 1984
TO	Mr. Steven Spielberg
FROM	SID SHEINBERG
SUBJECT	BACK TO THE FUTURE
COPIES	Bob Zemeckis ✓ Bob Gale

Although I believe that the present draft is terrific and
I marvel at the improvements that have been made from the
"Columbia" version, I continue to believe the title leaves
much to be desired. There are a number of reasons why I
found the title less than "wonderful;" but my primary con-
cern is that it appears to make the picture a "genre" pic-
ture. I think the script (and, hopefully, the film) de-
serves a better title.

Now that I have buttered you up, I would suggest we consi-
der the title "Space Man From Pluto."

Underpinning these suggestions are the following thoughts:

 i. Modify the dialogue on Page 35 so that
 Sherman calls Marty a "space man from
 Pluto."

 ii. Modify Marty's dialogue on Page 77 so
 that he identifies himself as a "space
 man from the Planet Pluto" (instead of
 "Darth Vader from Vulcan."

 iii. Change the title of the book written by
 George and referred to on Page 130
 from "A Match Made in Space" to "Space
 Man From Pluto."

Obviously you get the idea.

I am sure there will be those who will argue that the movie
will appear to the audience to be a cheap, old-fashion sci-
fi flick. Nonsense! I think it's a kind of title that
has "heat, originality and projects fun." Most importantly
I think it avoids the feeling of a "genre" time-travel
movie.

SJS:sl

FROM ZERO TO 88 MPH

NOW THAT *BACK TO THE FUTURE* was a "go" project, the first person who would join the team was a line producer, someone with a background in the physical aspects of production who would compliment the creative talents of Zemeckis and Gale. Frank Marshall suggested Neil Canton as the ideal candidate. Canton had worked with Marshall over the course of several films, starting as the assistant to director Peter Bogdanovich on the screwball comedy *What's Up Doc?* The chemistry was perfect, and Canton was hired.

Zemeckis, Gale, and Canton set up shop in the new Amblin Offices on the Universal lot and began hiring the crew. Some of the first members had worked with the director on *Romancing the Stone*, including cinematographer Dean Cundey, production designer Lawrence G. Paull, and composer Alan Silvestri. The crucial position of first assistant director (1st AD) would go to David McGiffert, whose multitude of responsibilities would begin with breaking down the script and coming up with an expedient shooting schedule. All other departments would be guided by that master plan. Once in production, McGiffert and his team would oversee the day-to-day, minute-by-minute operations of the filming, making sure all elements for each scene were fully in place as Zemeckis rehearsed his actors and prepared to call "Action!"

McGiffert remembers his first meeting with the trio of Zemeckis, Gale, and Canton: "We were sitting in the conference room, and it was all very congenial and laid-back. Bob Z. had his feet up on the table. It was very relaxed." They talked a bit about the film, as well as David's experience. "At one point, Bob Z. said, 'McGiffert, why don't you get up on that conference table and assistant direct something for me? Show me what you do.' I looked at them and said, 'Wow, you guys really are crazy, aren't you?' and they started laughing. I somehow got out of having

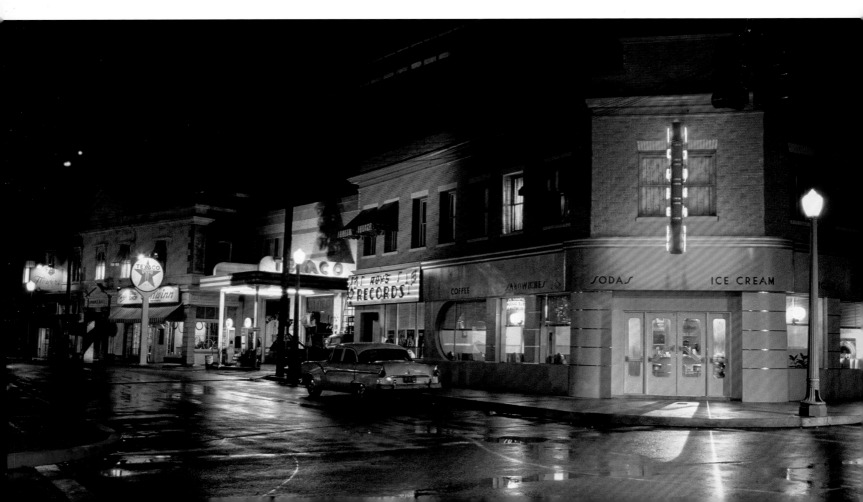

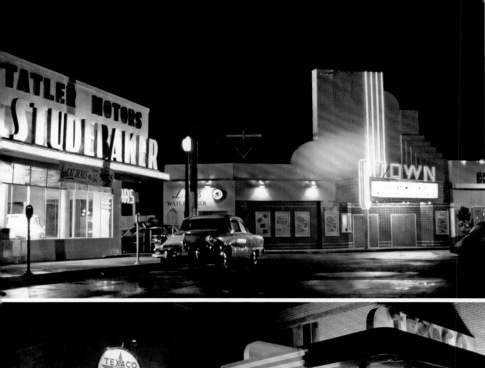

to do that, and in the midst of that, they asked me if I wanted to come and be crazy with them."

Each department head began examining the script and putting together the elements that would give the film a look that, up until this point, had existed only in the heads of Zemeckis and Gale.

A pair of location scouts went to Northern California to find a town that could be transformed into Hill Valley. "We scouted Petaluma in the Sonoma county area," recalls Bob Gale. "It was where Joe Dante shot *Explorers*, and we liked it very much." Knowing they would need a train for the end of the skateboard chase, they also traveled to Sonora, California, which would ultimately become the location for *Back to the Future Part III*.

But there were problems with shooting the film on location. First and foremost was the financial cost. Location filming is normally an expensive proposition, and in this case, the filmmakers would have to remove and replace all of the modern fixtures to make streets appear in a 1955 incarnation. In addition, they were scheduled to begin filming in November 1984, so they would have to deal with the barrage of Christmas decorations customary to the holiday season.

Paull had come onto the production just after the location scouts had begun their search and thought there was a much simpler solution: "I went out to the Universal back lot, and I discovered that all the elements could have been put there for [*Back to the Future*]. I walked Bob [Zemeckis] through what I thought could be Hill Valley. It had the corner drug store / diner where the kids hung out, and there was a municipal building in the center of the square. One of the things that filmmakers like is total autonomy in what they're doing—total control over everything. It basically came down to a big meeting where I pitched the back lot again to everyone involved—Frank Marshall and Kathy Kennedy were there, as well as Bob and Bob. Everyone was pleasantly surprised it could be done right there."

Even before Paull joined the production, illustrator Andrew Probert had been hired to storyboard the major action scenes of the film. "I was called in to interview, and I didn't know anything about the film," says Probert. "It had the word *future* in the title, so I was hoping it involved some design work, because that's what I enjoy doing the most. Things involving the car and action are typically the

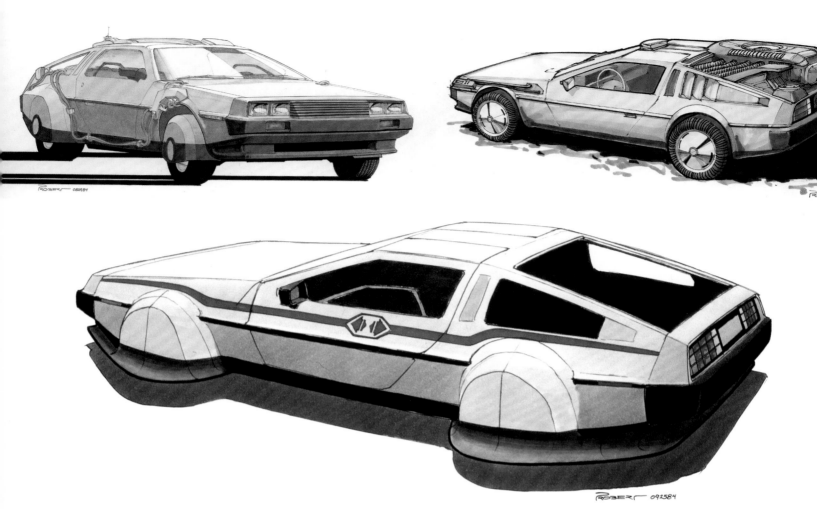

things a storyboard artist excels in." In addition to the vast number of illustrations he sketched for the various scenes, Probert came up with the original logo for *Back to the Future*, which would be slightly modified by the Universal Pictures advertising department.

Concept artist Ron Cobb had worked briefly with Zemeckis and Gale on *Used Cars* and was working at Amblin on a number of projects when Steven Spielberg asked him, "How would you make a DeLorean into a time machine?" After reviewing some of Probert's illustrations and having a conversation with Zemeckis and Gale, Cobb set out to design the iconic vehicle. "I'm kind of a science groupie," says Cobb, "and I always liked a really heady mix of technology and something that would be more believable in a film. I started with the premise that Doc Brown was building this time machine in his garage and that, since he didn't have a big industry financier behind him, he was buying all this stuff from hardware stores. It would give the car a look that was modified but obviously meant to do something a car wasn't meant to do. I wanted to have the coils that surround it because they were creating a field around the car as it started the time-travel process. The other important detail that was part of my design was that, underneath it all, it was clearly a DeLorean."

The design and construction of the DeLorean would ultimately be a team effort, with design concepts by Lawrence Paull and Ron Cobb and contributions by Probert who, in his spare time, had done his own take on what the time-traveling DeLorean might look like. After Cobb's vision was approved, the artist left to join another show. Spielberg, Zemeckis, and Gale had seen some of Probert's early sketches and asked him to continue that work and embellish some of Cobb's design.

ABOVE Andrew Probert's original design sketches for the time-traveling DeLorean.

BELOW Probert's first design for the *Back to the Future* logo.

OPPOSITE Probert's storyboards show Doc presenting his ultimate invention to Marty.

TPM-6a

BROWN (MOVING TOWARD
MARTY) CONTINUES:

"WELCOME TO MY LATEST
EXPERIMENT."

TPM-6B

"THIS IS THE BIG ONE —
THE ONE...."

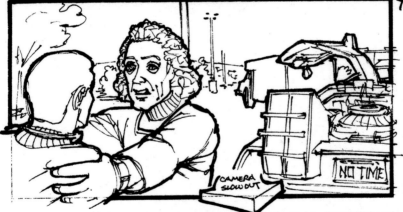

TPM-6c

.... I'VE BEEN WAITING
FOR ALL MY LIFE!"

TPM-7

WIDER SHOT AS MARTY
SAYS:

"IT'S A DELOREAN — BUT
WHAT DID YOU DO TO IT?"

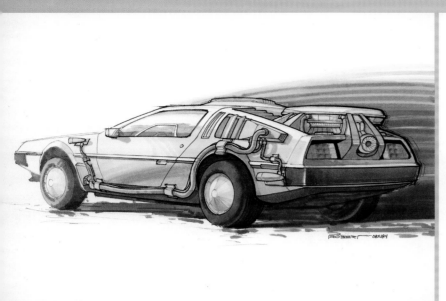
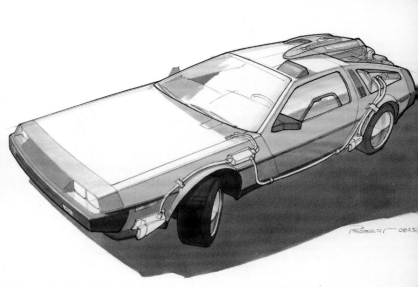
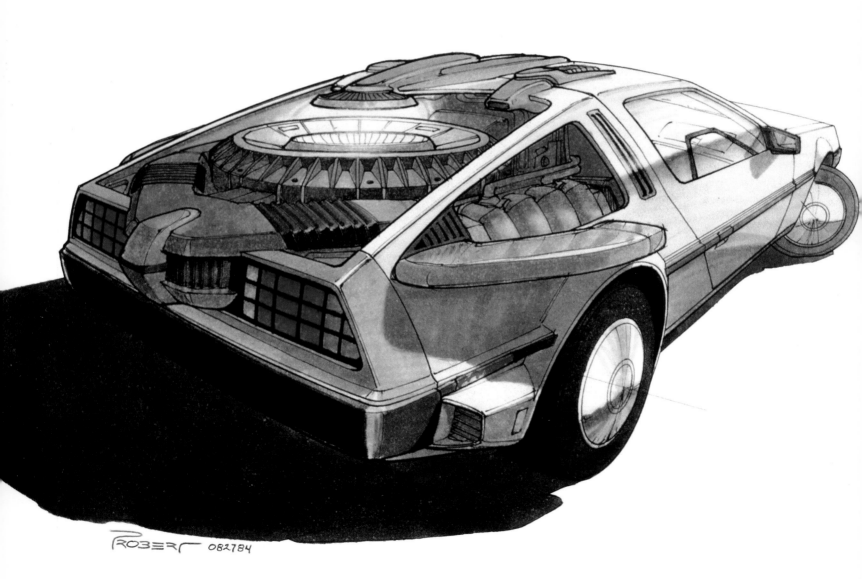

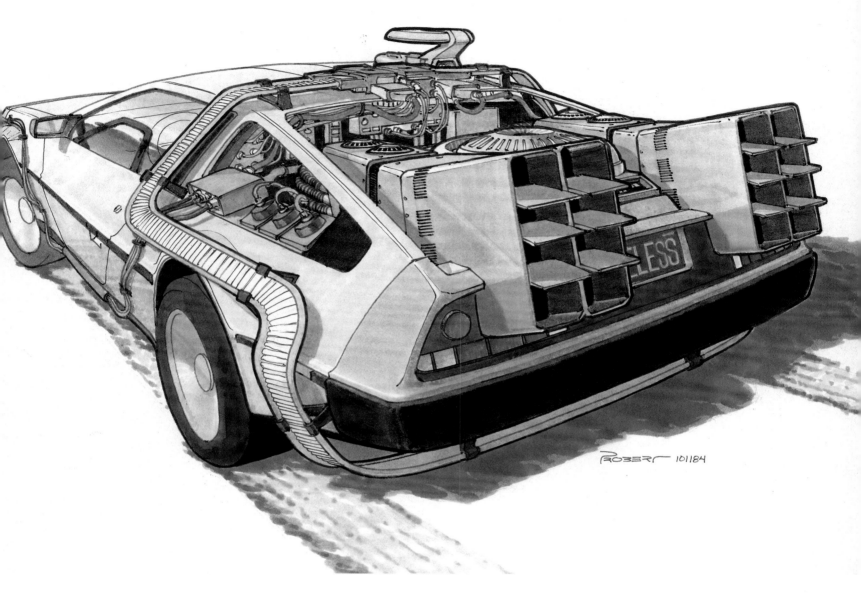

The responsibility of overseeing the creation of the actual vehicle went to special effects supervisor Kevin Pike. After joining the production in October 1984, he made a trip to Glendale, California, to visit a former DeLorean dealership that still had a large selection of cars available. Pike bought three of them at a total cost of $58,000. They would be designated the A, B, and C cars.

Shortly thereafter, Michael Scheffe, who had been instrumental in creating the "Kitt" car for the *Knight Rider* TV series, was brought aboard to supervise the refitting and reconstruction of the DeLoreans. Art director Todd Hallowell remembers how the DeLorean's distinctive look was augmented for the movie: "In the San Fernando Valley, there used to be a kind of a junkyard for the space program, because, at that time, so many suppliers to the space program were based in the area. A lot of these really specialized machine shops would be building these kind of one-off pieces of equipment for testing, but then they had no use for it, so they sold it to the

junkyard. We took a pickup truck and just bought interesting-looking bits, beautifully milled bits of aluminum that had been some kind of a fuel block for NASA or something like that. We dragged it all back to special effects and just started placing it around the DeLorean, seeing what would look cool on the car."

"We started on the A car," says Pike. "That would be the hero car, which needed the most work. The first step was disassembling it: taking off parts, cutting the back open, taking the window out, taking the

THESE PAGES Additional design sketches by Andrew Probert for the modified DeLorean.

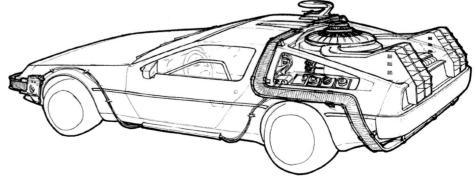

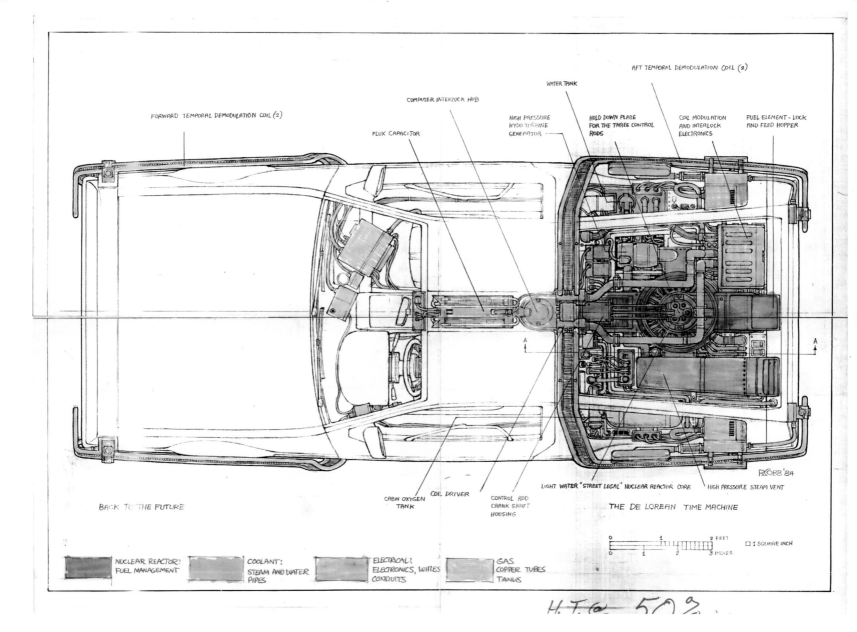

FORWARD TEMPORAL DEMODULATION COIL (2)

COMPUTER INTERLOCK HUB

FLUX CAPACITOR

WATER TANK

AFT TEMPORAL DEMODULATION COIL (2)

HIGH PRESSURE HYDRO TURBINE GENERATOR

HOLD DOWN PLATE FOR THE THREE CONTROL RODS

COIL MODULATION AND INTERLOCK ELECTRONICS

FUEL ELEMENT - LOCK AND FEED HOPPER

R.COBB '84

BACK TO THE FUTURE

CABIN OXYGEN TANK

COIL DRIVER

CONTROL ROD CRANK SHAFT HOUSING

LIGHT WATER "STREET LEGAL" NUCLEAR REACTOR CORE

HIGH PRESSURE STEAM VENT

THE DE LOREAN TIME MACHINE

NUCLEAR REACTOR: FUEL MANAGEMENT

COOLANT: STEAM AND WATER PIPES

ELECTRICAL, ELECTRONICS, WIRES CONDUITS

GAS COPPER TUBES TANKS

deck off, and then rebuilding it so that the additional pieces we had would fit when we put an aluminum deck on the exterior. We started on welding the design of the fins and laying out the pieces that would work for the size and shapes, reflected by the drawings we got. The B car was just going to be used for driving shots and only needed the goodies put on the outside. They said [the audience] would never see the inside of the B car. That was until the first day of shooting, when they came back and said, 'We need to see the dog get inside the other car' when they were going to do the driving shots. We basically had to make the B car identical to the A hero car.

"The C car was sliced up like a sausage. We cut the back off of it, and we used it for some towing driving shots and on the process stage at Universal, where we were doing rear-screen projection and blue screen at the time. We were able to put a camera inside the car."

As special effects supervisor, Pike was also responsible for a myriad of other effects throughout the film, including the trademark fire trails left behind in the wake of the car's trip into the time-space continuum.

Before *Back to the Future* went into production, there would be one more major revision to the script, and it was Sid Sheinberg who was indirectly responsible for the change. Zemeckis and company had already opted for using the Universal back lot as Hill Valley, thus saving the production millions of dollars in travel and location expenses. They were still expecting to take one trip out of the state for the climactic nuclear test site / atomic bomb detonation that would send the DeLorean back to 1985. Despite the cuts to the budget, they still needed to trim additional expenses, and Sheinberg refused to allot even one penny more.

ABOVE Artist Ron Cobb's blueprint of the DeLorean gives a detailed breakdown of its inner workings.

OPPOSITE TOP AND BOTTOM LEFT Michael Scheffe's design sketches for the console and time-circuit displays.

OPPOSITE BOTTOM RIGHT Photographs from the final DeLorean interior show how Scheffe's sketches were realized for the final film.

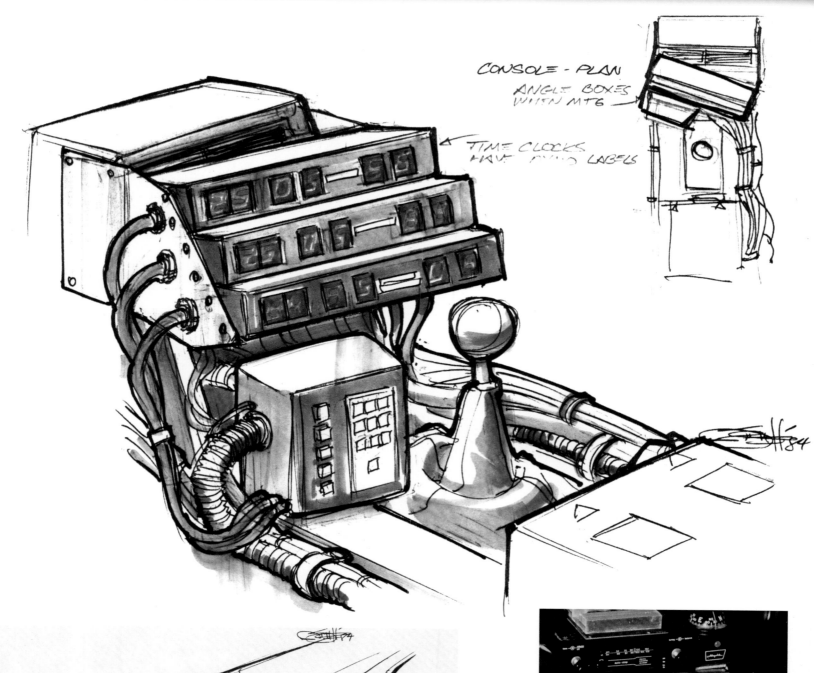

CONSOLE · PLAN

ANGLE BOXES
WHEN MTG

TIME CLOCKS
HAVE DYMO LABELS

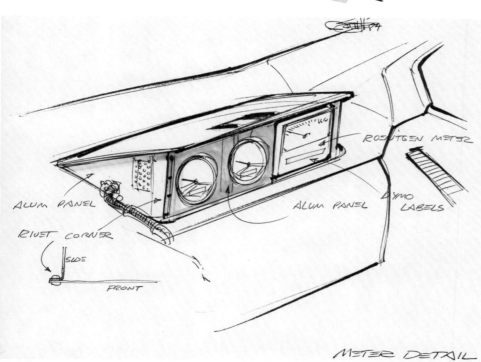

ROENTGEN METER

ALUM PANEL

ALUM PANEL

DYMO LABELS

RIVET CORNER

SIDE

FRONT

METER DETAIL

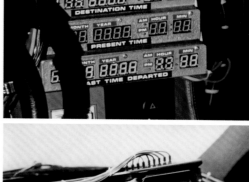

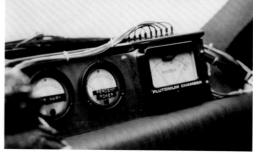

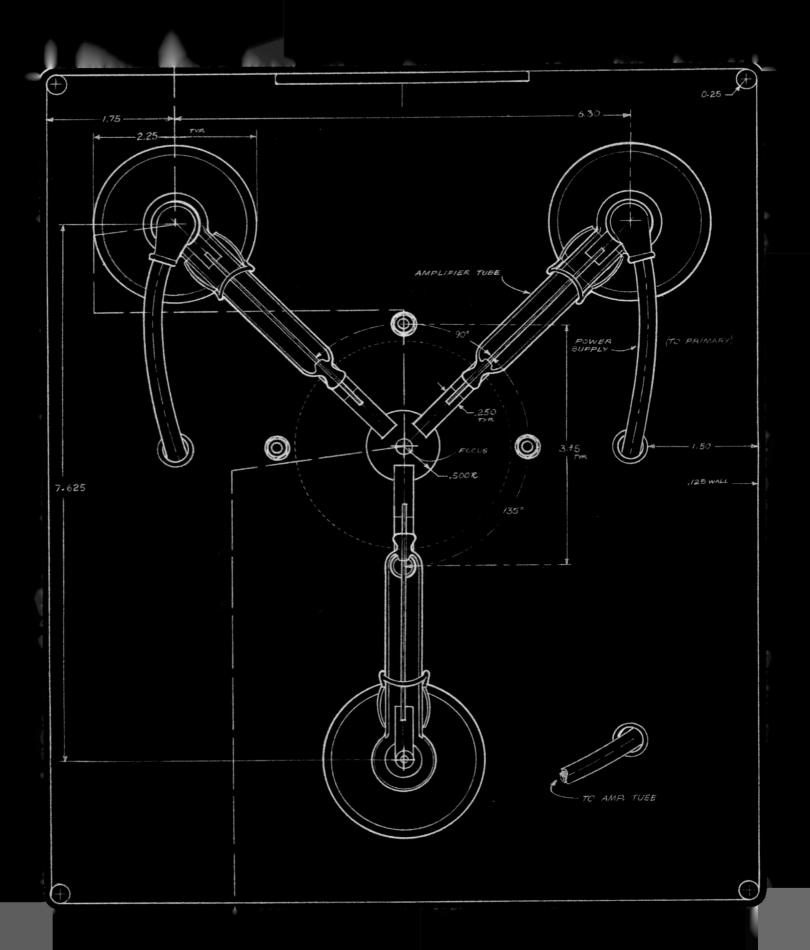

AMPLIFIER TUBE

POWER
SUPPLY

(TO PRIMARY)

90°

135°

FOCUS

.250
TYP.

.500 R

3.45
TYP.

1.50

.125 WALL

0.25

1.75

2.25

TYP.

6.30

7.625

TO AMP. TUBE

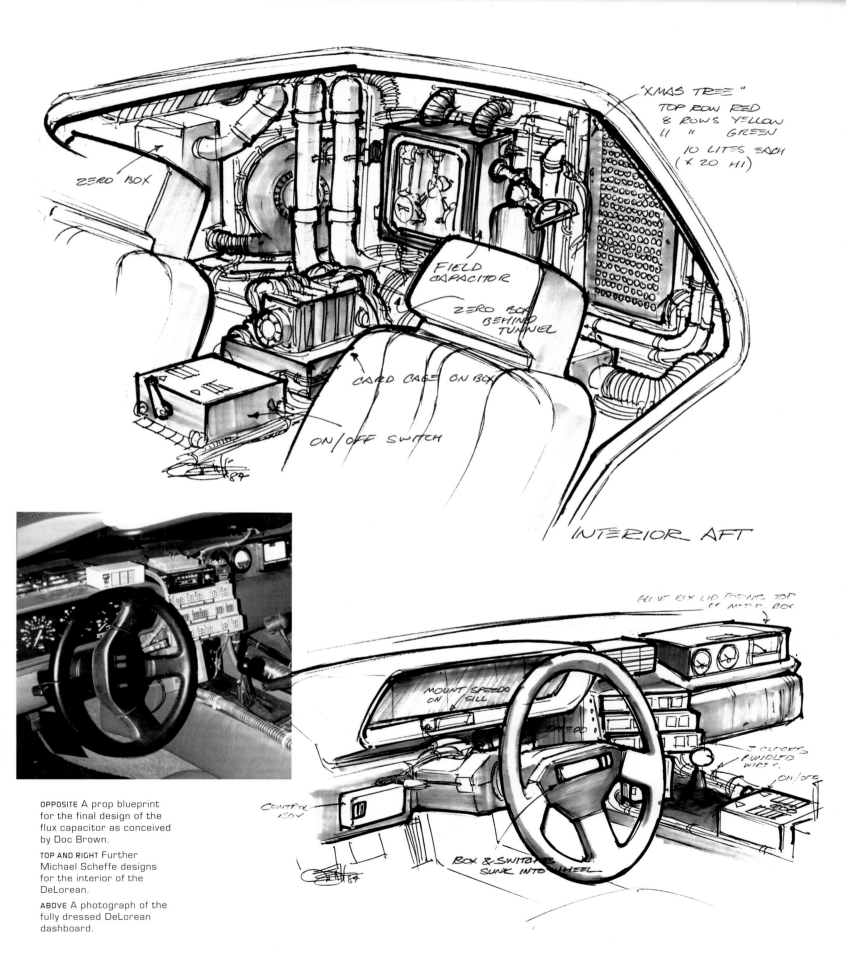

"XMAS TREE"
TOP ROW RED
8 ROWS YELLOW
11 " GREEN
10 LITES EACH
(X 20 HI)

ZERO BOX

FIELD
CAPACITOR

ZERO BOX
BEHIND
TUNNEL

CARD CAGE ON BOX

ON/OFF SWITCH

INTERIOR AFT

GLOVE BOX LID FORMS TOP
OF METER BOX

MOUNT SPEEDO
ON SILL

SPEEDO

2 CLOCKS
BUNDLED
WIRES.

ON/OFF

CONTROL
BOX

BOX & SWITCHES
SUNK INTO WHEEL

OPPOSITE A prop blueprint for the final design of the flux capacitor as conceived by Doc Brown.

TOP AND RIGHT Further Michael Scheffe designs for the interior of the DeLorean.

ABOVE A photograph of the fully dressed DeLorean dashboard.

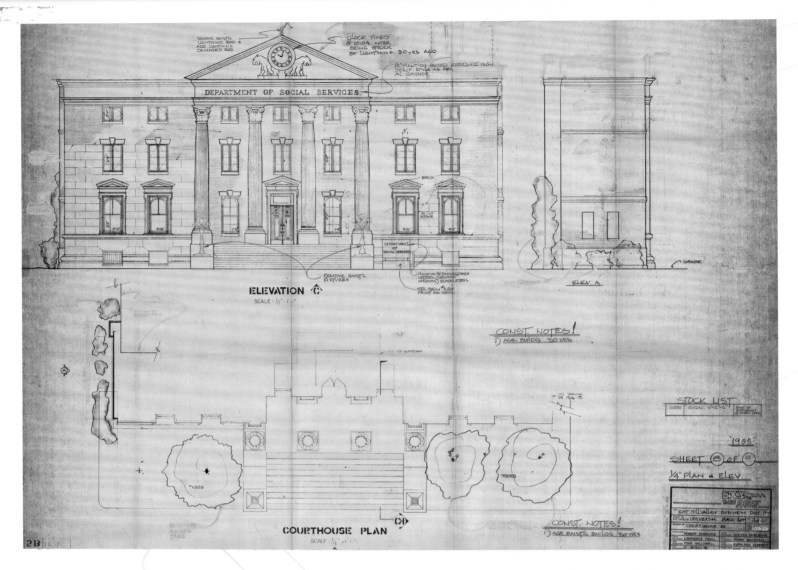

ABOVE Construction blueprints for the Hill Valley courthouse.

RIGHT A storyboard panel shows the unforgettable moment when lightning strikes the clock tower.

OPPOSITE Doc (Christopher Lloyd) hangs from the clockface constructed on Stage 12.

"The best thing that Sid did," says Zemeckis, "was that he wouldn't give us any more money to make the movie. He didn't know how, but he told us we needed to take $5 million out of the budget. We were going to go to Nevada for the sequence at the nuclear test site, and so we then had to figure out how we could get all the elements for the ending and move them to this one location that we could afford, which was the Universal back lot."

Zemeckis and Gale spent a weekend wandering the back lot, trying to devise a spectacular ending that would eclipse even an atomic bomb explosion. It was there that lightning struck. Figuratively.

"We had used lightning as the climax for *I Wanna Hold Your Hand*," says Gale, "and I don't remember if it was Bob or me, but we came up with the idea of the bolt of lightning. It occurred to us we could put a clock on the pediment of the courthouse. Once we had determined it was going to be a clock tower, it made perfect sense. It's all about 'time.' At some point, we also realized the allusion to Harold Lloyd's *Safety Last*, and when we told Steven about it, he immediately made that association. 'It was Harold Lloyd then, and now it's Christopher Lloyd,

and they're both going to be hanging on clocks. It's perfect.'"

"It was a giant improvement," agrees Zemeckis, "based on totally financial-minded, corporate orders: 'I don't care what you do. We're not giving you that money.' And you get that all the time from a studio, so there's a method to that madness. But if you're passionate and you're clever and creative, there's more than one way to skin a cat."

EXT. CLOCK TOWER — THE MOST SPECTACULAR BOLT OF LIGHTNING IN THE HISTORY OF MOVIES — STRIKES THE LIGHTNING ROD!!! CT-103

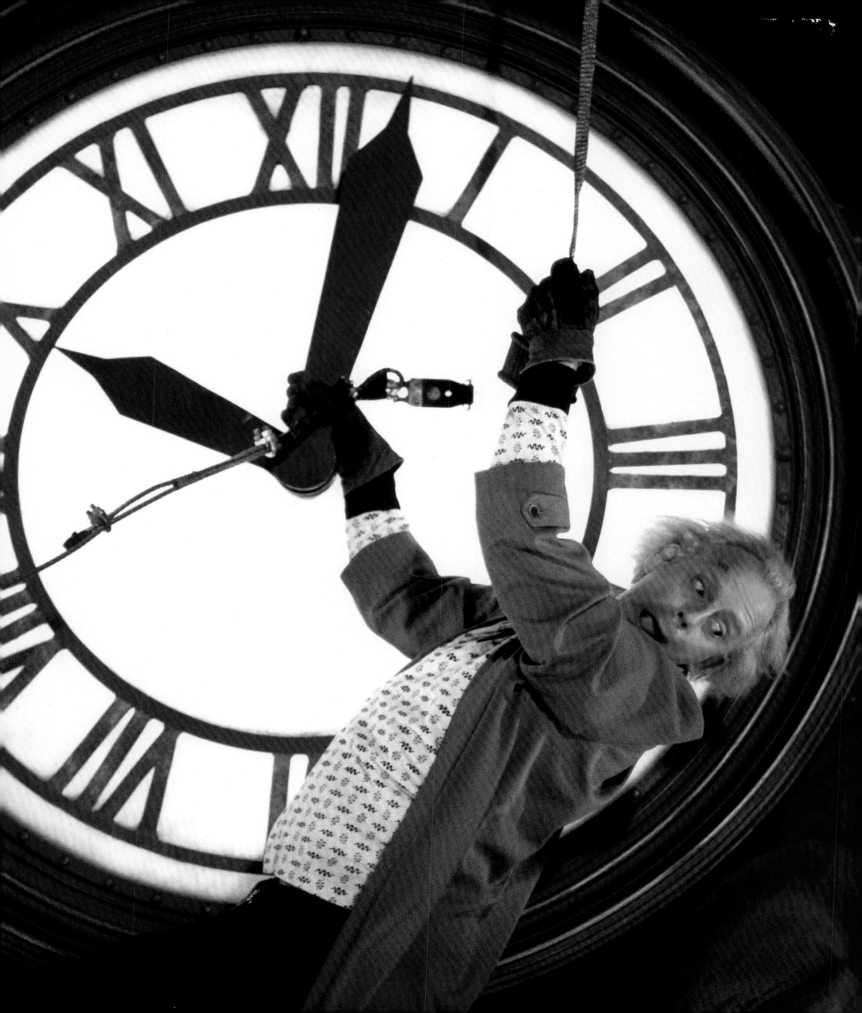

CASTING ABOUT

WHEN A MOVIE IS RELEASED, directors and producers often proclaim that the leading actor was always their first choice. It's a statement that's not always accurate because usually a great number of possibilities are discussed before one actor gets to embody that particular character.

For Spielberg, Zemeckis, Gale, et al., there was no discussion. Their unanimous choice for the role of Marty McFly was Michael J. Fox. The young star of the hit television sitcom *Family Ties* had all of the qualities that made him the perfect Marty—an affable on-screen persona, boundless energy, and an oft-demonstrated mastery of comedic timing.

Unfortunately, timing initially proved to be the undoing of the perfect match between actor and role. Fox was committed to another season as Alex P. Keaton on *Family Ties*, and circumstances on the series prevented producer Gary David Goldberg from even considering the possibility of working around his absence. At the time, the sitcom's star, Meredith Baxter Birney, was pregnant with twins, and Fox's role as Alex was greatly expanded during her maternity leave. "I love this script, Michael will love this script, and that's why I won't let him read it, because he'll hate me when I won't let him out of *Family Ties* to do it," recalls Bob Gale of the late Goldberg's thoughts on the matter.

Even though Goldberg didn't tell him about the offer, Michael J. Fox was aware of Zemeckis and Gale's movie. Ironically, Birney's pregnancy had caused a delay to the production of *Family Ties*, and Fox was able to make use of that time to take on a different movie role during a brief window of opportunity. As he sat in his trailer on the set of *Teen Wolf* in August 1984, the actor was told there was a scouting crew nearby for some big Steven Spielberg production called *Back to the Future*.

"I was on location in Pasadena, sitting in my trailer," he recalls thirty years later. "It's 110 degrees, I'm wearing latex and yak hair, and sipping my lunch through a straw. I knew Crispin Glover was going to be in this movie, and I knew Crispin. I had worked with him on *Family Ties*, and I liked him a lot, but at that moment I hated his guts. I couldn't even go to the set to meet these location people. They wanted to meet me, but I didn't know there was already a connection and that there had been conversations about me doing the movie, and I had no idea."

Although Michael J. Fox would not be an option at that time, in August 1984, the casting process for *Back to the Future* had begun in earnest.

For the role of Doc Brown, the creative team did not have an immediate candidate in mind, so casting directors Mike Fenton and Jane Feinberg, along with their associate Judy Taylor, put together a list. In a memo dated August 21, 1984, they compiled more than forty names for the role of

FENTON-FEINBERG CASTING

[handwritten: ERIC STOLTZ, C.T. HOWELL, RALPH MACCHI, KUSAK (CLASS)]

Meetings with:
BOB ZEMECKIS
JUDY TAYLOR
JANE FEINBERG

August 21, 1984

"BACK TO THE FUTURE"

Role of SCIENTIST

✓ Jeff Goldblum
~~John Lithgow~~ N/A
~~Joe Piscopo~~ N/A ?
~~Peter Boyle~~
~~Donald Sutherland~~
~~Dabney Coleman~~
~~Richard Mulligan~~
✓ Ron Silver
~~John Heard~~ N/A
✓ ~~Robin Williams~~
✓ [John Cleese]
[Tom Conti]
✓ ~~Mandy Patinkin~~ ??
~~Treat Williams~~
~~Mickey Rourke~~
✓ Gene Hackman
~~Alan Arkin~~
David Dukes ??
~~Charles Grodin~~
~~Gene Wilder~~
~~Rene Auberjonois~~

[handwritten: (2) HAROLD RAMIS]
~~(Paul Le Mat)~~
~~Albert Brooks~~
~~Chevy Chase~~
~~Steve Martin~~
~~Mark Blankfield~~
Robert Klein
✓ James Woods
✓ Chris Lloyd
~~Danny De Vito~~
~~Bob Balaban~~
~~Kevin Conway~~
~~Paul Dooley~~
~~John Candy~~
~~Henry Winkler~~
~~Eddie Murphy~~
~~Bill Cosby~~
~~Joe Bologna~~ ??
~~Cliff Gorman~~
Randy Quaid
~~Michael Keaton~~
(Deal with Fox)

~~CHARLIE MARTIN SMITH~~
[handwritten: (2) Gerrit Graham]

LEFT A memo from the casting department offers a plethora of suggestions for the role of Doc Brown.

OPPOSITE Christopher Lloyd, seen here as Reverend Jim in the TV show *Taxi*, was always the first choice to portray Doc Brown.

— 38 —

"SCIENTIST" including Jeff Goldblum, John Cleese, Gene Hackman, Harold Ramis, Steve Martin, Chevy Chase, Eddie Murphy, Randy Quaid, and Joe Piscopo, among many others.

It was producer Neil Canton who first suggested Christopher Lloyd. "When I read the script, two people came to mind for Doc Brown. One was Chris, and the other was John Lithgow, both of whom I had just worked with [on *The Adventures of Buckaroo Banzai*], and I imagined they both would have been great. Bob and Bob really sparked to the idea of Chris, so we brought him in to Amblin."

Unbeknownst to the filmmakers, the actor was not as enthusiastic to take that meeting. "I was doing a film in Mexico at the time," recalls Lloyd, "and my agent sent me the script. I was expected to read it and come back to Los Angeles to meet Bob Zemeckis. I did not know Bob Zemeckis, but I did know that Steven Spielberg was involved. At the same time, I got an offer to go back to New Haven, Connecticut, to do a play about Hans Christian Andersen with Colleen Dewhurst, and it was pretty exciting to me.

"I was having doubts at the time whether I had made the right choice to leave New York, where I was beginning to work on a steady basis in theater, and coming out [to Los Angeles] and trying to make it in film. I had a lot of misgivings about it, and I had pretty much decided I was going to go back to New Haven and play Hans Christian Andersen. That's where my roots were; that's where I belonged. Then I got the script and I read it without making any kind of commitment. That draft that I first read was pretty crazy. To be honest, I kinda had trouble trying to make sense of it. I called my agent and told him I wasn't coming back and chucked the script into the wastepaper basket."

It was Lloyd's wife at the time who reminded him of an important ethic the actor had established for himself in terms of his career: "My motto regarding getting work had always been 'Never leave any stone unturned.' I would read the trades in New York and whatever it was, if there was some inkling that maybe I might be appropriate for the part, I'd show up. After I had thrown the script away, she reminded me of that, and it made me think. I called [my agent] Bob Gersh and said, 'Okay, I'll come back and meet Mr. Zemeckis.' Upon meeting him, that was that."

"I do remember very distinctly the moment that Chris came in the room," says Zemeckis. "And he didn't say anything, because he's very shy, but I thought he was perfect. I just knew it." Zemeckis, Gale, and Canton did see other actors. "I remember meeting Jeff Goldblum, and we liked him a lot," says

Gale. "He was probably the runner-up to Chris." However, there was never really any doubt that Christopher Lloyd was Doctor Emmett L. Brown.

Some of the casting came relatively easy. Of the numerous actresses the filmmakers saw for the role of Lorraine, including Jennifer Jason Leigh, it was Lea Thompson who had all the qualities they were seeking. They were first exposed to her while viewing scenes from a film called *The Wild Life*. She fondly remembers her audition: "I remember clicking with all of the parts, the old and the young. I understood the character immediately.

AMBLIN
ENTERTAINMENT

September 5, 1984

TO: Receptionist

FROM: Gail Oliver, BACK TO THE FUTURE

Please call in passes for the following people:

TIME	NAME	ROLE: Lorraine/Marty
2:30	Jason Gedich	
2:45	Chris Nash	
3:00	Toni Hudson	
3:15	Barbara Howard	
3:30	Johnny Depp	
4:00	Chris Rydell	
4:15	Robert Delapp	
4:30	Chrispen Glover (NOTE: Reading for "George")	
4:45	~~Julianne Phillips~~	
5:00	Joyce Hyser	
5:15	~~Charlie Sheen~~	
5:30	Fisher Stevens	

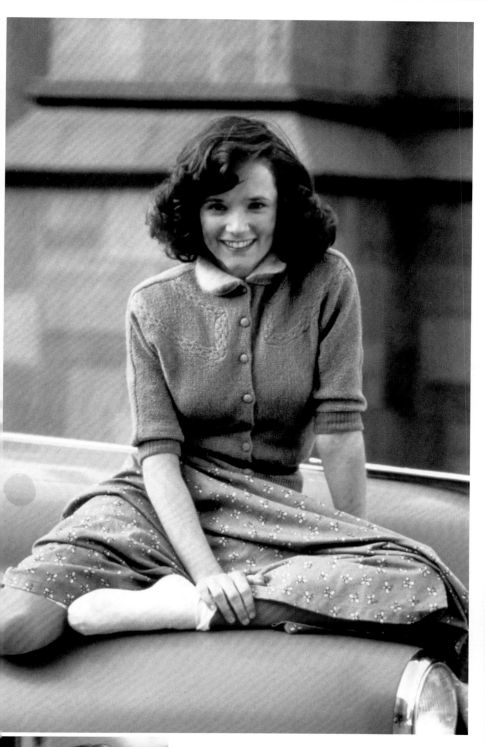

Glover found himself as one of the first hired for the movie. "Crispin had an unusual and memorable approach to the character," says Bob Gale. "The way he spoke, combined with his body language, created an endearing gawkiness that really hit the bull's-eye with us."

A bevy of young ingénues auditioned for the role of Marty's girlfriend Jennifer Parker (as she became known in the final script), and Claudia Wells emerged as the favorite. She was brought in for wardrobe fittings and some still photos as Jennifer. At the same time, Claudia had filmed a pilot for an ABC sitcom called *Off the Rack* starring Ed Asner and Eileen Brennan. When the pilot was picked up for a six-episode commitment, Wells was forced to withdraw from *Back to the Future*.

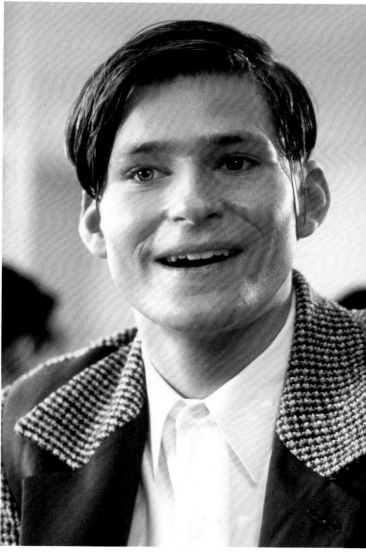

My screen tests were at Amblin, and they would put wigs on me, trying to make me look older, and Steven Spielberg was operating the camera, I think. They really made me feel so at home." Not only did everyone think she was perfect to play the young, vivacious teenage Lorraine, but she perfectly captured the middle-aged Lorraine, ravaged by the toll that an unhappy life has taken over the course of three decades.

Although they read a number of actors for the pivotal role of George, the filmmakers found Crispin Glover a unique and organic choice, and

OPPOSITE A casting schedule for the roles of Marty, Lorraine, and George.

LEFT, TOP LEFT, AND ABOVE In their first auditions, both Lea Thompson and Crispin Glover immediately impressed the filmmakers.

Even the show's star intervened on her behalf. "Ed Asner went to the producers and said, 'Let the kid go do a movie instead of sitting around eating bagels,' but they said I had signed with them first and wouldn't let me go," recalls Wells. "It was weird. I remember sitting in my living room, and I didn't feel bad or sad about anything. I don't know why. It just wasn't a tragic moment for me. I was at peace about it. And they hired my main competition to play Jennifer."

Wells's competition was actress Melora Hardin who, by the age of seventeen, had amassed an impressive list of film and television credits. "We were major friendly competitors," says Wells. "Every role we went out for ended up being between her, Sarah Jessica Parker, and me."

According to Judy Taylor, one of the most difficult roles to fill (apart from Marty) was über-bully Biff Tannen. "The role that took the longest was Biff," she says. "Bob Zemeckis had a very specific image in his head. We looked and we looked, because you could go a million different ways. You needed that comedy sensibility, because even though he's the bad guy, you don't want the audience to necessarily like him, but [you do want them to] to find him fun."

The casting directors saw dozens of young actors, including Tim Robbins and Jeffrey "J. J." Cohen, but none of them quite hit the mark. Eventually Taylor spotted a potential Biff candidate in the casting office, there to audition for another project: "I saw Tom Wilson in the waiting room, and I called his agent right on the spot. I'll never forget how happy Bob, Bob, and Neil were. Tom was not only funny, but he physically telegraphed everything we wanted in the character of Biff."

Marc McClure and Wendie Jo Sperber were cast as Marty's siblings, Dave and Linda. The two were already part of the Zemeckis and Gale repertory company, having appeared in both *I Wanna Hold Your Hand* and *Used Cars*. Sperber was also featured in Steven Spielberg's *1941*, which had been written by Gale and Zemeckis. No readings were required, and no other actors were seen. "Wendie Jo and I both got calls out of the blue, saying we were hired," says Marc McClure.

There was one other actor that Zemeckis and Gale wanted from the start, and, unlike Michael J. Fox, he had no conflict to keep him from accepting the role. The duo had been taken with James Tolkan after seeing his dramatic turn in Sidney Lumet's *Prince of the City*. They sent him a script and an offer to play Mr. Strickland. At the time, Tolkan was appearing on stage in a production of *Glengarry Glen Ross* and saw this as an opportunity to take a step he had long been contemplating. "I'd been a New York actor for many years," he explains, "and I said I was never going to go to Hollywood until they sent for me. I saw it as my chance to go to Hollywood and have that experience."

ABOVE Marc McClure, Wendie Jo Sperber, and James Tolkan were the only actors considered for their respective roles.

OPPOSITE Tom Wilson was discovered by casting associate Judy Taylor at an audition for another project.

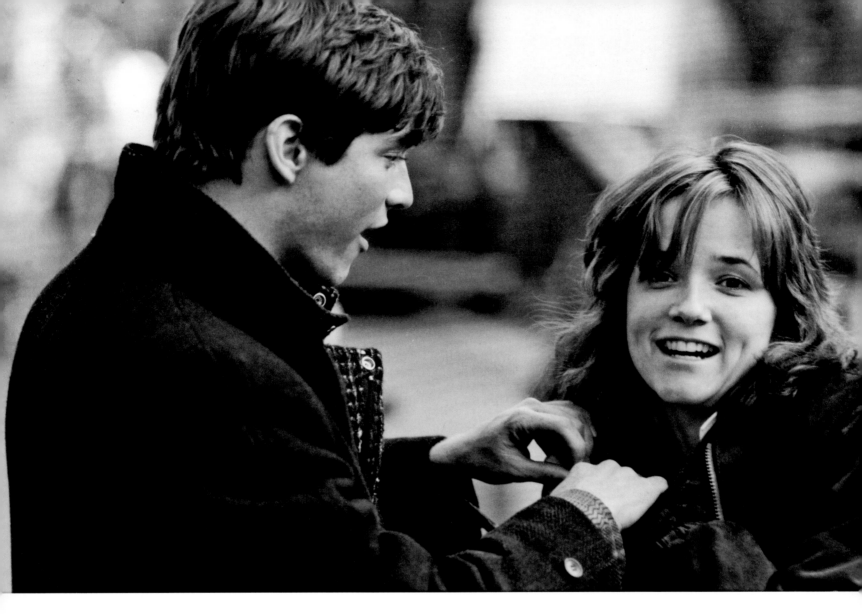

WHERE'S MARTY?

AS MICHAEL J. FOX SAT stewing in his *Teen Wolf* trailer, the search began to find an actor who could fill the sneakers of Marty McFly. Dozens of meetings ensued, and the Amblin conference room found itself host to the likes of Johnny Depp, Charlie Sheen, Fisher Stevens, Jason Gedrick, Chris Rydell, John Cusack, and Doug McKeon. Matthew Broderick had also been approached but wasn't available.

With their choices in Los Angeles dwindling, the casting team's search for Marty turned into a massive open casting call that expanded to a number of cities, including New York, Chicago, and Atlanta. Theater companies were scouted, and even high schools were visited by casting representatives. One of the unknowns flown to Los Angeles from Chicago to test was George Newbern, who, a year later, would appear in an episode of *Family Ties* alongside Michael J. Fox before gaining further recognition as Steve Martin's prospective son-in-law

in *Father of the Bride* and its sequel. Billy Zane and Casey Siemaszko were also brought out from the Midwest and would ultimately join the cast as Biff's cronies, Match and 3-D, along with Biff prospect J. J. Cohen, who would play Skinhead.

With no clear front-runner, the film's start date was pushed back twice as the search continued. The actor who most impressed the filmmakers by that point was C. Thomas Howell. Howell had previously appeared as a friend of Elliott's older brother in Spielberg's *E.T.* and had given a powerful performance as Ponyboy in Francis Ford Coppola's *The Outsiders*. "We had seen Tommy relatively early in the process," says Bob Gale, "but Steven wasn't ready to commit to him. I guess he just didn't see him as Marty McFly."

It was Sid Sheinberg who then suggested the star of a yet-to-be-released Universal production whose work was already receiving tremendous acclaim. Eric Stoltz's performance in *Mask* excited

ABOVE Eric Stoltz and Lea Thompson had previously worked together in the 1984 film *The Wild Life*.

OPPOSITE Writer/producer Bob Gale with Eric Stoltz.

Sheinberg, who thought him to be a genuine star on the rise. Sheinberg made it very clear to the filmmakers that he was only going to allow them to push production back to a certain date before they would be obliged to start filming in order to have the movie in theaters for a summer 1985 release. "We still wanted Michael, but again, we were told we couldn't have him, and Sid was not going to wait for him to come out of *Family Ties*," says Zemeckis. Sheinberg was confident that Stoltz would be the perfect actor to take the role of Marty. "I saw the character as Jimmy Stewart-ish and not as flat out comedic," says Sheinberg. "Two or three people can be talking about a character and each seeing a different one in their heads."

"Our unanimous first choice to play Marty McFly was Michael J. Fox, but because of *Family Ties*, it was impossible to work out Michael's dates," says Spielberg. "Bob Zemeckis, Bob Gale, and I went back to the drawing board and we came up with a lot of choices—several of whom turned the picture down. All of us felt that Eric Stoltz was a good choice although he lacked the buoyancy of Michael J. Fox. Still, he was a serious actor and a very good one."

Zemeckis was unsure and was still hoping to find an actor with whom he would be totally comfortable, but the pressures from the studio began to mount: "Sid told us, 'I want this movie by this release date, and if you're not starting the movie on that date, we're not making the movie.' As a young filmmaker, that becomes tough stuff."

"Sid was just in love with Eric and was convinced he had made the discovery of the decade with this kid," adds Gale. "He was so convinced that

Eric was going to be great as Marty, [he said that] if it didn't work out, we could shoot the movie with somebody else."

Sheinberg doesn't absolutely deny ever having made that offer: "It's not likely I said it. I wouldn't think that way. If I was fighting for Eric, I wouldn't concede the fact he might be wrong for it. But Steven Spielberg and Robert Zemeckis are two of the strongest, most successful directors/producers/writers in the world. If they thought it was such a terrible idea, they could have just said no."

Nevertheless, Zemeckis didn't feel as if he was in a position to say no. Sets were being built, locations being locked in, and DeLoreans were being modified. Threatened with the cancellation of the entire film, he began a process of rationalization that would allow him to accept the situation. "I was arrogant," he admits, "and I was drinking the Kool-Aid, thinking, yeah, he's a competent actor, the script is so powerful, and the story is so unique, we'll power through. I thought I could just make it work." Neil Canton agrees: "We had to cast somebody. The train was rolling. It was one of those things where you could deceive yourself because Eric was a talented actor—that was never in question—so, because Chris was so good and Tom and Lea and Crispin were all so good, we could trick ourselves into the belief that it would work."

It ultimately came down to a choice between Howell and Stoltz. With Sheinberg's encouragement, Zemeckis gritted his teeth and chose Stoltz.

Once hired, the young actor made several demands of the production before they even started

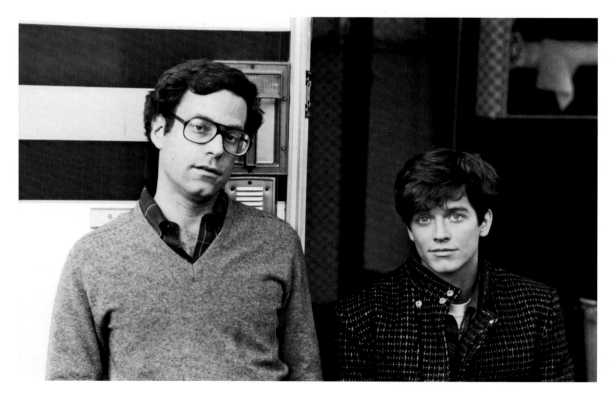

shooting. Very much a proponent of the Method approach to acting, Stoltz requested that, from the beginning of production until the wrap, all cast, crew, and filmmakers refer to him as "Marty." He would never answer to "Eric," except to Lea Thompson, with whom he had previously worked. "Marty" would arrive and leave the set in his on-screen wardrobe. Looking back, Lea Thompson admits, "That was not a good plan."

Another bad omen came during the table read, when the cast read through the entire script with Zemeckis, Gale, and Canton, as well as the executive producers and key department heads. As Thompson vividly recalls: "After the table read, everybody was really excited, and someone asked Eric what he thought. He said, 'It's kinda sad, because Marty remembers the past, and everyone else he loves remembers a completely different past.'" When he said that, it was like it was happening in slow motion. I wanted to yell, 'Don't do it!'"

Over the next several days, the cast underwent hair and makeup tests. After having his hair cut for the film, Crispin Glover surprised everyone by showing up the very next day having cut his own hair into a different style. Glover had made the decision to sheer the sides of his head to a degree no one had approved, and the production was stuck with that look for the duration. It would be the first of many occasions where the actor attempted to go his own way, much to the chagrin and aggravation of the filmmakers.

Despite any misgivings about the film's leading man, beginning on November 15, Zemeckis rehearsed with Stoltz, Lloyd, Thompson, Glover, and Wilson for four days on Universal's Stage 16, as the various departments continued their preparations for the beginning of production.

On November 21, Stoltz, Marc McClure, and Wendie Jo Sperber gathered to pose for the integral "fading" McFly sibling photo, shot by still photographer Ralph Nelson Jr. Donald Fullilove, cast as malt shop worker Goldie Wilson, also had his photo taken for the "Goldie Wilson For Mayor" poster.

While the casting search didn't lead the filmmakers to the Marty McFly they were hoping for, it did bring Zemeckis into contact with the duo who would become *Back to the Future*'s film editors. Viewing footage from an unreleased Michael Apted film called *Firstborn* in the hope that one of its two leads might be suitable for Marty, Zemeckis concluded that the boys weren't right. However, Zemeckis said that he really liked the way the scenes were cut, much to the embarrassment of Arthur "Artie" Schmidt, the film's editor, who was running the footage. Several weeks later, Schmidt received an invitation to join the *Back to the Future* team. Once onboard, Schmidt quickly determined that the postproduction schedule was going to be brutal and advised Zemeckis, Gale, and Canton to hire a second editor. Once they agreed, Schmidt brought his friend and colleague Harry Keramidas onto the project.

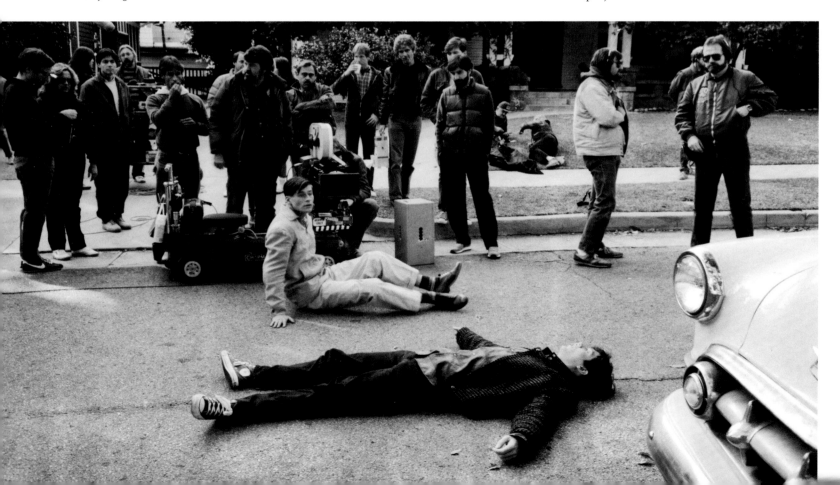

TIME CIRCUITS ON FLUX-CAPACITOR... FLUXING

AFTER OVER FOUR FULL YEARS of writing, rewriting, pitching, and experiencing the various frustrations of trying to get a movie from script to production, the first shot of *Back to the Future* was captured on Monday, November 26, 1984, at 8:22 a.m. The cast and crew gathered on Bushnell Avenue in South Pasadena, California, to film the scenes in which Marty follows George, finds him in a tree outside Lorraine's window, and pushes him out of the way of the oncoming car driven by Lorraine's father Sam Baines (played by George DiCenzo).

For Zemeckis and Gale, there was no moment of exhilaration or shared excitement about the culmination of their dream project. "My sense of it was that it's such a slog to get to the first day of shooting," says Gale. "You're relieved that you're actually rolling film and that you're making the movie. You're always running in front of that train and hoping that you can keep up a pace and not get run over by it."

SHOOTING CALL — FILM

UNIVERSAL CITY STUDIOS, INC.
Due to Extreme Fire Hazard, Please Be Careful Smoking. Use Butt Cans.

1ST Unit — 1ST Day of Shooting

Picture	No.	Director
"BACK TO THE FUTURE"	02171	BOB ZEMECKIS

CREW CALL: 6 AM — Date: MONDAY NOVEMBER 26, 1984

Art Director: LARRY PAULL/TODD HALLOWELL — Shooting Call Time: 730A — Condition of Call: W/P

Set Dresser: HAL GAUSMAN — ☒ REPORT TO LOCATION — ☐ BUS TO LOCATION

PAGES	SET DESCRIPTION	SCENE #'s	D/N	LOCATION
1 1/8	EXT. HILL VALLEY ST. NR. BAINES HOUSE (MARTY, GEORGE, SAM BAINES, DBLS) (MARTY WATCHES GEORGE SPY ON LORRAINE - GEORGE FALLS - MARTY GETS HIT BY CAR)	49, 51, 53	D (1955)	1727 BUSHNELL AVE. SOUTH PASADENA
2/8	EXT. LORRAINE'S BEDROOM WINDOW (LORRAINE) (MARTY'S & GEORGE'S P.O.V. OF LORRAINE)	50, 52	D (1955)	↓
	COVER SET:			
3 7/8	EXT. GEORGE'S BACKYARD (INT. GARAGE) (GEORGE, MARTY) (MARTY TEACHES GEORGE HOW TO WIN LORRAINE'S AFFECTIONS)	104	D (1955)	1711 BUSHNELL AVE. SOUTH PASADENA

CAST AND BITS	CHARACTER	REPORT TO	CALL TIME	ON SET
* 1. ERIC STOLTZ (NEW)	MARTY	1515 GARFIELD SOUTH PASADENA	6A	730A
* 3. CRISPIN GLOVER (NEW)	GEORGE		6A	730A
4. LEA THOMPSON (NEW)	LORRAINE		8A	9A
* 26. GEORGE DiCENZO (NEW)	SAM BAINES		6A	730A
* 15. JERRY JACKSON (NEW) (F)	STUNT DBL. MARTY		6A	730A
* 35. MIKE CASSIDY (NEW) (F)	STUNT DBL. GEORGE		6A	730A
* 265. MAX KLEVENS (NEW) (F)	STUNT DBL. SAM BAINES		6A	730A
* — WALTER SCOTT (NEW)	STUNT COORDINATOR		6A	730A

— CAST AND CREW REPORT TO LOCATION — SEE ATTACHED MAP —
AND WELCOME "BACK TO THE FUTURE"! —

* N.D. BREAKFAST PROVIDED

ATMOSPHERE AND STAND-INS	REPORT TO	CALL TIME	ON SET
2 STANDINS (MARTY, GEORGE)	1515 GARFIELD So. PASADENA	6A	
1 STANDIN (LORRAINE)		8A	
2 STREET ATMOS.		6A	
1 TRUCK DRIVER		6A	
3 ATMOS. DRIVERS		6A	

ADVANCE

TUESDAY, NOV. 27, 1984 — EXT. GEORGE'S BACKYARD (D) sc. 104 — EXT. GEORGE'S HOUSE (N) sc. 85, 87 — 1711 BUSHNELL AVE. SOUTH PASADENA

COVER SET: INT. BAINES DINING RM. (N) sc. 55, 57

WEDNESDAY, NOV. 28, 1984 — INT. BAINES DINING RM. (N) sc. 55, 57

TOP LEFT Zemeckis and Stoltz on the Lou's Cafe set.

MIDDLE LEFT Zemeckis demonstrates the desired action to Glover and Stoltz.

ABOVE The call sheet for the first day of shooting on *Back to the Future*.

On the first day of shooting, the crew was called for a 6:00 a.m. start, and Crispin Glover arrived an hour and fifteen minutes late. The actual fall and car hit were performed by stunt doubles, with Jerry Jackson taking the car hit for Stoltz, Mike Cassidy falling out of the tree, and stuntman Max Kleven driving the car as Sam Baines. Kleven would continue to be a key member of the stunt team and in the sequels would take up second-unit directing chores. Lea Thompson was on set, but the company was unable to get to her first scene before the shooting day wrapped at 6:00 p.m.

The company remained on Bushnell Avenue for the next three days, filming the 1955 dinner scene with Marty and the Baines family, and the clothesline scene in George's backyard. On Friday they moved to the historic Blacker House in Pasadena (to which the company would unexpectedly return later in the shoot) for the interior of Doc Brown's house, where Marty tries to convince the 1955 Doc that he's from the future.

TOP In 1955, Eric Stoltz's Marty (far right) joins the Baines family (left to right: Jason Hervey, Maia Brewton, Frances Lee McCain, George DiCenzo, Lea Thompson) for dinner.

LEFT Bob Gale, Eric Stoltz, and Crispin Glover during shooting.

OPPOSITE Michael Scheffe's design sketch for Doc Brown's brain-wave analyzer.

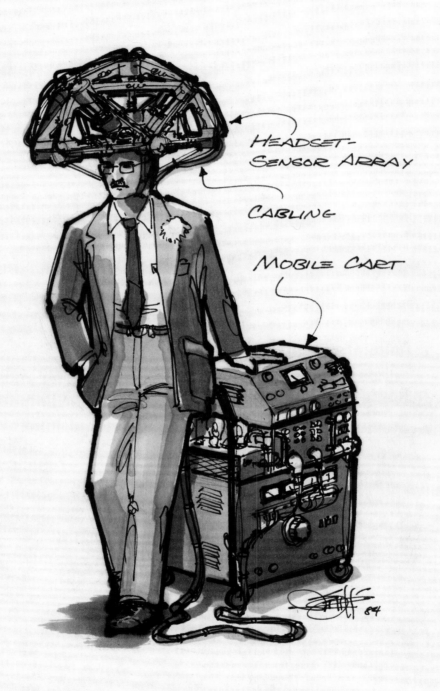

HEADSET-
SENSOR ARRAY

CABLING

MOBILE CART

BRAIN·WAVE ANALYZER

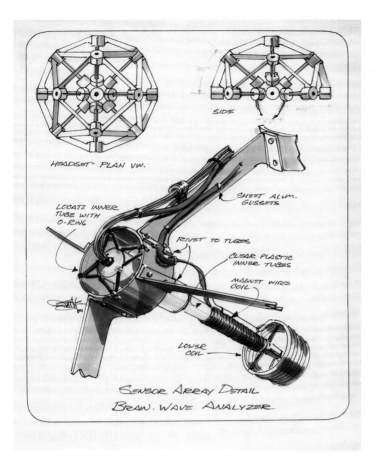

HEADSET PLAN VW.

SIDE

LOCATE INNER
TUBE WITH
O·RING

SHEET ALUM.
GUSSETS

RIVET TO TUBES

CLEAR PLASTIC
INNER TUBES

MAGNET WIRE
COIL

LOWER
COIL

SENSOR ARRAY DETAIL
BRAIN·WAVE ANALYZER

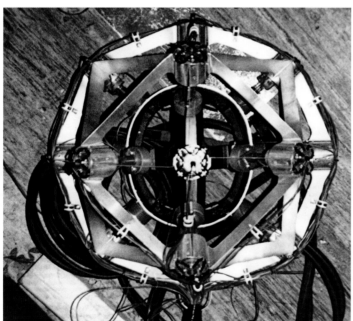

TOP Detailed sketch of brain-wave analyzer components by Michael Scheffe.

ABOVE A photo of the completed prop.

RIGHT Doc Brown's blueprint for the brain-wave analyzer by Michael Scheffe.

45°

45°

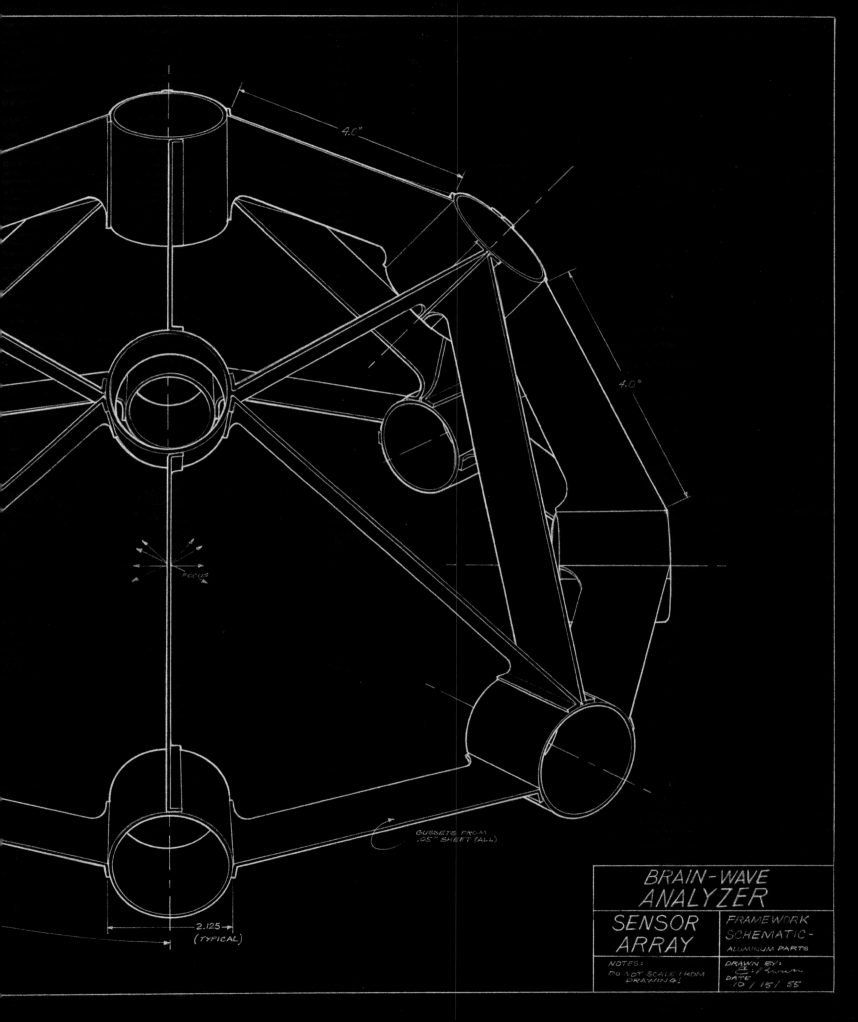

4.0"

4.0"

FOCUS

2.125
(TYPICAL)

GUSSETS FROM
.05" SHEET (ALL)

BRAIN-WAVE ANALYZER

SENSOR ARRAY	FRAMEWORK SCHEMATIC- ALUMINUM PARTS
NOTES: DO NOT SCALE FROM DRAWING!	DRAWN BY: E. Brown DATE 10 / 15 / 55

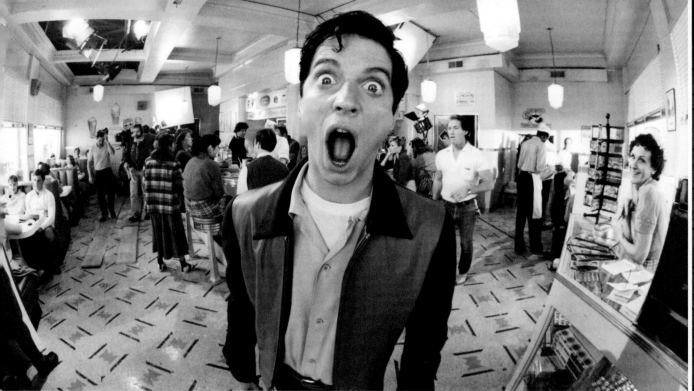

The first day of shooting on the Hill Valley back lot set at Universal Studios focused on Marty wandering through the courthouse square, realizing that he's truly in 1955.

Production designer Paull and his team had combed through 1950s issues of *Look* and *Life* magazines for inspiration in creating the charming town square, which would later show the urban decay of the intervening decades. The set was built over the course of nine weeks, with Paull working in conjunction with a product placement company who provided the proper signage and other elements and, in some cases, contributed money to the production to have the brands they represented prominently featured.

Zemeckis and Gale were keen to feature products and logos that had clearly changed over the decades. "It was something we loved about Kubrick's *2001*," explains Gale. "How great it was that in the future you saw all these familiar brand names: Pan Am, Bell Telephone, Howard Johnson. We took the approach that popular culture in advertising defines a time period in the mind of the public. We specifically wanted Pepsi and not Coke, because a 1955 Pepsi logo looked different than the 1985 one, but not so with Coca-Cola. The same was true with Texaco. Their logo had changed, whereas Shell's had not."

Numerous possibilities were brought to Gale by the product placement company, but he always consulted with Paull to see if they would enhance the look of the film. If Paull deemed them unworthy, those deals would be declined. On one particular day, the writer/producer was approached by the product placement executive with an offer that would potentially bring the film an additional $75,000, a sum that could have funded a full day-and-a-half of shooting. Recalls Gale of the conversation: "[He said we could have] $75,000 if we changed the DeLorean to a Mustang. I looked straight at him and said, 'Doc Brown doesn't drive a fucking Mustang.'"

After establishing the town square, the crew moved to the interior set of Lou's Cafe, where Marty first encounters the teenage George and has his initial run-in with young Biff.

From his very first moment on the set, Tom Wilson embraced his inner bully and added new dimensions to the character that had not appeared on the written page. Wilson introduced "butthead" as a term of endearment, coined the phrase "Make like a tree and get outta here," and was the first to inquire, "Hello? Anybody home?" accompanied by knocking his victim on the head. Throughout filming, he contributed more ideas that would further enrich the character.

As the week progressed, chronic lateness spread among the actors. Eric Stoltz, Lea Thompson, Donald Fullilove, and Cristen Kaufman, who played Lorraine's girlfriend Betty, were all late for their calls. Elsewhere, a falling street sign struck one of the extras, who was taken to the hospital and received three stitches before returning to work. Meanwhile, actor J. J. Cohen injured his pinkie and was taken to the Universal Studios hospital, where he was examined and released.

At the end of the week, the company was one day behind schedule.

TOP LEFT Eric Stoltz mugs for the camera on set in Lou's Cafe.

ABOVE AND RIGHT Specific brand logos were chosen for the storefronts of 1955 Hill Valley to highlight how they differed from their 1985 incarnations.

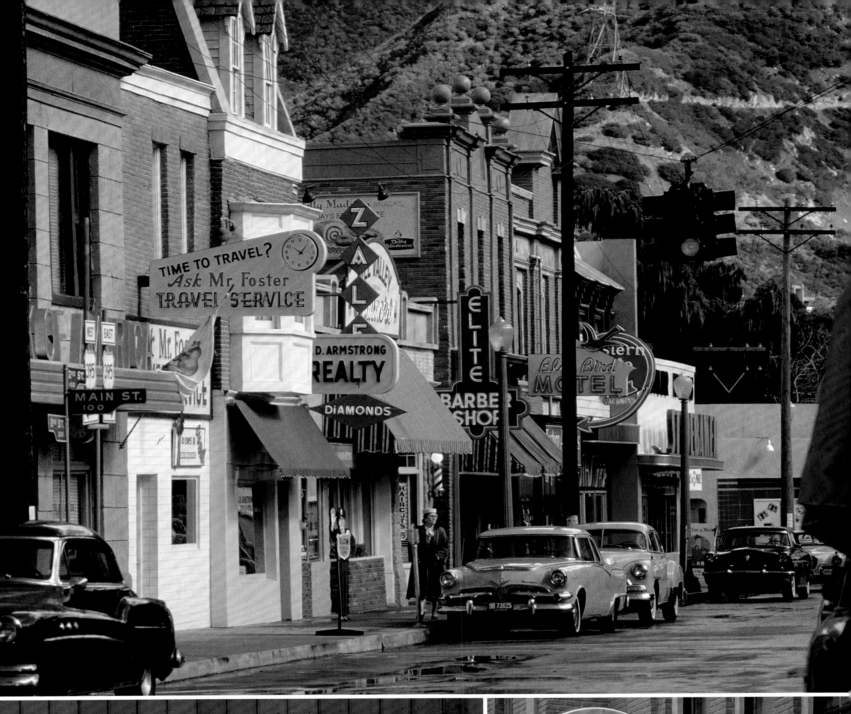

WEEK 3: DECEMBER 10–14, 1984

The first shooting day of the week brought rain, postponing the beginning of the skateboard chase. As a result, the crew was forced to shoot inserts and POV (point of view) shots inside the cafe.

The next day the weather cleared, and the filming of the skateboard chase began. It would ultimately take three days to shoot. During prep, Bob Gale had set off in search of some experts in the sport to help them with the sequence: "In 1984, skateboarding had come and gone as the cool thing. I thought if there's anybody still skateboarding, they're going to be down on Venice Beach. I went there on a Sunday with my fiancée, Tina, and sure enough, there were these guys skateboarding. And they were good. I went up to them and said, 'You guys might think that I'm full of shit here, but I'm actually producing a movie, and we've got a skateboarding sequence, and would you guys be interested in helping us out?' They immediately whipped out business cards with their agents' names on them." The pair turned out to be champion skateboarders Per Welinder and Bob Schmelzer, the latter proving to be the perfect double for Eric Stoltz.

In earlier drafts of the script, the skateboard chase ends when Marty zips across some railroad tracks just ahead of an oncoming locomotive. When it was decided the film would be shot primarily on the back lot of Universal, a new ending to the pursuit had to be devised. "It was probably a result of combined brainstorming," says Gale of the idea to have Biff crash into a manure truck. "I think we walked the area with our stunt coordinator Walter Scott and possibly our two skateboard guys to come up with things we could do on the town square. We knew we had to do something to incapacitate Biff and his car so Marty could get away safely, and the truck gag grew out of that. It may have started as a garbage truck, and someone figured that manure would be more memorable and humiliating."

At the end of their third week, the company had their first "split." (In movie-business vernacular, a split is a twelve-hour filming day that starts during daylight hours and concludes at night.) The split began in the town square with Marty and George approaching Lou's Cafe in search of Lorraine, while the evening shot featured Lloyd's Doc preparing for the "weather experiment" and Stoltz's Marty trying to give him information about the future.

With week three completed, the company was two days behind schedule.

OPPOSITE Eric Stoltz with stunt double and professional skateboard champ Bob Schmelzer.

BELOW Stoltz films the skateboard chase.

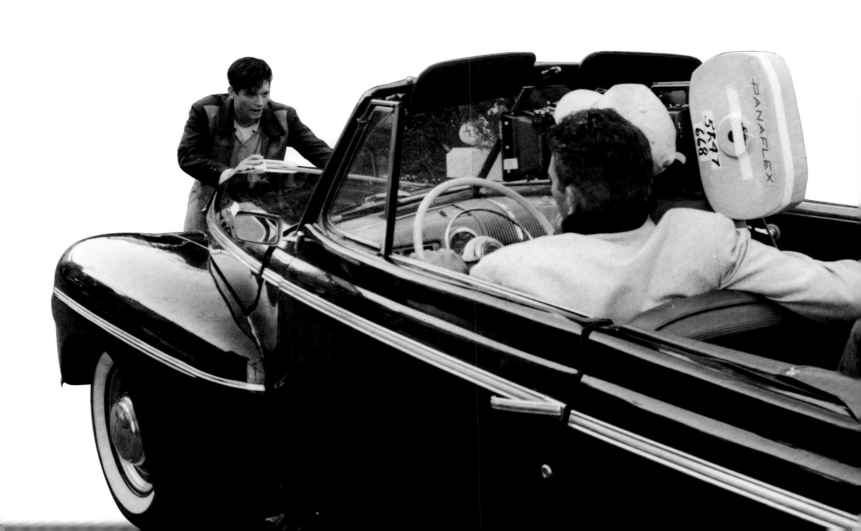

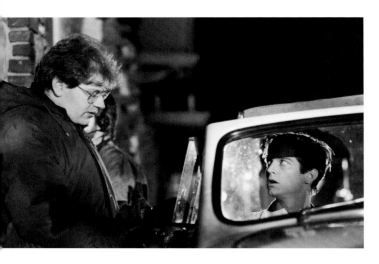

SC:183

BROWN - LOOKS THINGS OVER AND GETS AN IDEA. HE TIES.... CT-88

.....THE TWO CABLES TOGETHER AND THEN PLUGS THEM IN. CT-88A

B.

SC:184

MOVING WITH THE DELOREAN - AS IT ACCELERATES. CT-89

INSERT SPEED 40 r

SC:186

UP ANGLE - BROWN TESTS (PULLS) THE CABLES TO MAKE SURE THEY'RE SECURE.

A.

BROWN TURNS & JUMPS. CT-90A

WEEK 4: DECEMBER 17–21, 1984

The fourth week saw executive producer Frank Marshall begin work as second-unit director. Marshall was given a shot list by Zemeckis, which highlighted small pieces of coverage that were missed during the shooting. On their first day, Marshall and crew spent their time shooting Marty's point of view as he wanders the town square for the first time in 1955, filming beauty shots of the storefronts, movie theater, and clock tower, as well as the vintage cars driving through the area. Marshall also shot some retakes with Zane, Cohen, and Siemaszko to cover the final moments of the skateboard chase. When the sun set, the main unit began the first full week of night shooting, something to which they would soon become very accustomed.

On their first night, they continued the sequence that sees Marty return from the dance, as well as the scene in which Marty writes his letter to Doc. Heavy rainfall delayed production by ninety minutes the next evening.

Dean Cundey recalls an exchange that occurred during these night shoots between Zemeckis and Eric Stoltz, who would question the technical aspects of his director's technique: "For the scene where Marty is meeting Doc outside the DeLorean on the 1955 street, Bob wanted Eric to run down the opposite sidewalk, cross down the street, and when he got to the curb, trip a little bit in his excitement."

"After Bob told him how he wanted the action, Eric questioned the reality of the situation. He told Bob that Marty wouldn't really run along that side of the street and cross but would approach him directly. Again, Bob explained the idea was to frame the actor over the car, so when he made his appearance, all of the elements are visible in the shot. Eric then questioned why he would trip, as he didn't feel that Marty was a schlump. Bob patiently explained that his character was excited, and that little trip would humanize him. Eric wouldn't give up and asked again why he should run. Finally, Bob offered his solution. 'Why

don't we shoot one? You run down the sidewalk, cross over the street, trip, and when you get here, I'll tell you what your motivation is.'"

The cinematographer further recounts, "There was an awkwardness, always a separation between [Eric Stoltz's interpretation of] the character and those of us trying to make an engaging movie."

As the rains returned, the shooting schedule was revised, with the crew heading for a "cover set." Crispin Glover, originally not scheduled to work in week 4, was called to Universal's Stage 12, where he and Stoltz shot George's late night visit from "Darth Vader from the planet Vulcan."

For the last two nights, the rains ceased, and the company returned to their outdoor work, filming Doc Brown moving precariously along the edge of the clock tower parapet.

TOP LEFT Robert Zemeckis and Eric Stoltz confer during shooting.

TOP RIGHT Original storyboards show Doc Brown on the clockface as the DeLorean races toward the town square.

OPPOSITE Doc celebrates after successfully sending Marty back to 1985. *The Atomic Kid* is the film that inspired the original nuclear test site ending.

Christopher Lloyd was no fan of heights and had some concerns about this climactic sequence. Having read the script, he decided to take a look at the location. "Before we got to any of the clock tower stuff, I had some time and went to the building, climbed the stairs, and went up to that window between the two panthers, and I remember looking out. There was a ledge under the window. I was on my hands and knees because I thought there was no way I was going to stand on that ledge as written. I was thinking about alternative ways to do it. Like . . . on my knees. I talked to Bob Zemeckis about my idea of doing it that way, and I don't think he said it directly, but his words implied there was no fucking way he was going to let me do it like that. I was going to be attached

to a cable. Which I was, and when it came time to do it, I felt very safe." Lloyd was lifted to the ledge by crane, attached to the cable, and left to do the scenes surrounded by lightning effects, as well as powerful wind machines that would kick up leaves, dirt, and debris as Doc struggled to make the crucial connection between plug and socket.

For some of the longer shots of Doc dangling on the clock, as well as the zip line to the square below, veteran stuntman Bob Yerkes doubled Lloyd. He would continue to double for Lloyd in the sequels, as well as in *Who Framed Roger Rabbit* and *My Favorite Martian*.

Going into the week before Christmas, *Back to the Future* was now three days behind the original projected schedule of sixty-six days.

BELOW Zemeckis directs Crispin Glover in the Whittier High School cafeteria as Dean Cundey, Bob Gale, and Eric Stoltz look on.

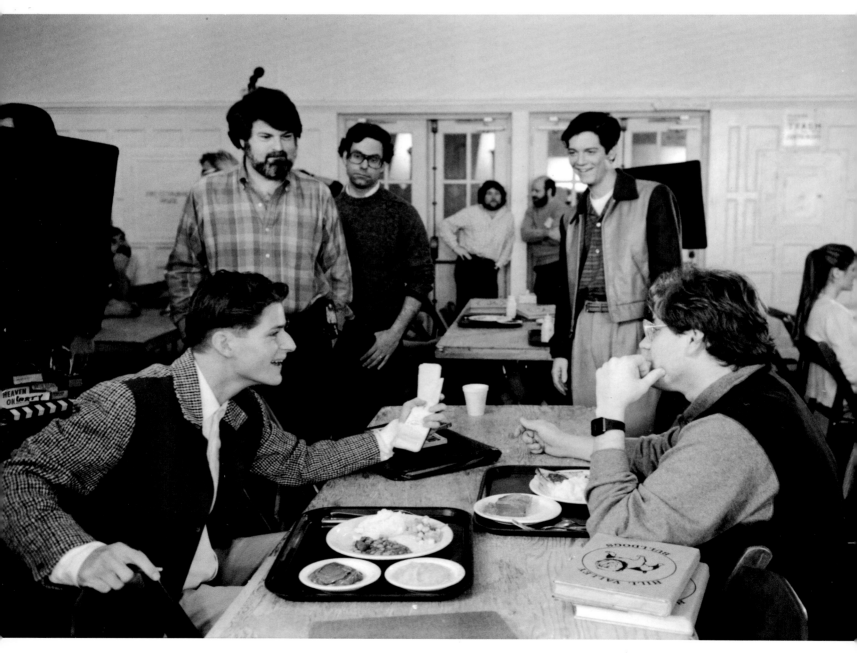

WEEK 5: DECEMBER 24-28, 1984

Taking advantage of the Christmas break for the public school system, the company moved to Whittier High School just southeast of Los Angeles.

The first scene filmed was of Stoltz's Marty in Mr. Strickland's office being sentenced to detention. This scene would later be dropped for a new sequence introducing Mr. Strickland.

The company next moved to the school cafeteria, where they filmed George's first attempt at asking Lorraine to the dance, as well as Marty facing off against Biff.

Actor Tom Wilson had already endeared himself to the company, showing himself to be one of the best-natured and most cooperative members of the cast. Unfortunately, an incident involving the film's overzealous leading man would test his amiable temperament.

Wilson remembers that the shooting of the Biff versus Marty scene was one of the times when Eric Stoltz's Method acting crossed the line. In a 2011 podcast aired on Nerdist.com, Wilson recalled that the action of Marty shoving Biff became particularly unpleasant when Stoltz dug in with both hands, delivering a painful blow to Wilson's collarbone. Between takes, Wilson asked Stoltz to ease up, assuring him that he could react just as realistically even if he was pushed less aggressively. The shove in the next take was as forceful as the first. Again, Wilson politely requested that Stoltz approach the action with less vigor, but to no avail. After several takes, Zemeckis (who was unaware of the situation) was satisfied and moved on. Wilson would carry bruises around the neck and chest as a reminder for the next couple of weeks.

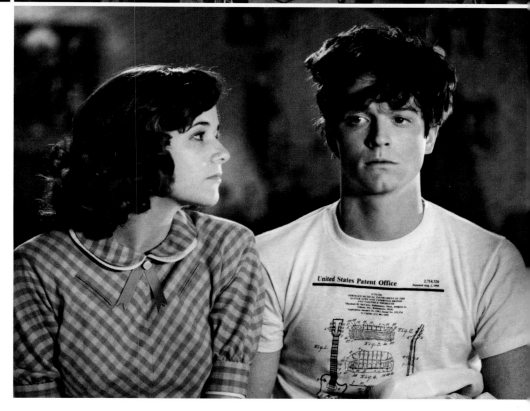

WEEK 6: DECEMBER 31– JANUARY 4, 1985

Having finished their work at Whittier High, the company moved back to Universal Studios. The final day of shooting in 1984 was spent on Stage 12 in Lorraine's bedroom, where Marty wakens in her bed, and she assumes his name is Calvin Klein.

The new year began with night shooting back at the clock tower as Doc successfully sends Marty and the DeLorean back to 1985.

TOP LEFT James Tolkan rehearses with Eric Stoltz.

TOP RIGHT Eric Stoltz's Marty takes a swing at Biff in Lou's Cafe.

ABOVE Marty McFly finds himself the uncomfortable object of his teenage mother's advances.

HALFWAY HOME?

ZEMECKIS AND HIS CREW had completed twenty-eight days of shooting—almost six full weeks—and were closing in on the halfway point in the filming, with the shoot scheduled to end on February 28.

Although they were three days behind schedule, Zemeckis's big concern had nothing to do with the timeline. The director had a very strong sense there was a major problem with the film. It was not unusual for Zemeckis to spend a Saturday or Sunday with Artie Schmidt to review the scenes that he and Keramidas had already cut together, but on one specific Saturday, after the lights came up, there was dead silence.

Neil Canton remembers getting a call from Zemeckis that night: "Bob told me there was good news and bad news. The good news was that Chris [Lloyd] is really good, and Tom's really good, and Lea and Crispin are really good. The bad news is there's a big hole in the middle of it all. It feels like Eric is in a different movie. Bob felt the audience was going to have a really hard time relating to Eric—he was just too standoffish." Bob Gale had also received the same call, and Zemeckis asked him and Canton to come to the editing room the next day. "There were many times we would watch a scene being filmed, particularly when Eric was working with Chris," says Gale, "and it just didn't seem right. We would tell ourselves, 'Okay, he was good in that take, or that part of that take was good, and when it all gets cut together, it'll be OK.' But it wasn't."

After acknowledging the seriousness of the situation, Zemeckis announced what he felt was the only solution. Eric Stoltz would have to be replaced.

The first step in this dramatic change was to get the support of Steven Spielberg and his Amblin partners. "I had been watching all the dailies up through week five and was concerned that Eric Stoltz wasn't landing all the comedy," says Spielberg. "Bob Z asked me if I would look at forty-five minutes of assembled footage. After he showed me the footage, he didn't say a word. We looked at each other. Neither of us was smiling." Everyone agreed that recasting was the only way to salvage the production.

Spielberg agreed to go to Sid Sheinberg, but before doing so, he counseled the team to have Stoltz's replacement lined up. Zemeckis knew exactly who he wanted and proposed that they try to get Michael J. Fox again.

Bob Gale recalls the second trip, accompanied by Zemeckis and Canton, to meet with *Family Ties* producer Gary David Goldberg: "It actually worked to our advantage in having to delay the start of production twice. By the time we went back to Gary, Meredith already had her twins and was back on the show. There were only a few episodes left in the season, so we went back to Gary practically on our knees, begging."

"I threw myself on the mercy of his court," says Spielberg of his friend Goldberg. "Gary thought about all of this for a few moments and said, 'Well, if you can shoot around his *Family Ties* schedule, especially letting him shoot with you all night, and we can have him for most of the next day for table reads, rehearsals, camera blocking, and finally taping in front of a live audience, and if Michael is up to it, I think this could work out.'"

"Of course, we agreed," says Gale. "To get Michael, we'd have danced naked on his desk if he'd asked us to."

While the filmmakers courted Michael J. Fox, Spielberg advised the team to keep shooting with Stoltz, even though they intended to replace him. "Steven said we'd be better off shooting another week even if we didn't use any of the footage," explains Gale. "It would keep the momentum going, keep Universal spending money, keep them from shutting down the movie, and also not publicly acknowledge we were horribly in trouble."

Canton and Gale began to discreetly investigate all of the issues they would need to address with Universal if Michael J. Fox agreed to take the role. Precious few were aware of the machinations that were taking place. "I worked out with the production team how much it was going to cost, and the two Bobs worked out what we would have to reshoot," says Neil Canton. "We'd obviously have to go back to locations, but we wouldn't have to reshoot everything. We would have to reshoot the masters [a shot that included everyone in the scene] and what would be Marty's side of everything. We knew exactly how many shots we needed." After taking everything into consideration, Canton estimated it would cost Universal an additional $4 million to make the change.

While waiting for Michael J. Fox's response, Zemeckis took Spielberg's advice. He kept on shooting.

OPPOSITE Stoltz and Lloyd shoot the first time-travel experiment at the Puente Hills Mall.

ABOVE In courthouse square, Stoltz's Marty watches Doc as he ventures out onto the clock tower ledge.

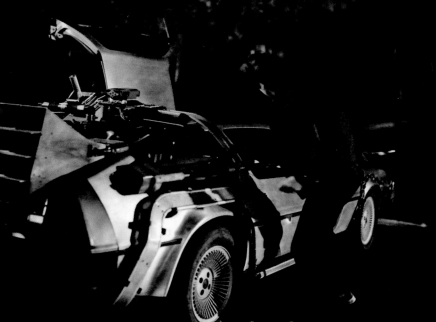

WEEK 7: JANUARY 7–11, 1985

Located in the Los Feliz neighborhood of Los Angeles, Griffith Park remains one of the largest urban parks in North America and is home to the famed Griffith Park Observatory, the L.A. Zoo, and the Greek Theatre.

On the first night of week 7, the crew filmed the DeLorean departing from the starting line on its way to the town square to receive the energy from the lightning bolt.

While the behind-the-scenes machinations were unfolding, Dean Cundey remembers a sense

of discomfort and a shift in the tone and focus on the set: "We would do the master shot of the scene, and Bob would say, 'Now we'll do the close-up of Chris Lloyd.' I suggested to him we would need to turn around and do a close-up of Eric . . . I mean Marty, and he said, 'I don't think we'll need that.' It became evident he was limiting his exposure of reshoots or changes." Zemeckis was purposefully minimizing the shots of Stoltz in the hopes his plan would succeed.

Some twenty-five miles east of Los Angeles, Puente Hills Mall in the City of Industry would prove to be a memorable location for a number of reasons. The shopping center had been outfitted with a "Twin Pines Mall" sign, and there the crew endured subfreezing temperatures in wet and windy conditions as they began shooting scene 17, in which the audience would meet Doc Brown, Einstein, and the DeLorean for the first time. Because the mall was open for business until 9:00 p.m., filming was restricted to a small, outlying section of the parking lot until an hour after closing time, after which the company had access to the entire area.

LEFT A variety of stills showing Stoltz's last scenes as Marty McFly.

ABOVE The time-traveling DeLorean is revealed.

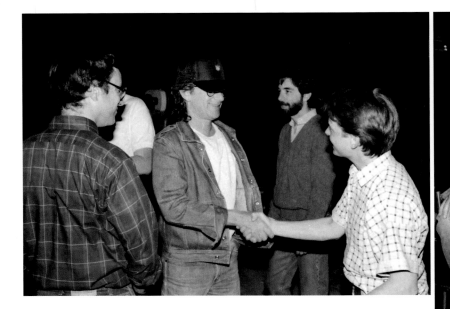

MEANWHILE . . .

True to his word, Gary David Goldberg called Michael J. Fox into his office. "I was nervous," says Fox of his immediate reaction to the summons. "I allowed for the possibility that I might be getting fired." Goldberg quickly allayed the young actor's fears and told him about the first time he had been approached regarding *Back to the Future* and also explained why he had turned down the request without consulting him. Fox totally understood the situation and had no ill will whatsoever.

Goldberg told Fox that Zemeckis and Gale had come back to him because things weren't working out with Stoltz. In addition, Goldberg made sure Fox completely understood what would be required of him. "Gary told me, 'I'm not going to give you any slack,'" remembers Fox. "'You're going to have to do both [*Family Ties* and *Back to the Future* at the same time].' I said if Bob and Steven [Zemeckis and Spielberg] are cool with that, I'm good with it." Goldberg handed Michael a manila envelope. "He said, 'Here's the script. Take it home, read it, see what you think of it, and let me know.' I picked up the envelope, kind of weighed the heft in my hand, and said, 'It's the best script I've ever read. When do I start?'"

Shortly after agreeing to take on the role, Fox actually read the script and immediately knew he had made the right decision: "I was thrilled. It was in my wheelhouse at the time—guitars, girls, and skateboards. I had done that. That was life growing up. I could totally relate to Marty. I don't think I would have articulated it like this at the time, but I loved that it was cross-generational, and I got to play in absentia, the possibilities, the way things turn, that we are the architects of our own future and responsible for our own past. That was just really compelling. You could tell that the authors let the story take them where it took them. Let the story say what it says. Later, when we went to England to promote it, people would ask, 'Well, isn't this an apology for Vietnam?' or come up with some other convoluted theory. Bob Z. would say, 'It's a movie! It's a joke!' and I loved that. It just was what it was."

With Fox onboard, the team leapt into action. Steven Spielberg notified Sid Sheinberg and made the Stoltz footage available for him to view. Then, Spielberg and Zemeckis, armed with the facts and figures, went to Sid with the bad news / good news scenario: The bad news was that they couldn't continue to shoot with Eric Stoltz, and the good news was they could replace him with the hottest kid from the hottest show on television.

There are varying memories of the meeting and its outcome. "One of the most nervous moments of my life was going up to the fifteenth floor of the tower at Universal and breaking the news to Sid Sheinberg," recalls Spielberg. "One of the most remarkable reactions to news of this kind I had ever received was Sid's absolute trust in Bob Zemeckis, Bob Gale, and me when he said, 'Do you really think recasting is going to make that much of a difference?' I said it would. He gave me his blessing."

Bob Zemeckis remembers being by the elevators on the executive floor, and as the doors closed in front of him, Sheinberg saying, "You, sir, are insane!" Frank Marshall recalls the studio head remarking, "If this works, I'll look like a genius. If this doesn't work, I'm blaming you."

What Sid Sheinberg distinctly remembers is his decision. "I told them [Spielberg and Zemeckis], 'You two are making this movie, and if that's what you believe, that was the end of the conversation.' The right decision is always to stop."

TOP LEFT AND RIGHT Steven Spielberg greets Michael J. Fox on his arrival to the production.

OPPOSITE There's a new McFly in town . . .

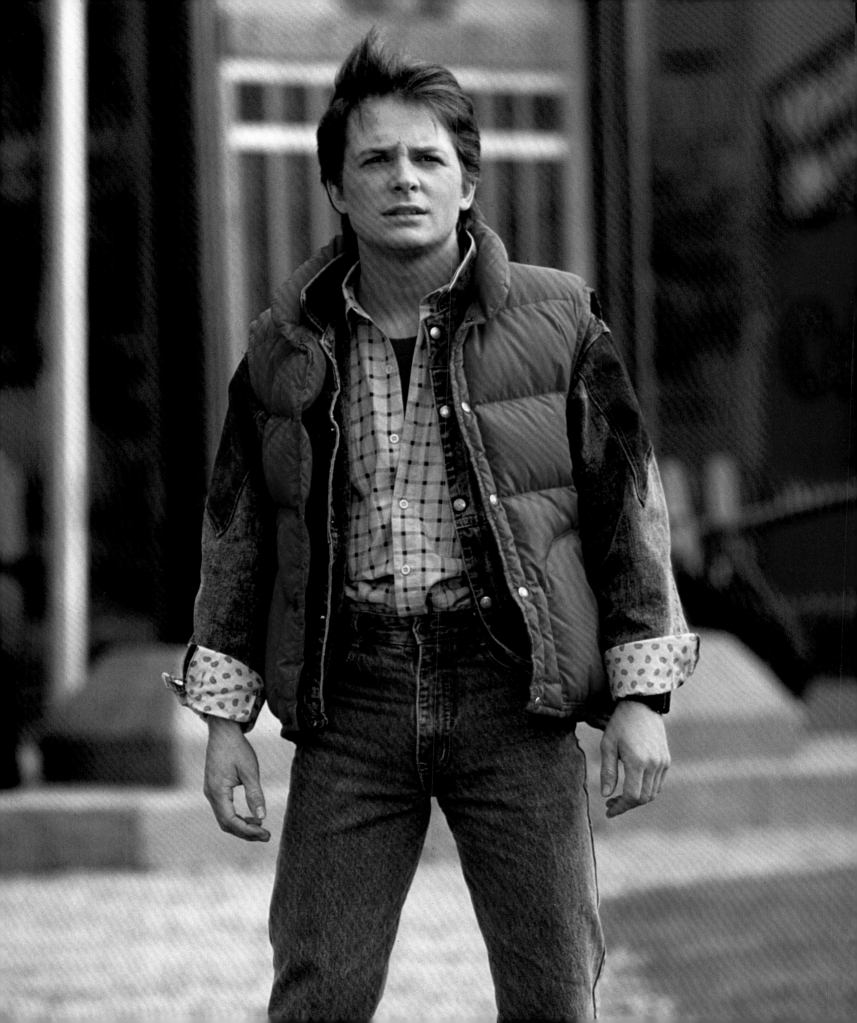

Still shooting at the Puente Hills Mall, the company carried on with scene 18, in which the DeLorean, with Einstein in the driver's seat, disappears in a blinding flash of light, leaving fire trails between the legs of Marty and Doc. In shooting the scene, Zemeckis was deliberately favoring Christopher Lloyd's pieces of the scene and not getting the coverage he would normally capture for Marty. Surprisingly, David McGiffert, the 1st AD, was not yet aware of what was to come, although he had suspicions that something was brewing behind closed doors: "From the time we began shooting at the mall, I could see Bob, Bob, and Neil talking a lot more than usual. I remember thinking there was a tremendous undercurrent of something happening. We were filming things, but there was no intent behind it. Everybody's attention was somewhere else. By then, everybody knew that something was up. I remember Frank Marshall saying to me, 'Just roll with it tonight. It might get a little weird.'"

At 10:30 p.m., the crew broke for lunch. (No matter the time of day, the meal served six hours after the crew call is always referred to as "lunch.") It was during this break that Zemeckis brought Eric Stoltz into his trailer to talk.

Neil Canton was given the task of telling Christopher Lloyd about the change in actors: "I went in and told Chris we're going to replace Eric with Michael J. Fox on Monday. And Chris looked at me and said, 'Who's Eric?' And I said, you know, Marty. And Chris said, 'I thought his name was Marty.' Since everyone had been calling him Marty for the entire show, Chris thought it was a coincidence that we had cast an actor named Marty to play Marty. I said, 'No, it's Eric.' He said, 'Okay.' It was such a Chris moment."

When Canton finished his chat with Lloyd, he went to Zemeckis's trailer to see if everything was all right, and he ended up coming in on the tail end of the director's heart-to-heart with the departing actor. "I remember Bob was telling Eric about *Cocoon* and how he was supposed to direct that and it hadn't worked out," recalls Canton. "We tried to explain to him that this happens more than anyone realizes, doesn't ultimately hurt anyone, and that he was a very talented actor who would go on to have a very successful career."

Canton remembers feeling a sense of relief from Stoltz: "I think he felt really uncomfortable and unsure of what to do or how to play the role. At that point in time, this was just a little movie, and I'm sure Eric was thinking these guys don't really know what they want to do anyway, and I'm not comfortable playing this part, so I'll go off and find something I want to do." Bob Gale speculates: "There was a sense that Eric had agreed to do *Back to the Future* because his agents told him it was a good career move. After Bob [Zemeckis] fired him, I asked Bob, 'How did he react? How did he take it?' Bob said, 'Well, he took it a lot better than I thought. He didn't seem all that upset.'"

When the crew returned from their lunch break, they were gathered together by Zemeckis, Gale, and Canton. "We laid out a fairly detailed plan for the crew," says Canton. "We said, essentially, we were replacing Eric, that no one was going to lose their jobs, that we would continue to shoot and have to go back to some locations for reshoots and so on and so forth."

First assistant cameraman Clyde Bryan has a very specific memory of that night: "When Bob and Bob were making the announcement of the casting change, [chief lighting technician] Mark Walthour and I looked up behind them to see a shooting star streak through the sky."

Neil Canton's memory is even more specific: shortly after they addressed the crew, his beeper went off, indicating that his wife had just gone into labor. Thus, for Canton, the birth of his daughter is forever linked to the birth of a new Marty McFly.

The next day Bob Gale asked Crispin Glover and Tom Wilson to his office to personally give them the news. As he would not divulge the reason for having them make the trip, both feared that they were being replaced. Lea Thompson had taken an unauthorized trip overseas and, when checking her home answering machine, found a great number of panicked messages from people trying to locate

INTER-OFFICE MEMO

To: Mel Sattler

From: Neil Canton

Date: 16 Jan 1985

Re: Eric Stoltz BACK TO THE FUTURE

I am confirming that we agree to pay Eric Stoltz's hotel room and tax and car rental bill for an additional two weeks (January 12-25, 1985) as part of his dismissal from BACK TO THE FUTURE.

Neil

cc: Frank Marshall
 Dennis Jones
 Leanne Moore

her. When she finally made contact with her agent and was apprised of the situation, her immediate reaction was relief. "I was happy that it wasn't me. It's a natural response. You're always happy it's not you, but it wasn't a big surprise because things were already hard, and they weren't getting any easier."

The production report for that Thursday night indicated Eric Stoltz as "WF" or "work finish," and he was officially signed out at 10:30 p.m. "We were doing a movie with Eric Stoltz the first half of that night, and by the second half, we weren't," says McGiffert. "It was that stark."

For the second half of the evening/morning, the crew shot with Christopher Lloyd and captured some driving shots of the DeLorean zooming through the parking lot. While Kevin Pike had come to love the DeLorean, the stunt drivers were not as enamored. On one take, the B car spun into a curb and sustained a broken radiator, broken rim, and frame damage. The radiator and rim were repaired on set. "The car was not built or designed to do stunts," says stunt coordinator Walter Scott. "The engine wasn't best suited to the kind of driving and acceleration we needed it for, and it was also weighed down with the aesthetic additions made by the production design [department]."

On the next night, their first without a Marty McFly, Zemeckis and company shot Doc's side of scene 23, in which he demonstrates the time display and tells (the unseen) Marty how the flux capacitor was conceived.

The crew wrapped at 4:30 a.m. on Saturday, January 12. Most would return home and rest up for the remainder of the weekend, but a number of key department heads would not have that luxury of a respite. The "real" Marty McFly needed to be brought up to speed.

Later that Saturday morning, Michael J. Fox found himself arriving at a beach house in Malibu rented by Steven Spielberg, where he met Zemeckis and Gale for the first time. "I got Bob Zemeckis immediately," he says of their initial encounter. "He's a visionary, and Bob Gale too. You felt like you were with people that were really ascendant and ascendant for the best reasons. They had stories to tell, and they felt a responsibility to tell them in as full a way as possible. I wanted to be part of that."

Fox spent the weekend being fitted for wardrobe. It was decided he would sport a different look than his predecessor. Around the time they had decided to recast, Bob Gale had seen someone wearing an orange down vest and had made a mental note that it would make a good gag. As Gale recalls, "Eric's wardrobe was basically chosen to make him more or less blend in in 1955, and at some point, Bob and I realized we were missing a good opportunity for humor so we made Marty stand out more."

Fox was fully involved in the choices regarding his character's look, but he inadvertently contributed

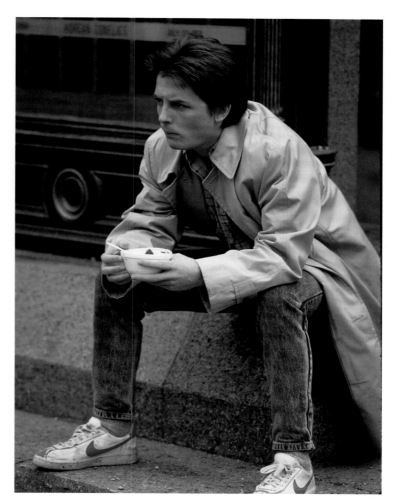

to one of the most important and long-lasting synergies between the production and a well-known brand. For the first six weeks of shooting, Stoltz had worn dark green Converse high tops. On the day of Fox's fittings, costume designer Deborah L. Scott had forgotten to bring the shoes with her. Zemeckis looked at what Fox was wearing—a pair of Nike Bruins—and said, "Just wear those."

The following Monday, Frank Marshall got a call from Scott, who had a dilemma. She needed ten pairs of the shoes for filming, but Nike had discontinued them. Marshall made a call to a friend who worked at the very first Nike retail store in Westwood for advice. He was given the contact information for Pam McConnell, who was working in a new department at the company. "I called Pam, and I said, 'Hi, I'm doing a movie, and we want to use some of your shoes, but you don't make them anymore. Can you help me?'" says Marshall. "It was a great opportunity, but the problem was we didn't have any," recalls McConnell. "They weren't in our warehouses or retailers. They were sold out, so we made new pairs for the film through our samples team." "She called the next day and said, 'You'll have twenty-five pairs on Friday,'" continues Marshall. "I asked how much it would cost, and she told me it would be free. That was the beginning of a beautiful friendship, and they have been our partners since then."

WEEK 8: JANUARY 14–18, 1985

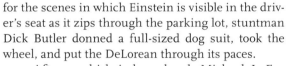

Michael J. Fox would spend one more day in prep, while Christopher Lloyd started week 8 back at the Puente Hills Mall shooting more of Doc's scenes as the DeLorean reappears with Einstein safely inside. The prop department was prepared with additional remote control units as Lloyd had put a little too much energy into his first take days earlier and had snapped off the toggle switch.

The remote device itself was a conceit of the film and unable to truly control the car. Therefore,

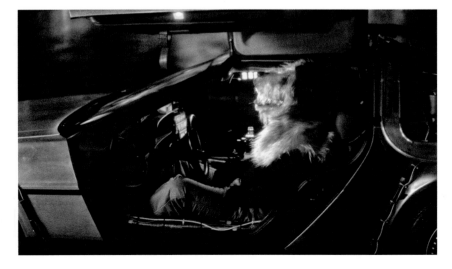

for the scenes in which Einstein is visible in the driver's seat as it zips through the parking lot, stuntman Dick Butler donned a full-sized dog suit, took the wheel, and put the DeLorean through its paces.

After a whirlwind weekend, Michael J. Fox went from a beach house in Malibu to "a parking lot in Puente Hills with flames running through my legs." Fox was introduced to the crew and immediately got into the swing of the action. His first scenes had him donning the familiar yellow radiation suit as Doc loads a plutonium cylinder into the hopper. Also shot was the beginning of the scene that sees Marty behind the wheel of the DeLorean while being chased by Libyan terrorists.

The company moved from the unfinished parking lot scenes to Golden Oak Ranch in Newhall for the remainder of the week. Located approximately thirty miles north of Los Angeles, the idyllic site, rented out to film crews by Walt Disney Studios, doubled as the Peabody barn and farm, with Michael J. Fox continuing to wear the radiation suit.

On his second night of filming, Fox continued to acquaint himself with his new coworkers. Bob Gale recalls, "He was so outgoing and happy to be there. I remember him introducing himself to the crew. Everybody knew who he was—he was on the second-highest-rated TV show at the time—but he'd

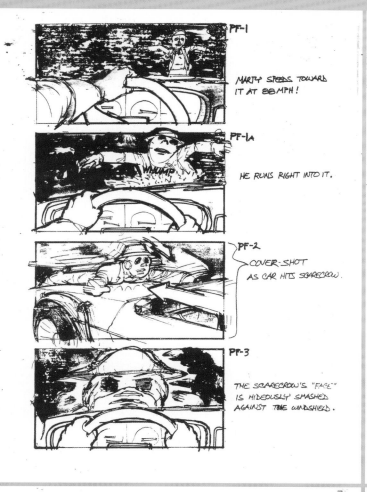

PF-1
MARTY SPEEDS TOWARD IT AT 88 MPH!

PF-1A
HE RUNS RIGHT INTO IT.
WHUMP

PF-2
COVER-SHOT AS CAR HITS SCARECROW.

PF-3
THE SCARECROW'S "FACE" IS HIDEOUSLY SMASHED AGAINST THE WINDSHIELD.

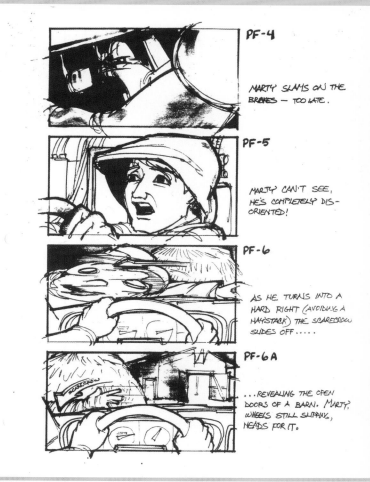

PF-4
MARTY SLAMS ON THE BRAKES — TOO LATE.

PF-5
MARTY CAN'T SEE, HE'S COMPLETELY DIS-ORIENTED!

PF-6
AS HE TURNS INTO A HARD RIGHT (AVOIDING A HAYSTACK) THE SCARECROW SLIDES OFF.....

PF-6A
SCARECROW
...REVEALING THE OPEN DOORS OF A BARN. MARTY, WHEELS STILL SLIPPING, HEADS FOR IT.

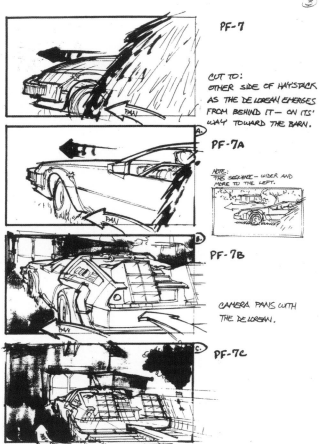

PF-7
CUT TO:
OTHER SIDE OF HAYSTACK AS THE DE LOREAN EMERGES FROM BEHIND IT — ON ITS' WAY TOWARD THE BARN.
PAN

PF-7A
PAN
NOTE:
THIS SEQUENCE - WIDER AND MORE TO THE LEFT.
PAN
PAN

PF-7B
CAMERA PANS WITH THE DE LOREAN.
PAN

PF-7C
WE TILT UP

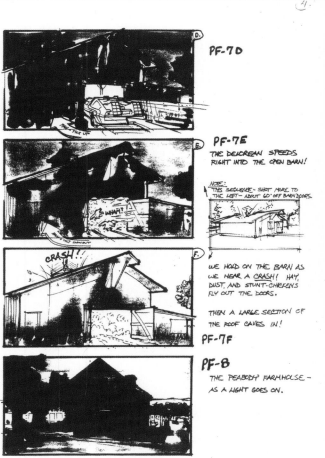

PF-7D
WE TILT UP

PF-7E
THE DE LOREAN SPEEDS RIGHT INTO THE OPEN BARN!
NOTE:
THIS SEQUENCE - SHOT MORE TO THE LEFT - ABOUT 60° OFF BARN DOORS.
WE TILT UP SLIGHTLY
WHAM!

PF-7F
CRASH!!
WE HOLD ON THE BARN AS WE HEAR A CRASH! HAY, DUST, AND STUNT-CHICKENS FLY OUT THE DOORS.
THEN A LARGE SECTION OF THE ROOF CAVES IN!

PF-8
THE PEABODY FARMHOUSE - AS A LIGHT GOES ON.

TALES FROM SPACE

THE FANATIC'S COMIC · EC

NO. 8
AUG. - 54

AUTHORIZED RZ - R8

CONFORMS TO NO COMICS CODE

10¢

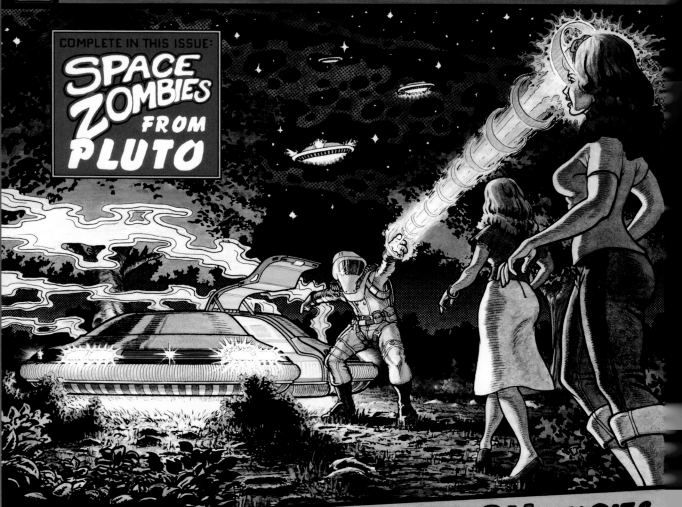

COMPLETE IN THIS ISSUE:

SPACE ZOMBIES FROM PLUTO

SHOCKING SCIENCE-FICTION STORIES

walk up to people and say, 'Hi—Michael Fox.' Duh. How great was that?" Recalls executive producer Kathleen Kennedy, "Once Michael arrived on set, the entire movie levitated in tone. His unique style and unbridled enthusiasm lifted everything. It became obvious this was what Bob Zemeckis and Bob Gale intended the movie to be."

Even with their new and improved Marty, there would still be other obstacles. Ivy Bethune, who portrayed Ma Peabody, arrived on location the first night with an injured ankle, rendering her unable to perform the physical aspects of the sequence. Hairstylist Dorothy Byrne was called upon to be Ma's photo double and complete the work.

Fox would work for two of the three scheduled nights at the farm location, because on Friday night he was taping that week's episode of *Family Ties*. In his absence, the company would shoot Sherman (Jason Marin) and Pa Peabody (Will Hare) taking a shot at the disoriented Marty—stuntman Dick Butler trading the dog costume for the radiation suit.

A week after Eric Stoltz was let go, the January 17 issue of *Daily Variety* broke the news with the headline "*Back to the Future* Star Fired Halfway Through Shooting," stating, "Summer release through Universal of the Amblin Pictures

presentation of *Back to the Future* seems highly problematic with the firing of star Eric Stoltz last Thursday, six weeks through an approximately twelve-week shoot." One month later, Stoltz was honored by the National Association of Theater Owners at their annual convention as the 1985 Star of Tomorrow for his performance in *Mask*.

OPPOSITE Andrew Probert's cover for Sherman Peabody's comic book.

TOP Probert's design concept for the barn scene.

ABOVE The crew sets up for the filming of the Peabody barn scene.

With Fox settling into his new role, it was determined that the priority would be the reshooting of scenes that had previously been filmed with Stoltz. In that way, editors Artie Schmidt and Harry Keramidas would be able to start putting together complete sequences combining the new and previously shot footage.

An enormous number of scenes were to be reshot in Puente Hills: Marty arriving at the mall and seeing the DeLorean for the first time; Doc explaining time travel and the invention of the flux capacitor; the Libyans arrival and chase; the DeLorean disappearing with Einstein at the wheel (complete with the trail of flames between Fox and Lloyd's legs, courtesy of Kevin Pike); and Doc preparing for his journey into the future, with Marty recording the event.

They would also shoot the scenes that they had not yet gotten to with Stoltz, including Marty's return to the mall (now renamed the "Lone Pine Mall").

Despite the challenges and the cold, harsh weather, over the course of week 9, Fox's energy and enthusiasm became infectious, lending a new spark to the beleaguered production. What became especially apparent was the chemistry between Fox and Christopher Lloyd. At first, Lloyd was not very happy about the replacement, not that he had anything against Fox, but he was worried about being able to bring the same intensity and nuance he had given in his first go-round. "I never thought there was anything lacking about Eric's performance during our scenes," he states. "I thought he was fine, and I was always concentrating on my own performance to make it the best it could be. The chemistry when Michael and I worked together was innate or inherent. It was just there. It wasn't as if we were trying to find it. There was a different, more heightened energy than there was between me and Eric Stoltz. I only know that by contrast."

"We didn't have much of a relationship off camera," adds Fox of Lloyd. "There certainly wasn't any animus between us. In fact, there was deep affection, but I had nothing to say to him that he had any interest in and vice versa. We were so committed to what we were doing and loved working with each other. He would take it to a place, and I would meet him there, and I think he loved that, and I loved being able to do that. He would match my energy. I would watch what he would do, and I would just want to go where he was going."

OPPOSITE AND BELOW
Reshooting a scene he had filmed only days earlier with Eric Stoltz, Christopher Lloyd found an immediate chemistry with new costar Michael J. Fox.

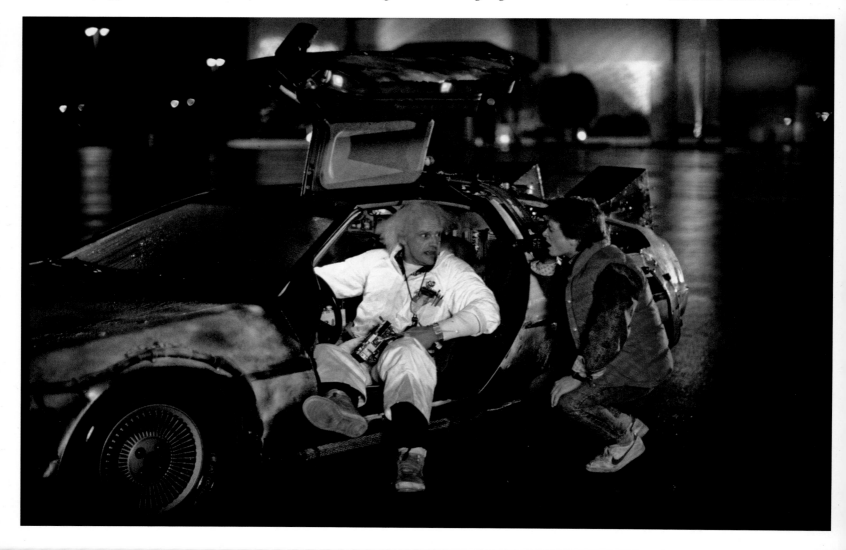

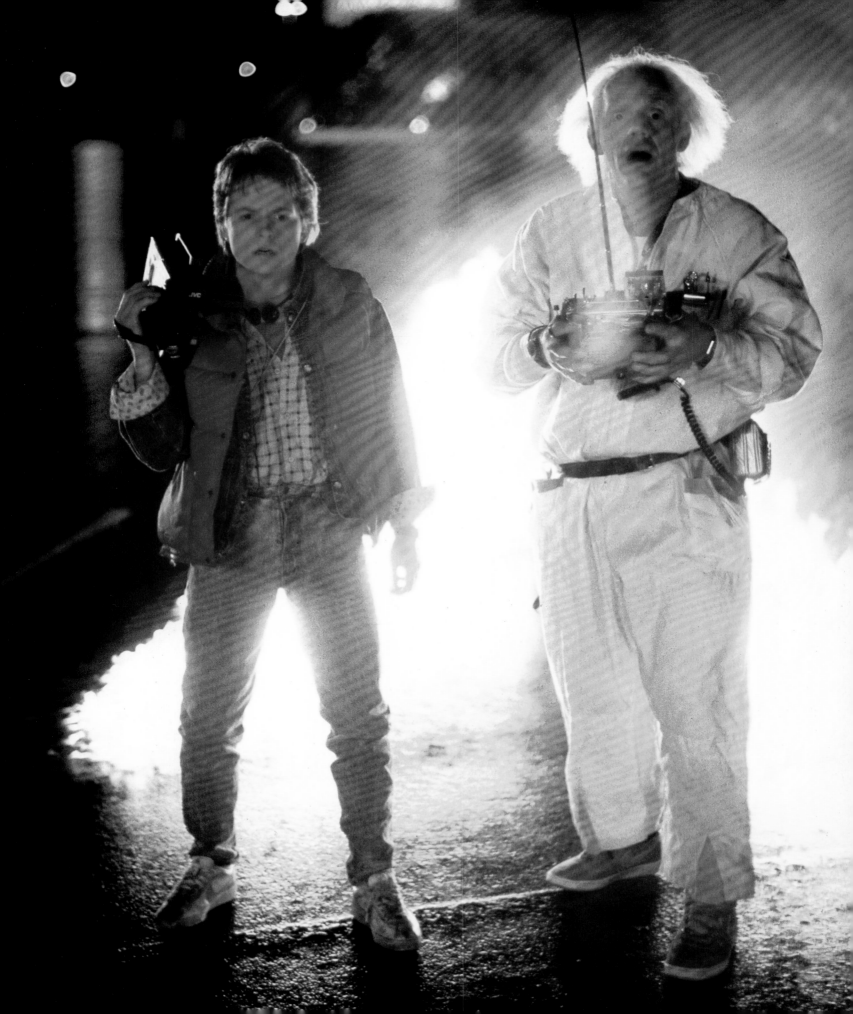

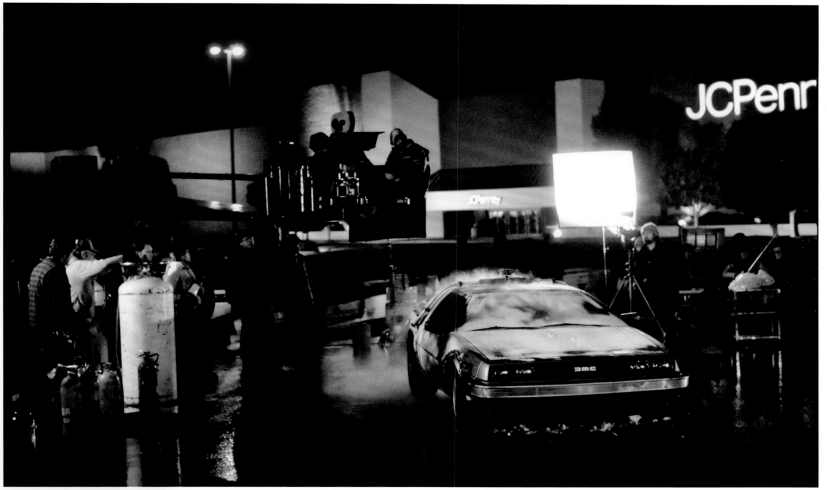

"What Chris did in that movie that people don't know or appreciate is that there's a standard thing you don't want as an actor, which is to be the one saddled with exposition, to be the guy who has to lay the pipe," explains Fox. "It's a thankless job, but in all that madness, what he was doing was really important stuff. He was laying out the rules, laying out the roadmap of what we were going to do. That's all exposition. It's thankless shit, but Chris raised it to an art form."

Lloyd credits the way the script was written as the key to being able to impart all the information necessary to the audience and make it palatable: "Doc's way of looking at things was written with real logic. It wasn't just gibberish. It made sense. I would work on it until the logic went along with the action of a scene, and that helped a lot. I knew the exposition had to be delivered with the same urgency as everything else. Doc Brown is always in crisis mode. There's nothing casual or matter of fact, even if the intention is just to make sure Marty understood—*really* understood—because the space-time continuum is at stake. [The dialogue] had a momentum to it, and you could ride it, and I loved that."

Although Zemeckis was gratified by the infusion of new energy Fox had brought to the production,

he was still troubled by the preceding events and the situation in which he found himself. "I was distraught and in so much pain," he admits. "I thought most of my crew was going to quit, because who does this? Obviously, I thought I was going to be somehow pilloried as a horrendous director who didn't know how to make his movie and didn't know what the fuck he's doing."

There was however, a "good news" side to the director's "bad news" scenario. With Michael J. Fox in the role of Marty, Zemeckis suddenly felt he "had a creative soulmate now. Somebody who understood the material, understood what I was trying to do and how to get there. We were all making the same movie now."

Indeed, Fox had a clear vision for how he should interpret the role from the first time he read the script: "I never saw any of Eric's footage, and I can only presume that it was good, honest work, because that's what he does, but the story didn't allow for any apology or self-consciousness. There was no room for that in the script. There was too much happening. You can't have a moment where Marty is angst-ridden or depressed or confused. You just had to go into it balls-to-the-wall, eyes open and rolling and just embrace it."

OPPOSITE Doc celebrates the success of his first time-travel experiment.

TOP Filming at the Puente Hills Mall. Liquid nitrogen was used to frost the DeLorean.

ABOVE A chemical compound provides the DeLorean's fire trails.

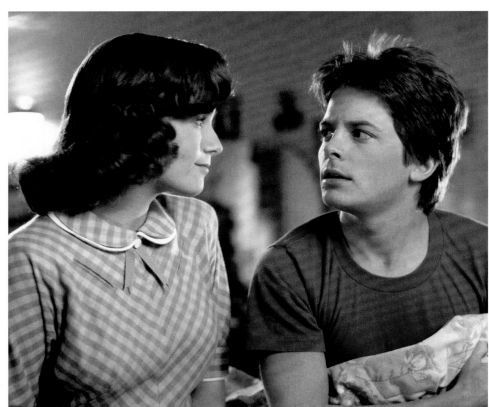

Back at Universal Studios, reshoots began with Marty's arrival in the pristine town square. It was soon interrupted due to heavy rain and because Fox was suffering a bout of gastritis. Fox recovered quickly, but the rains continued, so the company moved indoors to reshoot the scene in which Marty wakes up in young Lorraine's bed.

This was the first time that Lea Thompson would work with her new costar, and, at first, she wasn't particularly enamored of him. "I was cranky," she admits. "My friend had gotten fired. To be honest, at the time, I remember being really, really snobby about Michael. There were movie actors and then there were TV actors, especially sitcom actors. The movie actors looked down on the sitcom actors. There's comedy, and there's drama, and it's hard for the two to meet. I think Eric might have thought it was a little bit of a different kind of movie. Stylistically, Michael was perfect for what they needed."

When the rains finally abated, the skateboard chase was reshot. Although skateboarding was one of the talents he described as being in his

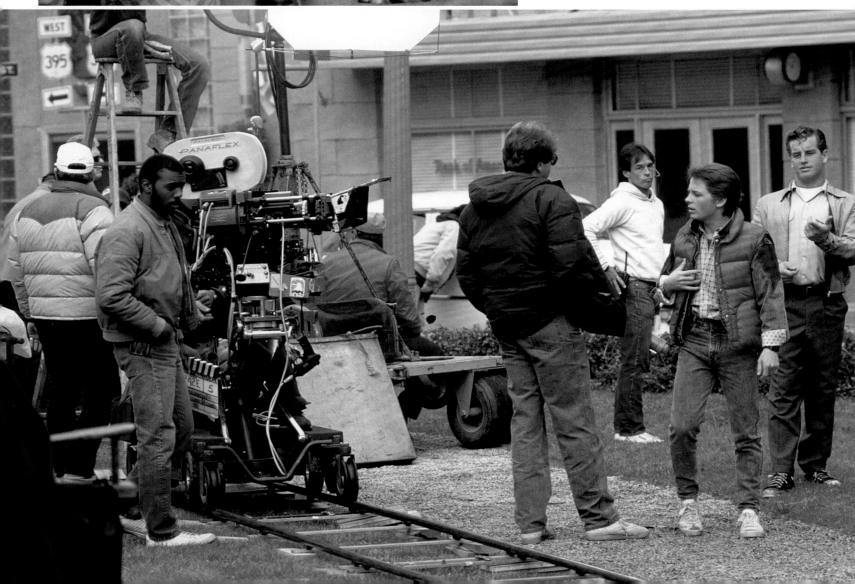

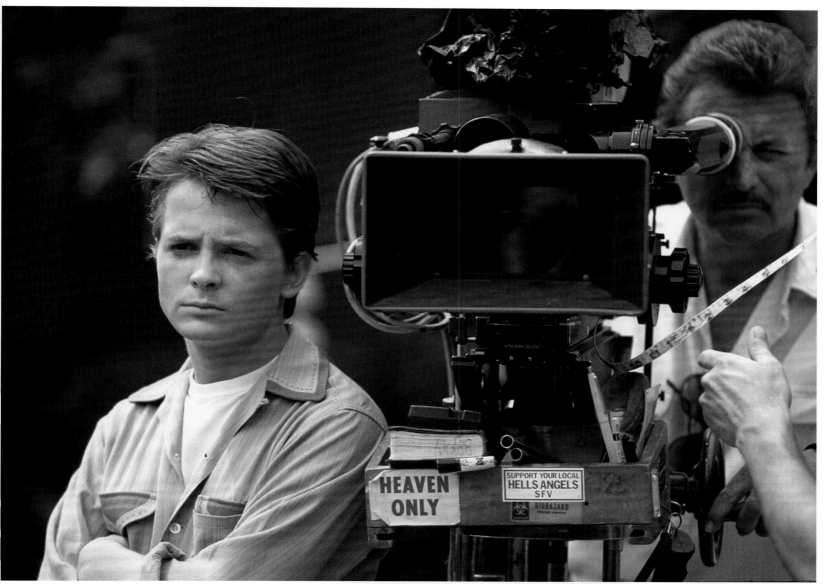

wheelhouse, Fox didn't rely on his existing skills, and he prepared for the scene with additional tutorials from experts. "If I couldn't get what they were trying to do, I would bust my ass to get there. I knew how to skateboard, but I wasn't on a level with Per Welinder [who would serve as Fox's stunt double for part of the sequence]." Fox's renewed skills were more than proficient enough for him to perform the majority of the scene, thus enabling Dean Cundey to film wide shots that showed the audience it was indeed Michael J. Fox wheeling his way through the town square.

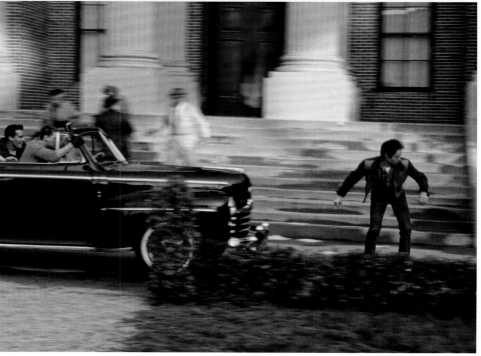

OPPOSITE TOP Lea Thompson in her first scene with Michael J. Fox.

OPPOSITE BOTTOM Zemeckis shoots Marty's arrival to the 1955 town square, as 1st AD David McGiffert (center with walkie-talkie) stands at the ready.

ABOVE Fox takes in the action.

RIGHT Skateboard pro Per Welinder performs some key action for the skateboard chase.

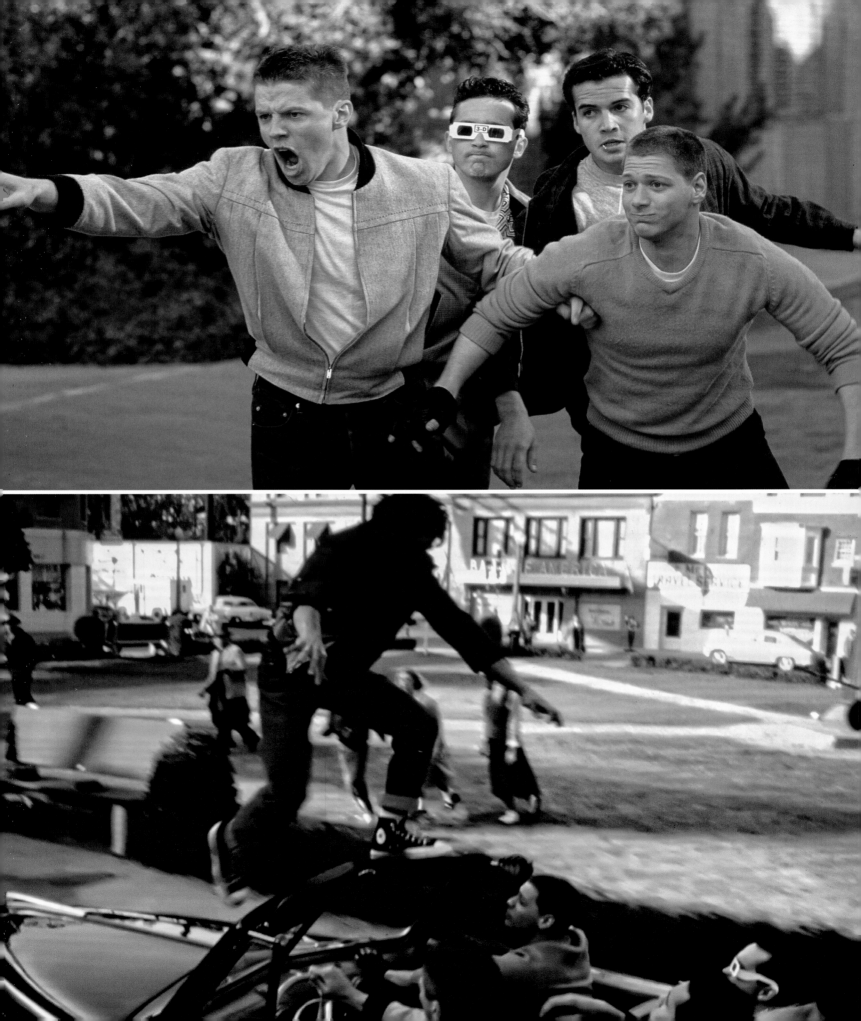

WEEK 11: FEBRUARY 4–8, 1985

Week 11 took place at Universal Studios and consisted primarily of split days, with Friday becoming an all-nighter. The evenings continued the action with Marty and Doc at the clock tower, while the early afternoon shooting focused on outstanding footage for the skateboard chase.

For the climactic shot of that sequence, Fox was assigned a new stunt double with whom he would work for many years to come. Charlie Croughwell, a new transplant to Los Angeles, would sneak onto studio lots to find out what was filming and introduce himself to whomever was coordinating stunts on that particular show.

One particular day at Universal, Croughwell found that the only film in production was *Back to the Future*. Coincidentally, the stunt coordinator working that day was Max Kleven, the father of an acquaintance of Croughwell from the East Coast.

Recalls Croughwell, "As Max and I were talking, Michael walked up to us, looked at me, and asked Max if I was his new stunt double. Max nodded, and Michael shook my hand and said he was looking forward to working with me. After he left, Max said to me, 'You *can* do stunts, right?'" "It was a total fluke," says Kleven about the timing. "I knew after Michael had come onto the show that the double we had for Eric wasn't going to work. There weren't a lot of stuntmen around at the time who were Michael's size."

Charlie Croughwell's first stunt (and big break) was the seminal moment in the chase where Marty is being propelled backward by Biff's car before leaping up on the hood, running the length of the vehicle, and landing back on the skateboard that has passed under the car. As Zemeckis called "Cut!" Croughwell received a thunderous ovation from the cast and crew.

The last night of week 11 was scheduled to focus on exteriors, but the rains returned and moved the production back to Stage 12. Just as on a previous rainy night, they again shot Marty making his midnight visit to scare some sense into George.

TOP RIGHT A pulp science fiction magazine from George McFly's bedroom.

RIGHT George receives a late-night visit from "Darth Vader."

OPPOSITE TOP Biff (Tom Wilson) and his gang, 3-D (Casey Siemaszko), Match (Billy Zane), and Skinhead (J. J. Cohen).

OPPOSITE BOTTOM Newly hired stunt performer Charlie Croughwell performs his first piece of action, leaping over Biff and the gang.

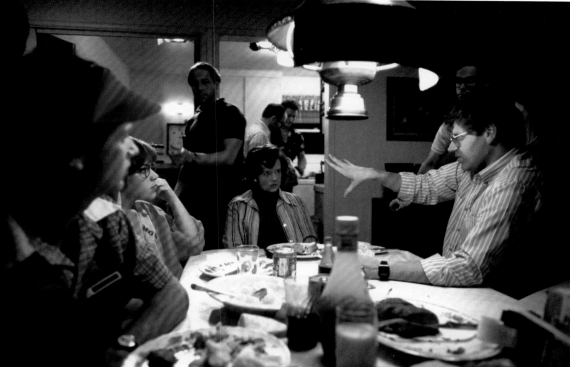

WEEKS 12–13: FEBRUARY 11–22, 1985

The next two weeks found the company on a dedicated split schedule, beginning around noon and wrapping early the next morning. The days began on Stage 12, with scenes on the clock tower pediment and in the McFly home. At dusk, with the arrival of Michael J. Fox, the production moved to the back lot to film Doc and Marty repairing the conducting cable that had fallen in the storm.

Powerful wind machines, including "The McBride," a huge aircraft engine mounted on a moveable crane, kicked up the dirt, leaves, and debris on the ground. The noise generated by this equipment not only made it impossible for Marty to be heard by Doc, but made it nearly impossible for the crew to hear one another.

On stage at the McFly house set, Crispin Glover and Tom Wilson (and later, Lea Thompson) had to endure three and a half hours in the makeup chair for their transformation into their middle-aged counterparts so that Zemeckis could film George McFly being bullied by Biff.

For makeup artist Ken Chase, the challenge of applying several decades of aging to the young actors was a much more subtle process than if he were asked to age them well into their senior years. When discussing the procedure in 1985, Chase explained: "It's much more difficult to make someone appear to be in their forties, simply because of the mechanics. If I were asked to make Lea look one hundred, I would cover her whole face with latex foam prosthetics, and there would be no skin visible. It would have the same texture and would be easy to do. But for this film, since we

couldn't change the appearance dramatically, we had to use foam rubber against skin, and there is a difference in textures. It's important for the audience to recognize these actors through a thirty-year span, and if we put too many appliances and wigs on, that's easily lost."

For his 1985 scenes as Doc Brown, Christopher Lloyd also endured the process that transformed the forty-six-year-old actor into the sixty-five-year-old inventor.

Wendie Jo Sperber and Marc McClure joined the cast, and the McFly family gathered around the dinner table to hear Lorraine wax rhapsodic about how she fell in love with George, while he watches a rerun of *The Honeymooners*. The scene was blocked with Marty alone on one side of the table so that all of the other actors could be filmed before Fox joined them later in the evening after finishing *Family Ties*. With Fox's arrival, the master shot and the shots featuring Marty were filmed.

A full-sized version of the clock tower pediment was also built on Stage 12. With controlled lightning and wind effects in place, Zemeckis was able to easily get the close-ups of Doc on the ledge and hanging from the clock from a much less acrophobic Christopher Lloyd.

On another part of the huge stage, the interior of Doc's garage was constructed. When Lloyd was not hanging around on the clock, he and Fox would shoot the scene in which Marty convinces Doc he's from the future with his knowledge of the origins of the flux capacitor.

BACK TO THE FUTURE

INTER-OFFICE MEMO

To: Frank Marshall

From: Bob Gale

Date: 14 Feb 85

Re: Change in Michael Fox's "Family Ties" schedule

As if we haven't already had enough nightmares, I learned Monday that "Family Ties" is NOT taking the February 25-March 1 hiatus originally promised, which thus screws up Michael Fox's schedule--and our own. After discussing the situation with Dennis and then with Gary Goldberg, Gary has agreed to let Michael off on February 25-26, which is the only time we are able to shoot in the Hill house in Pasadena (Dr. Brown's house interior). Unfortunately, our plan to finish up the 1955 Town Square material on February 25-March 1 can no longer be adhered to.

The good news is that the rescheduling gives us Michael on a full-time basis one week earlier, starting March 11 instead of the 18th. We are in the process of adjusting the schedule accordingly.

Unfortunately, since we had been so assured of that full week of February 25, we gave certain actors confirmed dates based on that week--specifically the 3 "Biff's boys" and the characters of "Lou" and "Goldie." We are now in the process of determining their availabilities and what havoc this change wreaks on their lives. In particular, J.J. Cohen ("Skinhead") was all set to do another picture with dates that would not have conflicted with our previous schedule, only to now have a conflict. We therefore had to put him on a weekly and are carrying him to keep him out of the other show. This will add at least $11,000 to the budget, not including fringes or overhead, all because of "Family Ties" changing their schedule. Undoubtedly, we will face other similar repercussions down the line which are completely out of our control.

Just thought you'd want to know.

cc: Neil Canton
 Dennis Jones

WEEKS 14–15: FEBRUARY 25– MARCH 8, 1985

Built in 1907 by lumber magnate Robert Blacker and designed by noted architects Henry and Charles Greene, the Blacker House in Pasadena, California, is currently on the US National Register of Historic Places. It had already served as the interior of the 1955 Brown residence during the first few days of shooting with Eric Stoltz, and, because there was a lot of useable footage of the location, it was necessary to return for the reshoots with Michael J. Fox. In arranging to secure the privately owned location, the producers discovered that the house had been sold and was in escrow. There was only a one-week window in which the production could return, otherwise they would have to negotiate with the new owners. "We knew it was a crapshoot whether the new owners would let us film there," says Gale. "Luckily, Mrs. Hill still owned the house and was totally cool with us."

In order to make the plan work, Gale had to ask Gary David Goldberg to allow Fox to miss two days of rehearsals for *Family Ties*. Thankfully, Goldberg accommodated the request.

After finishing the Pasadena interiors, the company moved back to Universal Studios for the interiors of Doc's garage/workshop and the scene in which Doc shows Marty the tabletop model of the town square he's constructed to demonstrate his plan to channel lightning into the DeLorean.

Production designer Larry Paull recalls this as his favorite set piece in the film. According to art director Todd Hallowell, it was inspired by an album by the rock group Supertramp called *Breakfast in America*. Says Hallowell, "For the album cover, they had taken household objects, and painted them all white, and created a cityscape. We thought that was a fun idea." He pieced together the elaborate model from a collection of cereal boxes, bottles, egg crates, nails, dozens of other knickknacks,

and a wristwatch to serve as the clock in the tower. Although Doc apologizes for the crudeness of the model because he "didn't have time to build it to scale or paint it," Hallowell and Michael Scheffe actually spent weeks designing and constructing this impressive diorama.

On another part of the enormous soundstage, the interior of the McFly home had been redressed to reflect the trappings of the "improved" McFly family.

During filming, Crispin Glover frequently expressed his opinion that the newfound lifestyle depicted at the end of the movie was a deliberate message by the filmmakers that equated money with happiness. These assertions were met with consternation by Zemeckis and the producers.

For cowriter Bob Gale, there was no such intent or hidden agenda: "We wanted to visually depict that the McFlys had a better life as a result of George's actions. A better furnished home, nice clothes— these were the pictures that told that story."

TOP LEFT Pasadena's Gamble House served as the exterior of Doc's house because it was more impressive than the exterior of the Blacker House.

TOP RIGHT Bob Gale's scheduling memo to Frank Marshall.

ABOVE Crispin Glover poses for George McFly's author photo.

OPPOSITE TOP Doc Brown prepares to demonstrate his plan to send Marty back to 1985.

OPPOSITE BOTTOM Concept designs for the cover of George's novel, *A Match Made in Space*, by Andrew Probert.

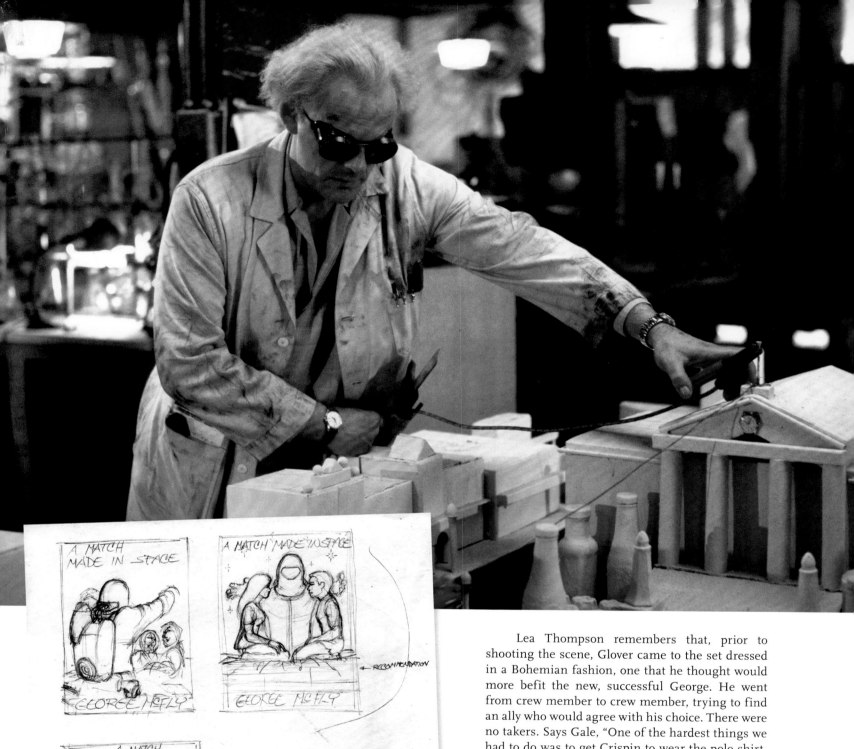

A MATCH
MADE IN SPACE

GEORGE MCFLY

A MATCH MADE IN SPACE

← RECOMMENDATION

GEORGE MCFLY

A MATCH
MADE IN SPACE

GEORGE MCFLY

ASTONISHING
SCIENCE FICTION

BOOK COVER #2

PICK ONE

WE'RE ON OUR WAY

TO
THE 2ND ANNUAL
3-D FILM FESTIVAL
(BACK TO THE FUTURE)

Lea Thompson remembers that, prior to shooting the scene, Glover came to the set dressed in a Bohemian fashion, one that he thought would more befit the new, successful George. He went from crew member to crew member, trying to find an ally who would agree with his choice. There were no takers. Says Gale, "One of the hardest things we had to do was to get Crispin to wear the polo shirt, carry the tennis racket, and act like a regular guy."

In addition to his wardrobe suggestions, Glover attempted to contribute to the production design and enlisted Lea Thompson in his efforts. A few nights prior to shooting the final scenes, the two collaborated on a painting that Glover hoped would be made part of the McFly home decor. "It was of a volcano," laughs Thompson. "Crispin was really into volcanoes. I laughed a lot. It was a funny way to try to bond." Although the painting, given to production designer Larry Paull, "disappeared" right before the filming, it was found shortly thereafter and has been kept in Thompson's garage ever since.

At courthouse square on the Universal back lot, it was now Michael J. Fox's turn to film the scene between Marty and George at the Texaco station, wander into Lou's Cafe to order a Tab and Pepsi Free, and encounter the 1955 versions of George and Biff.

From Universal Studios, it's less than a ten-minute drive to Hollywood Boulevard and Franklin Avenue where the Hollywood United Methodist Church stands. It was here that the all-important "Enchantment Under the Sea" dance sequence was shot. (The "Springtime in Paris"

moniker had been replaced in the fourth draft of the script.) "We changed the dates in the story to more closely reflect the time we'd be shooting the movie," says Gale. "Since we didn't think we'd be shooting the 'Springtime in Paris' dance in the spring, we changed it. As I recall, somebody in the art department found a real 1950s high school yearbook with an 'Under the Sea'–themed dance, and we loved that."

Larry Paull and his crew had spent the previous days preparing the church auditorium for the production, finding a local company that supplied all the backdrops, and, what he calls, "amateurish under-the-sea paintings that looked tacky and perfect for a high school dance."

Actor Harry Waters Jr. took his place on stage as Marvin Berry, with his Starlighters in support. Waters recalls there being lots of downtime between scenes, so he and the band (all professional musicians) entertained the nearly two hundred extras in attendance with a number of live performances.

The first few scenes shot focused mostly on George watching the band and checking his watch to make sure he gets to the parking lot on time.

Michael J. Fox took the stage on day two of filming, with Marty replacing the injured Marvin Berry on guitar, while day three saw George forcefully reclaim his dance partner and ensure the future of his three kids with that fateful kiss.

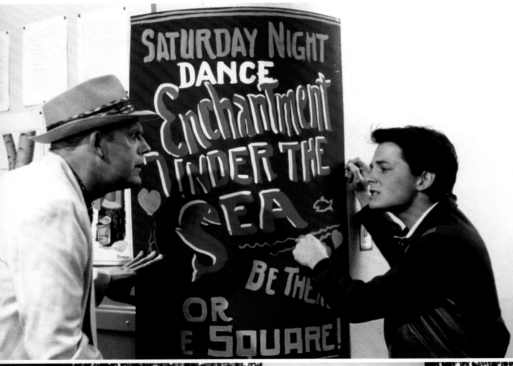

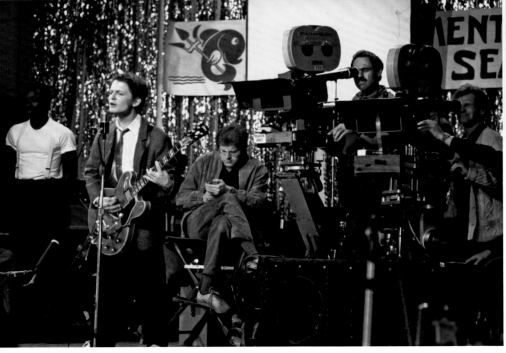

TOP LEFT Fox and Lloyd filming at Whittier High School.

ABOVE Lisa Freeman (left) and Cristen Kauffman (right) portray Lorraine's high school friends, Betty and Babs.

LEFT Cameras capture the students dancing as Michael J. Fox performs "Johnny B. Goode."

OPPOSITE Lea Thompson and Crispin Glover pose for their portrait at the "Enchantment Under the Sea" dance.

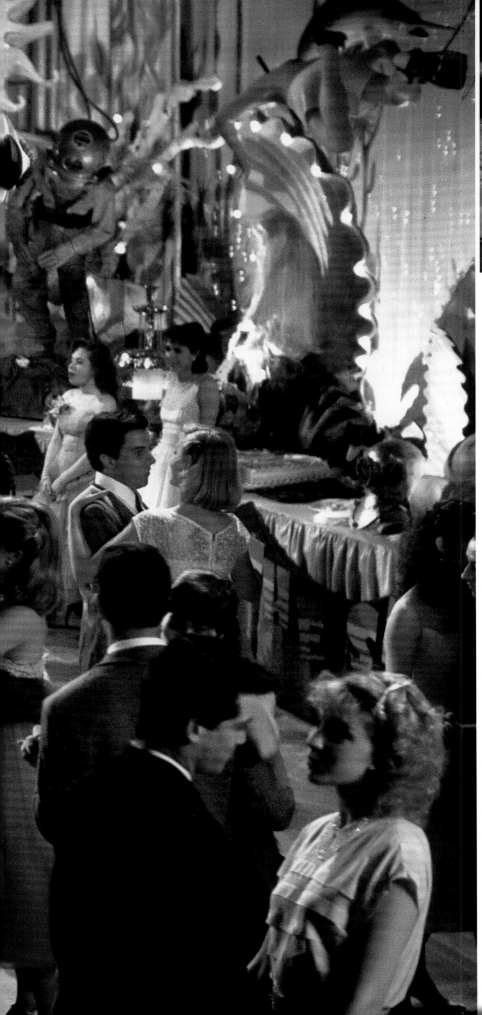

WEEK 17: MARCH 18–22, 1985

After two more days of shooting the school dance interiors at the church, the production moved back to Whittier High School to film night exteriors for the dance sequence. These three nights were some of the most hectic, as there were a multitude of scenes to complete within the allotted location time.

Filming began with Michael J. Fox and Lea Thompson in Doc's Packard, as Marty learns more about his mother than he ever wanted to. On one take (featured in the DVD gag reel), the prop department put real alcohol in the flask, and when Fox took a swig, he executed the perfect (and definitely unplanned) "spit take" to the delight of the crew.

During this visit to Whittier, they also shot Biff's unexpected arrival, his gang grabbing Marty and tossing him into the trunk of the car, and the skirmish that ensues when Marvin Berry and the band confront Biff's goons.

Harry Waters Jr. recalls there was a great deal of attention paid to the bandage that would cover Marvin's wound after his failed attempt to jimmy open the trunk containing Marty: "There were people who were concerned that if there was too much blood on the bandage, it would look way too serious. There had to be just enough so that it looked believable and that Marvin could still perform."

It was during this trip to Whittier High that Bob Gale first allowed himself to think that the film could yet be a hit: "Word had gotten out that Michael J. Fox was at Whittier High School, and we had kids—predominately girls—lined up seven deep to catch a glimpse of him. When we had shot there the first time with Eric, nobody came down to see that, but when it was Michael, the girls were out in force. Bob Z. was amazed too. We didn't truly realize how big a deal *Family Ties* was."

LEFT George and Lorraine share their fateful dance.

ABOVE Michael J. Fox meets his fans at the Whittier High School location.

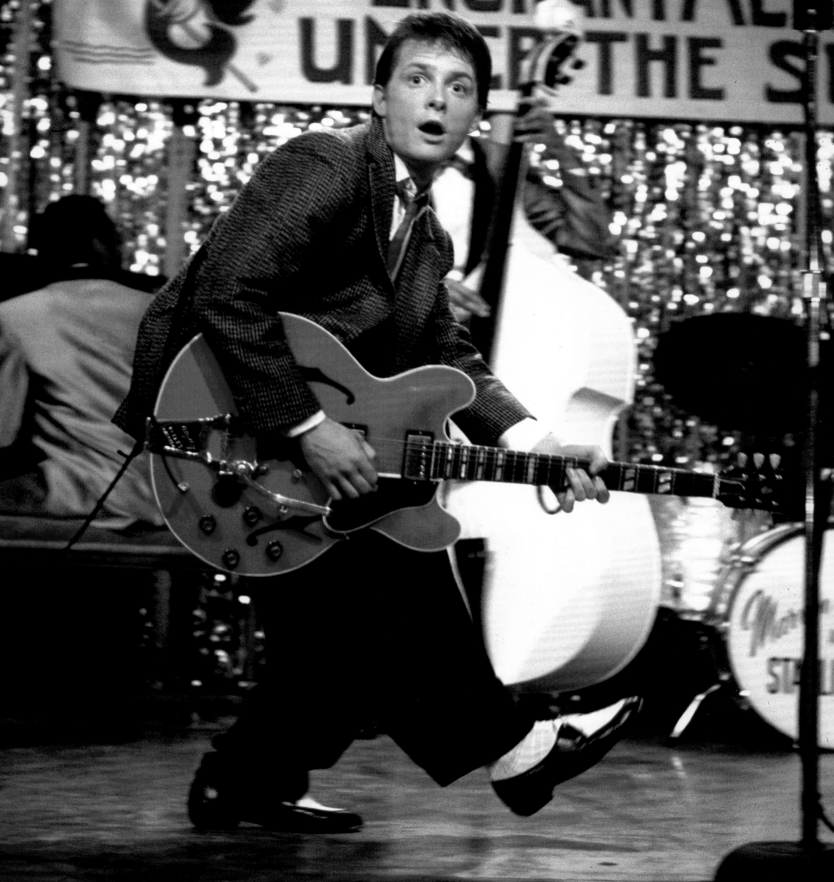

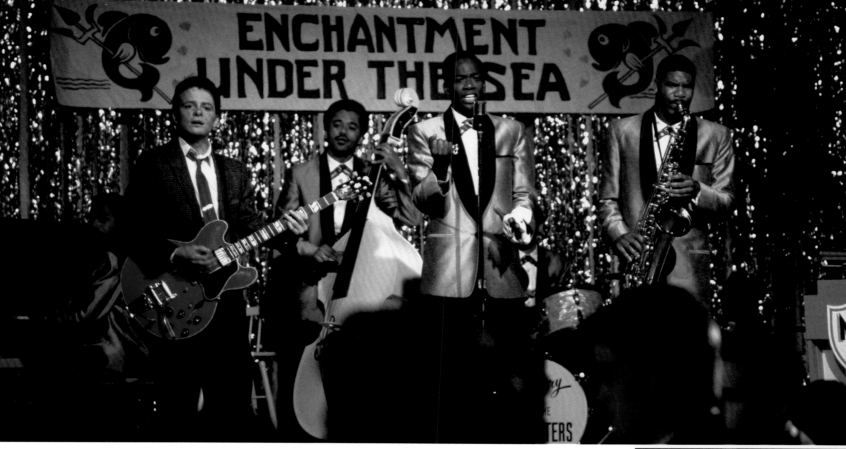

Throughout the filming of *Back to the Future*, Michael J. Fox continued to honor his commitment to *Family Ties*. He adhered to a brutal schedule, giving equal and unbridled enthusiasm to both of the projects, which he admits left little time for luxuries such as sleep: "A teamster would pick me up in the morning and literally pour me into the car, and I'd go to work all day on *Family Ties* and then get back in the van, have a milkshake or something, and go to *Back to the Future*."

Fox allows that his sleep deprivation was an element that carried through to his performance as Marty: "It was a whirlwind. The experience I was having was, in its own way, as much of a trip down the yellow brick road as [Marty's journey]." In addition to his acting chores, Fox threw himself into every aspect of the scenes ahead of him, including his extensive preparation for the upcoming "Johnny B. Goode" performance. (The production would return to the Hollywood United Methodist Church just to shoot this key sequence.)

Although an already proficient guitar player, Fox used whatever spare time he could find to hone his skills with one of the top guitar coaches in the business: Paul Hanson, who would also be featured as one of Marty's "Pinheads" in the band audition scene. It was the actor's intention to make sure he could play every note of "Johnny B. Goode" to match the musical track being played back on the set: "I told Dean Cundey he could film my hands, because I'm

going to be playing this note for note. I hate it when I see people playing the guitar in movies, and it's obvious they're not playing the real piece. I'll put all the work into playing it, but I want to make sure you show it. And he did an amazing job. It was spot on."

Cundey credits Fox's commitment to the process: "I think that's part of the intrigue and the success of that particular sequence. It's the fact that you absolutely believe. There's nothing that tells you it's not Marty playing the music. He is the guitarist. It opens up your ability to capture a sequence like that because you're not thinking about having to shoot him from the back or anything like that."

Acknowledging that he was not a trained dancer, Fox worked diligently with choreographer Brad Jeffries for the sequence and brought his own ideas to the table: "I said I wanted to go through the styles of all my guitar heroes. I want to go through Townsend, I want to go through Chuck Berry, Jimmy Page, Jimi Hendrix. I want to go through all of them. Bob was so open to it. I felt like I was contributing something to it other than just Marty playing the guitar."

The one thing that the actor didn't have to deal with was the actual singing. Prior to Fox joining the film, a version of the song had been recorded by vocalist Mark Campbell, known for his work with the band Jack Mack and the Heart Attack. "I had that track to work with when I was doing the guitar stuff and the choreography, which is good because

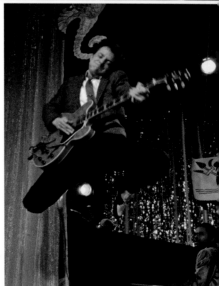

TOP Marvin Berry (Harry Waters Jr.) sings "Earth Angel," thereby ensuring Marty's existence.

OPPOSITE AND ABOVE Fox displays his guitar acumen and dance skills as Marty gives the high school crowd their first taste of rock 'n' roll.

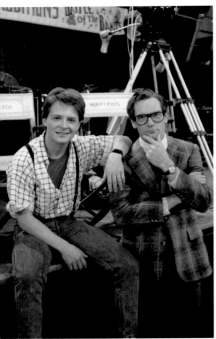

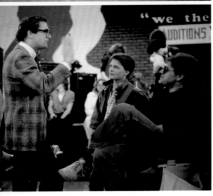

I'm not a singer," says Fox. "It would have been burdensome. Even with limited audio capabilities as compared with today, they could have made me sound reasonable, but it sounded enough like my voice and I was happy not to worry about it."

To this day, Fox recalls the filming of that scene to be his favorite memory of all his work on the trilogy. Over the years, he has performed the song with the likes of The Who and Bruce Springsteen: "I still get up and play every now and then, but when I play 'Johnny B. Goode,' people go crazy."

The last scene shot at the church was Marvin Berry's famous phone call to his cousin, Chuck. Actor Harry Waters Jr. was ready to go but expected he'd have to do it at least a few times. When Zemeckis called "action," "I said the line, pointed the phone at the camera, they called, 'Cut. We got it. That's a wrap.' One take."

Not long after, Waters received his own phone call, which came as a very welcome surprise. Alan Silvestri, the film's composer, called the actor and asked if he would record his version of "Earth Angel" for the official movie soundtrack album. Not only did Waters jump at the chance to record the song again, but, when the soundtrack sold in excess of 500,000 copies, the actor received yet another surprise—a Gold record.

After a day of shooting in Marty's bedroom back on Stage 12, the trucks packed up and moved to the nearby suburb of Arleta.

Exterior scenes of the McFly home marked the first shooting day involving Marty's girlfriend, Jennifer Parker. Melora Hardin had originally been cast as Jennifer alongside Eric Stoltz, but when Fox replaced Stoltz in January, it was brought to Zemeckis and Gale's attention that Hardin was two to three inches taller than Fox. "The women on the crew were very vociferous that she was too tall for him," says Gale. "Since all the women around us had a problem with it, we concluded that the women in the audience would have a problem with it as well." It was Gale's unenviable responsibility to break the bad news to the unsuspecting Hardin. "I don't mind firing someone when they mess up," said the producer, "but Melora was a sweetheart who had done nothing wrong, so this was really tough. I told her in person, and she was, of course, very broken up. Happily, she went on to have a solid career and we've remained on good terms."

Claudia Wells, who had originally been cast as Jennifer, had in the meantime become available after her TV series was not picked up. She returned to the production, and her first shot on the set was one of the last moments in the movie, appearing behind Marty as he admires his new truck.

The last day of the workweek had the crew traveling to two locations, the first being a recreational center in Burbank, doubling for the Hill Valley High School gymnasium. In this scene, before Marty and the Pinheads perform fifteen seconds of their audition, they are dismissed by a member of the dance committee who uses a bullhorn to pronounce their music "too darned loud." That guy was Huey Lewis, making his acting debut in an uncredited cameo. Months earlier, the megastar singer-songwriter had been asked to take a meeting at Amblin to discuss the possibility of writing some songs for an upcoming film. Lewis recalls sitting in a conference room with Steven Spielberg, Robert Zemeckis, Bob Gale, and his then manager, Bob Brown. "I remember them saying, 'We've written this film, and the lead character is called Marty McFly, and his favorite band would be Huey Lewis and the News,'" says Lewis. "They asked if I'd be interested in writing a song for the film. I told them I was flattered, but number one, I don't know how to write for film, per se, and number two, I don't much fancy writing a tune called 'Back to the Future.' They said, 'No problem. We don't need the title of the film in the tune. We want one of your songs.' I told them I'd send them the next tune I wrote."

Lewis sent the filmmakers a demo tape of "The Power of Love." "I was thinking the song probably wasn't going to work for them, because by that point, they'd shot some of the film, and I had read a script, and there was no overt love interest in it," he says. "But as soon as Bob Zemeckis got it, he loved it."

Zemeckis further suggested to Lewis that they give him a small part in the film, which, again, the singer resisted. As Zemeckis persisted with promises that they would disguise him, Lewis reluctantly agreed. The scene was shot in a matter of hours.

After a time, Lewis was approached again, with the filmmakers asking him to consider writing a second song that would play over the movie's closing credits. After seeing some footage and rereading the script, Lewis agreed: "I got it instantly. I thought, 'I'll write Marty's story.' Sean Hopper [keyboardist for Huey Lewis and the News] and I wrote ["Back in Time"]. I had the title and the concept, and we manufactured that one, so it turned out we could write for film after all. We didn't think we could, but it turned out it's not that hard!"

With Lewis's cameo on film, the company moved back to Pasadena, this time to shoot the night exterior of Doc Brown's 1955 estate. The location was the Gamble House, built in 1908 for David Gamble (of Procter & Gamble fame) by Charles and Henry Greene. An architectural landmark, it had never before been seen in a motion picture, and the filmmakers considered it a major coup to be allowed to shoot there. Here they filmed Marty first approaching Doc's 1955 abode and Doc traipsing across the spacious lawn running from house to garage with Marty in pursuit.

While the Whittier High School students were on spring break, the company moved back to the location to reshoot the 1955 scenes with Fox as Marty, as well as the 1985 scene in which Marty and Jennifer are late for class and run afoul of Mr. Strickland.

In reshooting the cafeteria scene where Marty confronts Biff, there was no clash of acting technique for Tom Wilson as there had been with his former costar. He and Fox completed the scene with relative ease and no residual bruising.

The headaches this time were clashes between Crispin Glover and Zemeckis. During the reshoot of the cafeteria scene, Glover decided to embellish his performance by bouncing back and forth in his seat, bobbing in and out of the shot and messing with his hair. To Zemeckis's dismay, he found himself pleading with the actor over the issue. "There are certain disciplines you have to have when you're making a movie, and he just didn't understand that," says Zemeckis. "I was as patient as I could possibly be, except that at some point your patience just runs out, and you just have to get the movie made."

After a number of unsuccessful attempts to keep Glover in check, Zemeckis asked producer Neil Canton to speak to the actor. Canton patiently tried to explain to Glover that he couldn't keep messing up his hair or bouncing around in his chair, as it wouldn't match from scene to scene or even take to take, which would wreak havoc with the editing. Glover steadfastly refused to give in, taking the position that George was a writer, and writers have messy hair. Canton pointed out that both Zemeckis and Gale were writers, and neither of them had messy hair. On the next take, the actor once again bounced around in his chair and messed up his hair.

Canton took Glover aside for a final time and read him the riot act, making it clear that, should the actor persist in this behavior, Canton would make sure that Glover's arms were literally duct-taped to his sides and that he would also be taped to the seat in order to keep him from wriggling around. To ensure Glover understood his intention, Canton asked a nearby grip how much duct tape they had. "Plenty" was the answer, and on the very next take, the director got what he needed.

After a few other shots featuring Fox, Glover, James Tolkan, Christopher Lloyd, and Claudia Wells, the production returned to Arleta for another visit to the McFly house.

There, Tom Wilson sat in the makeup trailer, enduring the two-and-a-half-hour procedure to transform into the forty-eight-year-old, subservient, car-waxing Biff, who's "just starting on the second coat." When he completed the scene, he had completed his role in the film. Tom Wilson wrapped on *Back to the Future* to cheers and applause from his fellow cast and crew.

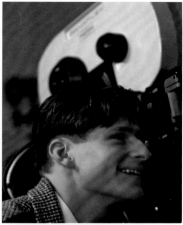

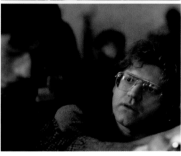

TOP Crispin Glover on the cafeteria set.
ABOVE AND BELOW Zemeckis discusses the cafeteria scene with Crispin Glover and Michael J. Fox at Whittier High School.

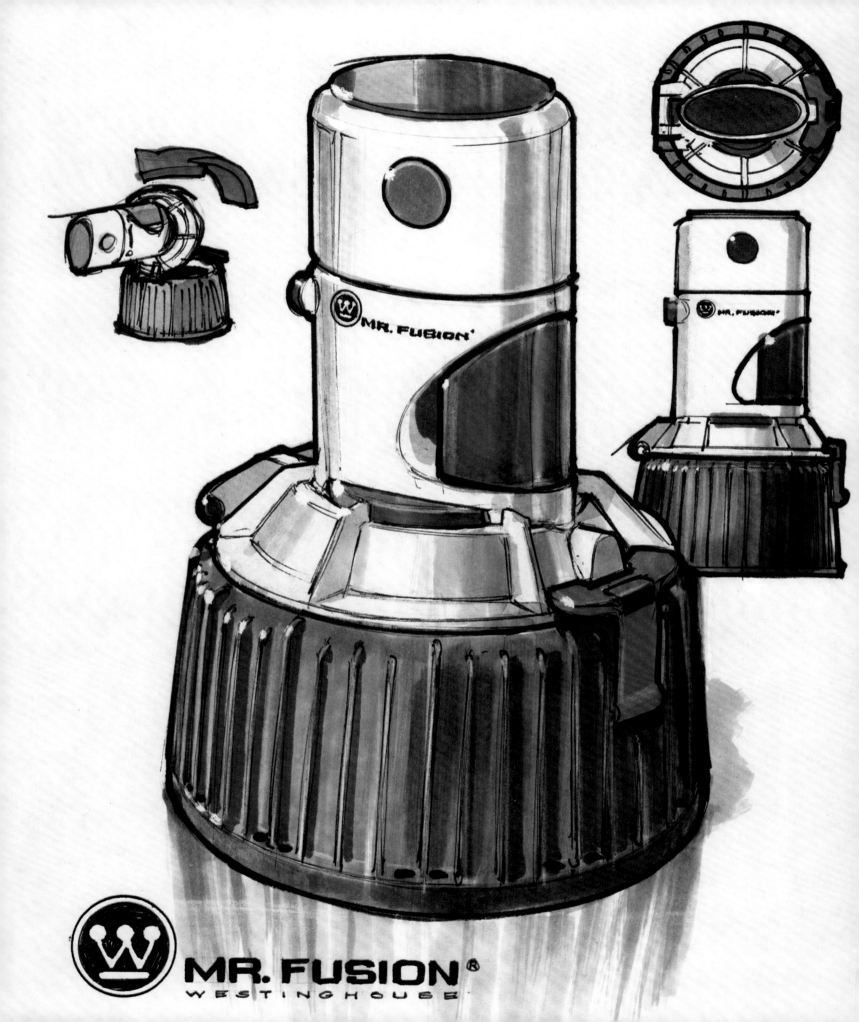

MR. FUSION ®
WESTINGHOUSE

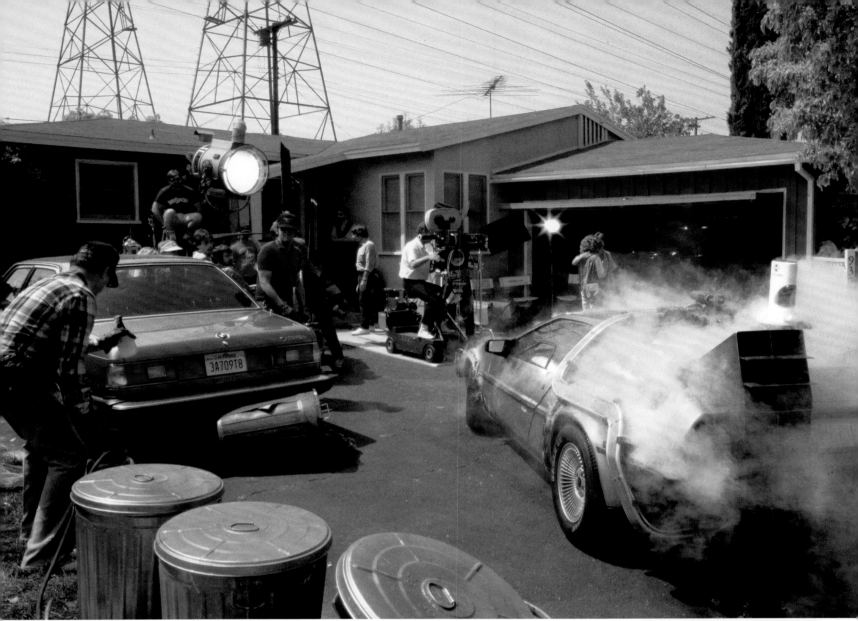

WEEK 20: APRIL 8–12, 1985

Nearing the end of the shoot, the company returned to the place where it all started, reshooting the scene in which Marty pushes young George out of the way of Sam Baines's oncoming car. This time it would be Charlie Croughwell—rapidly becoming Fox's go-to stunt double—who would take the hit. As he had done several months earlier, stuntman Max Kleven drove the car as Sam Baines.

Portions of all of the scenes that were shot in the first few days of filming were redone so the editors could integrate Fox into the salvaged footage. Crispin Glover hung out the laundry one more time because it was necessary to totally reshoot the scene of Marty outlining his plan for George to come to Lorraine's rescue. Following this scene, Crispin Glover was finished on *Back to the Future*.

After shooting the close-ups of Fox's Marty sitting next to Lorraine at the Baines family dinner, Lea Thompson also completed her work on the film.

For the last day of filming in Arleta, Zemeckis shot the finale of the film in which Doc, Marty, and Jennifer fly off in the futuristic incarnation of the DeLorean, unaware he would ultimately revisit that ending a few years later. Not unlike Marty McFly, the actions Zemeckis and Gale took in 1985 would have very real consequences for their futures.

Returning to the Universal Studios back lot, the crew shot the scene in which Marty is prevented from kissing Jennifer by the interference of the clock tower lady. Actress Elsa Raven wedged herself between Jennifer and Marty to give him a piece of information that will later (or earlier?) be used to change history. Claudia Wells recalls it being a fun scene to shoot, noting that in the entire movie Marty never gets a full-on kiss from his beloved. "The most he ever gets is her cheek," she laughs. At the end of the sequence, Claudia Wells became the next cast member to wrap her work on the film.

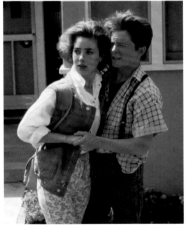

OPPOSITE Michael Scheffe's designs for Doc's new power source, Mr. Fusion.

TOP AND ABOVE The crew shoots the film's final scene in Arleta, California, with Fox and Claudia Wells.

In the original script, Marty's first appearance was in history class learning about the A-bomb tests. When the ending that featured the atomic explosion was scrapped, that scene was no longer needed.

The recasting of Marty necessitated five weeks of reshooting, so the mandate was to save money in any way possible. As a result, the unfinished classroom set for the original opening was scrapped, and the filmmakers saved costs by devising a new opening that used the Doc Brown laboratory set that had already been constructed.

Gale and Zemeckis came up with the sequence, which delivers another inventive visual that simultaneously entertains and imparts necessary information. The plan was to create one continuous shot that would give the audience their first look at Doc Brown without him actually being there. It would also communicate Doc's obsession with time, that a quantity of plutonium had been stolen, and, as Marty's skateboard rolls across the floor, the location of those radioactive materials.

"The plethora of clocks was an homage to George Pal's *The Time Machine*, which opens with a shot of a lot of clocks," explains Gale. Among the many timepieces he procured, prop master John Zemansky found a novelty clock that had the image of silent film star Harold Lloyd hanging from the face, which Zemeckis gave a prominent place in the scene. The clocks were manually operated by a team of around twenty technicians who were standing by holding the clock hands and pendulums in place until action was called. Thus, the various timepieces were in sync when the camera panned across them. The TV newscaster in this

segment was played by Deborah Harmon, who had been featured in *Used Cars*.

The toaster that ejected two pieces of burnt toast didn't have the right look on the first takes, so special effects supervisor Kevin Pike had a crew member hide under the camera to activate smoke pellets at the precise moment the camera made its pass.

Pike and his team, working with input from Zemeckis, were the inventors of the Rube Goldberg–esque dog-feeding machine. "You'd put the dog food in and press a button that opens the can and turns it over," recalls Pike. "Well, the day before [we shot it], they lost the license for the brand [of dog food] that they'd selected, and they gave us another brand that we had to use. But that dog food didn't come out as easily as the other dog food, so we had people underneath with torches heating up the bottom of the cans so that when it turned over, it [fell with a] plop, and we get the comedic reaction when it hits the dog dish."

The incredibly detailed and ambitious shot lasts for two minutes and thirty-six seconds on screen. The entire sequence was filmed only twice that day due to the intricate amount of planning, timing, rehearsal, and resetting that consumed the full twelve-and-a-half-hour workday. Although in the final edit the shot is broken up by one close-up of the dog food hitting the dish, the shot was achieved in one continuous camera movement.

On the following day, the crew shot another key opening moment for the film, and, while the specifics of this scene weren't as time consuming, they were extensive nonetheless. While the audience had been introduced to Doc Brown in absentia, Marty was brought in with a bang. Hooking his guitar to an oversized amplifier in Doc's laboratory, Marty strikes his first chord and becomes the victim of what Doc will call "a possible overload."

Fox's stunt double Charlie Croughwell took his position on an AirRam (known as a "leg breaker" in the vernacular of the business) that would push the stuntman back with nearly 2,000 pounds of air pressure. He would need to have his body at a specific angle when the effects technician fired the device and then pushed the button that would explode the giant speaker. "If the AirRam was fired too early, which it was, I went straight up into the rafters," explains Croughwell. "If too late, I would have been like a hockey puck shooting across the floor, which thankfully did not happen." Croughwell performed the stunt five times that day.

With the opening scenes complete, work continued on the remaining sections of the movie. Larry Paull and his team prepared the courthouse square for Marty's return to 1985, in which the DeLorean crashes into an abandoned theater, awakening Red, the town bum, from his park bench.

A number of delays plagued the shooting that night. First, the on-camera helicopter appearing in the sequence arrived forty-five minutes late. Then, it was discovered that its searchlight, a major element in the scene, was not operating, and it took an additional three hours to have it repaired.

More often that not, the final few days of a film shoot are the least exciting. The major scenes are well into the editing process, and those left to shoot can be tedious, albeit necessary. *Back to the Future* was no exception. The last days were filled with insert shots and process work in which reactions of Fox or Lloyd behind the wheel of the DeLorean were filmed in front of a blue screen. Another day saw the crew travel to a distant location in Chino, San Bernardino County, to film the scene in which Marty hides the DeLorean behind a billboard and starts his trek toward 1955 Hill Valley.

On Friday, April 26, 1985, *Back to the Future* completed principal photography—a total of 105 shooting days—finishing a little over two months after its originally scheduled wrap date. Michael J. Fox arranged for several wheelbarrows filled with beers to be rolled onto the set to celebrate the end of shooting, but the journey to the screen was far from over.

NO REST FOR THE WEARY

FOR ZEMECKIS, the shooting of *Back to the Future* had been a Herculean task. Says the director, "We had to pretty much shoot everything at night, and we didn't have enough time. It was a really, really tough movie, doing big stuff for very little money. I was also carrying around this black cloud, thinking it's probably my last movie. How am I ever going to survive this? I'm going to be known as the fuck-up director of all time. Don't forget: I had to deal with Crispin, too. There was not a lot of joy in the making of *Back to the Future*."

Even as he started to see the fruits of his labor taking shape in the editing room, Zemeckis still had his lingering doubts: "After Michael came in and the editors were putting the scenes together, it felt like it was working. We had that going for us. We looked at it, and I said, 'Am I crazy? This is good, isn't it?' And they agreed, it was good, but it was hard to separate myself emotionally from all the misery I was going through—to see the forest for the trees."

Although it was rare to start a film with two editors on board, it served the production well, especially when they found themselves having to replace the scenes featuring Eric Stoltz. Each of the men had specific scenes for which they would be responsible. Artie Schmidt took on the first major set piece, the Twin Pines Mall sequence. Harry Keramidas took charge of the concluding set piece, the clock tower sequence.

The danger of having two editors on a film is that the two individual styles of cutting could clash. In this instance, there was no such conflict, and the two men complemented each other under the input and direction of Zemeckis. As the lead editor, Schmidt would have the opportunity to review his partner's work, and if he felt there was an opportunity to make tweaks, he could broach the subject with Keramidas and Zemeckis. Those instances, he recalls, were few and far between.

For Schmidt, the action scenes were certainly of paramount importance, but he felt the smaller, less intricate scenes were equally as important: "Even though they were simpler than the elaborate action scenes, they were all kind of tricky and nuanced in the content and emotion. I remember having difficulty with the dinner table scene where you get introduced to the quirky McFly family, and that was fun and challenging. I spent a lot of time on that scene, wondering if I was doing the right thing, getting the balance right with this very strange family."

When the first assembly of the film was completed, there was no immediate sense of what they had. "As far as I was concerned, there was nobody saying, 'Oh, gosh, don't we have a terrific movie here,'" says Schmidt. "We had to rush onto the dubbing stage and do a temp dub, get it ready for the preview, and hope it was as right as the movie could be."

OPPOSITE TOP Having hidden the DeLorean, Marty starts his long trek to town.

OPPOSITE BOTTOM The crew ventures to Chino, California, to shoot Marty's arrival at the future site of Lyon Estates in 1955.

BELOW Fox and Zemeckis share some downtime at the Chino location.

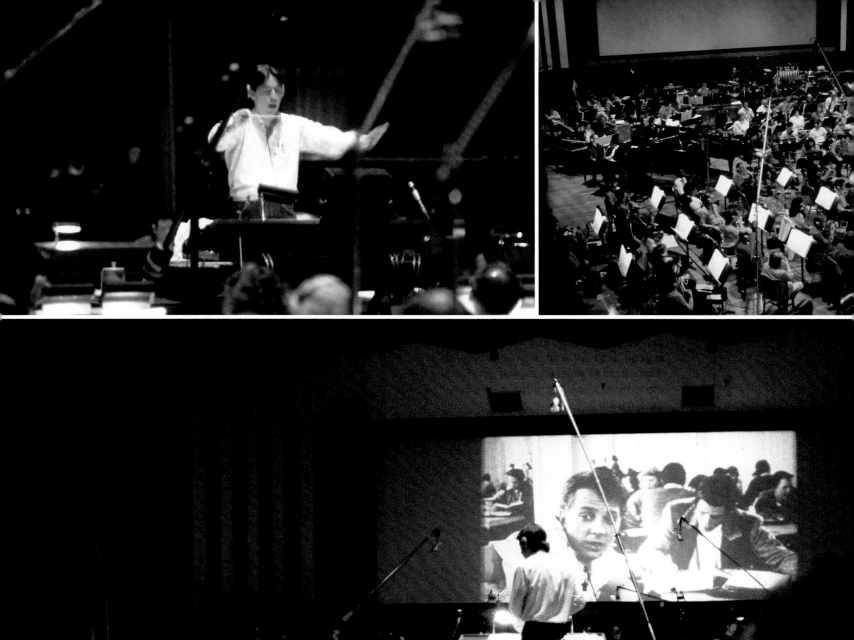
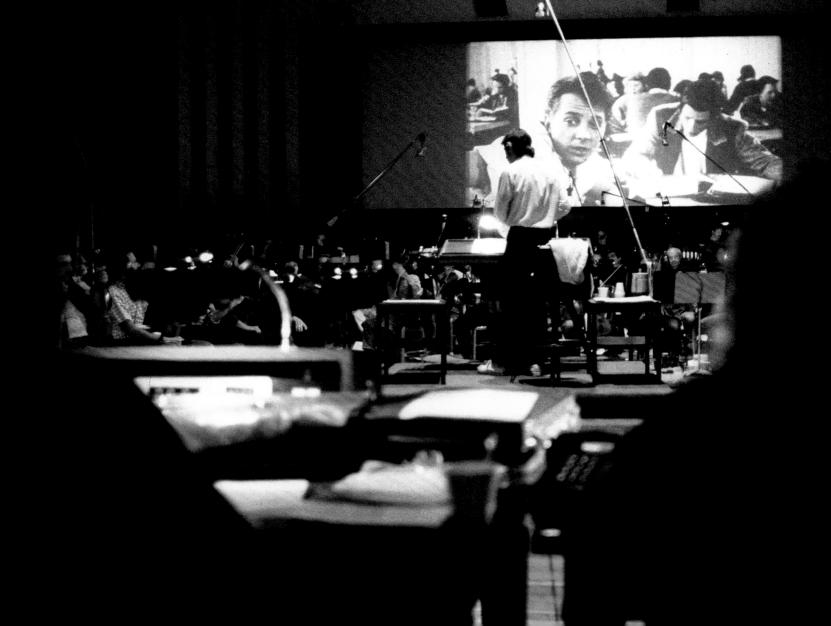

A MUSICAL INTERLUDE

WHEN SCORING A FILM, composer Alan Silvestri prefers to begin the process by seeing the movie in its entirety. To that end, it was shortly after the wrap of production that Zemeckis invited him into the editing room to see the first full assembly.

Due to the intensity of the postproduction schedule and the rush to get the film ready for a director's sneak preview, Zemeckis and his editors used a temp score, cobbling together well-known pieces of music to augment the scenes with a sense of the action and emotions they expected the final score to evoke. For Silvestri, watching the film at the preview would be exciting, frustrating, and a learning experience all at the same time.

"Because it's temp music," explains the composer, "the filmmakers have access to the greatest music ever recorded. Talk about the battle of the bands: Bernard Herrmann, Elmer Bernstein . . . I've always maintained that temp music is like a hammer. When used in the hands of a skilled craftsman, it's a tool to construct something beautiful. In the hands of a homicidal maniac, it's a weapon of death. When a director falls in love with something in a temp, it's very challenging for the composer."

But having gotten through their "first date" working together on *Romancing the Stone*, Silvestri knew that Zemeckis merely saw the temp track as a tool. "It's musical direction," he says. "Bob needs to find a way to create the conditions that will best allow the artist to work and bring forth the performance." No matter how much Zemeckis loved the temporary "place holding" music, he made sure Silvestri knew of the complete faith he had in his talent, "He would always say, 'You know, Al, we just threw some of this stuff in here because we needed something to see how it would play, but don't worry about any of that.' He would always—and still to this day—dismiss the temp even if he loves it and try to create conditions and the space for me to bring something original to his movie."

Zemeckis expressed his desire to Silvestri that the score be "big," but he confessed to the composer that he didn't really have any big shots in the movie, such as grand, sweeping vistas and panoramic cinematography. Essentially, the entire movie takes place in a small town, and most of the sequences were in family homes, Doc's garage, and a bucolic town square. "It was a very interesting piece of direction for me," says Silvestri. "Where it brought me to was that the images might not be big, but the archetypes of the story are tremendous. The archetype of friendship, the hero. The first thing I wrote in the score was that main theme. I wrote it

away from the film. I didn't write it to any specific moment, but I knew I needed to have a heroic theme, but it couldn't be too big, grand, or over the top. But Marty, in what he had to do and what he had to overcome, that became the underpinning of the score. Even though it's a guy in a car, this guy may as well be out on a battlefield with four thousand chariots. It's the same size and scope in terms of story."

Silvestri's score for *Romancing the Stone* had primarily been composed using electronic instrumentation. *Back to the Future* would only be the second time that Silvestri had composed an orchestral score for a movie, the first being the Amblin production *Fandango* for which Zemeckis had recommended him. On May 16, 1985, he walked onto a recording stage at the Burbank Studios (now the Warner Bros. lot) and faced more than a hundred musicians—at the time, the largest orchestra ever assembled to record a movie score. Silvestri dubbed them the "Outtatime Orchestra" and dove into the work. He had decided the very first piece he would record was the clock tower sequence that contained the main *Back to the Future* theme in its full glory. "Let's come out swinging here!" he remembers thinking. "I didn't want to start out with a ten-second little 'bridge' cue. We're going to start with something that Bob Zemeckis is either going to be out-of-his-mind excited about or go, 'Umm . . . we have a problem.'" It was the first time the director would hear a single note of the score, and his reaction was ecstatic.

As the scoring sessions continued, Silvestri enjoyed infusing his own score into the source music of the '50s, the most intricate and seminal moment being the "Earth Angel" number at the "Enchantment Under the Sea" dance, where George and Lorraine embrace their destiny.

The scene begins with Marvin Berry (actor Harry Waters Jr.) crooning and Marty on the guitar. As Dixon, a boorish classmate, cuts in on George, and Marty starts to falter, the song vocal fades out to the disjointed chords of the failing youth, even though the audience can still see Marvin Berry singing at the microphone. Silvestri's ominous and urgent music cues take prominence until there is a sudden moment of complete silence as George steps up to reclaim Lorraine. As the strains of "Earth Angel" slowly return, they kiss, and the full hundred-piece orchestra swells to reclaim the song in a lush and emotional arrangement.

Silvestri would revise and improve the score after two audience previews, but Zemeckis now had no doubt that the composer had created the iconic themes that his movie needed. It was music that would prove to be timeless.

SNEAKING AROUND

THE CENTURY 21 THEATER in San Jose, California, was chosen for the first public screening of *Back to the Future* on May 18, 1985, and it was Zemeckis's request that no executives from Universal Pictures be present. This was for the benefit of filmmakers only. The one exception he made was for Ed Roginski, who was the head of marketing at the studio and was considered a friend of the production.

The theater was filled to capacity with people who knew nothing about the film, as there had not yet been a teaser trailer to announce the movie's existence. All that the audience had been told was they would be seeing a movie starring Michael J. Fox and Christopher Lloyd. As the lights went down and the first few moments unspooled, there was a potential problem, not with the editing, but with one of the editors himself. Artie Schmidt recalls, "I was sitting next to Harry, and the teenage boys in the row in front of us were fidgety and talking and rolling their eyeballs. This wasn't their kind of movie, and they weren't getting it. Harry said to me, 'If those kids don't settle down and shut up, I'm going to go over there and punch one of them out.' I said, 'Harry, I think you better get up and go sit in the back of the theater.' And he did. Little by little, they got quieter and quieter, and soon they were mesmerized."

"There was some discomfort in the audience when Einstein disappeared," allows Bob Gale. "They were afraid something bad happened to the dog because they still didn't know the DeLorean was a time machine. Then there was a sense of relief when the dog was okay." Gale also remembers the exact moment when the audience totally clicked with the film. "When Marty goes into Lou's Cafe and sees Biff harassing George, that was the movie moment when the audience got it. 'Oh wow, that's brilliant!' 'This is so fucking great!' It's one of those things that's just etched in my brain, how they felt when Biff starts knocking on George's head. They were just there."

The excitement and enthusiasm continued to build throughout the rest of the movie. By the end, despite the fact that the last shot of the DeLorean flying away was unfinished and in black-and-white, the audience didn't care. They were euphoric.

The reaction to the screening was electric. "I've never seen anything explode quite so much like that in any preview I've ever been in," says Harry Keramidas. "They were stomping their feet, screaming and yelling."

After the lights came up, the audience was asked to fill out comment cards. There were boxes to check to indicate whether they thought the film was:

1. Excellent
2. Very Good
3. Average
4. Fair
5. Poor

When the cards were tallied, they had received 96 percent in the top two categories. No other Universal film had ever gotten higher scores. As they were leaving the San Jose cinema, the owner of the theater approached Artie Schmidt, not knowing his part on the film but aware he was a member of the company. "He said, 'Congratulations! You really have one helluva movie.' That was a great thing to hear, and by Monday they were telling us that, over the weekend, that theater owner had started calling the exchanges [other theater circuits], telling everyone what a fantastic movie it was and that they had to book it. So by Monday, there was a lot of buzz about what a successful preview we had."

Lamington Farm

RD #1 LAMINGTON ROAD
BEDMINSTER, NEW JERSEY 07921

July 25, 1985

Mr. Robert Zemeckis
Mr. Bob Gale
Amblin Entertainment
100 Universal Plaza
Universal City, CA 91608

Dear Gentlemen:

Last week I had the opportunity to see a screening of "Back To The Future" in New York, and want you to know I think it was absolutely brilliant.

I was particularly pleased that the DeLorean Motor Car was all but immortalized in the film, and want to thank all those responsible: Ron Cobb, Andy Probert, Mike Scheffe and Kevin Pike, for the outstanding job they did in presenting the DMC as the vehicle of the future. They can join my soon-to-be-revived design team at any time.

Thanks again for continuing my dream in such a positive fashion.

Sincerely,

John Z. DeLorean

JZD/mw
cc: Steven Spielberg

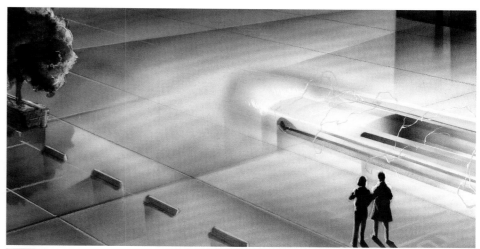

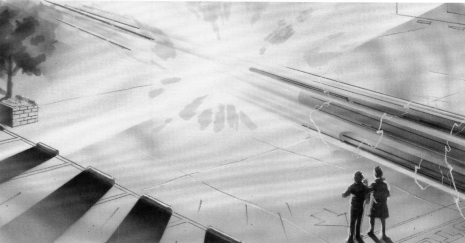

Another call that was made over that weekend was from Ed Roginski to Sid Sheinberg. When Roginski told his boss the tremendous reception the film had gotten, as well as the preview scores, Sheinberg was incredulous and immediately asked to have a follow-up screening at the Hitchcock Theatre on the Universal lot as quickly as possible.

"Bob was extraordinarily against previewing it at Universal," recalls Sheinberg. "He said there's an intimidation factor [of showing it on the studio lot]. They're not as ready to see a comedy. I said, 'Aw, horseshit.'"

With little time to find a public theater in Los Angeles at the last minute, Zemeckis agreed to the preview but made sure it would not just be Universal executives and marketing people in the audience. He brought in a large number of "civilians" who, like the San Jose audience, were unaware of the specifics of the movie they were about to see. Neil Canton understood the director's hesitance in screening behind the gates of the enormous facility: "If you have to screen a movie, you want to do it at a regular theater where people can have popcorn and soft drinks, so it's not an unusual experience. Doing it on the lot makes it totally different."

Based on the reaction of the first preview audience, a total of seven minutes was cut from the film before they showed it again. Recalls Bob Gale: "Some of the stuff we cut included a scene where Dixon locks George in a phone booth at the dance and some extensions in the scenes on the town square before the dance. There was a bit when Marty first arrives at the town square, thinks he's dreaming, asks a woman to pinch him, and she slaps his face."

The Hitchcock Theatre was packed, and the reaction to the film matched and in some ways even exceeded the previous screening. One contributing element was the music: half of Alan Silvestri's score was now incorporated, including the music for the clock tower sequence. Despite some technical aspects that still needed work, the audience embraced the film from beginning to end. Says Spielberg of the screening, "When I saw *Back to the Future* all finished for the first time, I thought it was the most engaging, infectious, and comedically irreverent movie in both recent and distant memory. The vocal participation of that preview audience was on a par with the preview audiences for both *Jaws* and *E.T.* The audience became part of the experience of watching *Back to the Future*. There must have been six times that the crowd burst into spontaneous applause. The laughter was deafening, and the sustained applause at the end was the greatest ovation that could have been given to Bob Zemeckis, Bob Gale, Michael J. Fox, Christopher Lloyd, and Sid Sheinberg."

Sheinberg was euphoric, telling Zemeckis he had captured lightning in a bottle, an especially apt metaphor given the film's explosive climax. Nevertheless, the studio head had one more emphatic request of the beleaguered production. Recalls Bob Gale, "After the screening, he said, 'Tell me what we have to do to get this out for the Fourth of July weekend and can it be done.' We spoke to our postproduction crew who were all in attendance, and they said, 'If you want to throw money at it, it can be done.' Sid said, 'I'll write the check.'"

When *Back to the Future* had been given the green light to start filming in the late fall of 1984, Universal targeted the film for a Memorial Day 1985 release, needing it in theaters by May 24. After Zemeckis recast the Marty role and began the process of reshooting, the film was given a release date of July 19. Now, with Sheinberg's edict that the film be in theaters by July 3, postproduction would be sped up to a degree that had never been attempted on a film of this size or scope.

Visual effects supervisor Ken Ralston and his crew at Industrial Light and Magic (ILM) had gotten a head start during production. Although the script called for a number of effects, Ralston found them to be manageable. In fact, there are actually only a total of thirty-two optical special effects shots in the entire movie. "Most of it ended up being the storm and the car effects as it goes in and out of

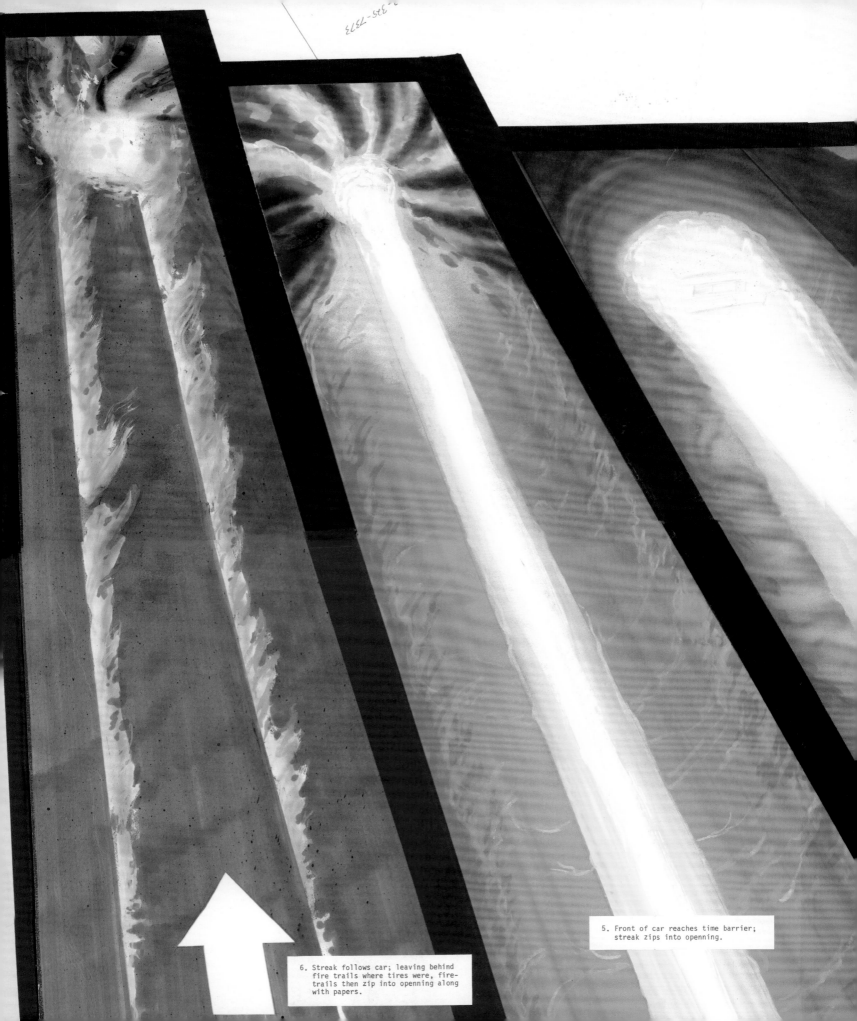

5. Front of car reaches time barrier;
 streak zips into openning.

6. Streak follows car; leaving behind
 fire trails where tires were, fire-
 trails then zip into openning along
 with papers.

1. Electrical EFX from headlights, racing to rear of car.

2. Front end heats up, starting to form fireball.

3. Car now totally engulfed in flame; long tail forming.

4. Fireball turns to meteor; mass of car thins out.

time," recalls Ralston. "And then the final shot of the DeLorean flying off."

The majority of the effects would be a combination of animation and real-time pyrotechnics. Animator Wes Takahashi played a principal role in creating the visualization of the DeLorean as it powers up to make the jump through time. "Come up with something no one's ever seen before," says Takahashi of the directions he received. "The more specific directive from Bob was, 'I want it to be extremely violent, something akin to a Neanderthal sitting on the hood of the car, chipping away at the fabric of time in front of him.'" This effect would come to be known as the "time slice." The animated shots would be tied in to the real in-camera elements, such as the fire trails the car leaves behind, that were shot on location at the Puente Hills Mall. Takahashi was also responsible for the animation of what Gale and Zemeckis had described in the script as "the most spectacular bolt of lightning in the history of cinema," as it strikes the clock tower, as well as the subsequent electrical current as it passes through the cables on its way to the DeLorean.

The last shot of the DeLorean flying off to the future involved the construction of a miniature car built from scratch by the ILM model shop crew, led by Steve Gawley. In a 1985 interview with *Cinefex* magazine, Ralston extolled the miniature as "one of the most beautiful models they've ever built." In a small display of prescience, he further offered, "If they ever decide to do a sequel, they'll have a great model to fly around the future in."

The abbreviated postproduction schedule left Ralston with his own good news / bad news scenario. The good news for Ralston was that there would be no more time for discussion, suggestions, or proposals on an effects shot: "It gave me the opportunity to move ahead without soliciting ideas. When I finalized a shot, it was going to stay final, and we would move on to the next one." The bad news was there was not enough time to perfect the shot of Marty's hand dissolving (denoted in the shooting script as the "$10,000 ILM shot"). Originally conceived by Zemeckis as a hole growing from the center of his hand, the initial attempt was deemed too harsh by Ralston, looking as if a bazooka had shot through the hand. He tried softening it until it resulted in the gradual fading of the appendage. With time running out, the effect would be judged acceptable.

Editors Artie Schmidt and Harry Keramidis had to make a few small tweaks to their edit after the Universal screening, but for the most part, their work was complete. Taking the film through the technical aspects of postproduction—dubbing, sound effects, Foley, sound correction, color correction, and the incorporation of the final special effects—would require the hiring of additional personnel who would

1) FIRST PART OF CAR APPEARS... END TOWARDS CAMERA GLOWS BRIGHTLY.

2) SECOND PART OF CAR APPEARS, SLAMS INTO FIRST PART, MOVING IT FORWARDS,

3) THIRD PART OF CAR APPEARS— SLAMS INTO SECOND PART— 1ST AND 2ND PARTS NOW WELDED BACK TOGETHER

4) LAST PART OF CAR APPEARS— SLAMS INTO 3RD PART— 2ND AND 3RD PARTS NOW TOGETHER

5) FINISHED CAR NOW RESUMES THE SPEED IT VANISHED AT,... SKIDS TO A STOP—

literally work twenty-four hours a day in order to get the film ready for that holiday weekend.

Despite the sensational reaction his film had received, Bob Zemeckis wasn't ready to celebrate. "I don't believe anything about previews," he states, "and I still don't. People will enjoy a movie they see for free—in those days we called them 'turntable hits.' It was like a record you loved listening to on the radio, but you wouldn't buy. We were always afraid we were the guys who made turntable hits." Zemeckis spoke from experience, having received very positive responses to the previews of *I Wanna*

OPPOSITE AND ABOVE Early ILM concept art for the reappearance of the DeLorean after a time jump.

recalls were the director's words, "Finally! I'm so happy I've done a movie good enough that I can ask you to work on it."

The artist was given background on the film, as well as some stills, and sent off to create the poster. "They had no concept. They wanted me to come up with some ideas, designs, and directions," says Struzan. "The first work I did was creating some comps for them. I started out in black and white and gave them eight to ten concepts. Steven was involved, and he gave me some concepts that he wanted to see. They took a look at them, and said they would pick one, and then have [me] do a color comp. They picked every one of them, and I took the black-and-whites into color."

As he continued to make alterations per the filmmakers' direction, Struzan got another call from the people at Universal asking him to draw up one additional concept that had been developed in-house. He did a color version, and that ultimately became the image everyone agreed upon.

When creating a final painting, Struzan's first choice would be to have the actor or actors pose for specific reference shots he could work into the image. Unbeknownst to Struzan, Michael J. Fox was already being photographed on his behalf: "The art director from the studio who I was working with kept me out of the swing of things, didn't tell me anything. Once the job was commissioned, he

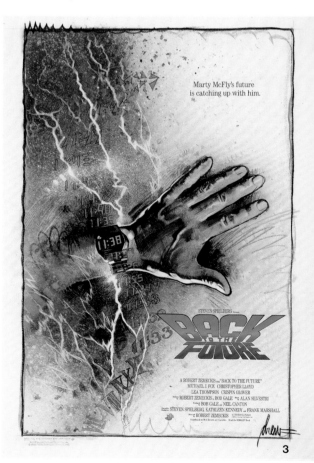

THESE PAGES After submitting pencil sketches of several concepts, Drew Struzan was asked to develop these ideas into full paintings for consideration by the filmmakers and the studio.

Hold Your Hand and *Used Cars*, only to have both go on to disappointing returns at the box office.

In an attempt to quell those fears, the Universal marketing department kicked into overdrive. In the final stages of filming, Universal had engaged, at Steven Spielberg's encouragement, movie poster virtuoso Drew Struzan to create the promotional one-sheet. Prior to his meeting with Zemeckis, Struzan had already become a favorite of Spielberg and George Lucas, with his iconic posters for films such as *Star Wars* and *Raiders of the Lost Ark*, among countless others. When he arrived for his meeting with Zemeckis, the first thing Struzan

Marty McFly has just
come between
the most unlikely couple
in high school...

His parents.

STEVEN SPIELBERG Presents

BACK
TO THE FUTURE

A ROBERT ZEMECKIS film "BACK TO THE FUTURE" MICHAEL J. FOX CHRISTOPHER LLOYD LEA THOMPSON
CRISPIN GLOVER Music by ROBERT ZEMECKIS & BOB GALE Music by ALAN SILVESTRI Produced by BOB GALE and NEIL CANTON
Executive Producers STEVEN SPIELBERG, KATHLEEN KENNEDY and FRANK MARSHALL Directed by ROBERT ZEMECKIS

17-year-old Marty McFly got home early last night.
30 years early.

STEVEN SPIELBERG Presents

BACK TO THE **FUTURE**

A ROBERT ZEMECKIS film "BACK TO THE FUTURE" MICHAEL J. FOX CHRISTOPHER LLOYD LEA THOMPSON
CRISPIN GLOVER Music by ROBERT ZEMECKIS & BOB GALE Music by ALAN SILVESTRI Produced by BOB GALE and NEIL CANTON
Executive Producers STEVEN SPIELBERG, KATHLEEN KENNEDY and FRANK MARSHALL Directed by ROBERT ZEMECKIS

stepped in, and Michael was available. This guy never told me and went and directed the photo session. He gave me the pictures, and they were terrible. They were not my taste and not what I wanted to do. So I came home and did what I always did: I posed as Michael. I put on similar clothes, lit it, and had my wife shoot the picture."

While Struzan was applying paint to canvas, the marketing team at Universal continued to analyze the finished product to determine the proper hook that would draw audiences to the theater. The one they identified came as a surprise to Zemeckis: the moment where Marty asks, "Are you telling me my mother has the hots for me?" This clip was to be used prominently in television ads at the expense of the more science fiction–based elements of the film. "The marketing lesson I learned," Zemeckis explains, "was that I have to stay out. I realized I was completely wrong and that, as a filmmaker, I'm too close to the material to have the understanding that that was a key line. When the alchemy works, it's

when the movie inspires the advertising. And there was somebody in the marketing department who was astute enough to say, 'That is what the people are gonna want to go see.'"

Back to the Future was officially unveiled in 1,341 theaters in the United States on Wednesday, July 3, 1985, just nine and a half weeks after completion of principal photography. The number of theaters expanded to 1,420 (which, at the time, was considered an extremely wide release) on Friday the 5th.

As Sheinberg had predicted, *Back to the Future* blew away the competition. At the end of the weekend, the numbers told the tale:

	TITLE	WEEKEND GROSS	THEATERS
1.	**Back to the Future**	$11,152,500	1,420
2.	**Pale Rider**	$7,032,807	1,710
3.	**Rambo: First Blood Part II**	$6,428,108	1,820
4.	**Cocoon**	$6,333,285	1,163
5.	**The Emerald Forest**	$4,345,150	1,110

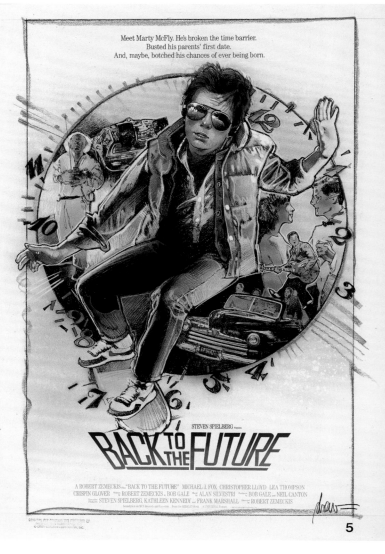

The years of hard work, frustrations, obstacles, and challenges had finally paid off for the filmmakers and the studio. Their opening weekend had been more than they could have possibly imagined, and they would be even more gratified in the weeks to come.

"The fun thing about opening movies back in the day," explains Zemeckis, "is that you open your movie, and you had this thing called 'legs.' You had to wait till you grew legs on your film, because it didn't matter if you were the number one movie on the first weekend. You had to have staying power, add theaters, and all this cool stuff. It wasn't until your fourth weekend that you knew it was a bona fide hit."

In its fourth weekend, *Back to the Future* dropped to second place on the box office charts, overtaken by the opening of *National Lampoon's European Vacation*. But the weekend after that, Clark Griswold and family found themselves staring into the taillights of a DeLorean as *Back to the Future* reasserted itself as the top box office attraction. It would remain number one for an unprecedented nine additional weeks through the end of September. When it finally relinquished the top spot on the

charts, the run was far from over. *Back to the Future* remained a solid and steady performer, finally vacating American movie theaters in the middle of March 1986, with its total domestic gross over the $200 million mark. The film had performed spectacularly in foreign markets as well, adding an additional $170 million to the coffers.

Huey Lewis and the News rocketed to number one on the pop charts with "Power of Love," and the song was nominated for an Academy Award. Zemeckis and Gale were also nominated for their original screenplay, as were Charles Campbell and Robert Rutledge for their sound effects editing. Campbell and Rutledge took home the Oscar that year.

At the end of the day, *Back to the Future* would stand out as the top-grossing movie of 1985. When asked if he ever admitted to Bob Zemeckis that casting Eric Stoltz was a mistake, Sid Sheinberg states, "I was wrong. I don't remember [if I ever said that to the director]. I hope I did. I certainly should have."

What Sheinberg does remember was that in the initial weeks of *Back to the Future*'s meteoric success, he was absolutely certain of one thing.

He wanted a sequel.

ABOVE More poster ideas by Struzan.

OPPOSITE The final, iconic poster art for *Back to the Future*. To achieve the finished product, Struzan donned Marty's wardrobe and took photographs of himself for reference.

PART TWO

7-21-85

...oductions,

I don't write letters as a rule but
the enjoyment & the togetherness as
a family that we got out of your
movie "Back to the future"
prompts me to give a — well done
and thanks for a great movie.

I was impressed with the humor,
the sci-fiction twists (seeing himself
go back in time - the letter etc) and the
lack of nudity, violence and excessive
bad language. You managed to create
real people that we see around us.
(Perhaps you accented the extreams a bit
but that was ok). We all enjoyed
the movie — my girl (9 yrs) my wife (33)
and me (36). We encourage a sequal
Please.

Wayne Wolf and family

4-24-87

Dear Universal Studios:
 I just finished watching
"Back to the Future" and at
the very end it said "To
be continued". I was wondering
when you are going to release
"Back to the Future II."
Although it has been two years
I don't have any doubt that
it will come out soon.
 Please write back.

Loyal movie freak,
Charles Painter

Dear "BACK TO THE FUTURE CAST"
 My name is Tony. I am deaf. I'eleven yrs old. I go
to Scranton State School for the Deaf. But I could lip read,
I am not deaf. I hard-hearing. I might move to hearing school
next year. I love your movie "BACK TO THE FUTURE". It is
AWESOME, I rent and watch in movies and V.C.R. When
will you make "BACK TO THE FUTURE pt 2" I have your movies
in my video tape, I tape it on HBO, I saw 3 times on
Video rent and movies 5 times and my tape alot. I want
to know if you are making a movie? Could you please
give me a picture of you all and your awesome car!
On the back of the picture please put your autograph
of Michael Fox, Christopher LLOYD, Lea Thompson, Crispin
Glover and Thomas F. Wilson.

Thank Your best fans

Tony Biehucke

Dear Sir or Madam:
 I am writing you because
I would really like to see a "Back
to the Future II." I have taken a survey
out of 45 people and 42 want another
movie. I would think that many
more people would like to see the
movie, too.
 I would appreciate it
if you would consider a new
"Back to the Future II"

Sincerely,
Kari Kreid
Kari Kreider

Dear Sir/Madam,
 I have just recently seen
Your movie "Back To The Future", for the fifth time and
enjoyed it immensely. I have four questions to ask:

1) At the end of the movie it says "to be con
is their a continciance i.e. a sequel.

2) If their is, is their a book on the sequel.

3) Is their a plastic model of the De Lorean,
the time machine.

4) If so, who makes the model.

Yours Sincerely
Steve Miller

YOU'VE GOTTA COME BACK!

THE FORTIETH PRESIDENT of the United States was an unabashed fan of *Back to the Future*. According to a member of his staff, when the president ran the movie in the White House screening room, he loved the Ronald Reagan joke so much that he made the projectionist stop the film and rerun the scene.

Reagan wasn't alone. Thousands of fan letters flooded Universal Studios and the Amblin offices, and a common thread was abundantly clear. People wanted a sequel. Yet no matter how much the authors of those letters declared themselves to be the biggest fan of the film, there was no one in the world who wanted a sequel more than Sid Sheinberg.

When first approached by Sheinberg with the request, Zemeckis and Gale didn't feel the idea of a sequel was a fait accompli. "Bob [Gale] and I were very arrogant about sequels," admits Zemeckis. "We thought they never worked, with the exception of *The Godfather Part II*. We were purists."

While Sheinberg may have respected the men for their principles, he let them know he meant business. Continues Zemeckis, "Sid informed us that *Back to the Future* was now 'corporate real estate.' They owned it, and we didn't. We could either be a part of it or not, but they *were* making a sequel."

Taking Sheinberg at his word, they began to discuss how best to approach this new development. "We told Universal if we got Michael and Chris back, we would come up with a sequel," says Bob Gale.

Michael J. Fox and Christopher Lloyd were in a unique situation. When *Back to the Future* went into production, it was considered a one-off. Nobody anticipated there would be demand for more adventures of Marty and Doc. "I had a contract for one movie," recalls Fox. "I hadn't agreed to do a sequel."

Once they were informed that Gale and Zemeckis would return, the two actors' responses were immediate. "When an audience wants to see a sequel, it's because they feel like they haven't gotten enough," says Fox. "I had the same feeling about the experience of making the film. I didn't play coy

about it. It was, like, 'Yeah, I'm in.'" Lloyd felt the same way. "I wasn't going to go against the tide. I'm a good boy. I stepped in line," he laughs, adding, "but I was delighted too."

Even before Zemeckis and Gale put a single word to paper, Sid Sheinberg was thinking about the future. Instead of signing Fox and Lloyd for one sequel, he made a deal that would commit them to two.

Gale realized that, in addition to Fox and Lloyd, they needed to know who else was willing to return so they would know what characters to include when devising the story. Gale made calls to Lea Thompson and Tom Wilson, and they too committed without hesitation.

Crispin Glover was another matter. Zemeckis and Gale thought long and hard about inviting him to return as George McFly. They concluded that despite the hardships, arguments, and eccentricities they endured on the first film, Glover's performance was undoubtedly a part of the movie's success. They decided to approach him for the sequel.

According to Bob Gale, the actor, through his agent Elaine Goldsmith at William Morris, responded with a fee so high and list of demands so extensive that it made his involvement in the project unviable. "Even she thought he was out of line," says Gale. The filmmakers gave her two weeks to come back with a more reasonable proposal, or they would write Glover out of the sequel. As the deadline expired, Goldsmith reported that her client remained steadfast in the original proposal. Thus Gale and Zemeckis began developing a story that would not require the services of Crispin Glover.

In May 1986, Universal Pictures let the cat out of the bag. While the studio never officially put out a press release announcing that *Back to the Future Part II* was in the works, they did alert fans that another film was on the way. When the home video of *Back to the Future* was released on May 22, 1986, Universal added the words "To Be Continued . . ." after the DeLorean flies toward the camera at the end of the movie.

OPPOSITE Thousands of fan letters poured in, praising *Back to the Future* and asking for a sequel.

IT'S THE SCRIPT, BOB! SOMETHING'S GOTTA BE DONE ABOUT THE SCRIPT!

WHILE A SEQUEL was definitely in the cards, Robert Zemeckis was set to direct *Who Framed Roger Rabbit* before *Back to the Future Part II*. Sid Sheinberg was not pleased. "He wanted the sequel, and he hated the idea I was going off to do a film for Disney," recalls Zemeckis. The director also ensured that Christopher Lloyd would be unavailable by casting him in the Disney film as the villainous Judge Doom.

Because of Zemeckis's commitment to *Who Framed Roger Rabbit*, he and Gale had agreed that they would develop the story together, but that Gale would write the screenplay. So, before Zemeckis became immersed in preproduction, the duo discussed some preliminary concepts. Both agreed that they had to address the dilemma introduced at the end of the first film.

"The point of the first movie was that the future could be changed," says Gale. "So if we're going to go into the future, and it's really so bad, Marty could just turn to Jennifer and say, 'Jennifer, we're breaking up. That solves the problem with our kids.' But we knew the audience would be really pissed off if we did that. We talked about all kinds of crazy things to get ourselves out of the corner we had painted ourselves into. We didn't know what we were going to do. What *is* the problem with Marty's kids? Ultimately, we knew we had to pay off the promise of that line by presenting a future in which Marty's kids were a mess."

In their conversations, they also established several concepts that would make it to the final film. The idea of Marty buying a futuristic sports almanac actually recalled the original draft of the first film where he suggests taking racing results back in time to make some easy money. Fleshing out that premise became a major element of the overall story. Explains Gale, "*Back to the Future* worked by having a revised present [1985] that was better than the one Marty left, but Marty didn't intend that. He just wanted to get back to the status quo. That he came back to a better present was the icing on the cake, because the character always ended up doing the right thing when the time came. Now we were going to do a story in which Marty does the wrong thing, by using future knowledge for financial gain, and of course, that had to backfire." Thus was born the idea of the altered 1985, which came to be known as "Biffhorrific" in which Biff had taken over Hill Valley, murdered George, and married Lorraine.

In creating a scenario with such a dark center, their third act would need to creatively resolve the conflicts in the most entertaining fashion possible. Zemeckis and Gale decided that the answer would lie in a visit to Hill Valley in 1967. "The creative thinking was that it would be a fun time period to put on the screen," says Gale. "We'd already done the beginning of rock 'n' roll, so we thought we would do the beginning of the counterculture and do Haight-Ashbury, Hill Valley–style. We could do all these '60s gags—Lorraine as a flower child, Doc doing LSD—and use some good music."

As Zemeckis left to toil in Toontown (aka Elstree Studios in England), Gale settled in front of the word processor to begin the first draft of the *Back to the Future* sequel, simply titled "Number Two."

Gale began the story as he knew he had to, with Doc taking Marty and Jennifer into the future to do something about their kids. In this version, Gale established some themes and plot points that would endure the journey through all subsequent drafts and end up on the screen.

As in the final movie, Marty has to take the place of his son (named Norman in this version) and refuse to take part in a criminal enterprise with Biff's grandson, Griff, and his gang. Likewise, Marty escapes the gang in a futuristic hoverboard chase and buys a 2015 sports almanac in hopes of making a quick buck back in 1985. Old Biff discovers Marty's scheme, steals the DeLorean and the almanac, and travels to the past to give the book to himself in 1967. Jennifer ends up at the future McFly home, where she learns that the past thirty years with Marty have not been filled with happiness. She also narrowly avoids being discovered by their daughter, Doris (renamed Marlene in a later draft). Unlike subsequent drafts, George McFly is dead in 2015.

Marty and Doc save Jennifer and head back to 1985, where they find Hill Valley in shambles as a result of Biff's actions. George McFly is also dead here, and mega-millionaire Biff is now married to Lorraine. Doc and Marty deduce the date in which the timeline was skewed and make their way to Hill Valley, 1967.

In 1967, Marty retrieves the almanac with little difficulty and normalizes the timeline, only to be arrested for vagrancy and thrown in jail. An altruistic Lorraine bails him out using money earmarked for a second honeymoon with George, who's away on a teaching assignment. Marty has once again unwittingly endangered his own existence, because he was to be conceived on the canceled honeymoon trip.

There are now two Doc Browns coexisting in 1967, and the 1985 Doc takes great precautions to never reveal himself to his younger counterpart. Marty enlists the 1967 Doc to help fix the DeLorean, which had been damaged in their escape from Biff's goons in 1985. The 1967 Doc must figure out a new way to power the flux capacitor to get Marty home.

In the meantime, Marty and 1985 Doc get Lorraine's bail money back to her so that she can join her husband in San Francisco. After accomplishing that mission, their next step is to follow 1967 Doc's instructions and fly the DeLorean into some high-voltage power lines, thereby activating the flux capacitor.

But 1967 Doc's calculations did not account for the added weight of the stowaway 1985 Doc, so our heroes' last obstacle is to lighten the car so that the DeLorean can attain the proper altitude to reach the power lines. Marty strips the car of all unnecessary items, including one of the gull-wing doors. When he's still just under the limit, he jettisons the sports almanac. This tips the balance and the car blasts forward in time to the fully restored 1985.

When Zemeckis returned from England, he and Gale discussed the new script. The future sequences were a good, solid start, and there was potential to have lots of fun with the Biffhorrific version of 1985. But they ultimately decided that they had chosen the wrong decade for the third act. "The '60s were too earnest," says Zemeckis. "Also, we were going into another time, but it had a lot of the same story elements that we had just done."

However, Zemeckis had an idea. With a time machine at their disposal, the director realized he could go where no sequel had gone before: right back into the first movie. "How much more sequel can you get?" says Gale. "We knew that when the audience clamors for a sequel, it's like they're regressing to television," he continues. "'We want to see Michael J. Fox on the next adventure,' that's what they're really saying. So they want it to be the same but different. It's almost an impossible thing to do, and that's what made it exciting."

Additionally, Zemeckis, who was a big fan of Westerns, proposed a fourth act to the screenplay that would send Marty and Doc back to the Wild West.

As Gale incorporated these new ideas into a fresh draft, he also made a decision about the future

of George McFly. In his "Number Two" screenplay, the writer had consciously written around the character with the mindset that, by killing off George, they wouldn't have to deal with the "will he / won't he" issue of Crispin Glover returning to the role. Gale had nevertheless inserted one brief moment when George appeared, feeling they could use another actor for that scene.

Now, both he and Zemeckis felt that having George dead in 2015 was a downer, so in the next draft Gale resurrected the character for the future sequences. "I came up with the gag of hanging him upside down in the back brace," says Gale, "because I knew from perception experiments that it's really hard for people to recognize a human face upside down. If we got somebody else to play George, put makeup on him, and hung him upside down, the audience wouldn't know the difference. And if Crispin decided to come back, we wouldn't have to worry about him hitting his mark because he'd be in this contraption, and he couldn't get out of it."

OPPOSITE TOP Promotional buttons for *Back to the Future Part II*.

OPPOSITE BOTTOM An early conceptual sketch for the Hill Valley town square in its "Biffhorrific" incarnation.

ABOVE The cover of the sports almanac that drives the plot of the second film, designed by Doug Chiang.

REWRITING
THE FUTURE

GALE WENT BACK TO WORK to incorporate Zemeckis's idea of leaping back into the story of the first film and adding the Old West into the mix.

The first draft to encompass the four time periods was dated September 8, 1988. It was composed of four acts across 126 pages and bore the code title "Paradox."

Act One, set in 2015, closely mirrored the previous draft. The main differences were that old Marty works for the stern Mr. Fujitsu at INI corporation and is deep in debt and constantly looking for get-rich-quick schemes. In this draft, as young Marty passes through the 2015 town square, the annual Hill Valley Festival—themed "Those Crazy '80s!"—is in progress. The grand marshal is Lorraine McFly, accompanied by her children, Dave and Linda, and behind the family is a "hover float" carrying the "It's hip to be old" rockers Huey Lewis and the News.

Act Two sees Marty and Doc return to a hellish version of Hill Valley, now controlled by the wealthiest man in the world, Biff Tannen.

When he learns Biff married his mother, Marty faints dead away, only to awaken in his bed on the fifteenth-floor penthouse of Biff's hotel, where he is tended to by Lorraine Baines McFly Tannen. Biff mistreats Lorraine, and Marty tries to intercede before leaving.

Doc finds Marty, and Marty confesses that 2015 Biff must have passed the almanac to a younger Biff. Doc phones billionaire Biff claiming to be the owner of the almanac and also says that he has information on Marty's whereabouts. Biff replies that he found the book in his car the night of the "Enchantment Under the Sea" dance. Now they know where and when it was passed to Biff.

In Act Three, Doc and Marty arrive at the high school in 1955 just after George has knocked out Biff. After watching 2015 Biff deliver the almanac to 1955 Biff's car, Marty tries to retrieve it but is stopped by police officers who have arrived to investigate the fight. Doc lifts off so as not to be seen, but the DeLorean is struck by lightning and disappears. Searching the skies for any sign of Doc, Marty is surprised by the arrival of a Western Union employee who gives him a letter from Doc, who has been transported to the year 1888 (this would be changed to 1885 in later drafts).

Marty runs back to 1955 Doc and shows him the letter, which instructs Marty to time travel to January 23, 1888, to retrieve 1985 Doc. Marty and 1955 Doc follow 1985 Doc's instructions and find the damaged DeLorean in a cave where he hid it in 1888. While 1955 Doc tries to repair the DeLorean, Marty sets out to get the almanac back from Biff. He sneaks into the sleeping bully's bedroom but must hide when ninety-five-year-old Gramps Tannen (not to be confused with 2015 Biff) bursts in to wake his grandson.

Marty springs from his hiding place, knocks out Biff, grabs the almanac, and bolts. Gramps, who wears an eyepatch, is so humiliated at having witnessed this runty McFly get the better of Biff that he suffers a heart attack, grabbing his chest and falling over.

With the DeLorean repaired, Marty and 1955 Doc make their way to the location from which the letter has specified Marty should leave, passing a sign that reads "Teacher's Cliff, Clara Clayton Memorial." Due to Doc's bad handwriting, they incorrectly input the destination time as June 23, 1888—six months after the date Doc requested—and Marty takes off, leaving 1955 Doc behind.

As Act Four begins, Marty arrives in 1888 in the middle of a flock of passenger pigeons that cause him to lose control of the DeLorean. The car drops from the sky and ends up battered and undrivable. Unfortunately, 1985 Doc is nowhere to be found, and Marty starts the trek into town.

Reaching the Hill Valley saloon, Marty comes face-to-face with Black Biff (the younger version of Gramps), who is trying to bully another man at the bar named "McFly." This young man is described to resemble George McFly, but the difference between him and his future descendant is that this man stands up to the outlaw Tannen.

When Marty intervenes, Biff and his gang throw a rope around him, drag him through town, and then try to hang him from a tree. Marty dangles until a shot rings out, severing the noose. He's saved by 1985 Doc, who sends Black Biff packing.

Marty explains how the DeLorean was damaged in his arrival to 1888, and they hitch up a team of horses to the vehicle to bring it back to town. On their way, they come across Black Biff trying to have his way with schoolteacher Clara Clayton, whom he has cornered on the edge of a cliff. She refuses to go down without a fight and throws a rock that lands squarely in Biff's eye. Doc and Marty intervene, and Doc saves her from slipping off the cliff. Marty realizes who she is, and that, according to 1985 history, Clara Clayton fell into that chasm, hence the name "Teacher's Cliff."

Doc assesses the damage to the DeLorean. The time circuits and Mr. Fusion device (seen at the end of the first movie) are still operational, but they have no way of driving the car, much less getting it up to 88 mph. Doc hits upon the idea of pushing the DeLorean with a locomotive.

Hill Valley Telegraph

Vol. XVII, No. 32 COMPLETE NEWS SERVICE A. R. S. NEWS PHOTOS MARCH 16, 1973 THE NEWSPAPER THE PEOPLE DEFEND UPON 25 Cents

GEORGE McFLY MURDERED

Local Author Shot Dead

PAUL CRUMRINE
Staff Reporter

George McFly, local author and professor, was shot dead last night enroute to an award dinner by the Hill Valley Civic Committee. McFly, who was to receive an award, was found dead in an alley 2 blocks from the HV Community Center at 9:35 p.m. by Police. There were no witnesses. Police speculate that robbery was the motive as McFly's wallet was missing. McFly a lifelong resident of Hill Valley, had long been an civic activist against the policies of BiffCo. He is survived by his wife, Lorraine and their 3 children, David, Linda and Martin. Funeral arrangements have not yet been made.

State authorities have finally announced the date for the opening of the new municipal court center. This long-anticipated event has been the source of much animosity among the civic leaders of the communities surrounding the capitol.

The facts regarding the situation remain the same, state the authorities. Details concerning the action have been given a preliminary investigation but it is felt that only by a more detailed study will the true facts become known.

New

While the final outcome of this situation has yet to be determined, it is possible that when all the facts come together at the conference now scheduled for next week, that a decision will be made to possibly satisfy the needs and demands of all parties.

Indians Continue Wounded Knee Occupation
South Dakota Standoff in 16th Day

Of no less importance was the common recognition shown of the fact that any menace from without to the peace of our continents concerns all of us and therefore properly is a subject for consultation and cooperation. This was reflected in the instruments adopted by the conference.

A suggestion that public hearings on applications be limited to one every six months was taken under advisement by the commission.

Residents feel that they have been taken advantage of ever since the tax laws governing their additional land

An immediate investigation is assured and indications are that some new light will be shed on the situation in the near future. Available facts seem vague but authorities feel that time will disclose some means of arriving at a solution.

A suggestion that public hearings on applications be limited to one every six months was taken under advisement by the commission.

Many persons feel at this stage that some legal action is forthcoming but it now becomes common knowledge that there is pressure from the inside which will materially change the aspect of the case.

Of no less importance was the common recognition shown of the fact that any menace from without to the peace of our continents concerns all of us and therefore properly is a subject for con-

GEORGE McFLY

TRANSIT PROBLEMS GIVEN AIRING AT B-M-R CONVENTION	More Rain

The facts regarding the situation remain the same, state the authorities. Details concerning the action have been given a preliminary investigation but it is felt that only by a more detailed study will the true facts become known.

Thus at this conference all our governments found themselves in unanimous agreement regarding this undertaking. Arrangements for dealing with questions and disputes between the republics were further improved.

Of no less importance was the common recognition shown of the fact that any menace from without to the peace of our continents concerns all of us and therefore properly is a subject for consultation and cooperation. This was reflected in the instruments adopted by the conference.

The facts regarding the situation remain the same, state the authorities. Details concerning the action have been given a preliminary investigation but it is felt that only by a more detailed study will the true facts become known.

Thus at this conference all our governments found themselves in unanimous agreement regarding this undertaking. Arrangements for dealing with questions and disputes between the republics were further improved.

A suggestion that public

Clara arrives and talks Doc into asking her to the Hill Valley Barn Dance. There, Marty runs into his ancestor who introduces himself as Angus George McFly. He also introduces his wife, Nelda.

After some time alone with Clara, Doc considers remaining in 1888, and Marty must talk him out of it. He capitulates and says farewell to a sobbing Clara.

Marty and Doc hijack the train to begin their journey back to 1985. Clara is onboard searching for Doc, and Black Biff and his gang are preparing to rob it. Biff makes it onto the speeding train, and Clara ultimately knocks him out with a piece of firewood. As the train approaches a speed of 88 mph, Doc starts to make his way to the DeLorean. Clara follows, loses her footing, and dangles from the outside of the engine. With no other recourse, Doc goes to save her as Marty and the DeLorean disappear.

In 1985, the DeLorean is destroyed by an oncoming freight train. Marty returns to Jennifer's house (conveniently located by the train tracks) and wakes her. He turns down an offer to join the burgeoning INI company, and he and Jennifer are startled by the sudden arrival of Doc, Clara, and their kids Tom, Ben, and Jules in a steam-powered time-traveling locomotive.

In reviewing this draft, Gale was not satisfied. The elements were all there, but he felt having so much content squeezed into one movie left many aspects of the tale shortchanged. Specifically, he was concerned about introducing an entire group of new characters in the last third of the script. He told Zemeckis that he wanted to take another pass, open it up and let things develop more naturally. Zemeckis agreed. This draft would not be officially circulated.

ABOVE With Crispin Glover's participation in the sequel doubtful, Gale and Zemeckis decided to write his character out of the movie.

GET READY

EVEN AS GALE REWROTE, preproduction began in fall 1988 without a finished script or budget. Universal wasn't happy about this, but there was little they could do: they wanted the sequel in theaters for summer, 1989, so the proverbial train had to leave the station immediately. The first aboard was Neil Canton, who had been standing by for several months. Zemeckis also brought back a large number of familiar faces (among them Dean Cundey, Ken Ralston, Artie Schmidt, Harry Keramidas, Judy Taylor, location manager Paul Pav, and David McGiffert), along with some new additions to the *Back to the Future* family. These included production designer Rick Carter, who had worked with Zemeckis on an episode of Spielberg's anthology series, *Amazing Stories*, production manager Joan Bradshaw, and three key players from *Who Framed Roger Rabbit*: special effects supervisor Michael Lantieri, costume designer Joanna Johnston, and associate producer Steve Starkey.

In order to minimize publicity, the movie would be produced under its working title, "Paradox," and was rarely referred to by its real name. "This was to keep spectators away," says Gale. "We also figured that if people knew in advance what we were shooting, we'd get gouged on location rentals and other deals."

Even without a shooting script, Zemeckis and Gale were able to give the department heads a clear understanding of the major beats of the film. Carter was one of the first to begin work. The production

designer had a head start because the town had already been established in the first film.

As Carter says, "For Larry Paull and Bob and Bob going into the first one, they had a concept of Hill Valley, but it didn't exist in anybody's consciousness yet, other than the idea. They created a Hill Valley that could be in more than one time zone. The way they established 1955 and 1985 were very clear to people. It had a very clear emotion to it. My challenge was to take that and, with Bob and Bob's direction, create places that could then project it to 2015, plus an alternate version of 1985 [Biffhorrific], and then go all the way back to 1885, right to the very beginnings of the town."

Zemeckis admits that although he was resigned to the premise, he had not been happy about having to do the first part of the movie in the year 2015. "I always hated—and I still don't like— movies about the future," he says. "I just think they're impossible, and somebody's always keeping score." Twenty-five years later, he concedes they did

TOP RIGHT Working under the direction of production designer Rick Carter, a team of artists began to illustrate various elements of the future, including the floating Hill Valley welcome sign.

BOTTOM "NO LANDING" and hazard zones were created for the town square.

OPPOSITE TOP Service robot concept art by Ed Eyth.

OPPOSITE BOTTOM Ed Verreaux's design for the futuristic Texaco station.

LENGTH OF LAST
SEGMENT OF ARM
DETERMINED AS
NEEDED TO ACCOM-
MODATE VEHICLE
USED IN SCENE.

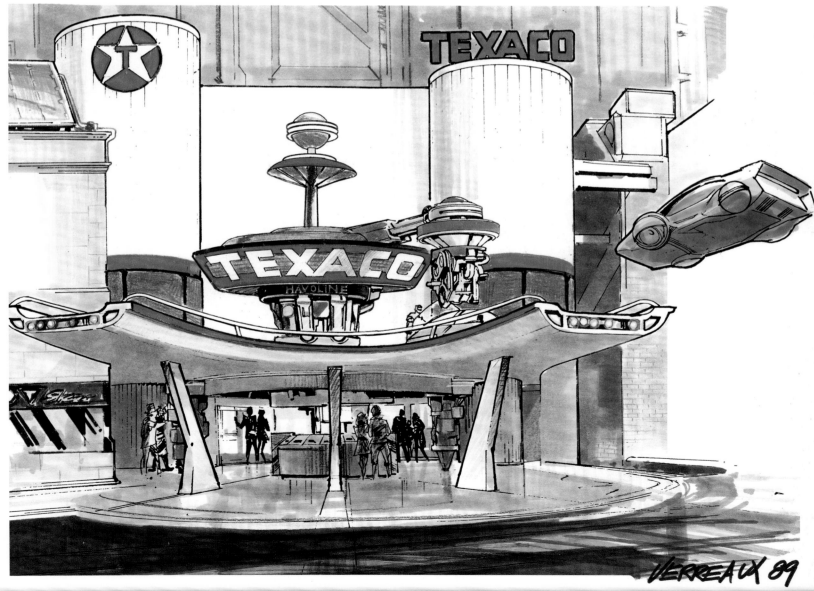

VERREAUX 89

better than anyone might have imagined: "We're doing pretty good. I think we're batting around .500 on our prediction of the future. We predicted a lot of stuff so I guess we're kind of futurists, but we also didn't think of a lot of things. At the time, no one could have imagined you would have a pocket–sized personal computing device with cameras and video and everything. I had a cell phone in my car at the time, and it was a big and clunky thing."

In approaching the future, the first thing that Zemeckis and Gale had decided was to eschew the dark, Orwellian take that had been depicted many times before. "We didn't want a totalitarian state where people dressed in uniforms and had their heads shaved, which is a very easy way to depict the future in movies," says Zemeckis. "We knew we had to resonate stuff, and the only way I could get a handle on doing the future was to make everything into a joke. I thought the only way it would be palatable was to just send it up." Adds Gale: "It had to have a sense of reality for the audience, because you can't identify with something that doesn't exist. We modified ordinary, everyday conveniences."

For Rick Carter, there was a key line in the script that gave him a clear vision for creating the future Hill Valley. "'Hill Valley has changed for the better,'" he

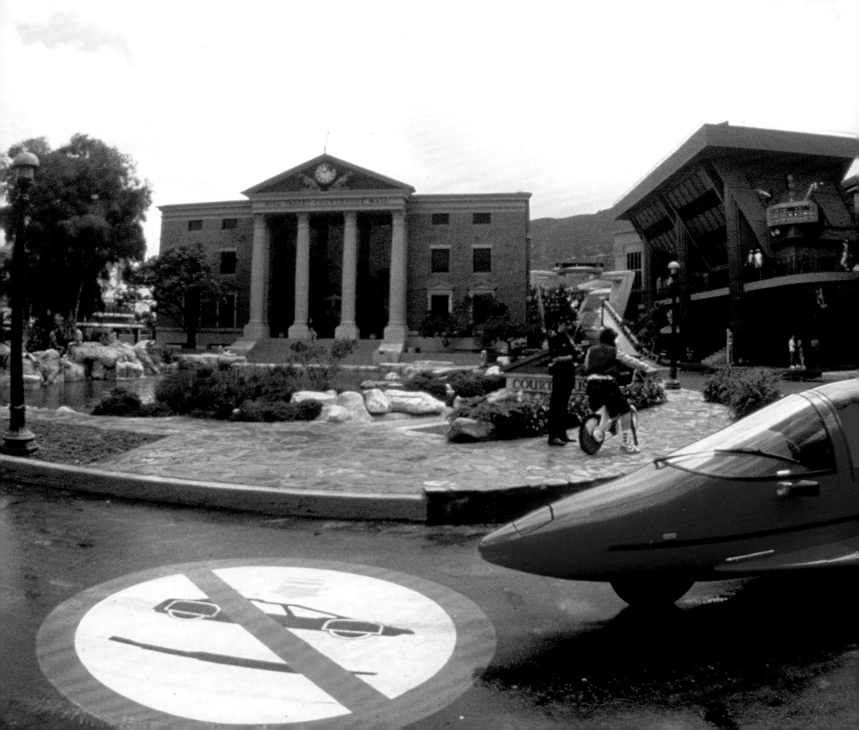

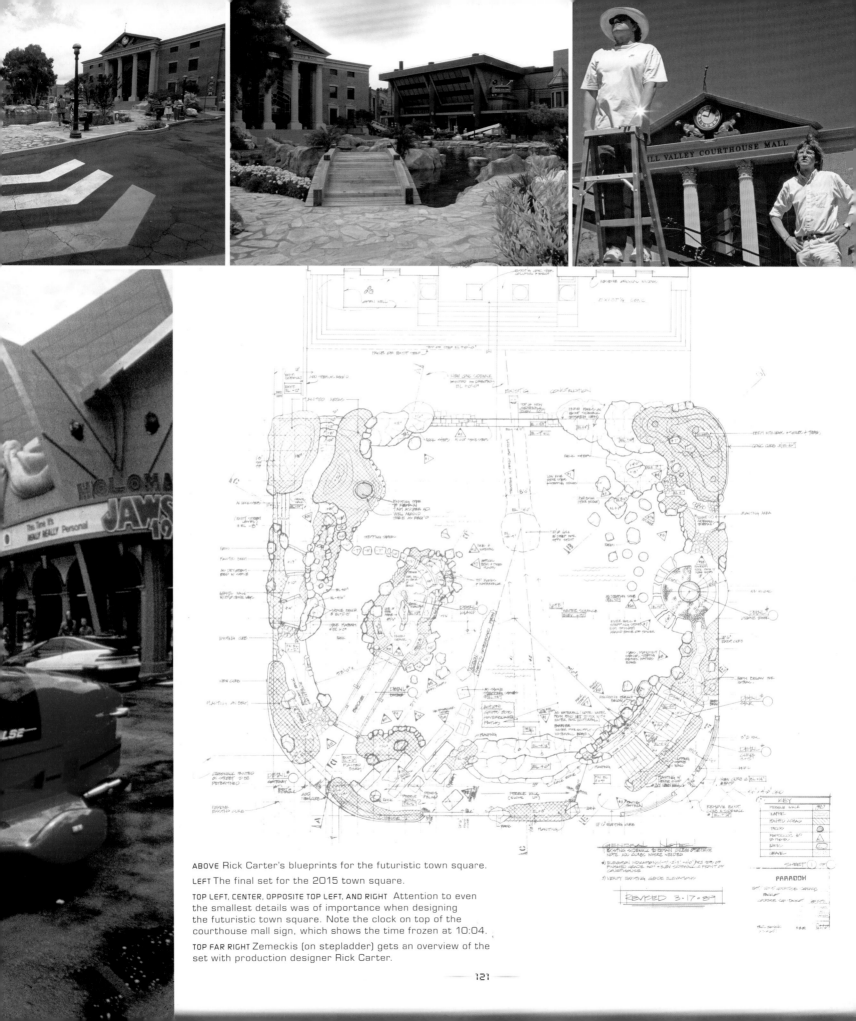

ABOVE Rick Carter's blueprints for the futuristic town square.

LEFT The final set for the 2015 town square.

TOP LEFT, CENTER, OPPOSITE TOP LEFT, AND RIGHT Attention to even the smallest details was of importance when designing the futuristic town square. Note the clock on top of the courthouse mall sign, which shows the time frozen at 10:04.

TOP FAR RIGHT Zemeckis (on stepladder) gets an overview of the set with production designer Rick Carter.

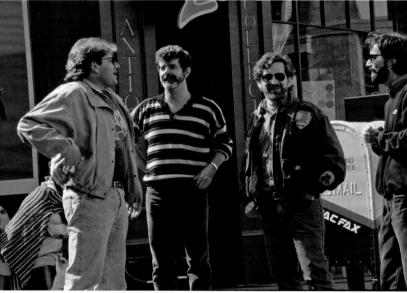

recalls. "It's a simple line to write, but when it came to actually building the town square, it had to be designed so the audience would immediately get that feeling upon seeing the image. The future was going to be optimistic."

Even before Carter started his designs, ILM's Ken Ralston had begun one of the most challenging aspects of the upcoming sequel. Early on, Gale and Zemeckis had decided that Michael J. Fox would play his own son and daughter, a prospect that delighted the actor. While filming *Who Framed Roger Rabbit*, Zemeckis spoke with Ralston about modifying their system of meshing live actors with animated characters for use in the *Back to the Future* sequels. "We had these silent VistaVision cameras,

and they were working well," relates Zemeckis. "I told Ken some ideas I had for shots in the sequel and asked what we were going to need. He said we're going to need a motion-control dolly. I said, 'Why don't you guys start building it?' That was the fun thing about having a giant sequel. I could commission something and Universal would pay for it."

Ralston and his colleagues at ILM did exactly that. Zemeckis had described a number of scenes in which either Michael J. Fox or Christopher Lloyd would interact with other versions of themselves. Up until that point, whenever a show depicted an actor playing two characters in the same shot, the camera would be locked down, and there would be a doorjamb or some other clear vertical line

between them that determined the split. The actor could never cross that split line, and two separate takes would be optically combined. The new system would enable Zemeckis to move that split back and forth within the scene, allowing the actors to walk around themselves or even pass objects between themselves. The focusing, dollying, panning, and tilting of the camera would be computer controlled so that its movements could be exactly duplicated take after take. ILM developer Bill Tondreau designed the software program for the system, and it was officially named the VistaGlide motion-control system. But to the cast and crew of *Back to the Future Part II*, it would forever be known as "the Tondreau."

TOP RIGHT A tribute to executive producer Steven Spielberg and one of his most enduring film properties.

RIGHT Lloyd and Fox shooting a scene in the 2015 town square.

MEANWHILE, BACK AT THE RANCH . . .

IN BETWEEN PRODUCTION MEETINGS and location scouts, and over the course of several nights, Bob Gale continued rewriting. The majority of his work went into expanding the Western portion and Doc's relationship with Clara. In one draft, Clara brings her class to Doc's workshop, where he shows them a science experiment, and Doc discovers that one of the young students is his mother. Before long, Gale realized he had enough material for two films. "I finished a 230-page draft just before Thanksgiving 1988, and that's when I first floated the idea of making it two movies," he says. "But no one wanted to go there—yet. So I pared it down to 157 pages and that was the version we distributed and budgeted."

When estimating the length of a film, the usual formula is that one script page equates to one minute of screen time. "I think we expected them to make this a three-hour movie," says Zemeckis. "And we thought we could cut it down to like two hours and twenty minutes or something like that—we'd tighten it up."

As Neil Canton remembers, the budget of that script, dated December 19, came to approximately $60 million. "We had a meeting at Universal that was just horrible and actually kind of frightening," he says. "Everyone was there—Bob and Bob, Steven, Frank, Kathy, and I—meeting with Lew Wasserman and Sid Sheinberg. Their response was, 'We're not going to make the most expensive movie ever made.' They were furious."

As they left the meeting, the filmmakers were told in no uncertain terms they would be making a movie but not the version they had just presented. It was then that Bob Gale revisited his "two for the price of one" idea. He revised the 230-page draft so that it could be neatly bisected, then had production manager Joan Bradshaw, budget for two separate movies to be shot one immediately after the other. Bradshaw came back with the two budgets, each around $35 million. "Everyone on the production thought it was a no-brainer," says Gale. "Why make one movie for $50 million, when you could make two for $70 million?" A few weeks later, another of their trademark good news / bad news scenarios was presented to Sheinberg. "We said, 'The bad news is we will not have *Back to the Future II* for you in theaters for the summer of 1989,'" says Gale. "The good news is we'll have *Back to the Future II* in theaters for Thanksgiving 1989 and *Back to the Future III* in theaters for the summer of 1990.'"

"Sid said, 'That's either the most genius or the most insane idea I've ever heard.' And he did it," says Zemeckis. In late January 1989, only a month before shooting was to begin, Universal formally agreed to shooting the two sequels back-to-back, although the first production draft of "Three" (its working title) would not be finished until July 6, 1989.

IF THE GLOVER DOESN'T FIT

BY DECEMBER 1988, the filmmakers had been notified that Crispin Glover was rethinking his decision to eschew the sequel, so the actor was invited to meet with Zemeckis. On December 16, the director walked Glover through the sets under construction on the back lot and talked him through the story and George McFly's roles in 2015 and in 1955. Glover responded positively, and was sent the December 19 draft.

In January, Gale began negotiating with Glover's agents, offering the actor double what he'd received on his last picture. "We thought it was a generous offer, especially since it was a relatively small part," says Gale. And then, to sweeten the deal, Gale offered Glover an additional fee to portray Seamus McFly in the third movie. Glover's response was to fire his agents and hire new ones who thought they could get more money for their new client. Gale patiently told them Glover's history with the sequel, explained that the budget was now fixed and that the filmmakers were fully prepared to make the film without their client. Gale repeated the previous final offer and told them that if they came back and pressed for more money, the offer would be lowered. They did, and Gale did just what he promised. On February 8, 1989, Crispin officially passed. "It was so sad," admits Zemeckis, "but there was nothing we could do."

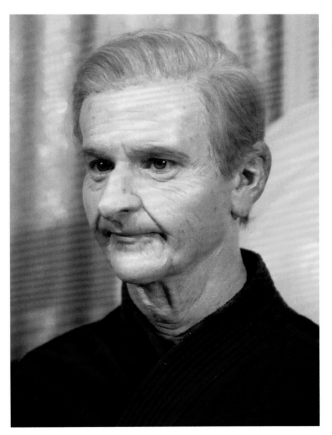

With Glover out of the picture, they decided that Michael J. Fox would play Seamus. However, they now needed a suitable replacement for George McFly.

Actor Jeffrey Weissman (*Pale Rider*) met with casting director Judy Taylor, who had him audition using the scene from the first movie where George is hanging the laundry. His next stop was to see makeup supervisor Ken Chase, who used the original molds he had created for Glover on the first film to make new prosthetics. Chase applied them to Weissman for a screen test. Weissman recalls a brief conversation between Zemeckis and Cundey after the test was complete: "Bob said to Dean, 'What do you think?,' and Dean says, 'I think we got Crispin without the trouble.'"

LEFT Jeffrey Weissman stepped into the role and prosthetics of George McFly when negotiations with Crispin Glover failed.

TOP Weissman is strapped into the futuristic Ortho-Lev prop.

ABOVE The special effects team was stationed in the rafters of the stage to help Weissman appear as if he was floating from room to room.

GET SET ...

ON JANUARY 19, 1989, makeup tests began. Tom Wilson was put into two looks for the film: Black Biff (later renamed "Buford"), and his Biffhorrific incarnation as the forty-eight-year-old, ultra-rich Biff Tannen. Lea Thompson was also put into her Biffhorrific makeup.

The following week, Tom Wilson and Lea Thompson got the full prosthetic treatment for the septuagenarian versions of their characters. Each would spend close to four hours under the supervision of Ken Chase. Fox also underwent the process for the first time, spending two and a half hours in the chair to become the forty-seven-year-old Marty before having that makeup removed and spending another hour and a half being transformed into Marlene.

Before shooting began, there was one further casting issue to deal with. Claudia Wells was unable to reprise her role as Jennifer due to personal issues. On February 3, auditions were taped in the Amblin conference room with Julie Warner (who would later go on to star opposite Fox in *Doc Hollywood*) and Lori Laughlin (*Full House, 90210*). Five days later Elisabeth Shue (*Cocktail*) came to Universal's Stage 14 to test for the role and was hired.

In the penultimate day leading to the start of shooting, there was a last-minute read-through of the script with Fox, Lloyd, Thompson, Wilson, and Shue, followed by a screening of the first movie in the Amblin Theater for cast and key crew. "We wanted to make sure we didn't forget anything and to remind everyone why we were there," explains Gale.

LEFT Lea Thompson in Lorraine's Biffhorrific incarnation.

BELOW (Left to right) Michael J. Fox chats with executive producer Kathleen Kennedy, associate producer Steve Starkey, executive producer Frank Marshall, and producer Neil Canton.

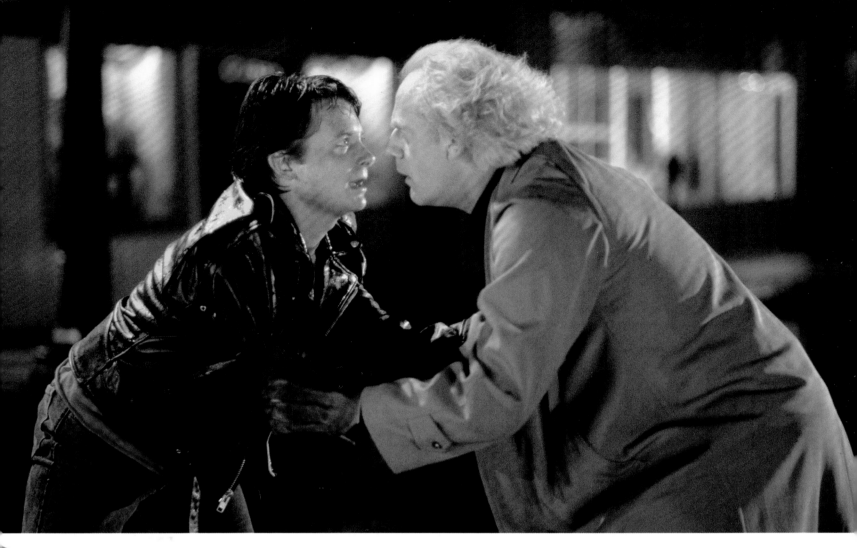

WE'RE BACK!

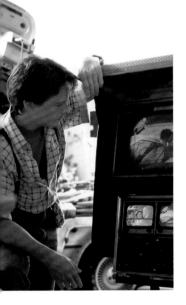

NIGHT 1: FEBRUARY 24, 1989

The first night of shooting was a chilly one, but there was a palpable excitement in the air, as the cast and crew gathered in front of the courthouse in the familiar town square.

Zemeckis decided to dive in headfirst and began with the scene of 1985 Doc riding a bicycle into the town square and running into 1955 Doc, who's setting up the weather experiment. It was the first scene shot with the new VistaGlide/Tondreau system.

While the atmosphere was convivial among the cast and crew, Christopher Lloyd was facing some difficult technical and emotional challenges. "My toughest night of shooting over the course of all three films was the first night of shooting *Part II*," he reveals. "I had to exactly replicate what I did at the end of [the first film], and it was four years later. I was sweating that; I just didn't know how I was going to get there. I remember my distinct concern was that I was still finding Doc as an actor."

The next item on the night's agenda was to re-create the moment when Doc celebrates Marty's successful trip back to the future. Zemeckis and his team had the original footage on hand to ensure the look and action of this new shot would perfectly match what they had shot years prior. "I had really worked to get a certain euphoria in Doc's manner and behavior, which had to be in the voice, too, because I'm crying out in glee about the whole thing," says Lloyd. "Getting that edge on it again, that same energy and euphoria, was the challenge, and I did it! I had wanted to tiptoe back, but it was a definite plunge."

Michael J. Fox arrived on the set later that night, coming directly from Paramount after taping a *Family Ties* episode. (Once again, the company had to contend with their star's split duties, but, thankfully, his television responsibilities were significantly lighter this season.) Fox was in high spirits and jumped right in, filming what would be the last scene in *Back to the Future Part II*, in which Marty runs around the corner to tell Doc he's back *from* the future. The chemistry between Fox and Lloyd reignited as if they hadn't spent a day apart.

WEEK 1: FEBRUARY 27–MARCH 3, 1989

Tom Wilson arrived for his 4:00 a.m. Monday morning call and climbed into the makeup chair for the four-hour process that would turn him into the septuagenarian Tannen. He would film his scenes as the elder Tannen first and then have sixty years' worth of prosthetics removed to play the obnoxious seventeen-year-old punk who accosts Lorraine and her friend Babs (Lisa Freeman, reprising her role from the first film) when they pick up Lorraine's dress for the dance.

As the week progressed, Christopher Lloyd returned to pick up the three-quarter-inch wrench and hand it to himself in the scene he had begun the week before. "I guess my biggest concern was 1955 Doc never sees 1985 Doc, and both men are in different places mentally at that moment," he says. "The 1985 Doc, who comes by to hand him the tool, is in one state of mind, and 1955 Doc on the ladder is in another state of mind. I really wanted to keep those performances separate for the audience point of view."

ABOVE Tom Wilson, Lea Thompson, and Lisa Freeman shoot a scene in 1955 Hill Valley.

LEFT Wilson, as old Biff, takes a moment to admire the advertising of the future.

OPPOSITE TOP LEFT AND RIGHT Filming continues on Biff's 1955 scenes. Rick Carter only had to dress a small section of town square for 1955 because there were very few scenes that took place there. Here, the crew shoots Biff with Lorraine and Babs, as well as Biff picking up his car from mechanic Terry (Charles Fleischer).

OPPOSITE BOTTOM On the first night of shooting "Paradox" (the code name for the production), Christopher Lloyd found himself playing a pair of Docs.

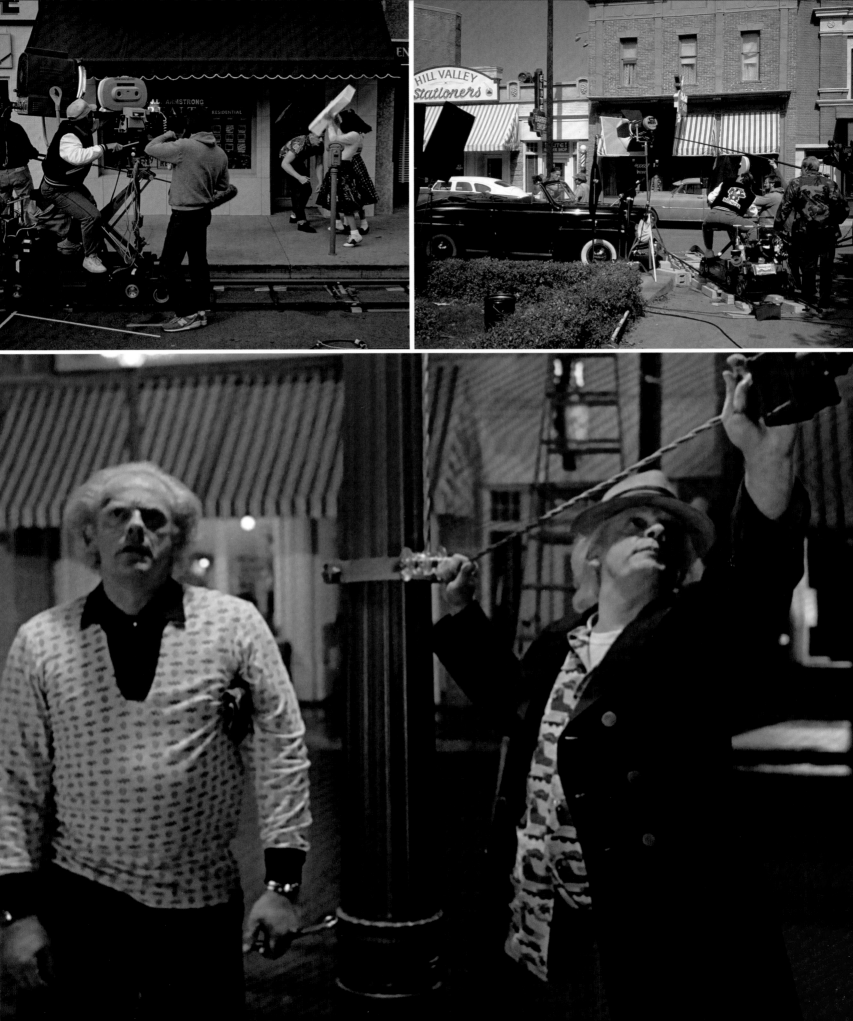

TOP Billionaire Biff Tannen shares a hot tub with actresses Tracy Dali (left) and Tamara Carrera (right).

ABOVE Tom Wilson strikes a pose with the wax figure at the entrance of the Biff Tannen Museum.

OPPOSITE TOP Zemeckis walks the crew through the Biffhorrific square to plan the night's work.

OPPOSITE CENTER Marc McClure returned for a scene with Fox in the Biffhorrific 1985 which was ultimately cut from the film.

OPPOSITE BOTTOM The familiar layout of the town square given a Biffhorrific makeover.

WEEK 2: MARCH 6–10, 1989

Universal's 29,500-square-foot Stage 12 had previously been the home to such classic films as *Dracula*, *Frankenstein*, *The Sting*, and *Scarface*. Despite this legacy, in later years it became known as "the *Back to the Future* stage," due to the vast amount of shooting undertaken there for the trilogy.

The first set that Rick Carter had constructed was the lavish and garish penthouse suite of billionaire Biff Tannen. The space was adorned in cheesy leopard-skin wall treatments, with black velvet artwork and a bubbling Jacuzzi occupying center stage. "I guess the word that comes to mind to describe anything about Biff and his Biffhorrific world would be *lewd*," smiles Carter. "Imagine a place where you wouldn't want your mother to be, and that's how we designed it. Because that's what it is for Marty. He wakes up, and that's where his mother is stuck."

In fact, that was exactly the scene where shooting began, as Marty wakes up on the "good old twenty-seventh floor." When shooting the penthouse scenes, the makeup trailer was a little more crowded than usual. In addition to Lea Thompson and Tom Wilson getting the full (and, in Thompson's case, "fuller" with the addition of prominently enlarged fake breasts) treatments, Billy Zane, Casey Siemaszko, and J. J. Cohen had returned as Match, 3-D, and Skinhead and also had to be aged.

For Thompson, the physical process of the makeup application was confining in the physical sense but liberating as an actor. "It's actually fun to get transformed that way," she reveals. "It gives you permission to be completely different. Actors need permission to go where they have to go, and that's a director's job in some ways, but when you have makeup like that, all of a sudden you get to be someone else. The three parts that women usually get to play are virgins, whores, and mothers, and in *Back to the Future Part II*, I got to play all three."

In approaching his new, powerful incarnation of Biff, Tom Wilson didn't rest on the laurels of his past performance, but instead imbued the character with a new depth and darkness.

During the making of the second film, Wilson reflected on the new layers he had to bring to the character: "The guy's a jerk. He's stupid, but there are also aspects of Biff, given the right amount of power, that are serious and really bad. I didn't want it to be all buffoonery, this kind of big, goofy cartoon character that just gets slugged. Let's face it. Bad guys aren't really funny. [Biff] doesn't have a kind heart. And he hurts people, and he doesn't care."

After two days of stage filming, the production moved to the back lot where Rick Carter and his team had transformed the courthouse square into "Hell Valley." "In my mind's eye, it was Las Vegas meets Bangkok in an industrially polluted environment," says the production designer. "On the one hand, it was tangibly provocative and seductive like Vegas could be, but also it was a setting without anything that could be considered to have a trace of sensitivity or be in any way ecologically positive. Everything would be fake, including Lorraine's breasts."

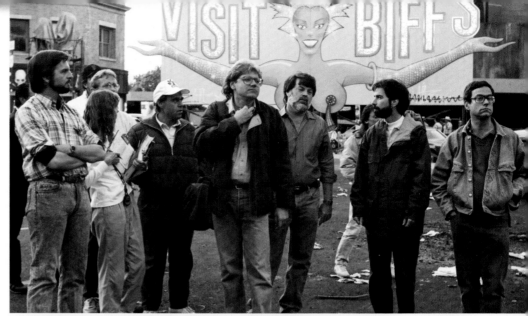

Marc McClure returned as Dave McFly, albeit a very much worse-for-the-wear version due to Biff's alteration of the space-time continuum. However, Wendie Jo Sperber, who played his sister, Linda, was pregnant during filming and was unable to reprise her role. McClure spent two nights shooting a scene in which Marty encounters his inebriated sibling, but it was ultimately cut from the film. Bob Gale later explained to McClure the reasoning for the excision. "Bob said, at the test screenings, everybody's asking, 'Where's the sister, what's going on here?'" relates McClure. "It was easier for them to just cut me out than to have unanswered questions."

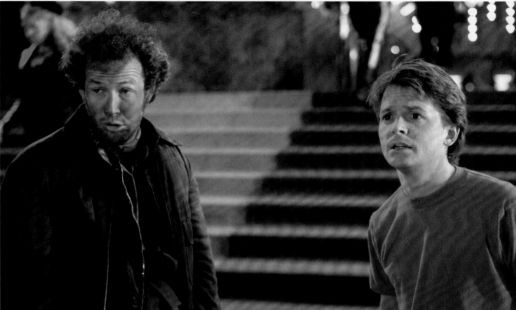

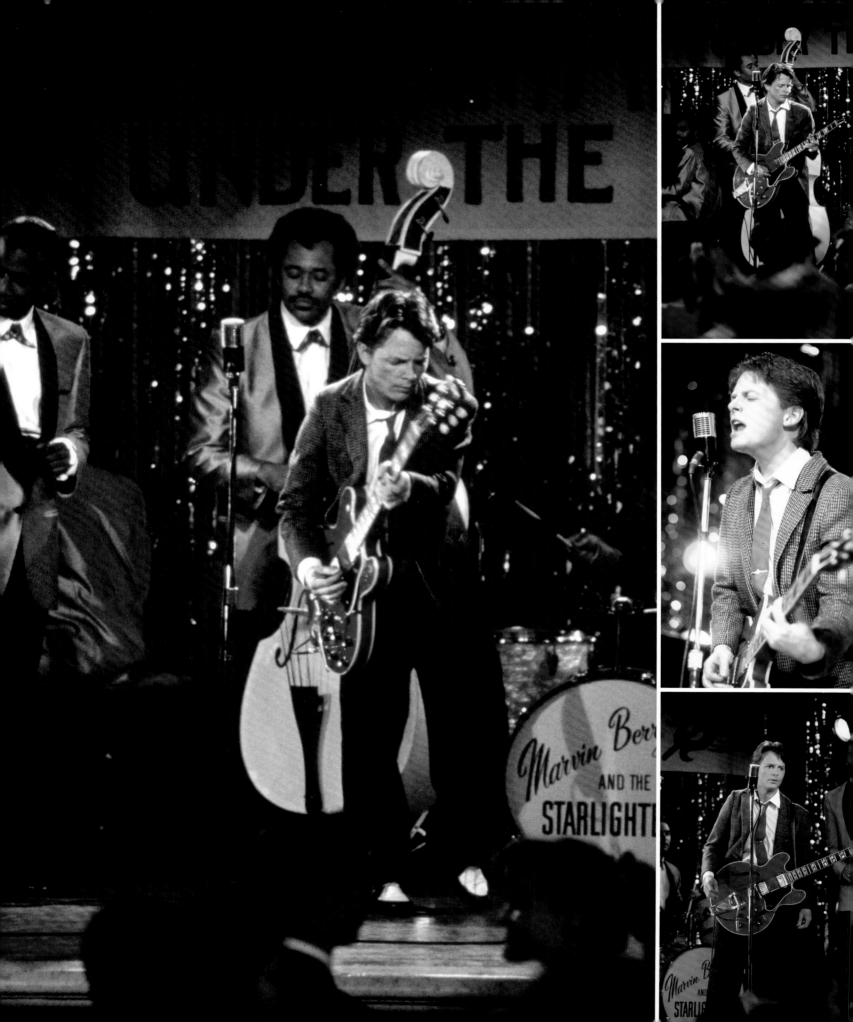

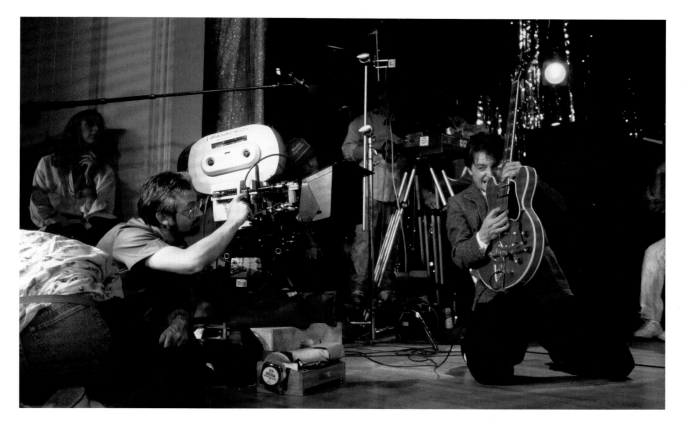

WEEK 3: MARCH 13-17, 1989

After one more day in Biff's penthouse, it was time to go back to the "Enchantment Under the Sea" dance, again held at the Hollywood United Methodist Church where it had been filmed four years earlier.

Jeffrey Weissman made his first appearance as the young George McFly, but it wouldn't be makeup supervisor Ken Chase applying the prosthetics. Bob Gale recalls being approached by Chase about two weeks into the production: "He came to us and said he wanted to leave the show to take another job. We let him go, confident that Kenny Myers and Mike Mills could handle the show."

Days prior to filming, Brad Jeffries, who had choreographed the dance for the first film, returned to rehearse a group of dancers for the reprise of the "Johnny B. Goode" number, including many who had participated in the original sequence. Likewise, Joanna Johnston and her staff had begun a scavenger hunt through the costume houses of L.A., seeking out dresses that had been worn in the first film. "[Associate producer] Steve Starkey had printed out all these pictures for us," recalls Johnston, "and it was literally like winning the bingo when we found any dress that was a match." Those that she couldn't find were specially manufactured using the photos as a guide.

The most important item that Johnston had to find was Lorraine's taffeta dress. Three of them had been created for the original film, but for the sequel, only one was found. Fortunately, it was hanging in Lea Thompson's closet. "And it still fit perfectly!" states Thompson proudly.

While various department heads reviewed the original dance footage to ensure accuracy, Dean Cundey and his team worked to mimic the original lighting and to ensure matching filter lenses were used for the re-created shots.

The first shooting day mostly focused on the new aspects of the scene, with Marty scoping out the gymnasium, searching for Biff and the almanac, and then trying to avoid both Biff's gang and his other self onstage (played by his double, Kevin Holloway).

On the second night, Fox went back onstage to repeat some of his fancy guitar and footwork, playing "Johnny B. Goode" for the appreciative crowd. While he continued to give all his energy to the scene, Fox admits something was missing the second time around. "The energy was different," he explains. "Not that it was bad, but you couldn't have that magical experience again. I was four years older, which, at that point in my life, was a lot of years. I couldn't move as well as I did [the first time], and I didn't know why. Unbeknownst to me, I probably had Parkinson's then. I just didn't have symptoms yet, but I was feeling that physical pressure, so it was a different thing. I just thought I was getting older, so things like that were hard, but it was a lot of fun to go back and revisit."

After finishing the work at the church and the interiors of the dance, it was time to head back to Whittier High School for the major exteriors in the school parking lot.

THESE PAGES Four years after his first appearance, Michael J. Fox retook the stage at the Hollywood United Methodist Church to re-create his performance of "Johnny B. Goode."

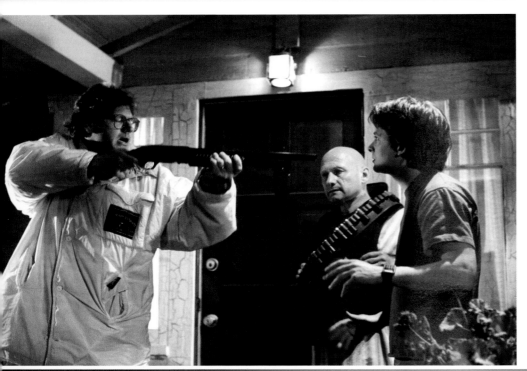

At the Whittier location, Rick Carter designed and constructed a three-walled section of Mr. Strickland's office, which was raised on a platform in the parking lot. From this unique vantage point, Marty (and the audience) would be able to see the action of George knocking out Biff, giving Marty the opportunity to reclaim the sports almanac.

The last night of location work in Whittier took place a block away, with the abandoned hulk of the Biffhorrific-era high school looming as Marty ends up on the porch of Mr. Strickland's house. "I loved being able to degrade everything for this reality," says Rick Carter. "Playing with the motifs was such a big part of how you actually ended up feeling about what the characters were up against. Bob and Bob came up with so many witty things, like the chalk outline of the body on the ground, which gave the audience a point of view."

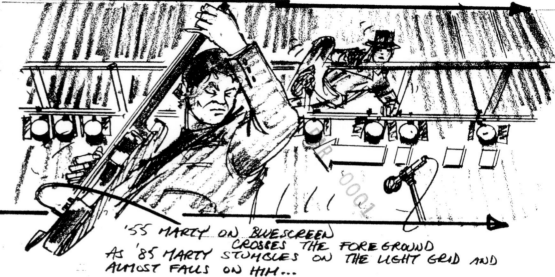

JC 340 E.2 EXTREME UP ANGLE - MARTY ON LIGHT GRID

'55 MARTY ON BLUESCREEN
CROSSES THE FOREGROUND
AS '85 MARTY STUMBLES ON THE LIGHT GRID AND
ALMOST FALLS ON HIM...

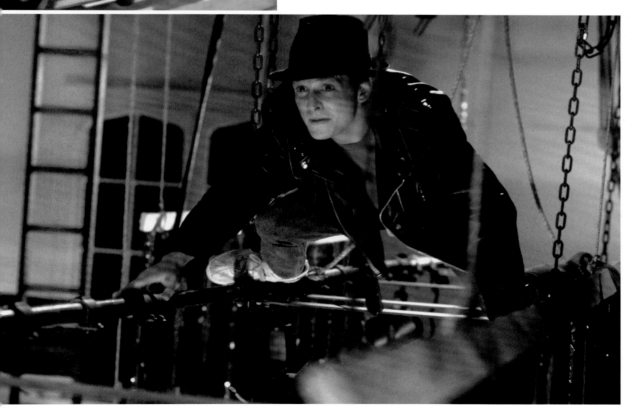

OPPOSITE TOP Zemeckis demonstrates the shotgun stance to James Tolkan.

OPPOSITE BOTTOM Tom Wilson and Jeffrey Weissman re-create Biff's torment of George.

TOP LEFT The Tondreau rig and blue screen are put in place on Stage 12 to shoot Marty as he makes his way across the rafters while his other self performs below.

TOP RIGHT A storyboard illustrates how the scene will look when shot with the Tondreau.

LEFT Michael J. Fox in a final frame from the film.

WEEK 5: MARCH 27–31, 1989

The final segment to be shot for the dance—the scene that sees "new" Marty climb into the rafters to escape Biff's goons, while "old" Marty plays guitar beneath—was a piece that couldn't be filmed on location. The Hollywood United Methodist Church had no rafters, so Zemeckis had the set built on Stage 12. Fox's stuntman Charlie Croughwell would perform some of the elevated long shots, while Fox belted out the song onstage. After a quick wardrobe change, the Tondreau would record Fox inching along the structure, exactly matching the camera movement from the previously filmed shot.

ABOVE LEFT AND RIGHT Although he avoided prosthetics in the original film, in the first sequel, Fox would spend much time in "the chair" being transformed, into old Marty and daughter, Marlene.

BELOW Designs for the pizza hydrator.

OPPOSITE Joanna Johnston's design for old Marty's look included the double tie.

WEEK 6: APRIL 3–7, 1989

The first day of the week was the last day of work in Biff's penthouse, as the filmmakers captured the scene in which Marty learns how Biff received the sports almanac. With that work completed, Rick Carter and his crew began dismantling the structure to make room for their next impressive set.

With so many sets to build in a limited amount of time, even the cavernous Stage 12 wasn't enough to hold them all, so Zemeckis and crew claimed nearby Stage 27. Over the coming weeks, they were to descend into "Tondreau Hell," with the camera system being the key component in shooting the extremely complex 2015 McFly family sequences.

In the original *Back to the Future*, Michael J. Fox had escaped the hardships of prosthetic makeup effects, but now he would be subject to the same rigors as castmates Thompson, Wilson, and Weissman. "I was used to it because I'd done *Teen Wolf*," says Fox. "The thing that people don't understand about it—and with the advent of CG, it might be different now—but they put it on with airplane glue and took it off with gasoline, and it used to ravage my face."

Despite the discomfort, the actor was more than happy with the results. "It's always fun to play with a mask," he says, "and it's interesting now to be around the same age as we imagined Marty to be [in the second movie]." In approaching the role of Marlene, Fox talked to the women in his life and watched a lot of movies released at the time that featured young women: "I had the physical and emotional attitude and rhythm perfectly set in my mind. When the time came to put on the high heels and the dress, I found myself embarrassed to be standing in front of a crew that I had been working with for years. I think the hardest part about Marlene is that the audience had to accept her as a

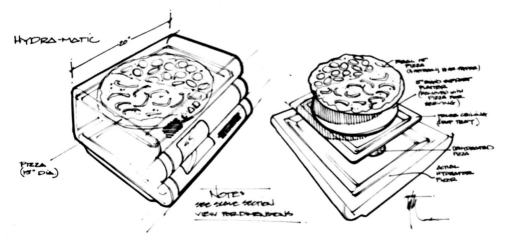

HYDRA-MATIC

PIZZA (13" DIA.)

NOTES: SEE SLICE SECTION VIEW FOR DIMENSIONS

GARNER
JOHNSON
J·BELL

normal teenage girl, even though I was playing her. Usually when you see a man dressed as a woman in a film, part of the joke is that you understand it's really a man in a dress. I didn't have the luxury of being able to wink at the audience."

Lea Thompson credited Kenny Myers and Mike Mills for their part in bringing Grandma Lorraine to fruition ("I think that was the best makeup they did on me") and Zemeckis in giving her one informative piece of direction: "He said, 'You're going to be eighty, but you can't be slow,' and that's why I created that crazy character. It was Grandma on drugs . . . I was spry. I looked around at many examples of older women who are hyper. She's still one of my favorite characters."

The McFly family filming began with a relatively easy Tondreau shot, with Marty Sr. sending Marty Jr. away from the multiscreened television and off to dinner. They would then tackle the most ambitious of the Tondreau work, which found Marty Sr., Marty Jr., and Marlene enjoying a rehydrated pizza, compliments of George and Lorraine.

The day's shooting was fraught with a number of challenges before anyone even stepped in front of a camera. At 7:00 a.m., Lea Thompson was taken to the Universal Studios hospital to be treated for blisters on her neck caused by the prosthetics. Back in the makeup trailer, the entire electrical system shorted out, causing all the appliances (of the electrical variety) to smoke and burn.

On set, Michael J. Fox had to go back and forth between characters and repeat his exact actions from take to take. The scene was split into three parts: A, B, and C. For the A side, with Fox as forty-seven-year-old Marty, the scene was shot in the usual way, with the camera movements recorded by the computer so they could be repeated precisely in the shooting of the other segments. This part was the most flexible in terms of shooting, with Zemeckis able to have Fox perform a number of takes until he got the one he was looking for.

Next came the B side, with Fox as Marlene with Grandma Lorraine bustling through the background. Marlene had to react realistically to the previously recorded movements of her father, and so Fox wore a miniature earpiece that played both his recorded dialogue from the A side along with cues from Zemeckis. Finally, after another wardrobe change, plus revised hair and makeup, Fox was ready to inhabit Marty Jr. for the C segment.

With a system rigged by video engineer Ian Kelly, Zemeckis and team could watch a rough composite of the final scene. With all the scenes filmed, the footage went to ILM, where the three elements were optically merged using mattes and rotoscoping to produce the final sequence.

The pizza scene took three full days to shoot, with Fox being dismissed from the set in the early hours of Friday, April 7. One of the hard-and-fast rules about shooting with the Tondreau was that nothing could be moved from take to take. Some of the set dressing was glued in place, and, when not in use, the camera unit was surrounded by police tape. Even the slightest jostle from an unsuspecting crew member could throw off the precise memory of the computer system, and if a prop was moved even a fraction of an inch, it would likewise ruin the process. So, when a mild earthquake struck Los Angeles after the second day's work, Zemeckis and company had a panic attack. Luckily, nothing was disturbed and the scene did not have to be reshot.

A SIDE Shot by the camera operator in the normal method. Camera movements were recorded by the computer, which, when other shots were filmed, repeated these movements exactly.

C SIDE Fox as Marty Jr. He was able to react to the other characters with the aid of a miniature earpiece that played the recorded dialogue, as well as the director's cues from previous takes.

B SIDE Fox plays Marlene. Lea Thompson's Lorraine is also added to the shot.

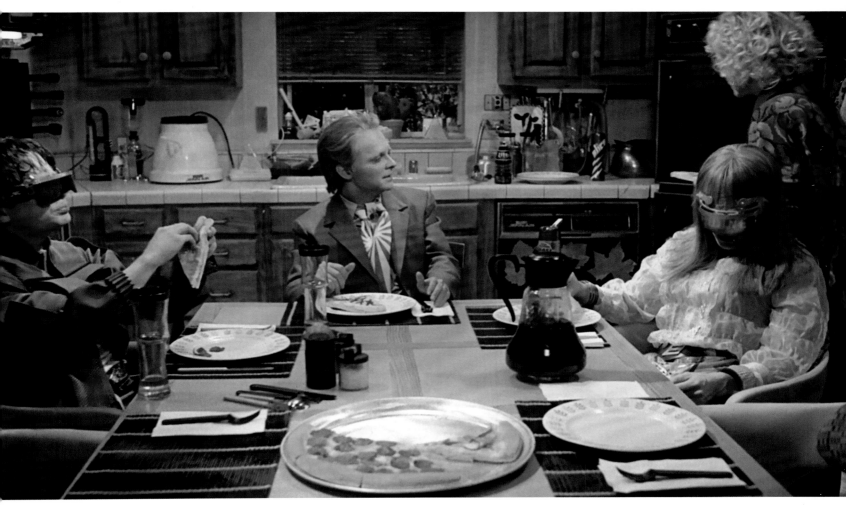

FINISHED SHOT After all the sides were filmed, the footage was sent to ILM where, by the use of mattes and rotoscoping, the three shots were optically merged into a single image.

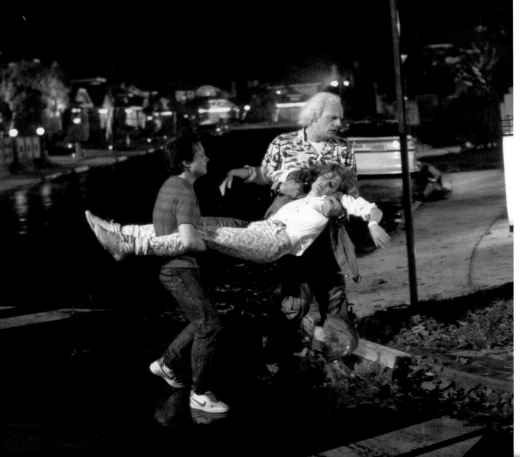

WEEK 7: APRIL 10–14, 1989

After shooting the scene of Marty Sr., Marty Jr., and Marlene gathering around the unconscious figure of the forty-seven-year-old Jennifer, the Tondreau work was completed for the time being.

The regular shooting continued with young Jennifer exploring her future home and discovering the bleak existence in store for her and Marty. Joining the cast midweek was actor Michael Peter Balzary, better known as Flea, bass guitarist of the Red Hot Chili Peppers. Flea made his first appearance as Douglas J. Needles on a big-screen video call. Rather than pretape his dialogue, a live video feed was set up onstage so that Needles and Marty could chat in real time.

In addition to the home's interior, Carter designed a piece of the house's exterior for the scene in which police officers Reese and Foley carry the semiconscious young Jennifer into her home. (In all of their scripts, Zemeckis and Gale used the names Reese and Foley for police officers or government agents.) In this vision of the future, the police are friendly, likable, sexy, and female. Zemeckis wanted them to be attractive so that people wouldn't mind being arrested.

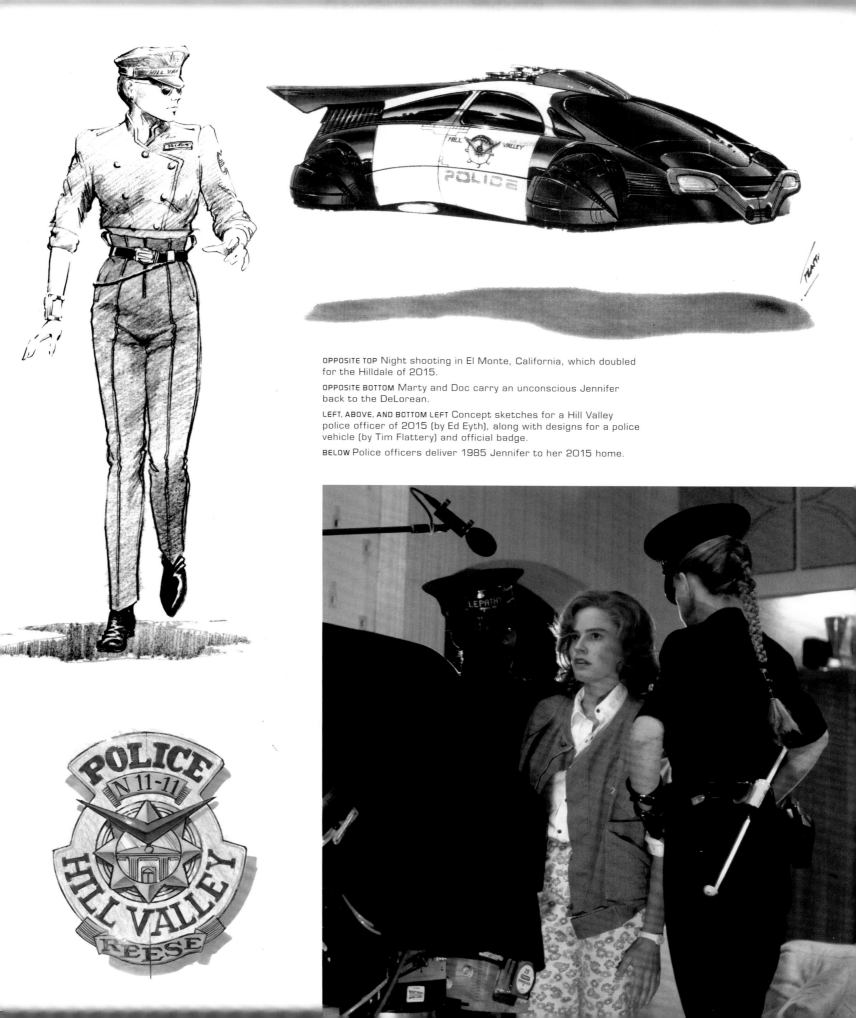

OPPOSITE TOP Night shooting in El Monte, California, which doubled for the Hilldale of 2015.

OPPOSITE BOTTOM Marty and Doc carry an unconscious Jennifer back to the DeLorean.

LEFT, ABOVE, AND BOTTOM LEFT Concept sketches for a Hill Valley police officer of 2015 (by Ed Eyth), along with designs for a police vehicle (by Tim Flattery) and official badge.

BELOW Police officers deliver 1985 Jennifer to her 2015 home.

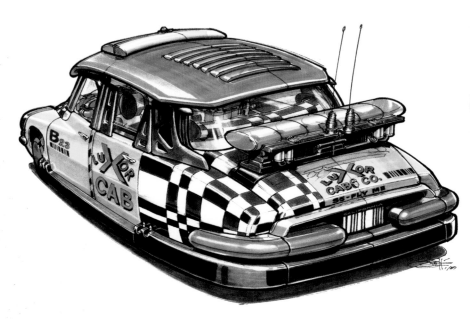

WEEK 8: APRIL 17–21, 1989

This week of shooting began and ended on Stage 27, starting with the scene in which Marlene greets her visiting grandparents.

The company then moved to El Monte, California, standing in for Hilldale, where the McFlys reside. The Tondreau was used for filming the landing and takeoff of several flying cars.

The futuristic taxicab that Biff uses to follow Doc and Marty was designed by John Bell and Michael Scheffe. Bell designed many of the future items and decor, and his major contribution to the automotive side was the cab: "In my first sketches for the taxi, there was no car specifically in mind,

but when Michael Scheffe saw it, he said, 'I think this kind of looks like a Citroën DS 19.' We ran the idea past Bob and Bob, and they said go for it."

To make the cab fly, Steve Gawley at ILM built a miniature replica, complete with a driver who has a tiny parrot on his shoulder. Gawley also revamped his one-fifth-scale version of the flying DeLorean for *Part II*. "We hadn't made an interior for the model we used in the first movie, because it was only one shot," he explains. "On *Part II*, Bob [Zemeckis] asked if we could put an interior into it. We took it apart and rebuilt it and ended up putting twenty-four different functioning things into the model: the time circuit display, the flux capacitor, lights, etc. Everything you see in the real car was in our model."

Gawley's model was later used by ILM to augment the scene in which Biff steals the DeLorean. This version of the car also featured a moveable steering wheel and a puppet figure of old Biff with his hands tied to the wheel.

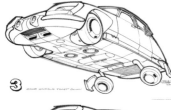

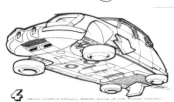

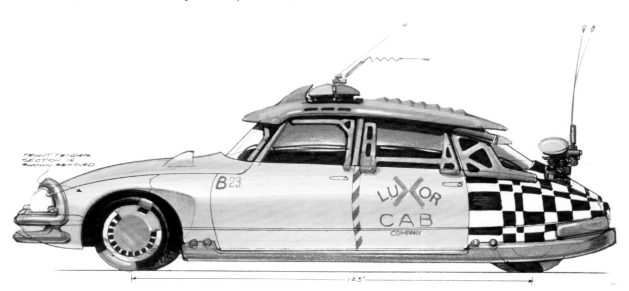

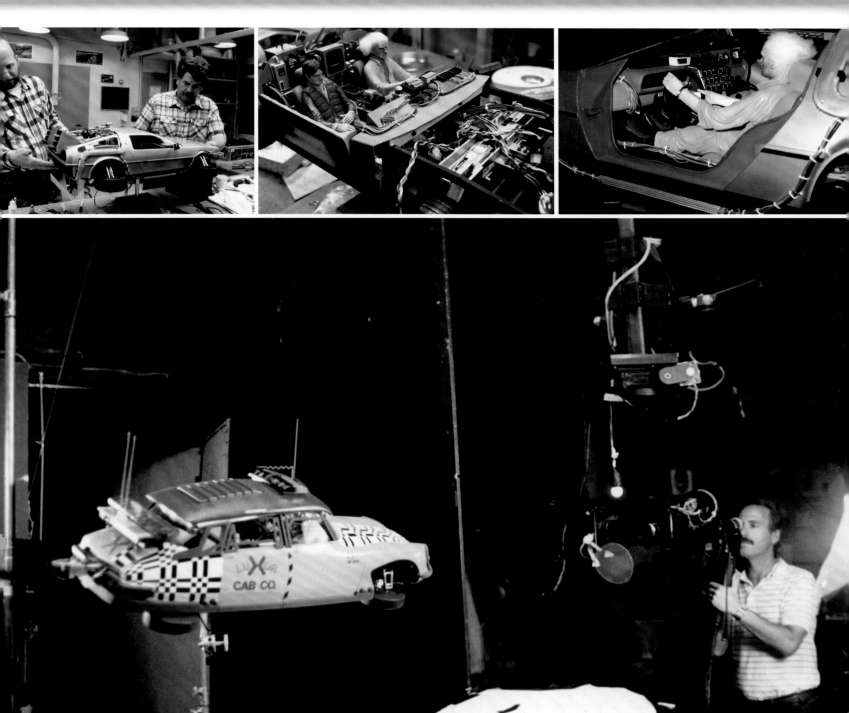

WEEK 9: APRIL 24-28, 1989

Michael J. Fox only worked with the *Back to the Future* crew on the twenty-fourth, with the rest of the week devoted to *Family Ties*, then in its final season. He spent most of that Monday on Stage 27 as Marlene, filming additional shots featuring Lorraine and George making their way from the den into the kitchen.

Moving for one day/night to Pasadena, the crew shot young Biff taunting a group of kids who just want their ball back, before tossing it onto the second-floor balcony of the neighboring house. The scene was shot from Marty's POV. Because Fox was unavailable, his close-ups were filmed later on the *Leave It to Beaver* street at Universal Studios.

The second unit began work this week, with Max Kleven directing. Executive producer Frank Marshall, who had performed the role on the first film, was overseas directing the second unit for Steven Spielberg's *Indiana Jones and the Last Crusade*. Kleven had previously served as a second-unit director on a number of films, including the US portion of Zemeckis's *Who Framed Roger Rabbit*.

Kleven and his team spent several nights in Griffith Park filming wide shots, aerial shots, and related footage of young Biff driving his convertible to and from the dance, and the DeLorean in pursuit.

OPPOSITE Original designs for the future taxi by Michael Scheffe and John Bell.

TOP ILM model makers put the final touches on their replica of the DeLorean, which even featured miniature versions of Marty and Doc.

ABOVE The flying taxi is filmed by ILM.

On the Tuesday of week 10, the crew began two days in Arleta, shooting the opening scene of the sequel, an exact re-creation of the final moments of the first movie, with two changes. The first was the replacement of Claudia Wells with Elisabeth Shue, and the second was the moment of hesitation in Christopher Lloyd's response when Marty asks if he and Jennifer become "assholes" in the future. In the original version, Doc brushes off that suggestion, but this time, Zemeckis had Christopher Lloyd falter for a split second now that Doc knows that, in the future he's visited, Marty does indeed become an "asshole."

Dean Cundey credits Zemeckis with not wanting to take the easy way out in his approach to the scene, citing it as one of the greatest challenges in reconstructing these seminal moments from the original movie: "Normally, they could make a duplicate negative of that scene and then tack on what Doc says, except for the fact that Jennifer had been recast. Bob said rather than shooting another scene where she shows up in another time or place, we had to do it shot for shot, so that anybody watching it says, 'Yes, of course, that's the time and place that was captured in the first movie, and I'm just seeing it again.' We looked at every single shot of that scene to reconstruct it, lit it as it had been lit, camera placement, the lenses, everything. It was a testament to the crew that they were paying such close attention because they remembered the problem solving or the setups that we did the first time around."

After Arleta, the company moved to Monrovia, where the exteriors of Jennifer's house were shot. Here Zemeckis also filmed the scene for *Back to the Future Part III* in which Michael J. Fox, dressed in his Western garb, runs to the porch to awaken the sleeping Jennifer with a kiss.

That night, the Tondreau recorded the DeLorean driving down the street to Jennifer's house, where Marty and Doc carry her to the porch. This shot was incorporated into one of Ken Ralston's favorite special effects shots, with a deft merger of miniature model work and physical shooting. Zemeckis turned over the selected take to ILM, where Ralston and camera operator Peter Daulton worked backward to duplicate the moves of the actual DeLorean with a detailed model that would fly down from the skies toward the street. They used a well-placed lamppost as the point where miniature morphed into reality. When the two pieces of film were combined, the action of the car flying, and then landing with the actors getting out, appeared as if it had been captured in a single tracking shot.

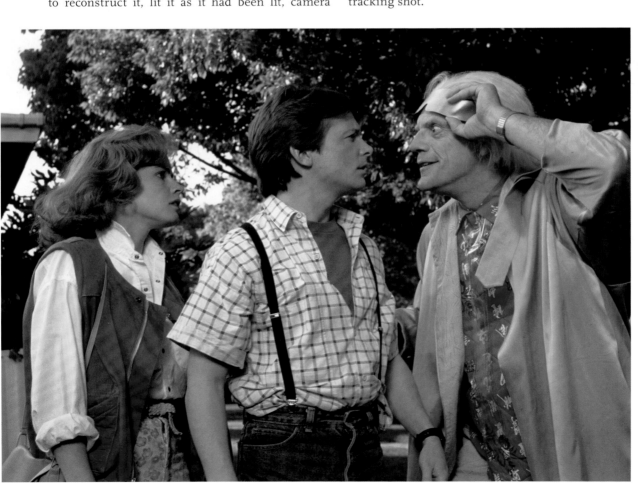

LEFT Fox and Lloyd re-create the final moments of *Back to the Future*, with Elisabeth Shue taking over for the unavailable Claudia Wells.

TOP AND RIGHT Sketches of the futuristic town square by concept artist Ed Verreaux.

ABOVE Futuristic fashion concepts by costume designer Joanna Johnston.

WEEKS 11-12: MAY 8-19, 1989

After two days shooting Doc's Biffhorrific lab on Universal's Stage 14, the production moved into the future: the 2015 courthouse square.

A great deal of the set had been constructed even before filming began on the sequel. "In the middle of November [1988], we started building the future parts of the set on two-thirds of the perimeter of the square," explains Rick Carter. "[In addition to the 1955 piece of the set], we did the courthouse as the Biffhorrific casino. So we started three time periods at once. About four weeks before shooting, we put facades over all the work we'd done on the future—the facades being all these sex parlors, bail bonds, and toxic waste facilities—and then trashed the place. After we shot the Biff part, we had eight weeks to finish the future, and there was no break. We worked flat out. There must have been 150 people out there working at the same time." The biggest change was the excavation of a sixty-by-eighty-foot section of the parking lot in the middle

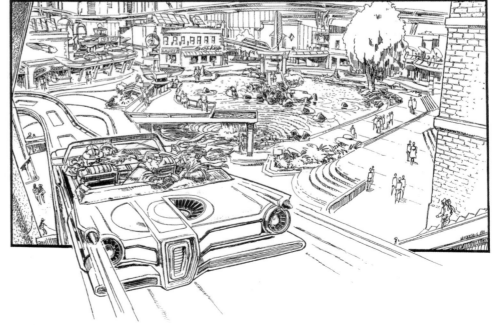

THESE PAGES Costume designer Joanna Johnston created fun, colorful designs for the citizens of Hill Valley 2015.

of the square that would be filled with more than eighty thousand gallons of water to make a peaceful pond for the centerpiece of this optimistic future.

Dozens of extras were fitted in Joanna Johnston's colorful, avant-garde costumes and placed strategically throughout the set. After numerous discussions with Zemeckis, Johnston embraced his vision for a future that was going to be what he described as "fun and upbeat and lively and funny."

"We also decided that the future was going to be quite sexist," says Johnston. "Men were going to look like men, and women were going to look like women." She also cites Japanese fashion as a major influence on her designs, as that was a prominent movement at the time.

Johnston worked in close collaboration with the art department for the look and function- ality of the future wardrobe: "John Bell, Doug Chiang, and Simon Wells and I dove into the future in a brilliant, no-restraint, fun-loving way. The production got actual futurists in to tell us certain things that were going to happen, like the device you're going to wear on your arm that's going to hold your communications and every- thing you need to know. It felt incredibly wacky to us, but we just ran with it. We put retro into it in that we took objects that were really new back then, like CDs, which [we assumed] were going to be completely useless and rubbish in 2015, and turned them into fashion accessories."

For the female police officers, Johnston wanted a sexy look with an additional touch: "I wanted them to have the old-fashioned caps, but I also wanted them to have flashing printout messages like 'Drive safe. Have a good day'—all very upbeat."

Overall, Johnston made use of bright colors but intentionally avoided fluorescents. "I also avoided silver because it was too space-age," she says. "If I did metallics, I used copper and kept it warm tones on the whole." In addition to the costumes for the main cast (which included the unique double tie, an idea Zemeckis came up with), Johnston created close to 150 original outfits for the background players of the future.

To help create the illusion of flight, the futur- istic cars were strategically driven behind objects in a way that allowed ILM to add miniature flying versions in postproduction, much like the shot of the DeLorean landing outside Jennifer's home. For example, a car might be seen driving through the set before disappearing behind a tree. ILM would then film a miniature version of the same car flying into the air and composite it into the shot to create one seamless take. A number of flying cars and floating highway-lane markers were added in postproduction.

The wide shot of the new, improved town square was finished in one shooting day, after which the company moved into the Cafe 80's set. "That was an idea that Bob Zemeckis came up with," says Carter. "It was a way of looking at the future that looked back on us, so that everything didn't have to be just about

COLOR YOUR OWN SUIT

91 32c 94A 94B 41Aa 36A 108

31A 31B 93A 34 32A 33 112 31c 109c 93B 41B 32B 98A 41Ab 43 98B

3A 4 2 48A 48B 114 5 103 110 47 46 45
"SPIKE" "GRIFF" "WHITEY" "HECK"

① KIT INCLUDES
REAR END AERO STABILIZER
PACKAGE

② NUMEROUS LIGHTS
(OPTIONAL SUNROOF
SOLAR PANEL?)

③ NEW, "IMPROVED"
CLEAR "AERO BRA"
· HOLDS AIRFLOW
ON THOSE LONG
WEEKEND FLIGHTS

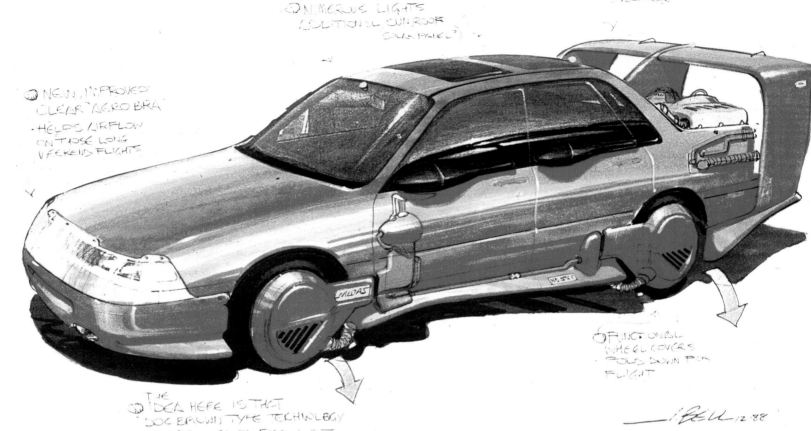

④ FUNCTIONAL
WHEEL COVERS
FOLD DOWN FOR
FLIGHT

⑤ THE IDEA HERE IS THAT
DOC BROWN TYPE TECHNOLOGY
HAS BEEN SIMPLIFIED A BIT
AND MIDAS HAS ADDED
FAIRINGS TO COVER ALL TUBING/WIRING

J Bell 12·88

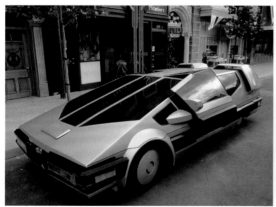

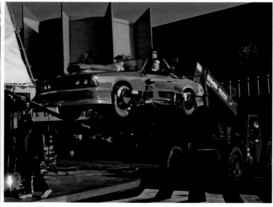

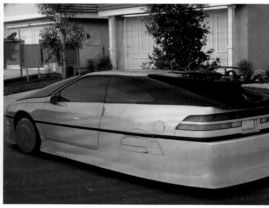

FREEWAY FLYER ①
(GENERIC FORM)

FREEWAY FLYER ③
('89 FIREBIRD CONVERTED)

FREEWAY FLYER ②
('89 MUSTANG CONVERTED)

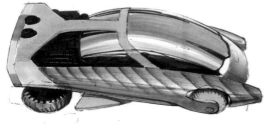

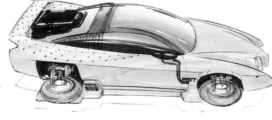

SCHEFFÉ 11/88

brown
RESEARCH

brown
RESEARCH

OPPOSITE John Bell's sketches of the futuristic cars and the finished prop cars that ended up on screen.

TOP Michael Scheffe designed a futuristic research vehicle / mobile lab for Doc, as per early drafts of the script. Following rewrites, it was dropped from the script and never built.

BELOW Mag-Lev sketches by Michael Scheffe.

the future. So that part of it was making reference to ourselves back in the day, asking what really ends up lasting from what we're doing right now that people in the future would care about." In addition to the various graphics and designs imagined by the art department, a dozen video monitors on the back wall played clips of '80s television fare, including *Family Ties* and *Taxi*, which starred Christopher Lloyd.

The inclusion of the exercise bikes was a remnant from an earlier draft in which the cafe was attached to a health club. In the original version, Marty (posing as Marty Jr.) and Biff's grandson Griff were engaged in the futuristic sport of slamball (a mishmash of handball and jai alai), which was played in an antigravity chamber. For Rick

Carter and special effects supervisor Michael Lantieri, this proposed scene was a constant worry looming over their heads. "The ongoing joke between Rick Carter and myself was slamball," says Lantieri. "My first thought was that it was completely undoable, but I also thought we would never have time to shoot it, even if we figured out how to build it. Rick and I kind of hung back, smiling, saying, 'Okay, we're working on it,' and in the back of our minds we just thought we were goners if it didn't go away." Lantieri's instincts proved right, and the sequence was finally deemed far too costly and time-consuming to accomplish.

In Cafe 80's, audiences were also introduced to an eight-year-old boy who would grow up to become

RETRO-FIT
MAG-LEV 1

RETRO-FIT
MAG-LEV 2

the star of his own blockbuster trilogy. Elijah Wood, aka Frodo Baggins from the *Lord of the Rings* films, made his screen debut as "Video Arcade Boy 1," who is less than impressed with the arcade games of the 1980s.

"I have pretty vivid memories of the process," says Wood. "It was only two days of work, but I had grown up watching the original film, so the environment, the town center of Hill Valley, was very familiar to me. It blew my mind on a couple of levels. One, I was going to be in the sequel to this film that I loved. My experience as an actor up until that point had just been a number of commercials and a Paula Abdul music video, so the idea of being in a film and then it being this cultural behemoth was not completely lost on me. I think I understood the significance of it. Michael J. Fox was very friendly with both myself and the other boy [Robert Thornton] who was my counterpart. The wardrobe I was in obviously was very futuristic, but then it had like a retrofit colander as a hat, which was sort of crazy. The whole thing was kind of like a fantasy come to life in front of me.

It was like a kid being let loose in an amusement park, so surreal and filled with eye candy."

Cafe 80's served as the only location for week 12, with a great deal of focus on the newest member of the Tannen family. Like his grandfather, Griff had his own posse, comprising Data (Ricky Dean Logan), Whitey (Jason Scott Lee), and Spike (Darlene Vogel).

The entire week was devoted to the scene in which Marty refuses to take part in Griff's "opportunity" and the complications that arise with the unexpected arrival of Marty Jr. Shooting the scene was Tondreau-intensive and not made any easier by an early wrap on the first day due to heavy rains that darkened the skies, resulting in the outdoor light failing to match the footage already shot.

OPPOSITE Cafe 80's design sketches by John Bell.

ABOVE Cafe 80's design by Ed Eyth.

LEFT Actors E. Casanova Evans and Jay Koch gave life to the *Max Headroom*–inspired video waiters.

BELOW LEFT Elijah Wood (pictured with Fox and Robert Thornton) expresses his disdain for Marty's favorite '80s arcade game.

BELOW RIGHT Marty finds that artifacts from his own present time have become "retro" as he enters the Cafe 80's.

MCFLYBOY

BOTTOM VIEW

TOP VIEW

THIS PAGE Over the course of two years, John Bell designed a variety of hoverboards for Marty, Griff, and Griff's gang.

OPPOSITE Fox holds the final hoverboard prop.

WEEKS 13–15: MAY 22–JUNE 9, 1989

In 1986, when ILM's John Bell heard there was to be a sequel to *Back to the Future*, the first thing he was told about the project was "it's thirty years in the future, and there's something called 'hoverboards.'" Bell was told to sketch whatever came to mind. "In the first drawing I did, the hoverboard was round, and it had two jet-engine-type fans on the bottom of it," he says. "I was a big fan of the Japanese comic book *Akira*. They had some great designs in there, so I was riffing off some of the things being done and applying senses of them into a hoverboard design. I ended up doing about thirty different drawings at the time." Marty's hoverboard originally sported a Swatch logo. "Swatch was such a popular brand at the time, so I began with them," says Bell.

The hoverboard chase was one of the most planned, storyboarded, and rehearsed segments of the entire film. On screen, the sequence is less than three minutes, but it took three full weeks to shoot. Robert Zemeckis came at the sequence with the mindset that hoverboards actually existed, and all he would be doing is shooting an exciting chase. He detailed his ideas to his storyboard artist David Jonas and then distributed the sketches to the department heads whose job it was to make the improbable a reality. Rick Carter would come to describe the challenges presented by Zemeckis as "insurmountable opportunities."

If there is one word that sums up how the chase was conceived, it would be *misdirection*. The team worked out how to film each shot in a unique way. By mixing up the myriad methods, the audience would never see the same approach twice, and thus would be unable to figure out how the trick was accomplished.

Special effects supervisor Michael Lantieri estimates that over sixty different hoverboards were built to be used in a wide number of ways. Prior to shooting, he and Fox's stunt double, Charlie Croughwell, had gone searching for flying harnesses, which they found collecting dust in a storage attic on the Disney lot. "We found the harnesses that

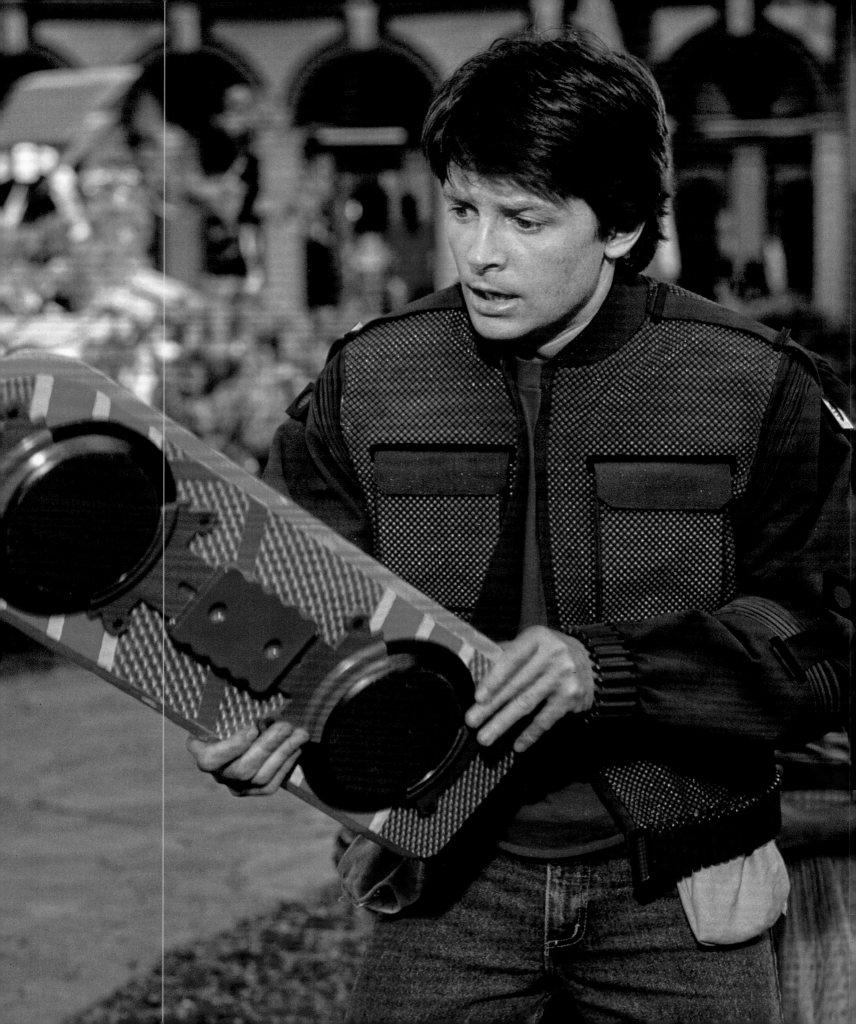

had been used in the original version of *The Absent-Minded Professor* from 1961," relates Croughwell, "which were basically a pair of jeans that had been cut off and a plate attached to the side. I got into those things, and it cut off the circulation to my legs in a minute. I knew they weren't going to work."

They next went to stuntman R. L. Tolbert, who had built the first modern flying harness. They worked together to design a new device that would be tolerable for long periods of time while worn by a performer. The actors were brought to Max Kleven's ranch to learn the basics of wirework and how to control the boards.

The team developed a number of ways to create the illusion of flight, but some were rejected. Recalls Lantieri, "A real simple thing we found out when we put flying harnesses on the people and attached the boards to their feet, it didn't look like the board was lifting the person. It looked like the person was lifting the board. Bob Z. and I saw it right away." Lantieri quickly solved the problem by attaching the wires to the board itself, so when it was lifted, it lifted the person on top of it. "You could see the pressure on their legs or on their knees as it really would be. It was a matter of physics."

For the first shot in which Marty takes off on the hoverboard, Michael Lantieri was able to make the device actually hover. He placed rare earth magnets (capable of attracting up to six-hundred pounds) in three places: in Marty's shoes, on the underside of the hoverboard, and in

the ground beneath the board. The magnets from the board and ground were at opposite poles and thus repelled. By attaching very thin wires to the sides of the board, Lantieri was able to keep the board in place as it hovered between the magnets. When Charlie Croughwell was swung onto the hoverboard via a crane, the magnets in the shoes connected with those in the board, and he continued out of frame.

For wider shots, the actors' harnesses were attached to a special rig suspended from a crane. The rig was equipped with individual steering wheels for each rider that were controlled by special effects technicians strapped on the top more than one-hundred feet in the air. When Griff and his gang chased Marty, there were a total of eight people on the rig: the four actors and their personal handlers who used the steering wheels to guide the direction of the boards as the crane swung them into action.

Michael J. Fox spent his fair share of time suspended in the harness, running, flying, and swinging his way through various pieces of the action. For one shot, Fox was fitted in the harness with his Nikes actually screwed into the hoverboard. The sequence began with Fox anchored on a dolly attached to a jeep driven by stunt coordinator Walter Scott. The camera started on Fox's free hands, and as it panned down to his feet, he was lifted by the crane, and the dolly under his feet was removed to give the appearance that he was hovering on the board.

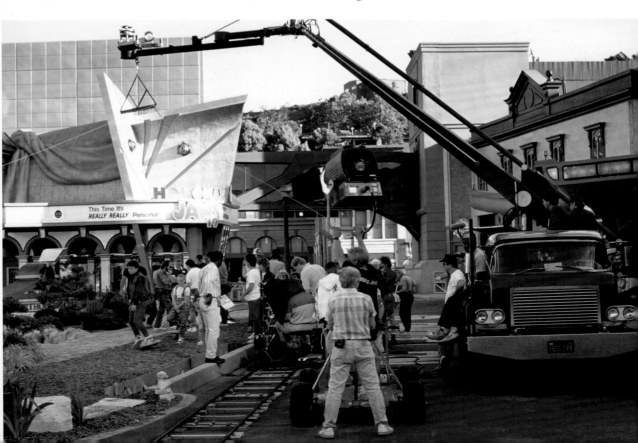

The experience prompted Fox to concoct a new nickname for Zemeckis: "Cardinal Richelieu," a reference to all the torturous contraptions and body contortions the director required his actor to endure. Despite some temporary discomfort, Fox was game. Just as he wanted audiences to know it was him playing the guitar for the "Johnny B. Goode" scene, he wanted them to know it was him in the action scenes: "When something's happening, and you turn and look towards the camera, and it's undeniably and unmistakably you, that has a lot of value to the audience, and it adds a lot of credibility to the action sequence. Bob [Z.] and I had an expression we used on the first movie, and it carried on into the sequels: 'Pain is temporary; film is forever.'"

The crew had a three-day weekend for Memorial Day, but when they returned, it was without their star. Michael J. Fox took five days off, as his wife, actress Tracy Pollan, had given birth to their first child, Sam Michael Fox.

Even without Fox, the company had enough work to keep busy, shooting Griff and his gang in pursuit of Marty, with Charlie Croughwell filling in for the proud new father.

Upon his return, Fox finished his part of the sequence with a dip in the courthouse square pond. Then the footage was shipped to ILM, where the visual effects artists began the painstaking process of removing the wires from the scene.

The hoverboard sequence was one of the most talked about highlights of the final film. "We created this device and made it so realistic that people said, 'I gotta have one of those. Hoverboards are the coolest thing ever!'" says Dean Cundey. "It attests to how much care and creativity we put into those moments in the film that have continued to intrigue generations of people."

BELOW Michael J. Fox poses with (left to right) photo double Kevin Holloway, stand-in Robert Bennett, and stunt double Charlie Croughwell.

THESE PAGES Shooting the hoverboard scene with special effects supervisor Michael Lantieri (opposite top left), stunt coordinator Walter Scott (opposite center), and special effects foreman Donald Elliot (opposite bottom).

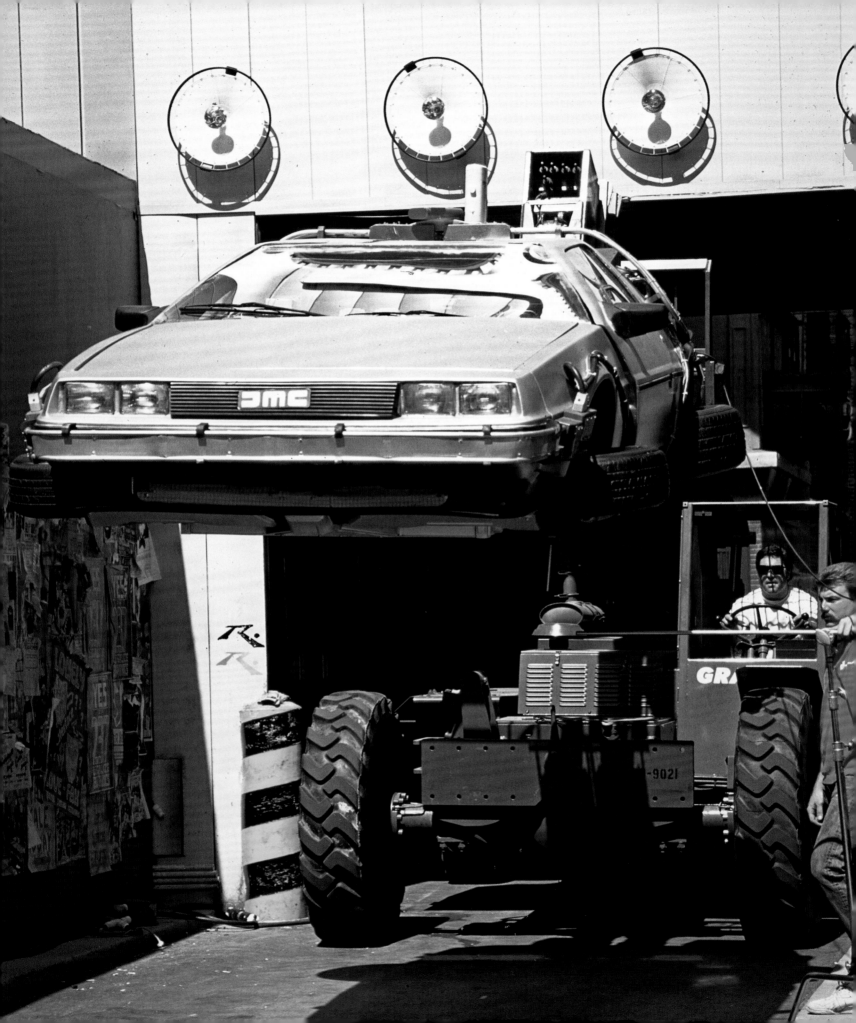

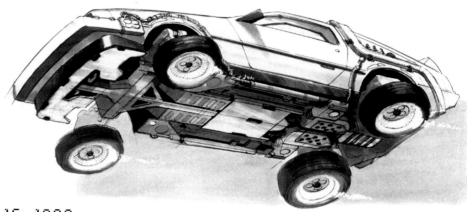

WEEK 16: JUNE 12–16, 1989

Still filming in the future, the production shot the DeLorean landing in the alley adjacent to the town square. Another inventive collaboration between production designer Carter and special effects supervisor Michael Lantieri resulted in a novel way to simulate the vehicle's descent. Carter had designed the set with a black gap where two alley walls are joined, and the space was filled with brushes as one might find in a car wash. A full-sized fiberglass DeLorean was attached to a crane arm, and as the crane arm lowered the car to the ground, the brushes closed around it, hiding the mechanism.

A number of special effects would come into play during the week. Both Marty's size-adjusting jacket and power-lacing Nikes were accomplished by Michael Lantieri's special effects crew. For the Nikes,

a raised platform was built to match the pavement. A series of wires went up through the platform, attached to the shoes. Lantieri and his technicians lay flat on the ground under the camera, and when Fox slipped his foot in each shoe, the wires were pulled tight and the blue Nike logo illuminated. A similar rig was devised to adjust Marty's jacket size.

Costume designer Joanna Johnston had worked closely with Nike on the designs, starting with her original query to them: What would a shoe look like thirty years in the future? A team was assembled to explore that question, led by top designer Tinker Hatfield and including Mark Parker, then a VP of products (currently the company's CEO). The Nike team flew down to Southern California and met with Zemeckis, Gale, and

OPPOSITE A forklift is used to move one of the fiberglass DeLoreans to the 2015 square.

TOP LEFT The crew prepares to film the DeLorean's alley landing.

TOP RIGHT Concept art by John Bell detailing the underside of the DeLorean.

BELOW Ed Verreaux's sketch of the futuristic alley.

BTTF II ALLEYWAY...

12/5/88

VERREAUX 88

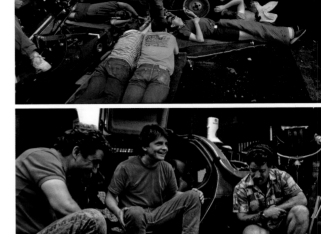

Johnston, who gave them background on the story and the future concepts they would explore. Hatfield eventually came back with the idea for a shoe they dubbed the "Nike Mag," as well as the idea for the jacket that would adjust to the person wearing it.

"When we started thinking about the future, my first inclination was to design a shoe that had a unique look to it," says Hatfield, "but as we thought a little further out and what could be available thirty years down the road, the possibilities were wide open. We liked the idea of a future shoe being really active, literally waking up. So we wanted to light it up and eventually came to the idea of the shoe lacing itself, fitting the foot perfectly."

For the 1985 scenes in the original *Back to the Future*, Christopher Lloyd underwent the application of prosthetics so he would more closely resemble a man in his midsixties. Although the process was uncomfortable and took approximately three hours to accomplish, Lloyd never objected. "I'm willing to put up with whatever it takes to get me there," he says. "If you don't feel you look right, it takes away from your enthusiasm." Even though Lloyd didn't mind the prosthetics, Gale and Zemeckis gave him one moment in *Part II* that would allow him to remain prosthetics-free for the rest of the trilogy. In detailing to Marty the cosmetic and health treatments available in the future, Doc removes the thin mask to reveal his newly rejuvenated face. "We had him specifically say that the process added decades to his life so that when he ends up with Clara, the audience knows they will have many happy years together," says Gale. But in order for him to stay out of prosthetics, Lloyd would have to have them applied one more time. In preparing for the scene, Lloyd admits being nervous about getting it right. "I had all kinds of trepidation about it because it's pretty thin stuff, and it could tear pretty easily," he explains. "Then, you'd have to do it all over again, which meant at least another two or three hours putting on another layer. I had to talk during it,

a lot of hyperenergized stuff to say when I was taking it off. The odds were not great."

If there was to be another take, production wanted to make use of the time it would take to get Lloyd back into makeup, so a contingency Tondreau shot of the DeLorean was put on the call sheet in the event another take was required. Thankfully, Lloyd got it right the first time. "I remember catching a piece of it and keeping my mouth moving, and it came off in one piece," says Lloyd. "I don't think Bob Zemeckis ever expected that."

For the last two days of main unit work, the team returned to Stage 27 and the Tondreau to shoot Marty hiding in the back seat of Biff's convertible, while the elder Biff gives his younger self the sports almanac. In order to pass the book across the split line, Tom Wilson had to put it onto a mechanical rig that moved the almanac to the passenger side in sync with the camera. Thus, the movement of the book could be perfectly duplicated for the B side of the shot.

While the first unit toiled on stage, Max Kleven and the second unit were in future square, preparing for the finale of the hoverboard chase when Griff and his gang go careening through the courthouse windows. The stunt had been carefully choreographed and successfully rehearsed several days prior and stunt performers David Rowden (Griff), Gary Morgan (Data), Richie Gaona (Whitey), and Cheryl Wheeler-Dixon (Spike) climbed into their harnesses and were hoisted into position. They would be pulled back from a device called an arbor to which their wires were attached. The arbor would, in turn, be attached to a cherry-picker crane that would hoist the four of them into the air. They would then be swung toward the courthouse between the two pillars, and as they crashed through the candy glass windows, a technician would hit a button releasing them to fall to the stunt pads below.

In an online blog, stuntwoman Cheryl Wheeler-Dixon recalls how the stunt went amiss: "As we traveled towards the window, we started listing to the left. I was on the far left to begin with, so when we started listing to the left, I realized that I was going to hit the left pillar. Cabled, with no control and nowhere to go, I simply brought my knees and feet up and tried to soften the blow of the pillar when I hit it."

Wheeler-Dixon goes on to explain that by hitting the pillar, when the other stuntmen crashed through the windows, the cables were released. The three men made it to the stunt pads, but the pillar had stopped Wheeler-Dixon's momentum, and when she dropped, it was a twenty-foot fall to the concrete below. Wheeler-Dixon suffered a severe concussion and broke several bones in her face and right arm. She was hospitalized for several weeks and later endured a number of reconstructive surgeries. To this day, Wheeler-Dixon credits the custom harness originally made for Michael J. Fox for protecting her from a broken back and/or hips.

Speaking about the incident twenty-five years later, Wheeler-Dixon insists she has no ill feelings toward the production and actually remembers the time prior to the accident being a fun experience, with her final thought being, "Man, I would really like to have a hoverboard."

ABOVE John Bell's concept art for the look of futuristic Marty and the female gang member who would later be renamed Spike.

BELOW LEFT Still photography captures the gang's arrest.

BELOW RIGHT Costume designer Joanna Johnson (center) poses with Griff's loyal minions, played by Ricky Dean Logan, Jason Scott Lee, and Darlene Vogel.

WEEK 17: JUNE 19-23, 1989

After a rare non-Tondreau day in Biff's garage, the company wrapped on Stage 27 and returned to future square. Michael Lantieri and his crew were called upon to activate the blow-dry function on Marty's future jacket as he emerges from his dip in the pond. "That was one of our toughest gags," states Lantieri. "Bob came to me on the day of [shooting] and said, 'I want him to walk up the stairs, across the edge of the lake in one shot, and have the jacket work.' Which meant we had to crawl below Michael, and when he hit his marks, plug-in cables, a hose, and wires and make the effect work." Fortunately, Fox was always willing to lend a hand to make the crew's job easier. "We could always ask him, 'When you hit your mark, if you can remember to do a little turn to the left . . .' He was great and always helped out."

BELOW The tunnel chase featured ILM's first-ever CGI shot: the digital removal of a pipe attached from the shooting rig to the hoverboard.

RIGHT Before the chase scene is shot, the production team makes a very short tunnel appear to be extremely long.

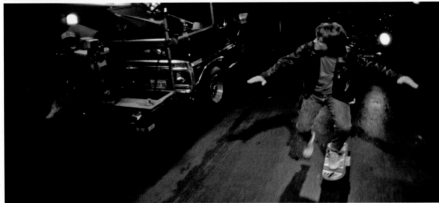

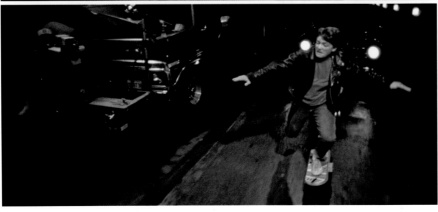

WEEK 18: JUNE 26-30, 1989

Earlier in the schedule, Max Kleven and the second unit had filmed major pieces of the tunnel chase. Now it was Zemeckis's turn to return to the Griffith Park location he had used as the link between 1940s Los Angeles and Toontown in *Who Framed Roger Rabbit*. What made the tunnel an ideal location was the privacy and control it afforded the production. Once the park closed to the public at 6:00 p.m., there would be no curious onlookers or traffic to direct around the filming.

The tunnel leads from a Los Feliz neighborhood into the hills toward the famed Griffith Park Observatory. Audiences who have only seen it on the screen may not realize that it's a relatively short 328 feet. To give the appearance of additional length, various tricks were devised. Before dusk, both ends of the tunnel were tented, with forced perspective backings in place to provide the illusion that the tunnel was much longer than it was. When filming at one end, the crew arranged the lights that ran through the tunnel so that they were closer together toward the far end, tapering off to a distant point, and thereby giving the appearance that the tunnel was longer.

To capture the hoverboard scenes, Michael J. Fox utilized a number of harnesses, flying rigs, dollies, and even a real skateboard so that Zemeckis could again shoot the segments in a myriad of ways to prevent the audience from figuring out how the effects were achieved.

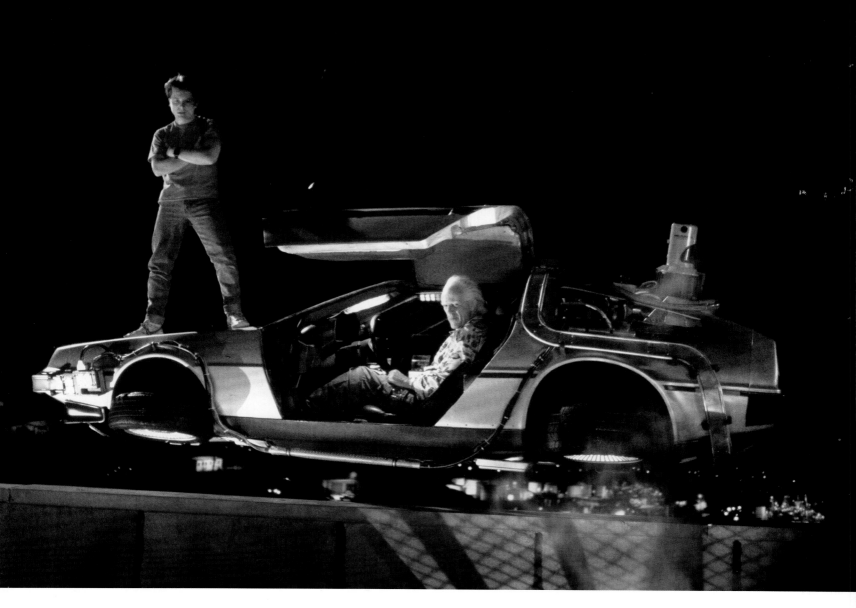

ABOVE On Stage 12, the fiberglass DeLorean was suspended by wires and lifted by a crane for the scene in which Marty escapes from the roof of Biff's casino.

WEEK 19: JULY 3-7, 1989

On Stage 12, the roof of Biff's Pleasure Paradise had been constructed for the scene in which Tannen reveals himself as George McFly's killer and forces Marty to leap from the roof, only to be saved by Doc in the flying DeLorean. Once again, the fiberglass DeLorean was levitated with the use of a large crane. The company took one day off to celebrate the Fourth of July and continued the scene on July 5.

Wilmington, California, was chosen as the location for Oak Park Cemetery, where Marty discovers George's grave and Doc comes to retrieve his young friend. Wilmington is home to a number of oil refineries and was the perfect background for Biff Tannen's altered reality. It was not, however, the perfect location for anyone with respiratory problems. Noxious fumes from the refineries permeated the area, and crew members were forced to wear air filtration masks.

WEEKS 20-21: JULY 10-21, 1989

Over the weekend, the roof of Tannen's hotel/casino morphed into the rooftop of Hill Valley High School, where Marty tells the waiting Doc that he's lost the almanac yet again.

Then, it was a quick move out to Universal's Colonial Street (aka the *Leave It to Beaver* street), where the disguised Marty spies on Biff's house, the rest of the sequence having been previously filmed in Pasadena.

With the end of shooting on *Back to the Future Part II* approaching, it was time for the mandatory process shooting on Stage 27. For the balance of this two-week period, a combination of blue screen and rear projection techniques were utilized as Christopher Lloyd, Michael J. Fox, Tom Wilson, and Elisabeth Shue all took turns inside the DeLorean, reacting to the external mayhem.

WEEKS 22-23:
JULY 24-AUGUST 1, 1989

After one more day of process work on Stage 27, the company moved back to Stage 12, where they would remain until the end of the schedule.

All of the remaining scenes took place in 1955 at the same location: the Lyon Estates billboard that had been filmed on a stretch of highway in Chino for the original film. Because the scenes were set at night and required special effects, the location was re-created indoors.

Michael J. Fox had wrapped up his duties on *Family Ties* and was now available on a full-time basis. With the work contained on the stage, the production was afforded the luxury of working normal hours, as opposed to the all-nighters that had been considered the norm.

For the final three days, the call sheet advised the crew to "bring rain gear!" Lightning effects on the stage were triggered along with rain towers that unleashed a torrential downpour that enveloped the stage as a car drove into the action. Its driver, a Western Union agent with a seventy-year-old message from Doc, was portrayed by comedic actor Joe Flaherty, who was well acquainted with Zemeckis and Gale. They first met in 1979, when Steven Spielberg cast Flaherty in *1941*. Later that year, Zemeckis gave him a featured role in *Used Cars*.

Michael Lantieri was tasked with a number of challenges for the scene. Before the rains, a bolt of lightning had to strike a tree next to the billboard and sever a branch. "We used a bunch of phosphorus and some graphite on a string [coming from the rafters of the stage down to the precut tree limb]," he says. Fire-safety crews were on hand to make sure that the compound, which burns at a temperature of five-thousand degrees Fahrenheit, could be properly extinguished. Although the scene went without incident, Lantieri had a contingency plan in place: "I already had the stage rigged for the rain. If there had been a problem, all I had to do was hit the valve."

To augment what was on hand, Lantieri ran additional hoses to hydrants more than half a mile away on the other side of the Universal lot. In addition, a water-pumping truck was also brought into the stage. Lantieri was satisfied he would be able to provide the torrential downpour he knew his director was expecting: "I'd already learned that when you ask Bob Zemeckis how big he wants something, the answer is always going to be, 'As big as I can get it!'"

As the crew toweled off, 1st AD David McGiffert called out, "That's a wrap!" There was applause and congratulatory handshakes all around, but there would be no tears, no promises to keep in touch, and certainly no goodbyes. If anything, the prevailing sentiment expressed was "See you in a couple of weeks!"

There was another movie to be made.

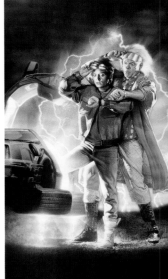

TOP In the last few days of filming *Back to the Future Part II*, the cast and crew gathered for a group photograph.

ABOVE The final art for the *Back to the Future Part II* poster.

OPPOSITE Drew Struzan photographed Fox and Lloyd as reference for *Part II*. Struzan traveled to the set of *Part III* for the photo shoot, as filming had already begun.

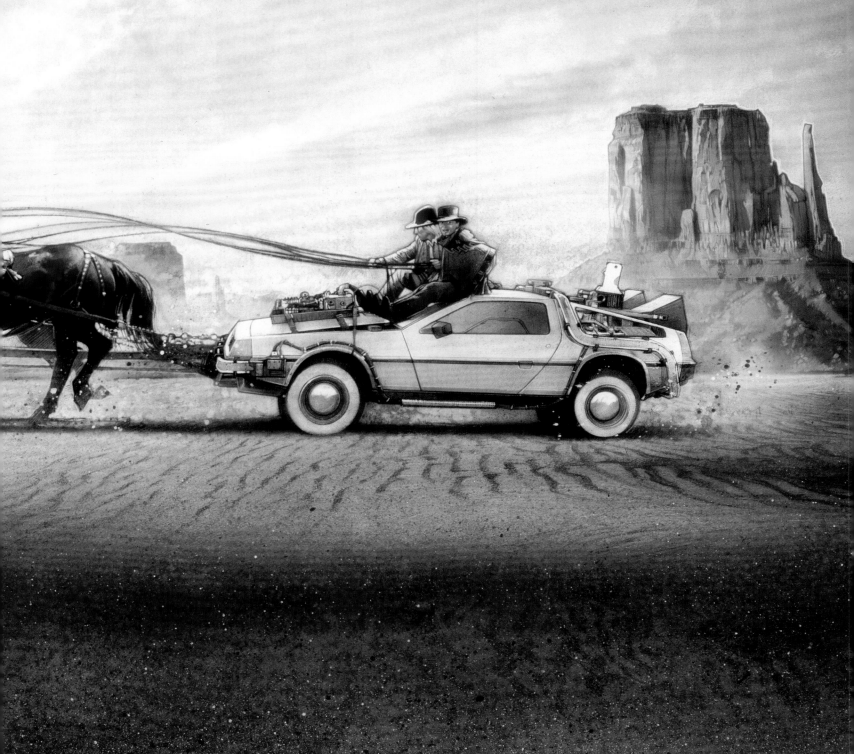

PART THREE

GO WEST

AFTER A BRIEF RESPITE, the cast and crew traveled 350 miles north to Sonora, California, their home for the next several months. It was decided early on that, given the scale that Zemeckis wanted for the Wild West version of Hill Valley, the back lot of Universal Studios wasn't practical. The town that production designer Rick Carter subsequently built covered several acres. "It would have been very difficult to shoot 1885 Hill Valley on the back lot," says Carter, "because even if we built a lot of facades, you couldn't see beyond them to the countryside, which is the way it would have been back then."

The Sonora and Jamestown area already had a distinguished résumé when it came to Westerns. Since the early days of silent film and through present day, the region has been host to more than 225 film and television productions, including such classics as *Santa Fe Trail*, *Rawhide*, *My Little Chickadee*, *High Noon*, and *Pale Rider*.

The filmmakers had previously considered Sonora for the original movie when the skateboard chase involved Marty zipping in front of a speeding locomotive. It was that locomotive—now the pivotal element of the script's third act—that would bring Zemeckis and his team back to the area. The nearby town of Jamestown was the home of the Sierra No. 3 steam engine—originally built in 1891—that, over the years, had been used in films such as *High Noon* and *Pale Rider*. "We knew we had to orient the town around the railroad tracks," says Carter. "We finally found a place, and Bob and Bob said this is it. One of the great things was to be able to see the progression of a Western town in the way we're used to seeing, like in a

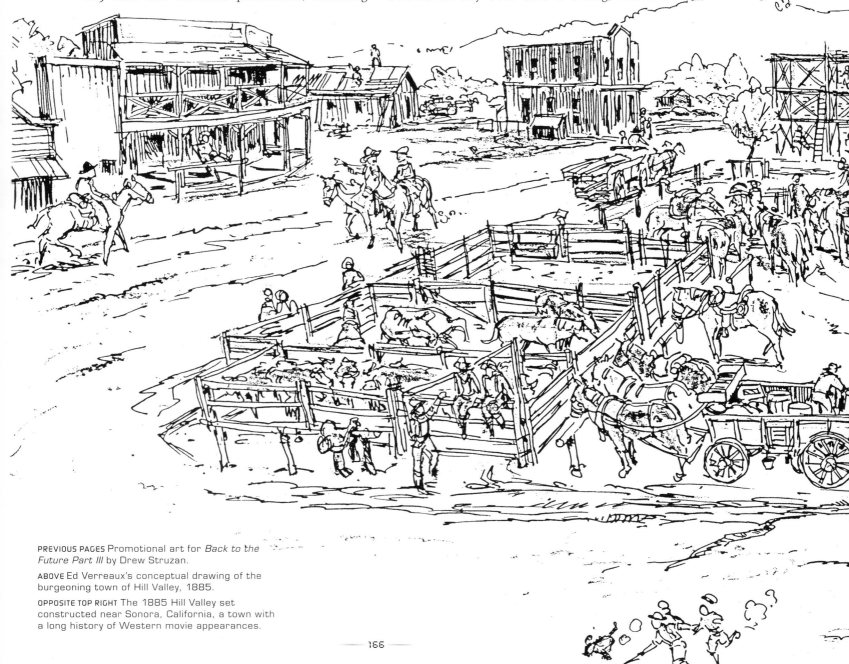

PREVIOUS PAGES Promotional art for *Back to the Future Part III* by Drew Struzan.

ABOVE Ed Verreaux's conceptual drawing of the burgeoning town of Hill Valley, 1885.

OPPOSITE TOP RIGHT The 1885 Hill Valley set constructed near Sonora, California, a town with a long history of Western movie appearances.

Sergio Leone movie, a rougher version that leads all the way up to where the cafe is a saloon, and they're just building the courthouse."

While scouting the location, Zemeckis decided to have a little fun with his friends: "We were laying out the entire scene of the train chase, and at some point, I stopped and, with a complete straight face, said to [David] McGiffert and Max Kleven, 'What would it take for us to get a herd of fifty buffalo in here?' And they're all going, 'I don't know. Yeah, we'll look into it. We need a herd of buffalo.'"

Looking back on the sequels, Zemeckis considers *Back to the Future Part II* to be one of the most interesting movies he has ever made. "I loved it for all the esoteric, weird shit that's in it," he says. He also recalls that he wanted to go back to basics for

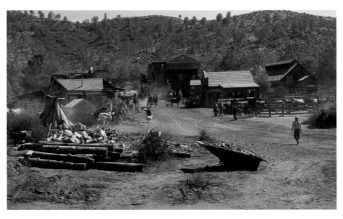

the third installment. "*Back to the Future Part III* was the movie I really wanted to make," he says. "It was basically like *Back to the Future*—a stranger in a strange land. It was an old-fashioned, classic kind of American movie."

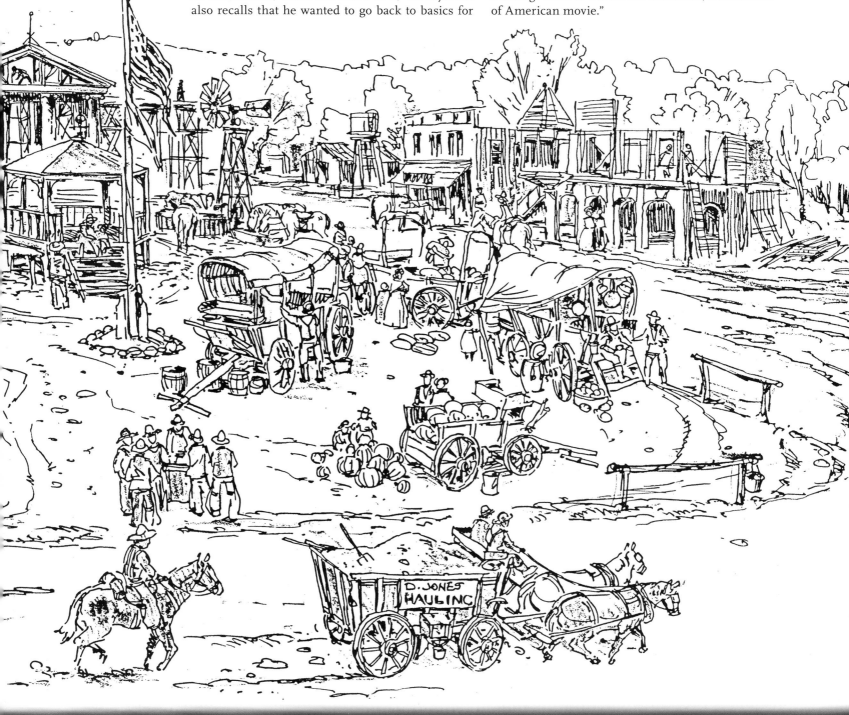

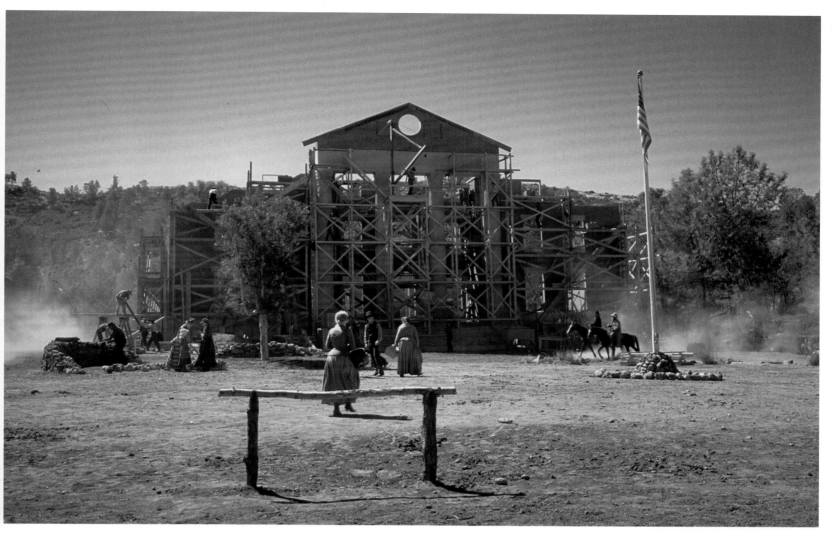

WEEKS 1–2: AUGUST 29– SEPTEMBER 9, 1989

With the move to a distant location, the shooting week expanded to six days, a standard industry practice to minimize the total amount of time the crew would be away from home. As on the first day of filming for *Back to the Future Part II*, Zemeckis began with an ambitious shot, one that captured the entire town in full swing. Beginning on Fox's Nikes plodding along the railroad tracks, the crane-mounted camera pulled back and rose over the roof of the railway station, panning to the full wide shot of Hill Valley, 1885. As the camera rose past Fox's head, the actor had to run several hundred feet through the railway station and out the other side so that he could be seen making his way toward the courthouse just as the camera cleared the roof of the station.

The scene featured 130 extras all dressed by Joanna Johnston. Because the Western outfits she found in the costume houses in L.A. lacked the historical accuracy that both she and Zemeckis demanded, Johnston researched and uncovered original clothing patterns which she and her team used to create new, authentic costumes.

Apart from the DeLorean, there were few notable cars in *Back to the Future Part III*. There were, however, buckboards, wagons, and stagecoaches. The filmmakers also needed horses and lots of them. Veteran trainer Corky Randall was tasked with the transportation, care, and feeding of

OPPOSITE Tom Wilson makes good use of the Western training he underwent in the weeks before filming.

ABOVE Rick Carter was able to build the 1885 version of Hill Valley from the ground up in an area that afforded majestic views of Western landscape.

RIGHT The camera crew uses a go-kart rig that was developed for Zemeckis for the shooting of *Who Framed Roger Rabbit.*

more than ninety horses that were brought to the set in Sonora. The ambitious opening shot made good use of these elements, but it took considerable time after each take to reset everything for the next take. Whereas cars can be easily backed up to their original positions, horses pulling carts don't have a reverse gear, so they had to take a circuitous route to their starting point.

For Zemeckis, one of the advantages of building his own town was the ability to place the buildings where he wanted in order to create the shots exactly as he had conceived them. Likewise, he was thrilled to have Carter build the sets as fully functional, practical edifices featuring both exteriors and interiors. When Michael J. Fox walked through the swinging doors of the saloon from the town exterior, he entered a fully furnished interior set ready to continue the scene. When the camera pointed out the doors and windows, there was a real Western town in the background, not a backdrop.

Inside the saloon, Marty meets an array of colorful characters, including the Western chorus of old-timers seated around a poker table. Zemeckis and Gale seized the opportunity to fill those seats with the faces of some classic Western character actors. Dub Taylor (who also appeared in *Used Cars*), Harry Carey Jr., and Pat Buttram (who provided voice work for *Who Framed Roger Rabbit*) brought decades of experience and Western cred to their roles. The bartender was played by Matt Clark, another veteran of the genre. In between takes, the men shared colorful anecdotes about their legendary films, directors, and costars to a rapt cast and crew.

Even before he had finished *Part II*, Tom Wilson began training for his upcoming turn as Buford "Mad Dog" Tannen. The actor took extensive riding lessons and trained with famed quick-draw artist Arvo Ojala. He also underwent a crash course in roping. Those newly acquired skills came into play during the second week of production, as he and the gang charged out of the saloon in pursuit of a fleeing Marty.

A note on the production report that week mentioned that Fox injured his left hip ("an early sign of Parkinson's," Fox says) during a running scene. The injury recurred a few days later. At the end of the week, Fox filmed the scene in which Marty is strung up by the neck by Tannen in front of the courthouse. In the first few attempts, he stood on a platform with a rope around his neck, leaning into it to make the rope appear taut. "Bob asked me if I could make the swinging motion more natural," says Fox, "and I said, 'Not unless my feet are dangling. But if I put my hand here [on both sides of the rope], I can do it, and you can get that dangling effect.'" Fox was put into a harness by stunt coordinator Walter Scott and suspended by his chest. "I remember saying to Bob, Now you're going to see some acting. Watch this!" On action, Fox inserted his hands on both sides of the rope and his knuckles pressed against the artery in his neck, cutting off the blood. "I knocked myself out," says Fox. Scott saw what was happening and brought him down immediately. "Bob thought I was just doing a really good job," continues Fox, "and I was unconscious for ten seconds at the end of this rope."

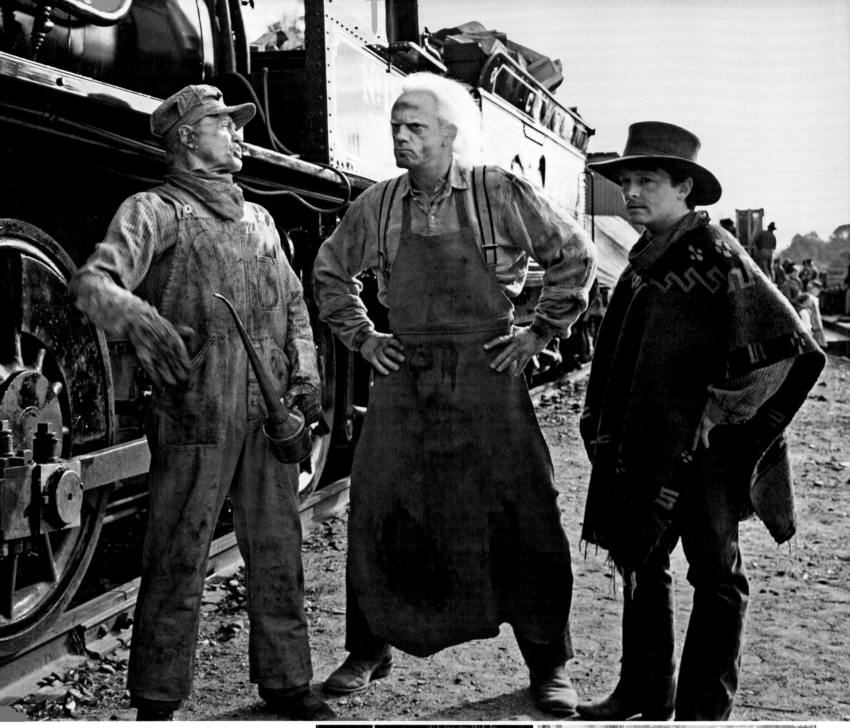

ABOVE Doc and Marty quiz the engineer (Bill McKinney) on the locomotive's potential speed.

OPPOSITE BOTTOM LEFT Michael J. Fox poses with Western film veterans Pat Buttram, Harry Carey Jr., Dub Taylor, and Matt Clark.

OPPOSITE BOTTOM RIGHT Burton Gilliam hawks the Colt Peacemaker at the Hill Valley Festival.

RIGHT Zemeckis allowed some of his crew to play dress up in the film. Script supervisor Marion Tumen appeared as the madam of the Hill Valley saloon.

FAR RIGHT Zemeckis and his "gang," assistant chief lighting director Anthony Wong, key makeup artists Kenny Myers and Michael Mills, and unit publicist (and this book's author) Michael Klastorin.

WEEK 3: SEPTEMBER 11–16, 1989

Michael J. Fox and his stunt double Charlie Croughwell spent the first couple of days of week 3 being dragged around the town by Tannen and his boys. Then it was time for Doc Brown to make his entrance and rescue Marty. This would be the first time in the trilogy that Christopher Lloyd and Tom Wilson share a scene (other than the brief moment when Doc knocks out Biff on the rooftop of Biff's casino). "It was great watching them play off of each other," says Gale. "A good actor makes other actors better, and we had two great actors."

As Doc enters, he cuts a dashing figure, bronzed by the sun and decked out in Western regalia. "Doc Brown is the romantic leading man of *Part III*, so we wanted him to look the part," says Gale. "It's been said that actors love doing Westerns because a man always looks good in those clothes. Bob Z. always loved how great those duster coats made everyone look in *Once Upon a Time in the West* and *The Long Riders*, so that was on his mind when he chose one for Chris. And

his hat was reminiscent of the one Henry Fonda wore in *My Darling Clementine*, a movie from which we borrowed liberally."

The crew moved indoors for the rest of the week for the first of several sequences in Doc's barn/workshop. As with the saloon, Rick Carter had designed the complete structure (both interior and exterior), orienting it just off the courthouse square. Zemeckis wanted to show that Doc had adapted well to his surroundings in the eight months he'd been in 1885, using a gag that recalled the dog-feeding device in the original film. Doc's latest invention—a behemoth machine powered by steam and replete with assorted gauges, switches, and levers—turns out to be a nineteenth-century refrigerator.

Michael Lantieri and his band of technicians were hidden within the machinery, prepared to hit various triggers on cue to activate specific mechanical actions. "They were tricky deals," says Lantieri. "If you got part of the way through and something messed up, you'd have to start the

OPPOSITE Joanna Johnston's design for Marty's "Atomic Cowboy" outfit.

TOP LEFT Stuntman Charlie Croughwell and Michael J. Fox prepare for the potentially dangerous scene where Marty is dragged through the dirt by Mad Dog Tannen.

TOP RIGHT The crew films Mad Dog and his gang's arrival at the courthouse construction site.

RIGHT Joanna Johnston's concept drawing for Marty's boot showcases the level of detail that went into each item of wardrobe.

DOC'S ICE MACHINE

shot all over again. Usually you'd have one, two, or three cues, but here we had ten or twelve different cues, and everything had to be right on time."

Also shot was the scene in which the mayor of Hill Valley calls on Doc. Zemeckis wanted the mayor to be played by one of *Back to the Future*'s biggest fans: President Ronald Reagan, who left office on January 20, 1989. Zemeckis had Universal's chairman Lew Wasserman make the offer to the former president because Wasserman had been Reagan's agent during his acting career. Despite his affection for the first film, Reagan declined. Ultimately, the role went to Hugh Gillin, who had appeared in the director's Academy Award–winning short film at USC.

OPPOSITE Concept art by Joanna Johnston and John Bell for 1955 Doc, and (inset) his classic Western look for 1885.

LEFT Production illustrator Marty Kline's rendering of Doc's ice-making machine.

BELOW Michael Lantieri and his effects crew take their place behind the scenes to operate Doc's ice machine.

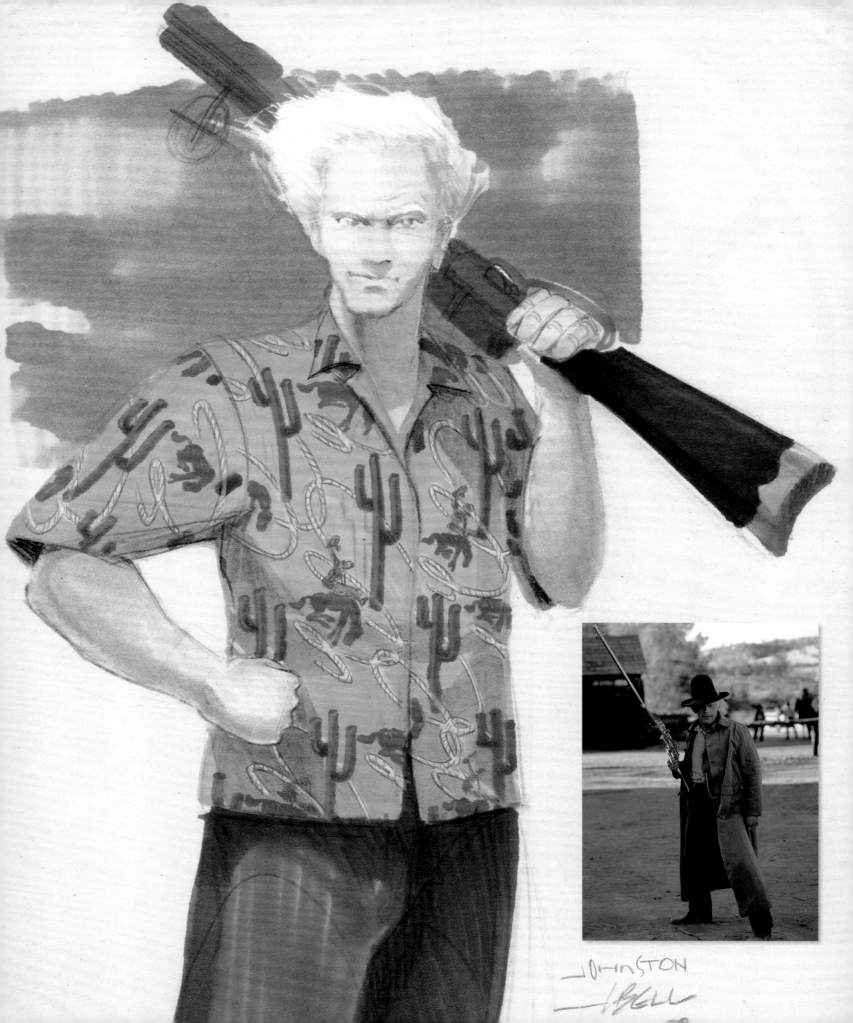

JOHNSTON
I BELL

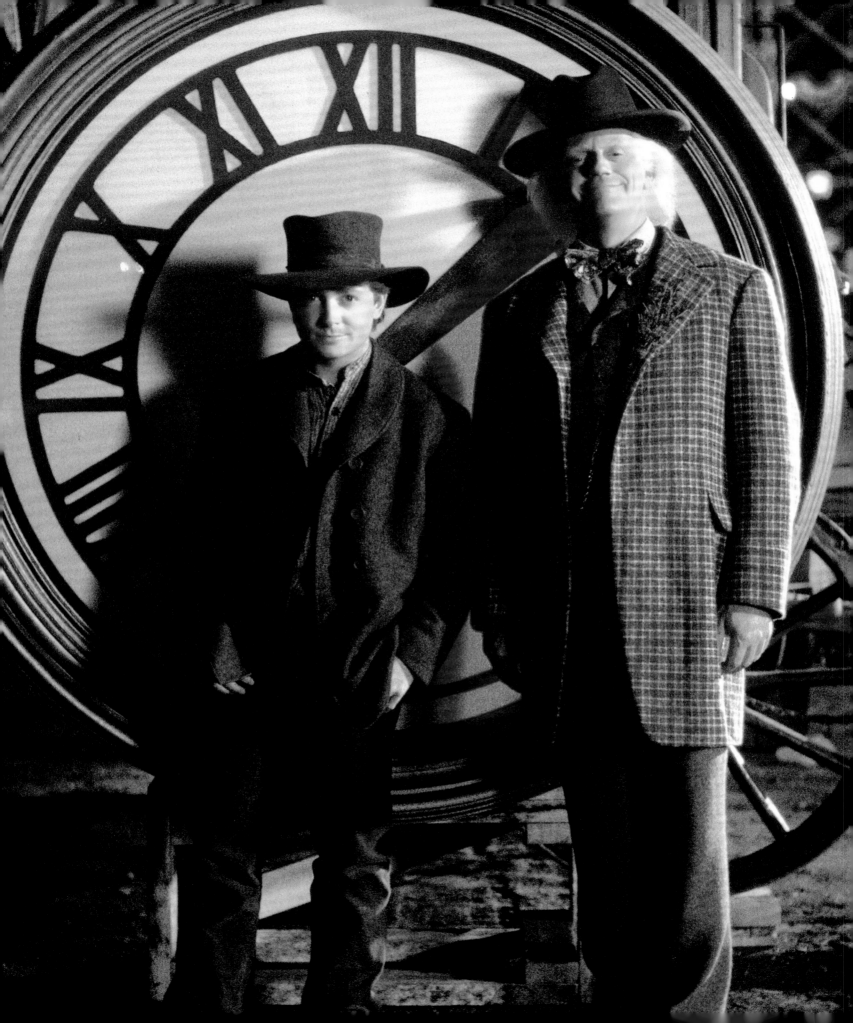

For the next two weeks, the crew went into night mode to film the Hill Valley Festival. The first night featured the return of James Tolkan playing Mr. Strickland's suitably stern ancestor, Marshal James Strickland.

While writing the second film, Bob Gale, with input from Zemeckis, created Doc's love interest, Clara Clayton. In May 1989, they had turned their attention to finding the perfect actress to inhabit the role. "There are some actresses whose faces shout out 'Put me in a period movie,'" says Gale. "Mary Steenburgen had the persona of someone who could fall in love with Doc Brown. She had this accessibility and quirkiness about her. Bob Z. and I had loved Mary in *Melvin and Howard* [for which Steenburgen won the Best Supporting Actress Oscar], and we liked her in *Time After Time*, so we knew Mary in a time-travel movie made sense." In the same way he had known Michael J. Fox was the only choice to play Marty, Zemeckis had the same instinct about Steenburgen. "We never went to another actress," he says. "And we didn't have a plan B. From day one, I loved the idea of her as Clara, and we couldn't think of anybody else."

Steenburgen arrived in Sonora a few days prior to filming to begin rehearsals with Lloyd and choreographer Brad Jeffries. In the film, Marty is taken aback as he watches the duo, marveling, "Doc can dance!" In rehearsals, Christopher Lloyd was not as fleet of foot, and a misstep caused him to bring his partner down. "Chris and I were being kind of overly zealous about our dancing," recalls Steenburgen, "and he went one way, and I went the other, and I tore a ligament in my foot, which made it not quite as much fun over the next few weeks to dance on it." Her leg was wrapped tightly and, luckily for production, was covered by her long dress in the scene.

Before the big dance number was shot, the dedication of the clock was filmed with a cascading backdrop of fireworks—a last-minute request from Zemeckis to Lantieri. The scene went off as per Zemeckis's impromptu revision, but the next day, Lantieri had to go to the Sonora town permit office and beg forgiveness for having unleashed the pyrotechnics without official approval.

When it was time for Marty and Doc to be photographed in front of the clock for a souvenir of their time-traveling adventures, Zemeckis decided that director of photography Dean Cundey was the ideal candidate to play the photographer. After a whirlwind trip to wardrobe, Cundey found himself

OPPOSITE Marty and Doc stand before the clock that has been of key importance in their adventures.

LEFT Director of photography Dean Cundey as the photographer who takes the photo of Doc and Marty.

BELOW Steenburgen performed all of the dance sequences with her ankle taped to protect the torn ligament she suffered in rehearsal.

making his on-screen debut. Also making an appearance was a familiar face from the Old West: Burton Gilliam (*Blazing Saddles*), who played Elmer Johnson, a fast-talking gun salesman who extols the virtues of the Colt Peacemaker.

The next night saw three more visitors arrive in Hill Valley, 1885. The conspicuous trio was wandering the town in awe of what the filmmakers had created, when Zemeckis spotted them and asked Bob Gale who they were. "That's ZZ Top, Bob," said Gale. "You hired them to write the title song."

A big ZZ Top fan, Zemeckis had indeed invited them to the set to discuss some song ideas. "We were in the middle of a tour," recalls lead guitarist and vocalist Billy Gibbons, "and we had a two-day break. Bob and Bob were insistent that we come up there. They said they wanted us to walk the set, get a feel of what's going on to give us a head start on creating the song for them."

"While Bob [Zemeckis] was talking to us, he goes, 'Are those beards real?' We assured him they were, and he said, 'Get them in the picture. I can expand the town band, and we'll save some on makeup!'"

True to his word, Zemeckis got the props department to find two aged acoustic guitars and

an old marching drum from the turn of the century. The set carpenters took the instruments and made some modifications to enable them to spin, a trademark of the band since they had first performed the move in their classic 1984 "Legs" video.

The planned thirty-minute meeting turned into two full nights of filming, with ZZ Top entertaining the cast and crew between setups as they jammed with the local festival musicians. "At one point, there was a problem with one of the cameras, which stopped filming for a while," says Gibbons. "We started knocking around, doodling and playing. I finally looked up at Zemeckis, and he was standing there grinning. I said, 'Hey, Bob, how long does it take to fix one of these cameras?' He said, 'It's been fixed a half hour ago. We just like hearing you play.'"

After filming, the band headed to the studio to work on their contribution to the film. "We

submitted a couple of songs, and of course, the one that was selected was the one we thought was going to be rejected," explains Gibbons. "It was *Back to the Future Part III*, but the song was titled 'Doubleback.' We went back in the studio, and I changed it to 'Doubleback Again' to make it a three. Then we all got into an argument. They said, 'If you double back again, doesn't that make it four?'"

With the main cast members already established, the family was completed when Lea Thompson rejoined the company. For the first time in the series, Thompson would play a character who was not a blood relation of the McFlys. In trying to explain why she would look like Marty's mom, Zemeckis and Gale theorized that the McFly men were inherently attracted to women who look like Lea Thompson. But Neil Canton summed it up best: "She's there because she's in [the first movie] and *Part II*, so she just has to be there."

No matter what the explanation, the actress was happy to be back, although a tad disappointed she wouldn't have as much to do as in the preceding films. "I realized that I was going to have to wait a month between scenes," she says. "I felt like all my friends were playing, and I didn't get to play that much, but I do love Westerns." For their roles as Irish immigrants Maggie and Seamus McFly, both Thompson and Fox spent time with dialect coach Tim Monich. "I thought I did a pretty good accent," she comments, "but no matter how well you do, some people are going to be like, 'That's terrible.' There's no way to please people when you're doing accents, ever."

While the entire cast and crew were happy to see Thompson, she also heralded the return of the dreaded Tondreau camera system. Over the first nights of Tondreau filming, rain caused delays, with the machinery needing immediate cover from the elements. Fortunately, the rains weren't heavy enough to send the production scrambling to a cover set, and before the night was over, Fox and Thompson had finished their exterior scenes together.

For the last night of the shooting week, Doc Brown shared a romantic moment under the stars with Clara. When Zemeckis and Gale first told Lloyd what was in store for Doc in *Part III*, he recalls his reaction. "I didn't feel badly about it," he laughs. In the early morning hours, Lloyd shared his first on-screen kiss with Steenburgen. It didn't hurt that he had known Steenburgen for a number of years and admits upon their first meeting to have been "somewhat infatuated with her. We never had a date, but the chemistry between us was perfect, and the scene needed that."

After the completion of the elaborate Hill Valley Festival, the crew was finished with the majority of the night shooting in Sonora. After so much time on sound stages enmeshed in technology for *Back to the Future Part II*, the cast and crew enjoyed their time in the great outdoors. "It almost felt like a vacation," says Zemeckis. "There were no vehicles. The basecamp was far away, and you had to get there on an electric cart. There were horses and livestock. It was like camping out. I remember the quiet. And I realized why directors wanted to make Westerns—it's peaceful."

OPPOSITE TOP LEFT Marty Kline's rendering of the Colt Peacemaker display at the Hill Valley Festival.

OPPOSITE TOP RIGHT James Tolkan as Hill Valley's first disciplinarian, Marshal Strickland.

OPPOSITE CENTER Michael J. Fox with last-minute additions to the cast, ZZ Top: Dusty Hill, Frank Beard, and Billy Gibbons.

ABOVE Lea Thompson makes her first filmed appearance at the festival as Marty runs into his ancestor, Seamus McFly, and his wife, Maggie; the resulting image is the final product of the Tondreau system.

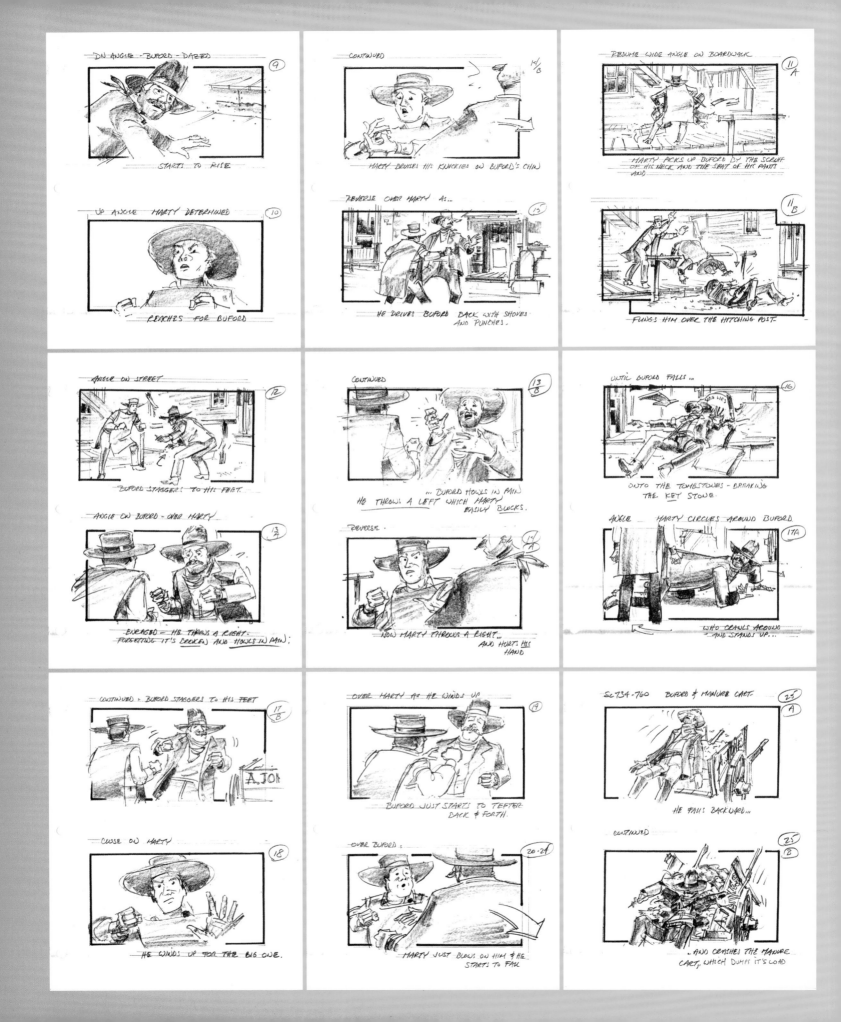

WEEKS 6-7: OCTOBER 2-14, 1989

The showdown between Marty McFly and Buford "Mad Dog" Tannen occupied the next two weeks, along with numerous Tondreau shots of Marty and Seamus, plus the heartbroken Doc regaling the saloon crowd with tales of the future and the effects of his rather extreme drinking problem. In the original production draft, Doc had imbibed many shots of alcohol by the time Marty arrived, but Zemeckis thought it more in character for Doc to be a teetotaler.

The final confrontation between the earliest Tannen and the most recent McFly took several days to shoot, with actor Tom Wilson once again getting a face full of manure, this time a combination of peat moss, alfalfa pellets, and food coloring.

Mary Steenburgen filmed her departure from Hill Valley wearing Clara's signature purple dress, created by Joanna Johnston. "That purple was a very fashionable color in the second part

OPPOSITE Storyboards by Marty Kline for the final showdown between Marty and Mad Dog Tannen.

BELOW Cameras roll as Marty battles another member of the Tannen bloodline.

RIGHT Mad Dog gets covered in manure, beginning a long Tannen family tradition.

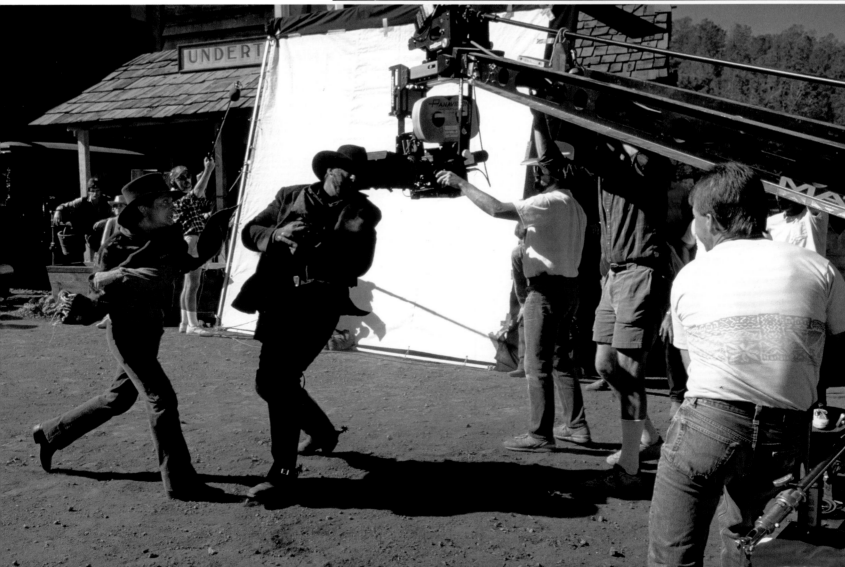

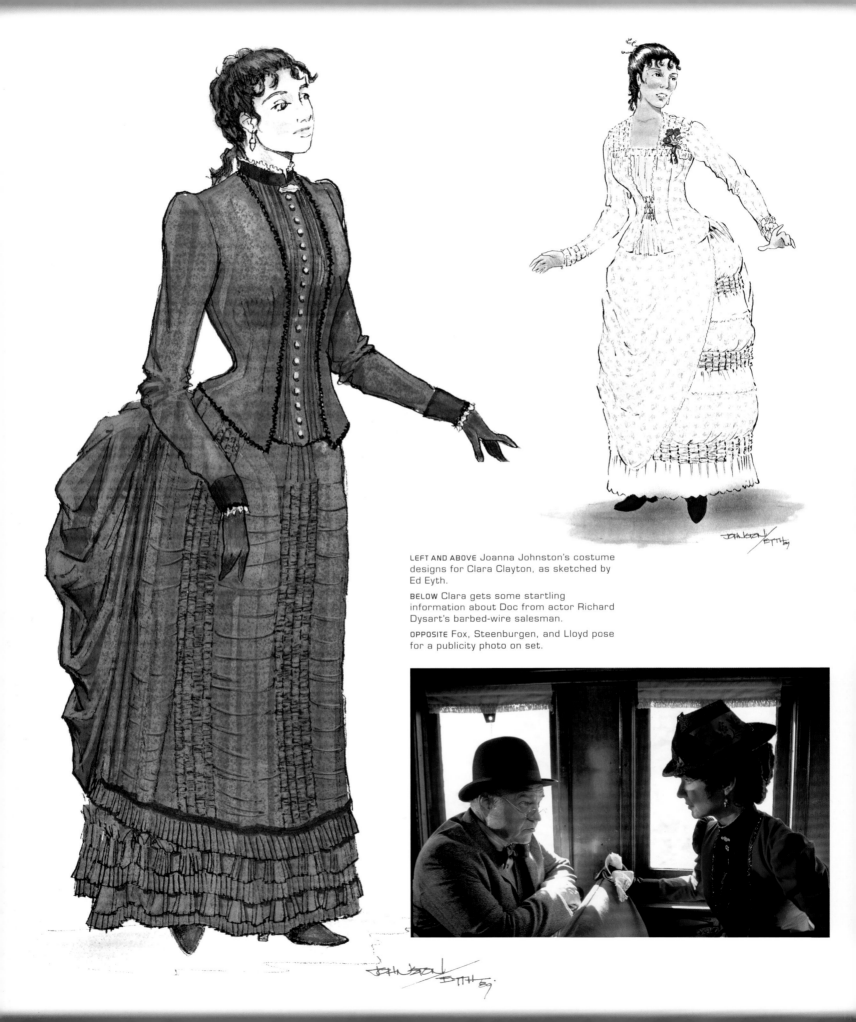

LEFT AND ABOVE Joanna Johnston's costume designs for Clara Clayton, as sketched by Ed Eyth.

BELOW Clara gets some startling information about Doc from actor Richard Dysart's barbed-wire salesman.

OPPOSITE Fox, Steenburgen, and Lloyd pose for a publicity photo on set.

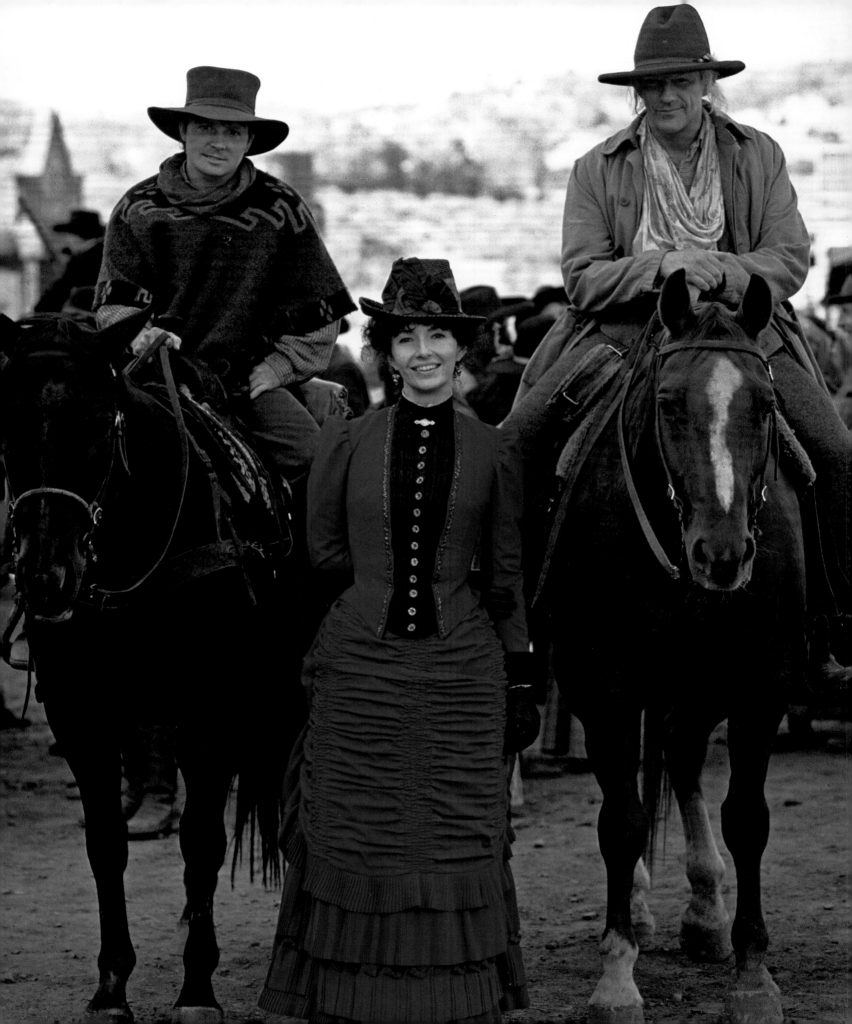

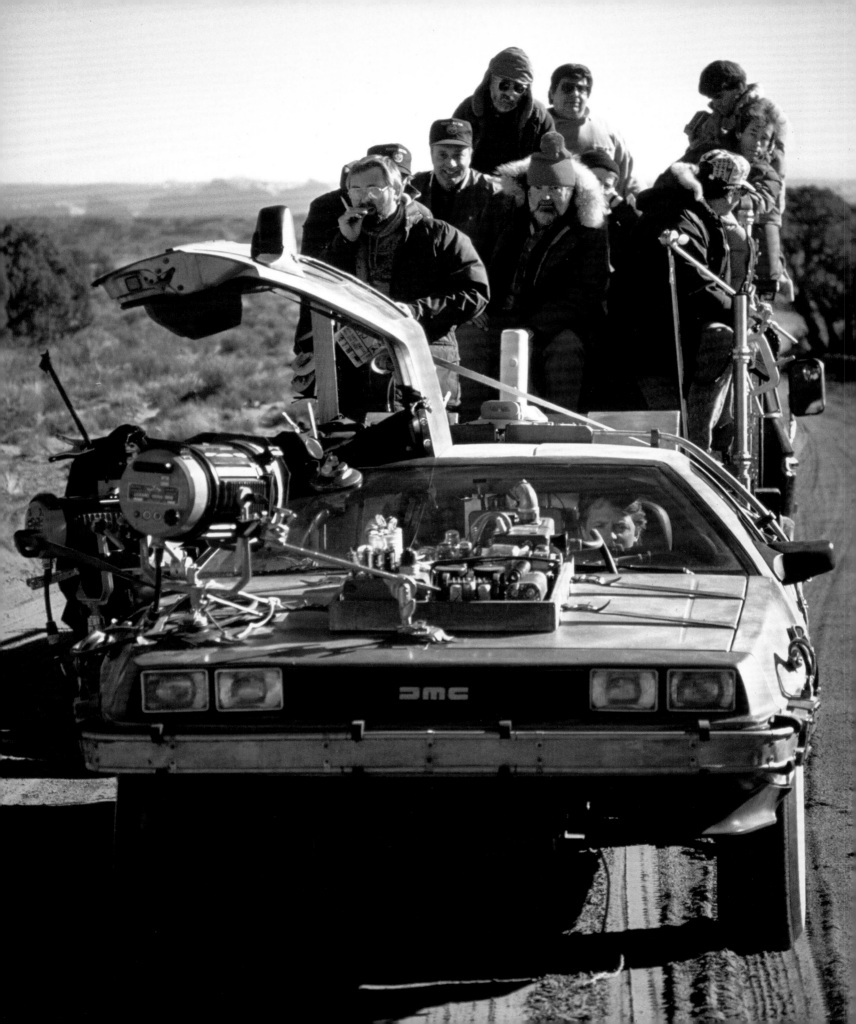

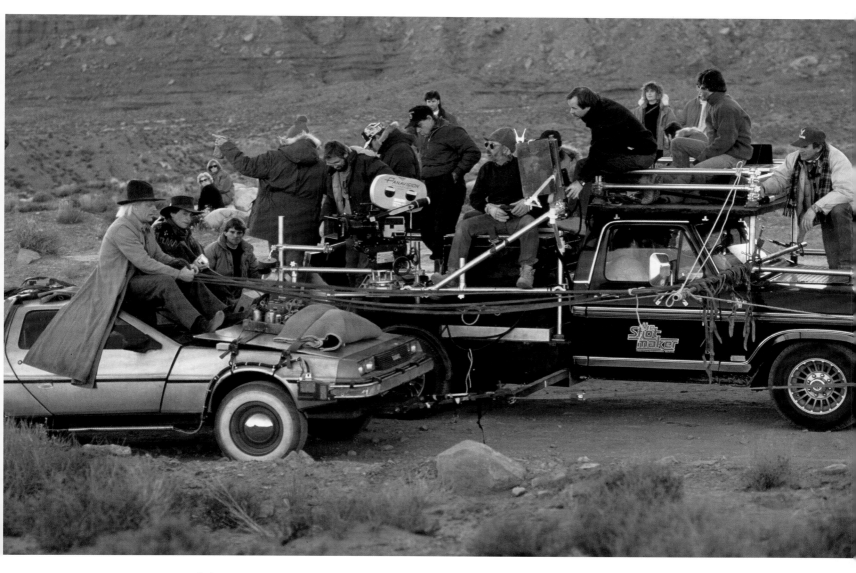

of the nineteenth century, and it's got incredible richness," says Johnston. "I used that against the backdrop of that desert landscape we were shooting in, where everybody else is falling into clay . . . She's the heroine and I wanted to lift her right up."

While Clara waited for her train, Robert Zemeckis, Michael J. Fox, and Neil Canton were on a private jet, headed for Monument Valley, Arizona, for the first of two trips to the area. On this quick weekend jaunt, they would join the second unit and film Marty backing the DeLorean into a cave to avoid the tribe of Native Americans he encounters upon arriving in 1885.

To shoot in this historic area, much negotiation had gone on between location manager Paul Pav and local Navajo tribe elders, who debated long and hard on whether they wanted the film production on their lands. When the proper permissions had been granted, it was decided that this scene could be done quickly with the second unit, and the full company would come back weeks later for most everything else.

Second-unit director Max Kleven had spent several days prior to Zemeckis and Fox's arrival

rehearsing the action with not only the Native Americans but with the cavalry who would be in hot pursuit. Many of the Navajo tribe members were hired as extras, and while a large number of them assured Kleven they were good horseback riders, many in fact were not. As a result, the second-unit director had to make quick adjustments so that the most experienced riders were front and center when filming began.

To play the cavalry, the filmmakers hired a group of reenactors who specialized in portraying United States military forces from the years between 1845 and 1890. The group brought their own costumes and horses, and they didn't need to be lodged in a hotel. All they required was a plot of land in which they could set up camp, utilizing tents and accessories true to the period they were there to represent. The day of shooting went as planned, but the trip back to Sonora was delayed twenty-four hours when an intense thunderstorm grounded the private plane that would carry Zemeckis, Canton, and Fox back to the main unit.

ABOVE A promotional button for *Back to the Future Part III*.

OPPOSITE AND TOP The retrofitted DeLorean goes off road in Monument Valley along with the crew in the camera car.

Scenes shot in the eighth week included Doc Brown unveiling one of his signature models to demonstrate his plan to get the DeLorean up to speed, and Clara asking Doc to fix her telescope, casually mentioning the upcoming town dance in the process.

A number of shots necessary to wrap up Marty and Buford's showdown were also completed, including a reference to a legendary American movie director that was later deleted. After the gunfight, a young boy asks Marty how he came up with the idea for using a piece of stove to shield himself from Buford Tannen's bullets.

MARTY: I saw it in a Clint Eastwood movie.

BOY: Movie, what's a movie?

MARTY: You'll find out.

MAN: Move along, D. W., move along.

BARBER: That little Griffith boy—can't hold him down.

When work wrapped on Wednesday, October 18, Zemeckis and Fox hopped on a charter jet to Los Angeles, so the actor could rerecord some of his lines for *Back to the Future Part II*, set to open in theaters in just five weeks. In the meantime, second-unit director Max Kleven filled in for Zemeckis the next day, shooting Tannen and his gang in their camp preparing to head to town for Mad Dog's duel with Marty.

When Zemeckis returned to Sonora on Friday, he pulled off one of the most beautifully planned shots in the entire trilogy. The scene sees Marty and Doc at Doc's workshop trying to figure out a way to push the DeLorean to 88 mph. As they talk and move around the room, Doc stands with his back to the window, just as the locomotive pulls into the train station behind him, delivering the answer to his dilemma. This scene would require precision staging and timing, especially in the case of the arriving train. One miscue or flubbed line from the actors could result in hours of delays. Fortunately, with careful planning by David McGiffert and his crack production team, the scene went as Zemeckis envisioned it. "It was fun at the time to do that," he says. "To have the resources and the crew that was capable of doing it, so why not? I guess it was a hardship on the crew. They had to work really hard, but they made it great. As a filmmaker, my attitude was: If you're going to make a sequel, then you should just go for it. It was a chance to be liberated because when you're making a sequel, you can try things, because you've got the luxury to do it."

On Saturday, rains forced the company into the cover of Doc's workshop, to film breakfast being automatically cooked by another of Doc's homemade

BELOW AND OPPOSITE
Sketches by Marty Kline and Simon Wells of additional Doc Brown inventions: the telescopic rifle sight and the elaborate breakfast machine.

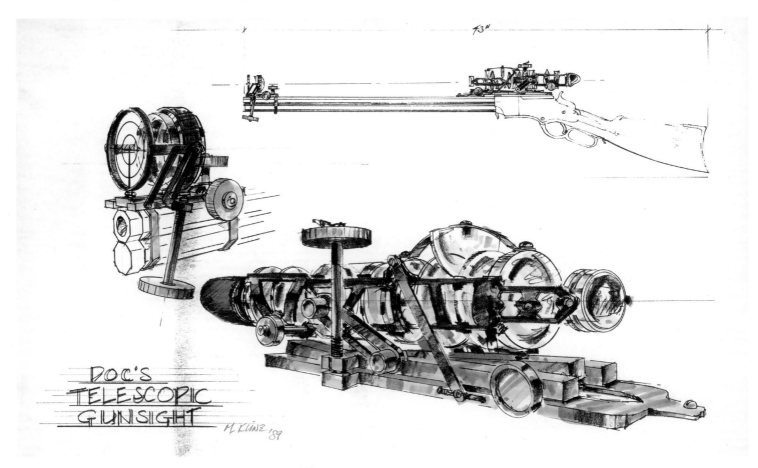

DOC'S
TELESCOPIC
GUNSIGHT

M. KLINE '89

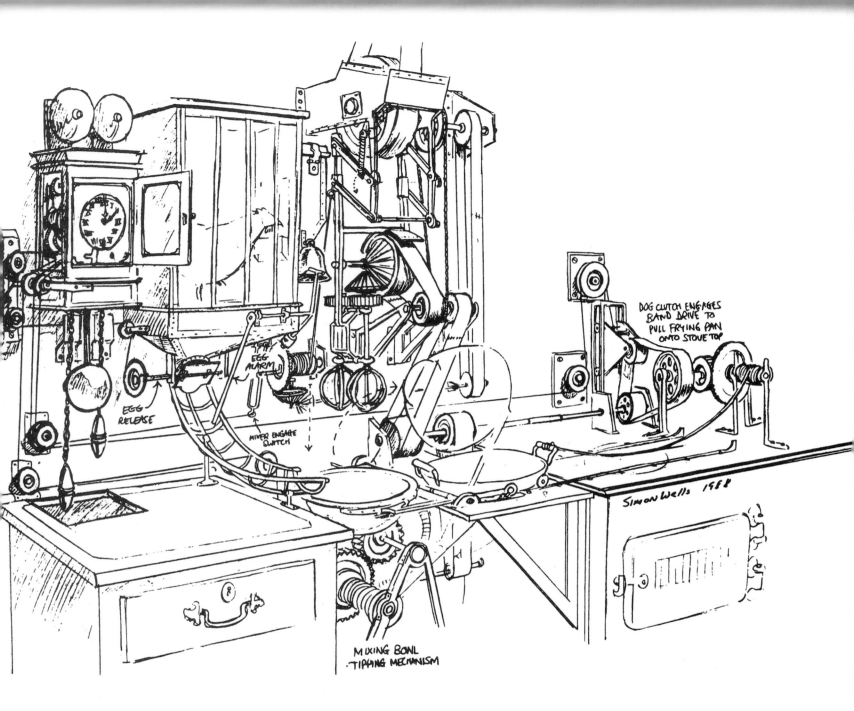

EGG ALARM

EGG RELEASE

MIXER ENGAGE SWITCH

MIXING BOWL TIPPING MECHANISM

DOG CLUTCH ENGAGES BAND DRIVE TO PULL FRYING PAN ONTO STOVE TOP

Simon Wells 1988

conveniences. The breakfast machine was another well-orchestrated effort by Lantieri and his team that gave Zemeckis the all-in-one shot results he had come to expect. The contraption was designed by Simon Wells, who had a unique pedigree that made him a natural fit for the *Back to the Future* family: He was the great-grandson of H. G. Wells, author of *The Time Machine*. Wells also added a Victorian element to several other designs, including the telescopic sight for Doc's rifle and the time-traveling train that appears at the end of the film. The filmmakers nicknamed this locomotive the "Jules Verne train," because it was inspired by the design of the Nautilus in Disney's film of the author's *20,000 Leagues Under the Sea*.

Another day of rain began the week, so the production moved to a warehouse where Rick Carter had built the interior of 1955 Doc's lab. The weather cooperated the next day and the crew headed back outside to shoot the only scene that would be cut from the film: the cold-blooded murder of Marshal Strickland by Mad Dog Tannen.

"It put a dark tenor on the film," explains Gale of their decision to delete. "Also, in terms of movie justice, when you kill somebody like that, you have to die for it. Obviously, we couldn't kill off Buford, so we made the decision to cut the scene."

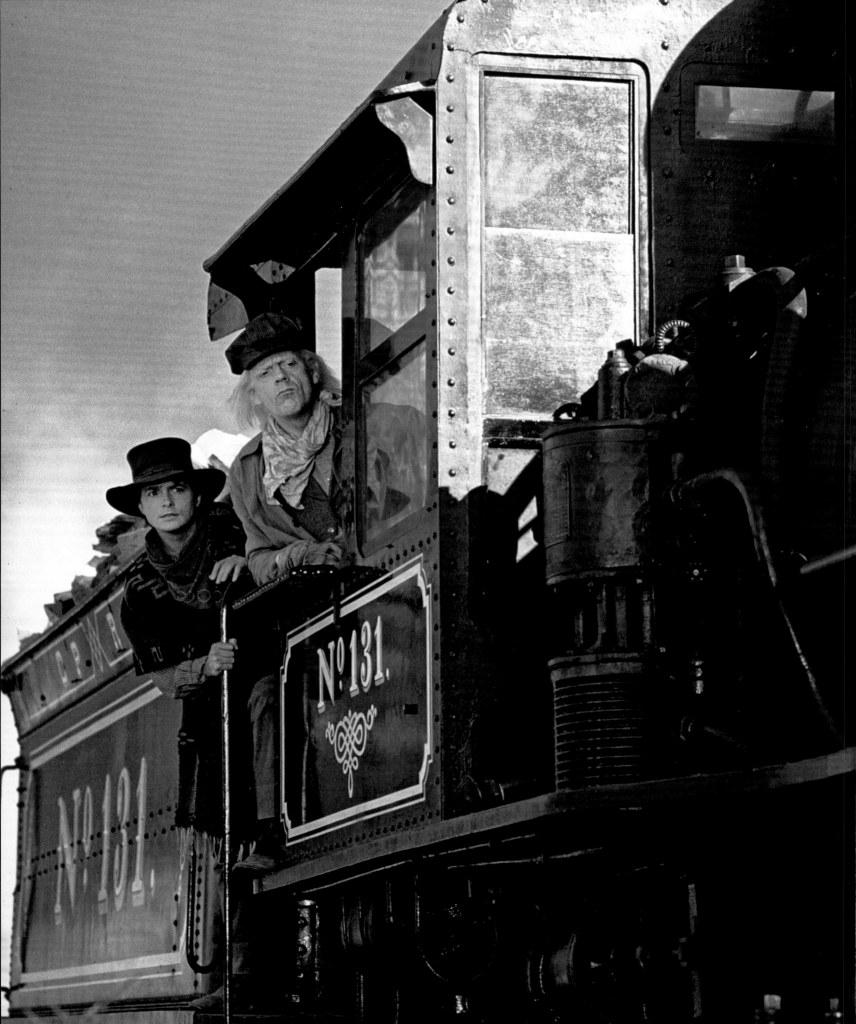

PLANES, TRAINS, AND DELOREANS

WHILE ZEMECKIS and the first unit had been shooting in Sonora, Max Kleven and his second unit were diving into the film's enormous roster of stunts and action sequences. Kleven and Walter Scott had no shortage of talent to draw upon, as performing stunts for *Back to the Future Part III* had become a highly coveted position. "Every stuntman in Hollywood wanted to work on our film," says Zemeckis, "because there weren't a lot of Westerns being made at the time, and that's the kind of film they got into the business to work on."

The team had already filmed large chunks of the train sequence using stunt doubles, but, after eight weeks, it was time for the first unit to get involved. Michael J. Fox, Christopher Lloyd, and Mary Steenburgen would now perform their own action in the scenes, with Zemeckis at the helm. Steenburgen cites the action as one of the reasons she wanted to be a part of the film: "I'd never really done anything like that at the time. For the last third of the movie, I felt like a female Indiana Jones."

One of the first sequences they shot saw Doc and Marty galloping to the moving train, grabbing a handle, and pulling themselves aboard. Christopher Lloyd had prior training on horseback, and, according to Walter Scott, "He damned could ride."

"I was confident in the horseback riding, but I remember one time I was riding along in a take, and my Western hat blew off," says Lloyd. "The wrangler, in a subtle way, said real cowboys don't lose their hats. I got the message and made sure it never came off again."

Unlike his costar, Michael J. Fox did not count horseback riding as one of his skills. However, according to Walter Scott, he "figured it out real quick."

"I had gone from not riding a horse to galloping beside a train in a chasm between a train and an arroyo wall," says Fox. "It was pretty hairy." Later Fox was told by the camera truck driver that he'd been galloping at 33 mph. "It was kind of neat to know that I had a horse going that fast," he says.

Zemeckis relished the action but admits to being daunted by the risks. "I was a complete nervous wreck," he says. "For me, there's nothing more terrifying than having your actor on a galloping horse, riding next to a locomotive with a camera car pinning him in there."

Despite the inherent dangers, the cast and crew enjoyed their time riding the rails. "Steam engines are amazing contraptions," states Christopher Lloyd. "To be walking along the edge of the locomotive with the wheels turning and the steam coming out was a thrill."

Michael Lantieri also became intimately acquainted with the mechanical behemoth. "We

learned everything about steam trains," he says. "We were covered in grease because we'd be riding that train all day long." In the film, Doc Brown creates a special chemical compound which he houses in logs that, when burned, allow the train to reach the all-important 88 mph and thereby shunt the DeLorean back to the future. The special smoke was produced with a mixture of pyrotechnics and chemistry. "All that stuff had to be figured out, tested, and shown to Bob and Bob," continues Lantieri. "I also had to deal with the local fire authorities because the area was prone to huge brush fires, so they hated us from the beginning. From a safety standpoint, you had to be careful, because in some of the places we went through, the trees and the brush had, like, two feet of clearance.

"One of the scariest things was the DeLorean doing the wheelie in front of the train as the third log exploded. That was a huge rig. We had cables and had it hooked to the front of the train. We shoved the car, hit the button, and a big cylinder would raise the front of the car. Bob Zemeckis said great, now we have to do it with Michael J. Fox. This was the only place where I refused to do something for him. I explained to him that if something happened with the car, or these homemade wheels go off the track, that train was going to go right on top of it. He got it, so we had to figure out an alternative. Finally, I talked him into doing it backwards. We ran the train in reverse so it was actually pulling the DeLorean and then raised the front of the car. If something happened and it broke loose, the train would just pull away from the car. Ken [Ralston] brilliantly put the smoke in so that it was going the right direction, and when Michael throws out the hoverboard, he's actually taking it in."

On Saturday evening, October 28, the filmmakers arrived in Orange, California, for a sneak preview of *Back to the Future Part II*. Although

OPPOSITE Marty and Doc take control of the locomotive.

TOP Christopher Lloyd's equestrian skills won him kudos from the stunt team.

ABOVE The crew would spend weeks shooting the DeLorean being pushed to 88 mph by the steam engine.

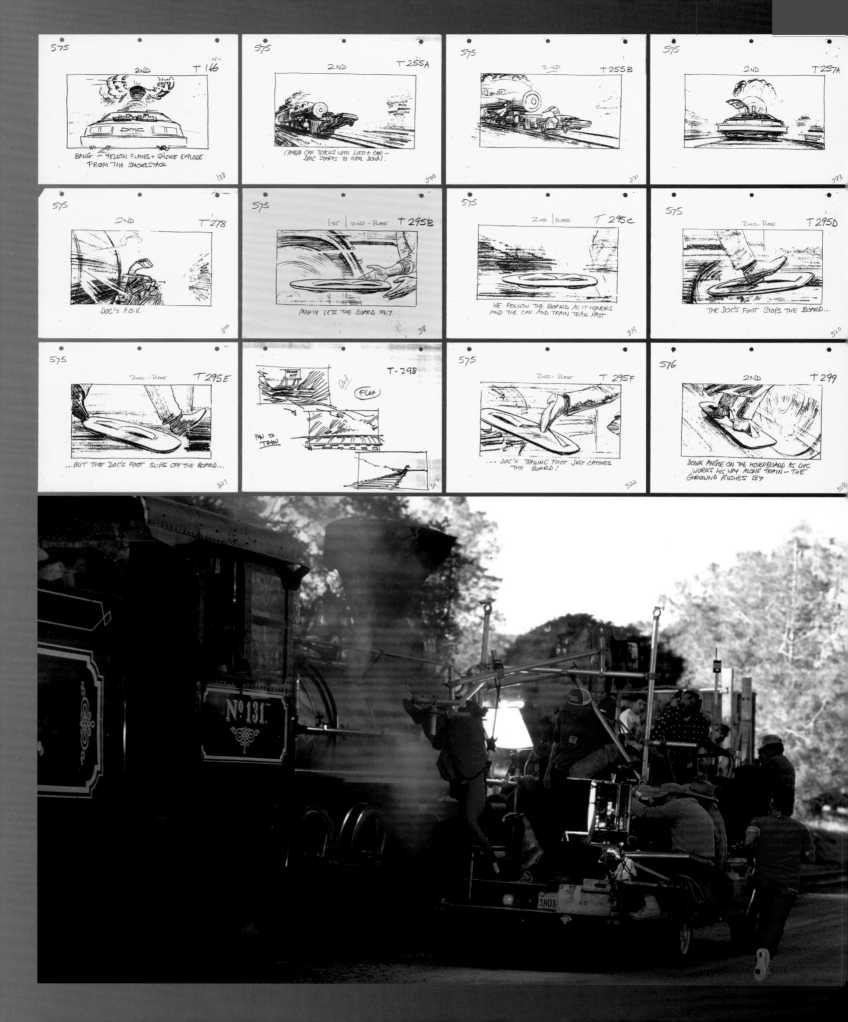

575 • 2ND • T 166
BANG — YELLOW FLAMES + SMOKE EXPLODE FROM THE SMOKESTACK
188

575 • 2ND • T 255A
CAMERA CAR TRACKS WITH LOCO + CAR — DMC STARTS TO COME DOWN.
290

575 • 2ND • T 255B
291

575 • 2ND • T 257A
293

575 • 2ND • T 278
DOC'S P.O.V.
300

575 • 1ST / 2ND - PLATE • T 295B
MARTY LETS THE BOARD FLY
38

575 • 2ND / PLATE • T 295C
WE FOLLOW THE BOARD AS IT HOVERS AND THE CAR AND TRAIN TEAR PAST
319

575 • 2ND - PLATE • T 295D
THE DOC'S FOOT STOPS THE BOARD...
320

575 • 2ND - PLATE • T 295E
...BUT THE DOC'S FOOT SLIPS OFF THE BOARD...
321

T - 298
FLOP
PAN TO TRAIN
321X

575 • 2ND - PLATE • T 295F
...DOC'S TRAILING FOOT JUST CATCHES THE BOARD!
322

576 • 2ND • T 299
DOWN ANGLE ON THE HOVERBOARD AS DOC WORKS HIS WAY ALONG TRAIN — THE GROUND RUSHES BY
323

No 131

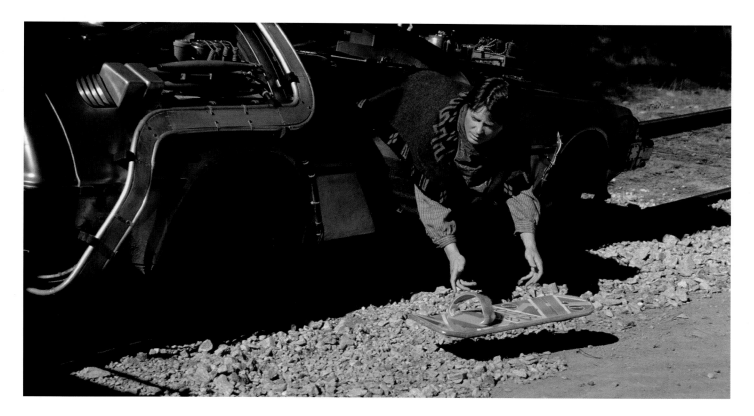

OPPOSITE TOP Simon Wells's storyboards detail the scene in which Doc saves Clara with the aid of Marty's hoverboard.

OPPOSITE BOTTOM Second-unit director Max Kleven and stunt coordinator Walter Scott devised a rig that would enable Steenburgen to hang safely from a stunt car, making it appear she was hanging from the train itself.

ABOVE In order to safely film the DeLorean performing a wheelie, the action was shot in reverse. Fox pulled in the hoverboard instead of pushing it outside the car.

the movie played well, most of the audience had a problem with the ending. "They weren't prepared for the fact that *Part II* didn't end and instead led into *Part III*," remembers Gale. "They thought they'd be seeing a complete story, so there was a lot of disappointment." As a result, Gale tried to convince the studio to promote the film as the second part of a trilogy, but studio head Tom Pollock thought it would make people stay away. "My only real regret of the trilogy is that I didn't fight harder for that," says Gale. "I think if audiences had been prepared for the ending going in, they would have enjoyed the movie more."

At this point, Bob Zemeckis had become a long-distance commuter. With the release of *Back to the Future Part II* rapidly approaching, the director had to approve the postproduction work being supervised by Bob Gale and Artie Schmidt in L.A. At the end of each shooting day, he and Neil Canton would board a charter jet, fly back to Burbank, and be driven to Universal where Zemeckis would review the work, give the team some notes, and then get a few hours of sleep at the Sheraton Universal hotel.

At 4:30 the next morning, he'd be picked up, and he and Canton would fly back to Sonora for the day's shooting. This went on for around three weeks. "The first day we did it, Bob and I were really excited," says Canton. "We had one movie in post[production], we were shooting another one, and we got to fly down on a private jet, and we'd have a glass of wine and toast. By day three, we would just get on the plane, not say anything to each other. We'd just close our eyes and go to sleep. We'd wake up and be in Burbank, they'd put us in a car,

and then we'd wake up at Universal. That was the hardest part of it."

The final scenes in Sonora were shot on the night of November 16, with Marty and Doc unloading the DeLorean onto the train tracks for the film's big finale. The company was mindful that they were shooting on a working rail line, and, armed with the local train schedule, they knew when a train would be coming through. A forklift stood close by to remove the car from the tracks and then return it after a train had passed.

With their work done, the cast and crew bid a fond farewell to the towns of Sonora and Jamestown, but a large piece of the production would be left behind. The property owners had allowed the film company to build the set on the land free of charge, with the proviso that it be left standing upon their departure. The company agreed, but with a proviso of its own: The town could stay, but the iconic courthouse and clock tower would have to be removed. Ironically, in 1996, a bolt of lightning sparked a wildfire that destroyed the entire set.

While much of the company had Thanksgiving week off and other crew were busy wrapping and striking the Sonora sets, Zemeckis and the cast did additional publicity to further promote the sequel's release. Monday, November 20, marked the world premiere of *Back to the Future Part II* at the Cineplex Odeon Theaters at Universal City. The star-studded red carpet event raised more than $400,000 for Tripod, a children's charity. Two days later, the movie opened on 1,865 screens across North America to mixed reviews but record-breaking box office.

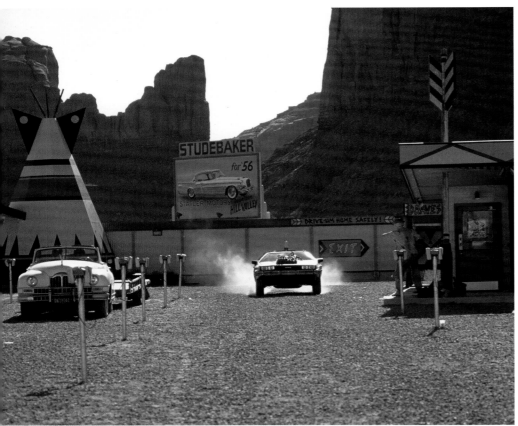

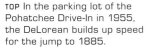

TOP In the parking lot of the Pohatchee Drive-In in 1955, the DeLorean builds up speed for the jump to 1885.

ABOVE Director Robert Zemeckis stands in front of the drive-in screen, with the historic mesa of Monument Valley visible behind him.

RIGHT Michael Scheffe's concept art of the 1955 modified DeLorean.

OPPOSITE TOP The crew shoots the DeLorean speeding toward the drive-in screen.

OPPOSITE BOTTOM Fox and Lloyd's summer wardrobe was contrasted by the heavy winter gear worn by the crew.

BACK TO THE PAST— WEEK 13: NOVEMBER 27– DECEMBER 2, 1989

On Monday, November 27, the cast and crew hopped on another plane to Kayenta, Arizona, the closest town to Monument Valley. The majestic buttes have served as the location of such classic films as *Stagecoach* and *The Searchers*, among many others, and Zemeckis knew the iconic rock formations would instantly transport audiences into the Old West. But when Marty left 1955 for 1885, Zemeckis and Gale wanted it to be from a location imbued with a sense of humor.

The Pohatchee Drive-In set was designed to look like a true product of the '50s, with the decor a reflection of the cartoony way in which Native Americans were often portrayed in the era. "Luckily, the Navajos had a sense of humor about it," remarks Rick Carter. "We were making fun of the Western more than we were the Indians, but nonetheless we were designing it around really corny-looking teepees and exaggerating how silly the Western version was in the '50s."

Negotiations between the production company and the Navajo Nation had left Carter with several obstacles before he could start building. There was only one road that led from the top of the ridge down to the valley floor below, and it was in a state of disrepair. Needing a sturdy road for transporting crew and equipment to the area, the production

offered to have it fixed, but their first overture was rebuffed. It was only after a series of meetings that the tribe allowed superficial improvements. The filmmakers also promised to clear away their footprint on the land once filming was done and pay to replant any vegetation they removed.

Arriving at the location on Tuesday, the crew was met by subfreezing temperatures that didn't warm much throughout the day. Both Fox and Lloyd had to perform their scenes in summer clothing so, as soon as the camera cut, parkas were immediately rushed to the actors. However, the cast and crew soon received some news that made the temperatures bearable: *Back to the Future Part II* had opened to more than $40 million at the box office, and there would definitely be an audience waiting for the film they were currently shooting.

The first sequence to be filmed saw 1955 Doc finishing his modifications to the DeLorean for its trip to 1885. Michael Lantieri had also made his own changes to the vehicle so it would be better suited to perform on the rocky terrain. In addition to the overinflated whitewall tires, Lantieri had gone under the hood to replace the engine with a more powerful and reliable model.

The production filmed in Monument Valley for a total of five days, going from the drive-in to the appearance of the entire Pohatchee tribe galloping straight toward Marty as he arrives in 1885. Again, members of the Navajo Nation took to horseback to serve as background players.

Throughout the shoot, the cast and crew developed a deep appreciation for the history of their location. "Anybody who works in movies who loves that aspect of the history of film can't be anything but moved by seeing this land," says Dean Cundey.

"It was the real deal," adds Michael J. Fox. "It was cool because it wasn't like being in the West. It was like being in a Western movie, which is better."

Following the shoot in Monument Valley, the company returned to Los Angeles for the remainder of the production.

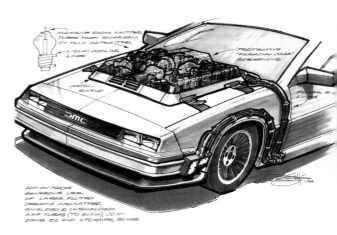

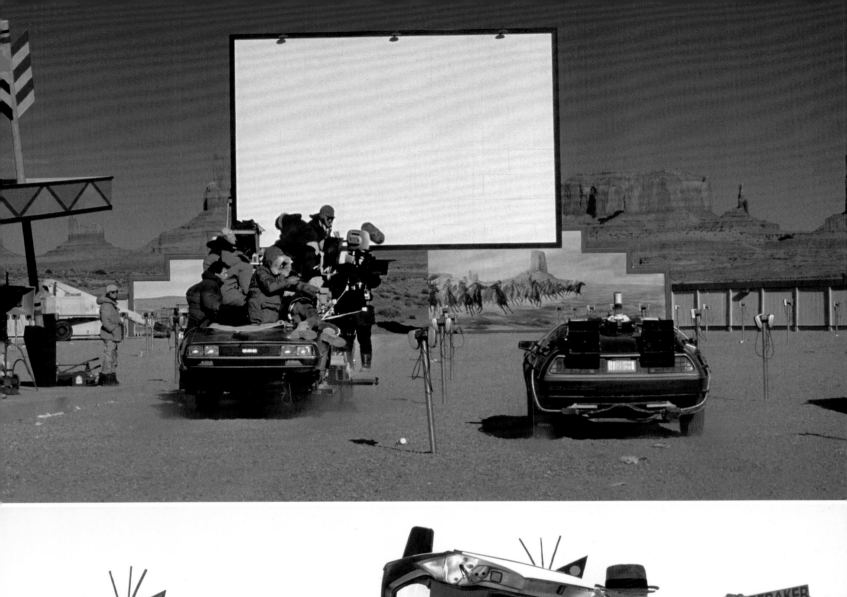
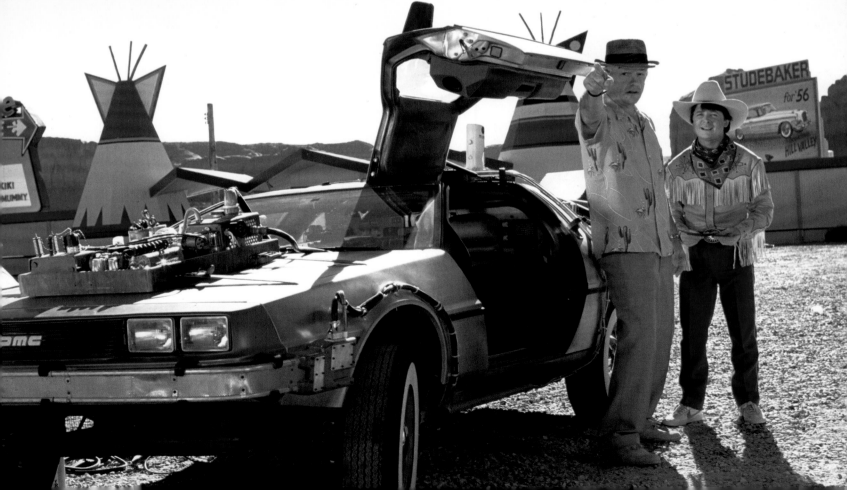

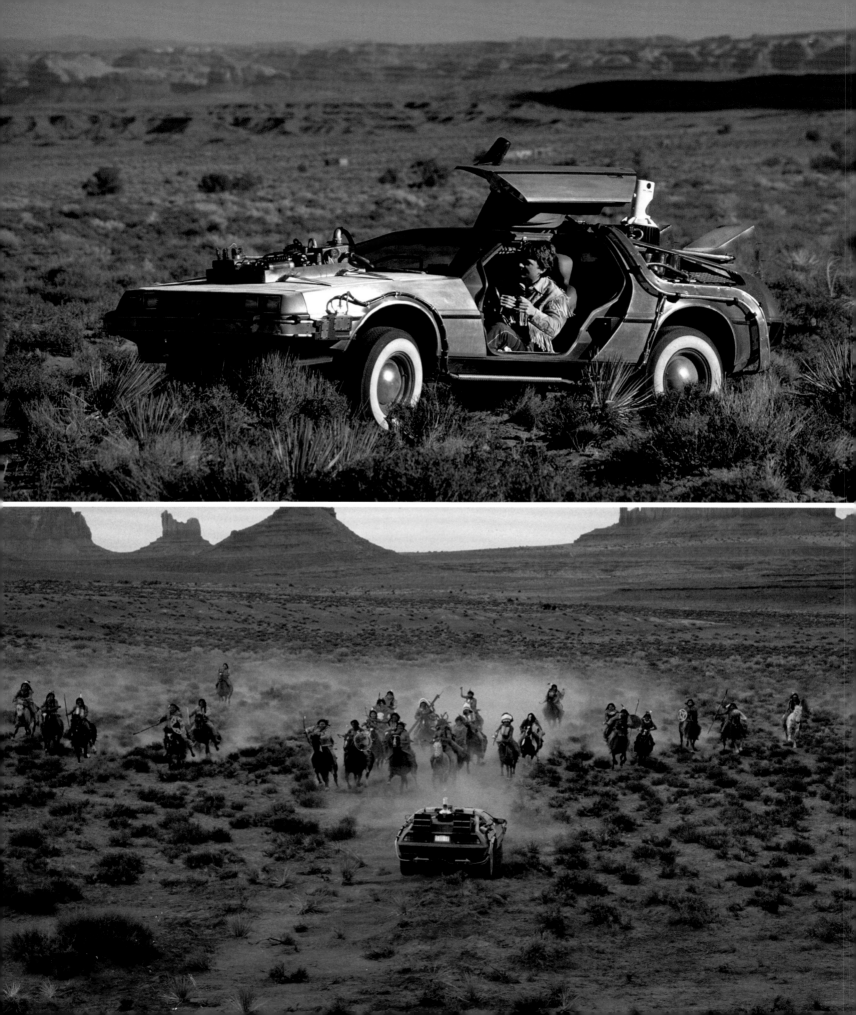

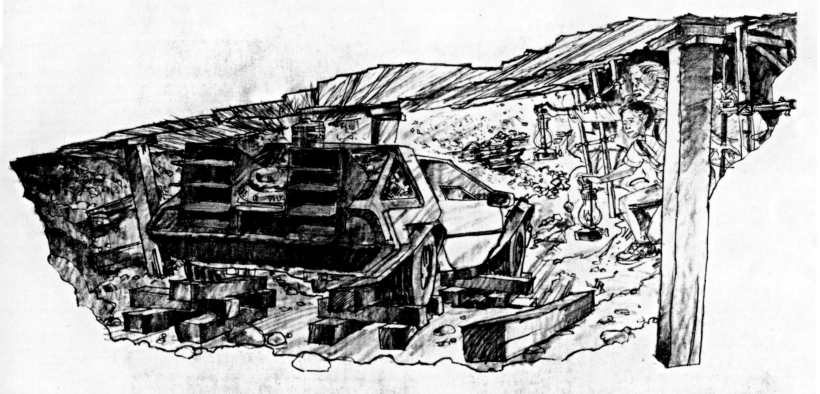

INT. DELGADO MINE:
HIDDEN INNER GALLERY WITH DELOREAN
M. KLINE '89

WEEK 14: DECEMBER 4-8, 1989

Back in the familiar confines of Universal's Stage 12, 1955 Doc led Marty through the tunnels of the Delgado Mine to uncover the DeLorean in the chamber where 1985 Doc had buried it seventy years previously. The two days it would take to film this sequence would be the only time shooting occurred in week 14.

While the main crew used the next three days to ready the following week's action, work continued apace for the departments that would be heavily involved in the upcoming postproduction period.

With *Back to the Future Part II* enjoying a successful run in the theaters, editors Artie Schmidt and Harry Keramidas were able to focus their attention on the cutting of *Part III*. Likewise, Alan Silvestri, who had only recently completed the score for the second installment, was already adapting his now-classic Back to the Future theme to feature a commanding Western influence while also composing additional new themes for the film.

For the artisans at ILM, *Back to the Future Part III* would present a lighter workload than its predecessor. In contrast to the mere thirty-two effects shots needed for the original film, *Back to the Future*

Part II required hundreds to bring the flying cars, hoverboards, and complex Tondreau sequences to life. Although the 1885 setting of the third film necessitated considerably fewer effects shots, there was still a lot of work to be done. In addition to seamlessly combining the footage of Fox as both Marty and Seamus and providing the iconic time-travel effects for the DeLorean, detailed models of the Jules Verne train and the 1885 locomotive that Doc and Marty commandeer were also being built for filming.

OPPOSITE TOP Michael J. Fox enjoys a rare quiet moment in the DeLorean.

OPPOSITE BOTTOM In Monument Valley, some members of the local Navajo Nation took to horseback to play warriors from the fictional Pohatchee tribe.

TOP Marty Kline's sketch of the interior of the Delgado Mine.

RIGHT Marty and 1955 Doc dig up the DeLorean buried by 1985 Doc in the Old West.

195

ABOVE In Oxnard, California, the crew films Marty's return from 1885.

BELOW Flea rejoins the production for the scene where Needles challenges Marty to a drag race.

WEEK 15: DECEMBER 11–16, 1989

Seventy miles to the west of Los Angeles, the coastal town of Oxnard, California, was the place where the time-traveling DeLorean would meet its end, smashed to pieces by a freight train.

But first, the company took one day to shoot Marty's arrival from 1885: The DeLorean, covered with post-time-jump frost, rolls down the tracks past a sign bearing the name "Eastwood Ravine,"

named in memory of Marty's heroic actions in 1885 under the pseudonym "Clint Eastwood."

The next two days were devoted to the drag race sequence in which Marty is challenged by the young Needles (Flea) and his gang. Needles's cohorts were members of the various Tannen gangs from all three films: J. J. Cohen (Skinhead / original film), Ricky Dean Logan (Data / *Part II*), and Christopher Wynne (Buck / *Part III*).

Once these scenes were in the can, it was time to obliterate the time machine.

In their initial preparation for the scene, Lantieri and Bob Gale watched videos of trains colliding with cars. "The first thing we realized is they're not that impressive," says Lantieri. "The train knocks the car off the tracks, and the car turns over and—maybe at best—looks like it's going to split in half. But that's not what we needed. Bob said to me, 'We have to make sure the audience knows that this is not usable anymore.'"

After considering the options, Lantieri came up with an explosive solution. "I ended up taking the car apart in about a hundred pieces," he says. "I laced the car with high explosives, and the car was sewn back together with a det[onation] cord. When the train came in contact, I had to time it so that it hit the car, and, just as it started to crush the car, I would hit a button and literally blow the det cord so that the train

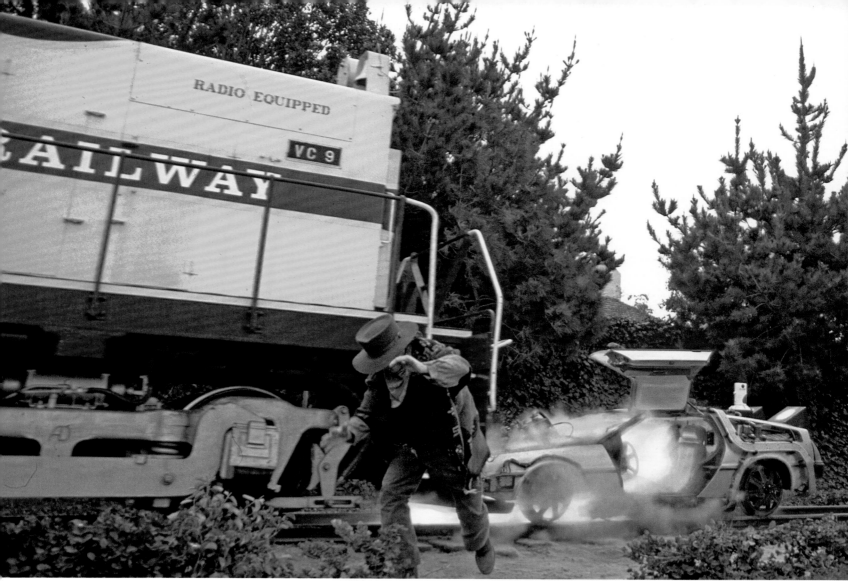

hit a pile of parts that was suspended in the air, and that's how they get thrown everywhere."

Before they shot the scene, Bob Gale had some concerns. "I went to the engineer," he recalls, "and asked him if there was any chance that the freight train engine could derail when it hit the car. He looked at me and laughed. He said, 'I've been waiting my whole life to do something like this.'"

Multiple cameras were set up to record the crash/explosion from various angles, as Lantieri went through last-minute checks and consulted with Fox's double, Charlie Croughwell, who would have to jump from the DeLorean at the last moment. Lantieri stressed to the stuntman he needed to be out of that car and at a safe distance before the detonation could take place. Croughwell followed instructions to the letter, and when Lantieri saw the stuntman reach the safety zone, he hit the button, detonating the explosives to the applause and delight of the crew.

TOP Stuntman Charlie Croughwell leaps to safety as the diesel engine strikes the DeLorean.

RIGHT Marty walks through the aftermath of the DeLorean's destruction.

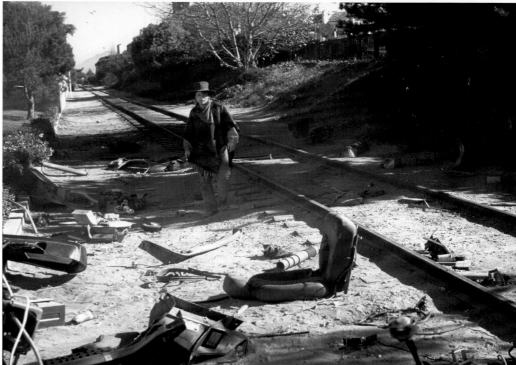

ABOVE AND RIGHT Early concept
sketches for the Jules Verne
train by Michael Scheffe.

TOP RIGHT Jules Verne train
sketch by Simon Wells.

BOTTOM Artist Marty Kline's
detailed color rendering of
the Jules Verne train in its
final inception.

OPPOSITE TOP LEFT Supervising
model maker Steve Gawley
(left), ILM visual effects
supervisor Ken Ralston
(center), and motion control
camera operator Peter
Daulton (right).

OPPOSITE CENTER LEFT
The full-sized Jules Verne
train on location.

OPPOSITE TOP RIGHT Doc Brown
returns to 1985 with his
new family.

Bob Zemeckis claims this was one of his
favorite scenes to film. "I loved that we were bold
enough to do that," he says.

With the DeLorean in hundreds of pieces, it
was time to bring in Doc's ultimate invention, the
Jules Verne–themed time-traveling train. Working
from sketches by Marty Kline, Simon Wells, and
John Bell, Lantieri also put his own stamp on the
construction of the train: "It was funny. I don't think
you could ever find a set of drawings anywhere for
this train. There were concept drawings, but we
kind of built it almost like an art project until we
were out of time, and it was what it was going to be."

After two days of filming the finale, in which
Doc Brown introduces Marty and Jennifer to his
new family, including sons Jules and Verne, Mary
Steenburgen was wrapped on *Back to the Future
Part III*.

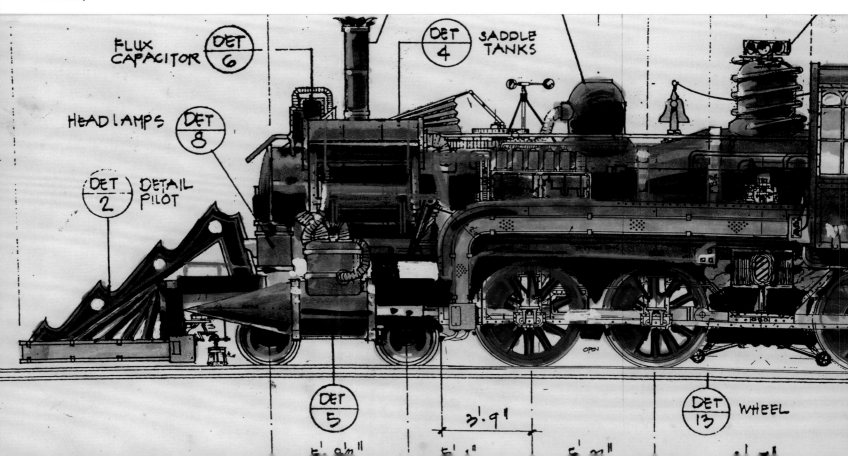

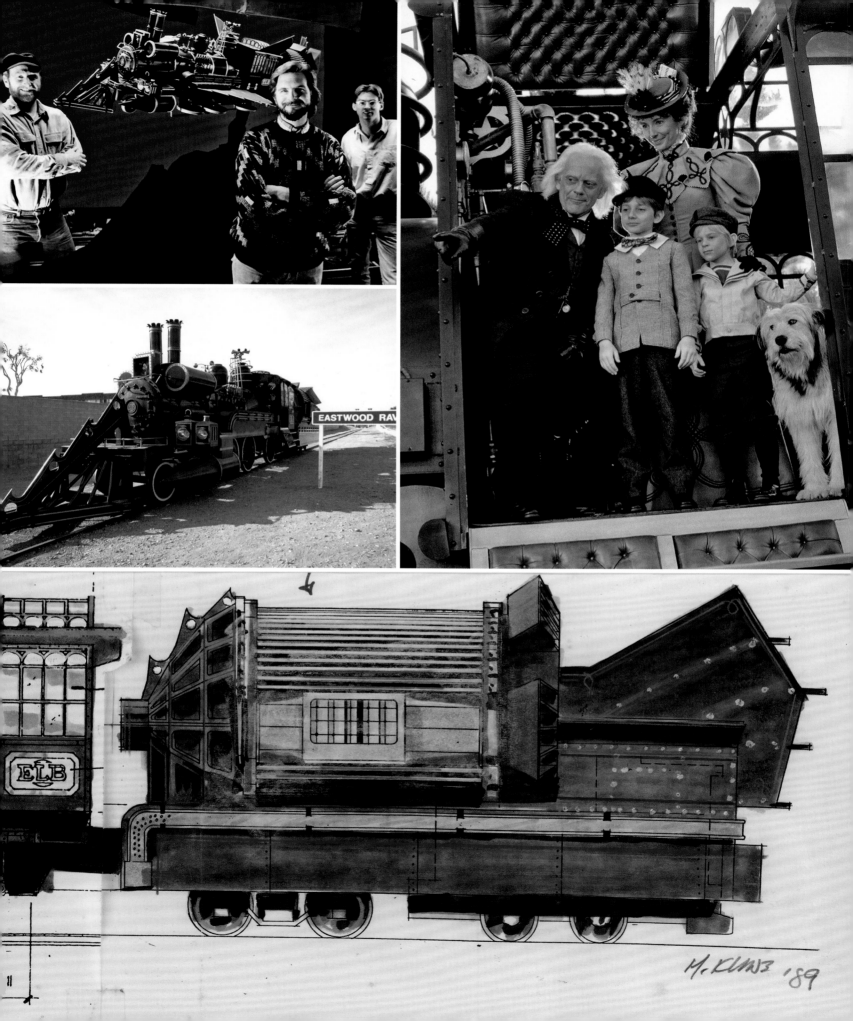

WEEK 16: DECEMBER 18–22, 1989

Lea Thompson, Marc McClure, Wendie Jo Sperber, Tom Wilson, Jeffrey Weissman, and Michael J. Fox gathered at the McFly house in Arleta for one last scene of the family restored to their happy and successful 1985 lives. With the scene complete, Wilson, McClure, Sperber, and Weissman were wrapped.

The company next moved to Agoura for the scene in which Marty rolls down the hill and crashes through a fence to be discovered by his ancestor, Seamus. The Tondreau recorded Fox in both roles, after which Charlie Croughwell tumbled down the steep hill in a wide-angle shot, landing perfectly in the designated spot.

They remained in Agoura two more nights for the scenes in which Doc blows up the entrance to the Delgado Mine and Doc's trusty canine, Copernicus, alerts Marty to the tombstone bearing Doc's name.

WEEK 17: DECEMBER 26–29, 1989

The Christmas holiday made for another shortened week, as the company returned to Stage 12. There Rick Carter had re-created the cave he originally built in Monument Valley, where Marty hides the DeLorean and comes face-to-face with a bear. This time, the animal seemed to have had a little too much Christmas cheer and opted to nap instead of performing. Production had a contingency in place, though, and a stuntman in a bear suit completed the shot.

The rest of the week was devoted to stage and process work. As Fox sat in the DeLorean, previously shot background footage was projected on a screen behind him, while crew members pushed and jostled the car, throwing debris across the windshield and activating appropriate smoke effects to augment the scene snippets.

WEEK 18: JANUARY 2–5, 1990

The library where Doc and Marty research the history of Hill Valley in the late 1800s was also built on Stage 12, while another part of the space was dedicated to the interior of the 1885 McFly cabin. There, Fox and Lea Thompson filmed the third iteration of the scene in which Marty wakes to find an unknown (but strangely familiar-looking) woman tending to him. "This was another reason we had to bring Lea back," says Gale. "We couldn't do this scene with another actress. It wouldn't have been the same."

For the scene in which Seamus comes home with some dead rabbits for supper, Fox decided to have a little fun. Walking through the door, he said his line, "Maggie, I've brought supper," and raised a giant, stuffed Roger Rabbit.

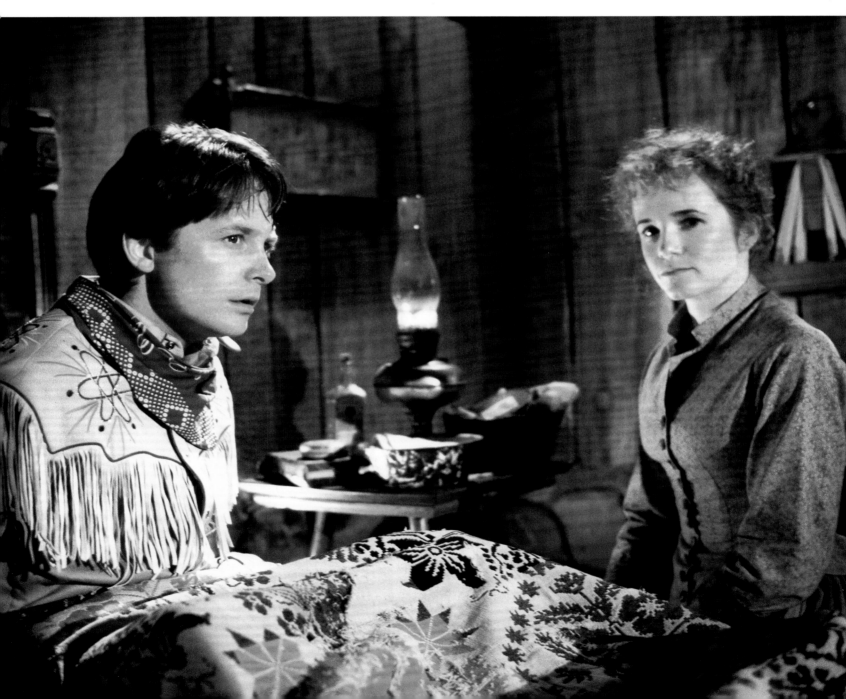

The benefit for Los Angeles's West Side Children's Center was followed by an outdoor "Western Extravaganza," featuring Western decor, music, a barbecue, and a replica of the courthouse clock.

On May 24, 1990, the day before the official opening of *Back to the Future Part III* on 2,019 screens, Universal held special screenings of all three movies in select theaters throughout the country. The showings all sold out, with attendees receiving a souvenir button that proudly proclaimed, "I've seen the Future Back to Back to Back."

REMEMBERING THE FUTURE

Looking back at all they accomplished, the key players are proud of their legacy, one that has endured over the course of three decades, as the movies continue to enthrall new generations of audiences.

"As a trilogy and a property, it's like *The Wizard of Oz*," says Michael J. Fox. "It's ironic and fulfilling that a movie about transgenerational relationships has endured and become a cross-generational treasure. The people that related to it at first, related to the '50s part of it. Now my generation relates to the '80s part of it, and the '80s have become the '50s in that way. So you understand why it endures."

"I think there has to be depth to anything that endures that well," offers Lea Thompson. "There's some deep resonant things that come from the first idea that Bob Gale had: that your parents were once young and they had the same passions and dreams. It's such a powerful lesson that you can reach back into the past and love your parents and their mistakes and their humanity and realize that they're just people too. People all have different reasons for thinking why that movie endures, but to me that's why it endures in my heart, because it's telling a real universal truth."

Says Christopher Lloyd, "I run into parents whose kids have just seen *Back to the Future* for the first time, and they're totally enraptured with it. I meet so many people who just say it changed their lives in some way. They just loved it. Many people have come up to me and said that the movies persuaded them to become engineers or physicists. They saw them when they were kids, and they said that's what they want to do. It's had a big impact."

"The movies say your future hasn't been written yet," says cocreator and producer Bob Gale. "You have control over your own destiny, and that's a message that people like to hear. They like to be reminded of that—that they have power over their own lives. So, on that level, *Back to the Future* is a very optimistic movie. It puts the power back into the hands of the audience."

ABOVE On the sound-mixing stage in postproduction: (Left to right) Robert Zemeckis, film editor Artie Schmidt, Bob Gale, Dean Cundey, film editor Harry Keramidas, and sound rerecording mixer Dennis Sands (seated).

BELOW A last-minute decision was made to add Mary Steenburgen to the final version of the poster.

RIGHT Fans who attended the special screenings of the entire trilogy before the premiere of *Part III* received a commemorative button.

OPPOSITE One of several concepts by Drew Struzan for the third poster of the trilogy.

WEEK 19: JANUARY 8–12, 1990

The Tondreau work continued in the McFly cabin for the scenes in which Seamus and Maggie talk about "Mr. Eastwood" in the privacy of their bedroom, while Marty babysits the first McFly to be born in America. The end of the shooting day marked a wrap for Lea Thompson.

Zemeckis and company next returned to a wooded area in Griffith Park for some assorted inserts, including a shot of Marty passing the hoverboard to Doc during the steam-train finale.

The final days of shooting took place on Stage 12, where the interior of Doc's house had been built for the opening scene, in which Doc awakens and dictates the events of the previous evening. It was appropriate that Fox and Lloyd be the actors on hand to end the monumental experience of making the *Back to the Future* trilogy. After Bob Zemeckis yelled, "That's a wrap," he began his thank you speech to the crew: "As General George Patton said about World War II, all good things must come to an end . . ." Champagne and beer bottles were opened, and, after many hugs and farewells, another chapter had closed.

After a combined total of more than two hundred shooting days over eleven months, the journey was almost over. A much less frenzied period of postproduction ensued, and marketing efforts ramped up to launch the final chapter of the trilogy. *Part III* had its world premiere on Monday, May 21, again at Universal City's Cineplex Odeon Theaters complex.

I've seen the FUTURE Back to Back to Back BACK TO THE FUTURE I II III May 24, 1990

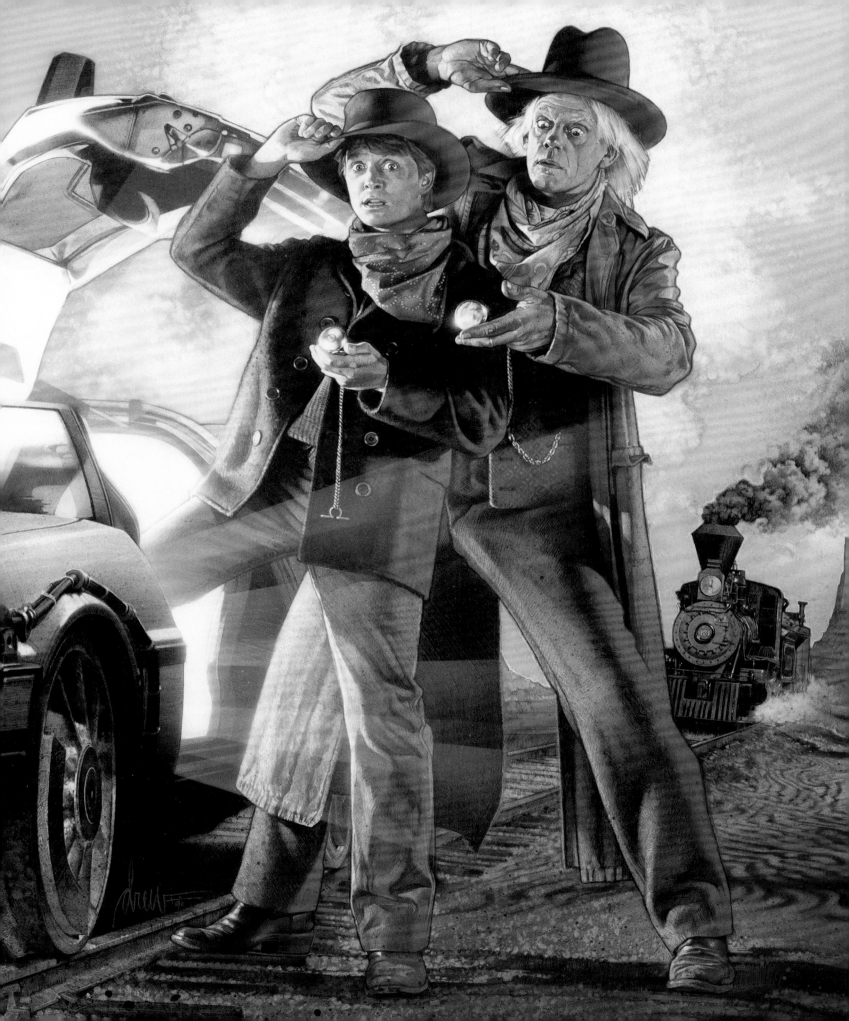

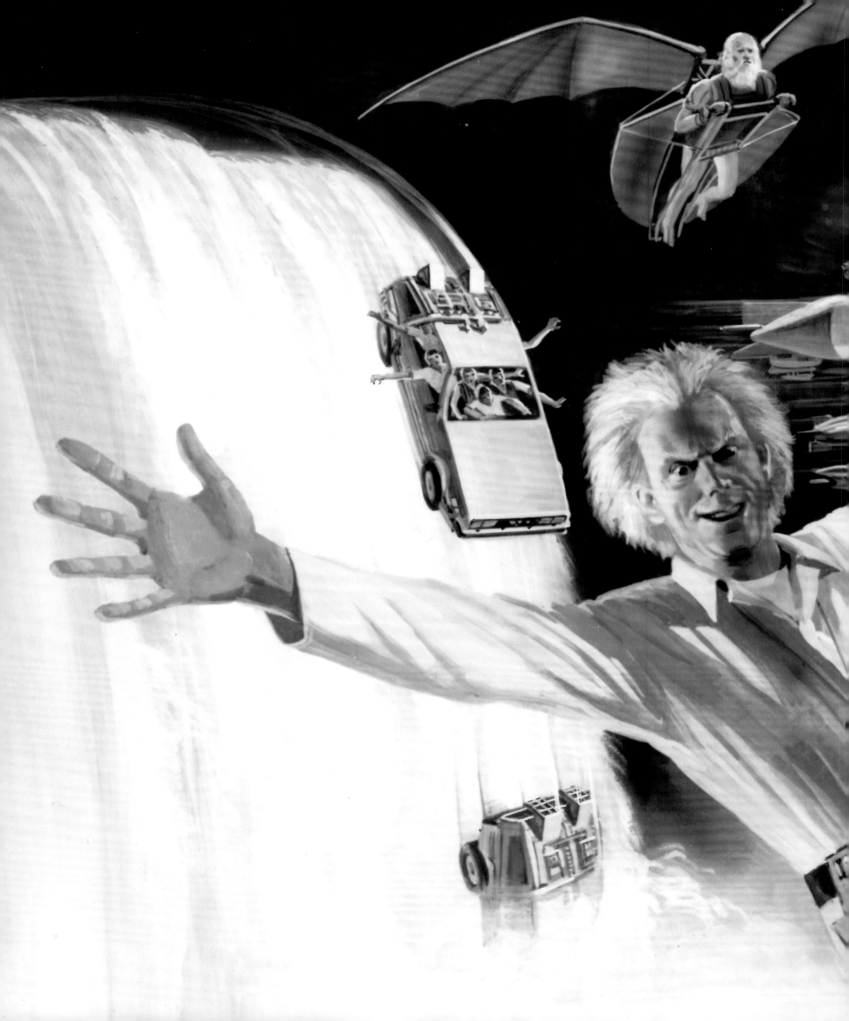

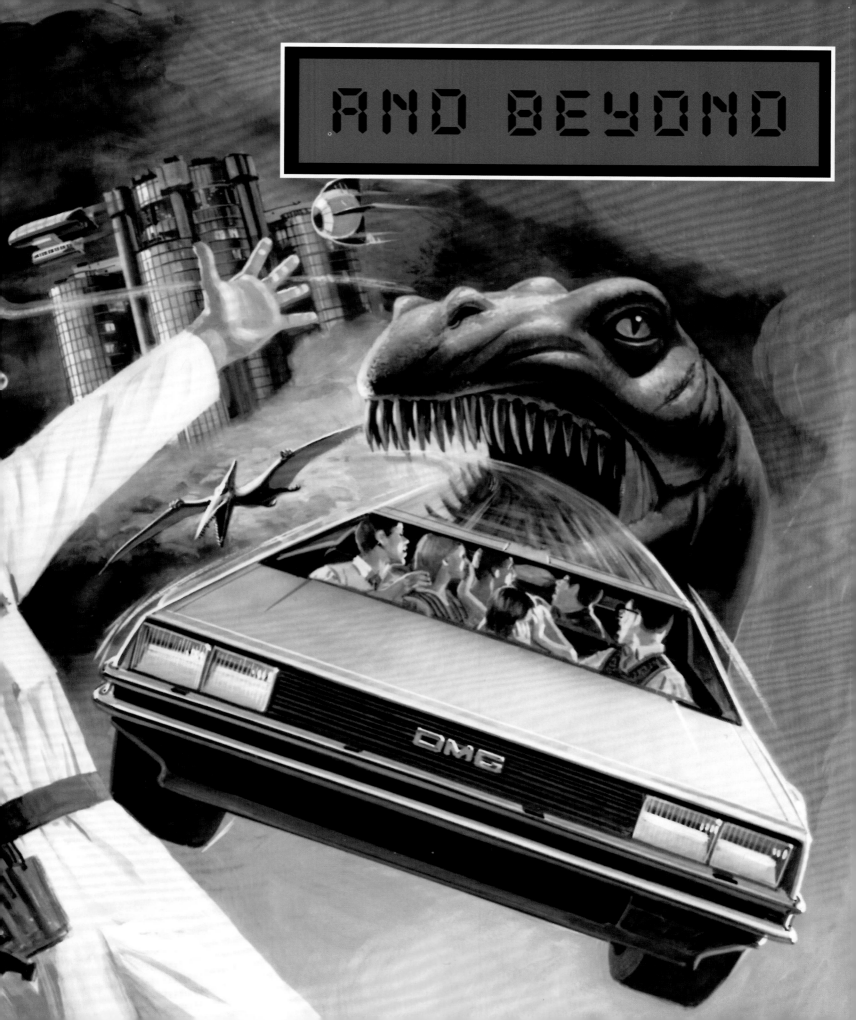

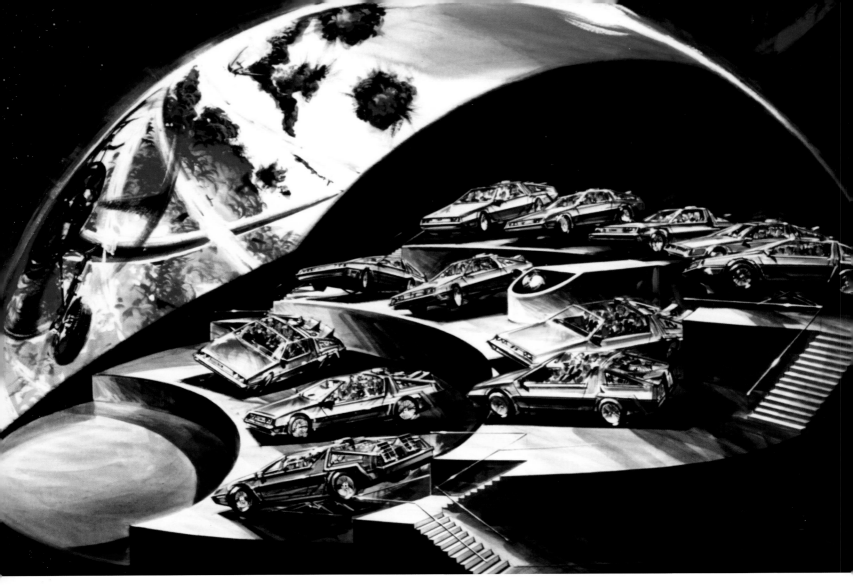

BACK TO THE FUTURE: THE RIDE

WHEN CARL LAEMMLE opened Universal Studios Hollywood in 1915, he had the visionary idea of allowing the public into the studio to watch how movies were made, charging twenty-five cents a ticket. Throughout the coming decades, the Universal tour became a central part of the studio's culture, and in 1981, MCA (the new owner of the studio) purchased 423 acres of land in Orlando, Florida, to develop a second studio tour and theme park on the East Coast.

In March 1987, director Steven Spielberg was brought onboard to act as a creative consultant for new attractions at both sites. This was the first time a filmmaker would have creative input into Universal's tours and theme parks, and hopes were high that many of the new rides he created would be based on movies from his remarkable back catalog.

By this time, *Back to the Future* had become a certifiable phenomenon, and the sequel was already in the early stages of development. Universal was aware that one of the most popular draws to the Hollywood studio tour was the tram ride through the Hill Valley town square on the back lot. As such, *Back to the Future* would undoubtedly be a strong addition to the new rides in development for both parks. "I thought that this was one ride that we couldn't let get away," said Spielberg.

With the Florida park still in its infancy, it was agreed that, whatever incarnation the *Back to the Future* ride eventually took, it should open in Hollywood first. The attraction still had not moved past the concept stage, and no story had yet been conceived. All that was established was that the ride would need to accommodate 1,800 people per hour and be more technologically advanced than Disney's popular *Star Wars* ride, Star Tours.

In the spring of 1988, the Universal team, led by Peter Alexander and producer Phil Hettema, sent recently hired project coordinator Steven Marble to Vancouver to set up a mock version of the potential ride. "We were creating this entire experience organically and doing it backwards," states Marble.

PREVIOUS PAGES Original concept art for Greg MacGillivray's ride proposal.

TOP Concept art for the proposed dome ride experience.

OPPOSITE Douglas Trumbull on the miniature Hill Valley set of Back to the Future: The Ride.

"We had a concept, there's a dome in the building with some vehicles that will move to an image, and there would be surround sound and some sort of effects." Similar to Star Tours, the ride would be motion-based, and so Marble and his on-site team installed a prototype DeLorean ride vehicle in a decommissioned Omnimax theater complete with a motion base that would rock the car back and forth.

While the project was moving forward, its visual content had yet to be decided. To take the ride to the next stage, filmmaker Greg MacGillivray, who had extensive experience working in the IMAX format, was hired to direct the ride film. Along with MacGillivray, special effects artist Richard Edlund, known for his work on the original *Star Wars* trilogy and *Raiders of the Lost Ark*, was brought in to create the visual effects. MacGillivray and Edlund put together a short demo film that included an attempt at shooting a real-life scenario that included the DeLorean. Unfortunately, they experienced technical issues and their efforts were less than satisfactory, the film being more of a travelogue through time than a *Back to the Future* adventure. Although Zemeckis and Bob Gale were not officially involved in the making of the ride, Gale recalls being appalled by the footage when he finally saw it: "There was a false start on this thing that was absolutely terrible. . . . It was just bad."

"It was more flying-oriented," says Steven Marble. "I think it was related to what Greg [MacGillivray] was used to doing, because he had done a lot of aviation-themed films in IMAX. So it didn't have much to do with the *Back to the Future* storyline."

In addition to the subpar content of the footage, the relationship between the motion of the camera and the motion of the vehicle was making test subjects sick.

By this time, more than a year of work had gone into development of the new attraction with nothing to show, and the clock was ticking. Universal had fully committed to Back to the Future: The Ride, even announcing their star attraction in a July 1989 advertisement in the *Los Angeles Times*:

> Buckle up! Doc Brown has plans to take you on the ride of your life in his time-traveling wonder car! The hit movie *Back to the Future* is going to become the ride of your life at Universal Studios Hollywood in 1991. Doc will take you climbing, diving, banking, and blasting back to the dinosaurs at the Dawn of Time. You'll catapult to Kitty Hawk for a run-in with the Wright brothers. Rocket to Venice for a brush with DaVinci. Whoosh through Niagara Falls. Doc Brown will literally hang you up on the brink of disaster and let you teeter on the edge, then plunge you down, down, down in the steepest drop imaginable. You're on your way to the most unbelievable time-travel adventure ever imagined.

While Universal was publicly showing confidence in the ride, behind closed doors they were going back to the drawing board. "I do know that when we heard that version of it wasn't going ahead, Bob Zemeckis and I were very relieved, because we hated it," says Gale.

That's when filmmaker Douglas Trumbull received a phone call from Sherry McKenna, a producer at Universal Studios, asking if he could recommend someone to help them with their problem. Trumbull had built a strong reputation as a visual effects artist, having worked closely with Steven Spielberg on *Close Encounters of the Third Kind* and on such landmark films as *2001: A Space Odyssey* and *Blade Runner*. He also had experience working with motion-based simulators, having produced Tour of the Universe, a space-shuttle simulation ride located in Toronto's CN Tower.

Trumbull was invited to see what the team had been working on and took a test ride on what had already been developed, which included the MacGillivray-Edlund footage. "It was largely based on live action, and I said you can't shoot live action," states Trumbull. "You have to completely control the camera with motion control; otherwise, it's not going to look right. One of the things that was

obvious in the original photography was that the blurring and strobing was really horrible when you moved the camera. If you ever try to move an IMAX camera really fast in a dome, it becomes really nauseating."

Trumbull offered a solution: "My proposal was that this film should be entirely visual effects, with almost no live action, and that we computer-control the movement of the camera through miniatures. We would have to build a small screening room at my studio, where we'd have one motion base, one eight-passenger DeLorean, one IMAX dome screen, one IMAX projector, and a small film lab. We basically needed to go through a series of evaluations to find out the relationship between the movement of the camera and the movement of the vehicle in order to avoid motion sickness."

The narrative Trumbull proposed was a chase through time that would follow a flying DeLorean as it zoomed by familiar *Back to the Future* settings, such as Hill Valley 2015. His pitch also included concept art and storyboards and, based on his enthusiasm and technical expertise, he was hired. His studio, Berkshire RideFilm, located in a former textile mill in sleepy Housatonic, Massachusetts, was given a $15 million budget and all the essential film and lab equipment he had requested.

As the Florida park began construction and costs started to escalate, opening the ride in Hollywood quickly became a dilemma. "It was financially stressful to the company at the time," says Marble, who was promoted to senior project manager during this period. Ultimately, Universal decided to delay construction in Hollywood and move full speed ahead at the Florida site.

As preparation began at the Berkshire RideFilm studios, Trumbull's first hurdle was contending with camera systems. IMAX cameras were far too bulky to fit the miniature sets that were being built, so Trumbull had special lightweight IMAX animation cameras designed just for the project.

Another challenge was that the fish-eye lens they were shooting with made it difficult for traditional lighting and set design: "We had to design the movie to occur at night and then started designing situations where I knew we could have the sets that were going to be miniatures actually light themselves. That way it could all be practical lighting rather than hidden lighting. It was the most fundamental problem of the whole show."

To clearly illuminate the set of Hill Valley 2015, various lights were incorporated into the buildings. In addition to the interiors of buildings, scale streetlights and various pieces of the set were also illuminated, including entire streets that were underlit, so that the directional signs built into them would glow.

Futuristic Hill Valley was only the first phase in the three-part chase sequence envisioned, as the ride would take passengers back to the Ice Age,

BELOW Concept art commissioned by Douglas Trumbull for the lava sequence.

OPPOSITE Storyboard sequence for the climactic encounter with the *Tyrannosaurus rex.*

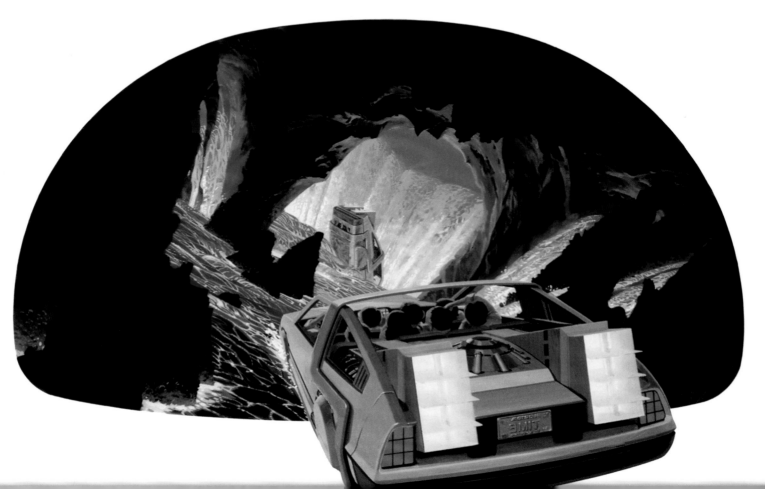

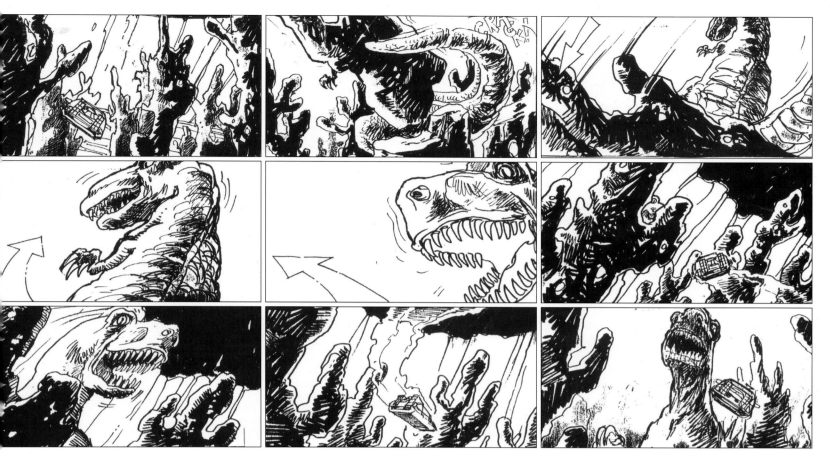

followed by an encounter with a *Tyrannosaurus rex* in the prehistoric era. The *T. rex* was developed in early storyboard meetings and was based on original concept art by visual effects supervisor Hirotsugu Aoki. Mechanical supervisors Kenneth Walker and Tom Culnan oversaw the design and fabrication of the nine-foot-tall animatronic dinosaur that took several months to build.

As production continued, Trumbull made tremendous use of the small black-and-white film laboratory and motion base simulator that he had installed in his studio. "I could program a shot, [so that] the camera should move this way, and [so that] the motion base should move that way," explains Trumbull. "We would shoot it, process it, and have it on the screen with the motion base within two hours, so that we could modify it and do another one in two hours. Sometimes it felt really great, sometimes it felt awful, sometimes it made you sick. We'd sometimes go through that several times until we'd find that perfect combination of physical motion and camera motion. So we would learn very quickly."

As Trumbull and his team continued production on the ride film, Steven Marble was working on trying to turn Trumbull's visceral experience into a workable narrative. "[At that time] it had no story to it other than it went through a series of events," says Marble. "Doug worked on developing those events—the idea that the DeLorean was going to

be flying through this and that. So there was the point-of-view experience, but just who was in that DeLorean was unknown at the time."

Producer Terry Winnick, Marble, and their creative team began brainstorming ideas for a preshow film that would lead into Trumbull's ride experience. "There were a number of different ideas," recalls Marble. "At one point, I was working on a storyline that was going to have Doc's dog Einstein somehow driving the car—we were chasing after Einstein. And even for a while we were kicking around the idea that there were two Doc Browns, one chasing the other."

With none of those ideas working, Terry Winnick turned to George Zaloom and Les Mayfield of ZM Productions, who had been producing the behind-the-scenes featurettes for the Back to the Future trilogy and a promotional film for the Florida park starring Christopher Lloyd as Doc Brown.

With the support of Amblin, Gale, and Zemeckis, Zaloom and Mayfield tasked one of their most ambitious young filmmakers with finding a solution for the preshow film.

"It took Peyton Reed to nail it," explains Marble. "Once he was handed the problem, he solved it. That's when the story came together, and everything started to click."

Reed and his writing partner, Mark Cowen, had to not only come up with a compelling storyline

but also one that was of a very specific length. "There was an estimate that people would stand in line for as much as forty-five minutes," recalls Peyton Reed. "They had to be entertained with a story in that forty-five-minute period while they waited in line and then have that story continue during the ride film."

When Reed and Cowen initially came on board the project, Universal was still working on the two Doc Browns concept. "Their concept had been that Christopher Lloyd was going to play two characters: He was going to play Doc Brown and Doc Brown's evil twin brother," explains Reed. "We were coming at it as fans, and when you're a fan, you get very protective about the mythology. The concept seemed so hokey to us that we very simply suggested that they've got this great antagonist in the movies, Biff. He was a juvenile delinquent, he would steal the DeLorean, and you'd have to chase him to get back and go through all of these time periods."

Due to the strong relationship between Zemeckis, Gale, and ZM Productions, Peyton Reed discreetly consulted with Bob Gale on their script. "He asked me to go over it and make sure he got

the characters right," recalls Bob Gale. "I had to make very few changes in Doc's dialogue. He got it right. And by then the ride was *Back to the Future*. It wasn't somebody else's idea of what *Back to the Future* should be. I was certainly glad that Peyton and ZM got involved, because they were fans, and they weren't going to let it get messed up."

With the new storyline in place, director Les Mayfield was appointed to helm the preshow film. "There was a lot of hardware with the motion base and with the Omnimax cinema, but ultimately it was a case of, 'Where are the characters from the movies?'" recalls Mayfield. "I had to reintroduce those characters and their comedy and keep the spirit of the film alive and put that umbrella over the ride film."

Mayfield directed all of Christopher Lloyd's scenes at Universal Studios Hollywood. The preshow film would see Doc take the audience through a tour of his Institute of Future Technology, instructing these "time-travel volunteers" about the perils of time travel. This segment would then segue into the ride film with Doc navigating passengers through the adventure in an eight-passenger DeLorean.

The majority of Tom Wilson's scenes were shot at the same time as Lloyd's and saw Biff wreaking havoc throughout the institute. The final shot of the ride's film, when Biff crashes the DeLorean into the institute, was shot at Trumbull's studio and was one of two possible finales. "We shot two endings," says Marble, "the one that was used and another one where

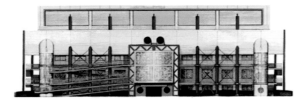

ABOVE Concept art of the DeLorean dodging boulders in the prehistoric era.

LEFT A concept rendering of the Institute of Future Technology for the Universal Florida park.

OPPOSITE TOP Model makers construct the animatronic *T. rex* at Trumbull's Berkshire RideFilm studios.

OPPOSITE BOTTOM Concept art of the DeLorean encountering the *T. rex*.

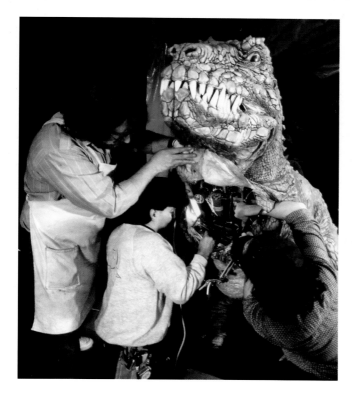

were script points that had been written, but it ended up being a lot of reaction. We called him one-take Tom. He didn't need to read the lines. He was the character, and that is some of the glue in the ride."

In early 1990, with the Florida park scheduled to open in June, the building that would house the ride was still under construction, and, due to the marshy foundations on which it was built, had become a challenge in itself. Besides construction delays and the tediously slow process of getting the ride systems and show controls operational, the show team had to wait for the final cut of the ride film to be completed to create the final sound mix for the ride.

Universal Studios Florida officially opened on June 7, 1990, only to be plagued with many of the problems common to newly opened theme parks. Not only was Back to the Future: The Ride still under construction but many of its other attractions were also facing similar delays. It wasn't until January 1991 that the ride was finally completed, and the building that would house the ride was fully constructed and ready to open. Universal had set a date to open the ride to the general public on May 2, but tests were first necessary to make sure that everything was functioning as it should be.

The ride debuted with a "soft opening": fully operational and open to the public but quietly rolled out without any publicity. With many vacationers unaware of both the new ride and the theme park itself, a large proportion of customers were local Orlando-area residents. Also taking an interest was the competition. "Disney Imagineers showed up," recalls Marble. "They wanted to know what was coming. We would see these folks come in, they were

we dumped manure on Biff. It was clever and funny, but we ended up going with the one that worked best."

In addition to the final shot, Douglas Trumbull also filmed Wilson's reactions behind the wheel of the DeLorean. That footage eventually ended up on a tiny screen inside the eight-passenger DeLorean dashboard. Steven Marble recalls shooting with Wilson: "We shot him inside the car reacting to the ride film and creating dialogue right on the spot. The thing about Tom is that he's an extraordinary actor and comedian and is amazing at improvisation. There

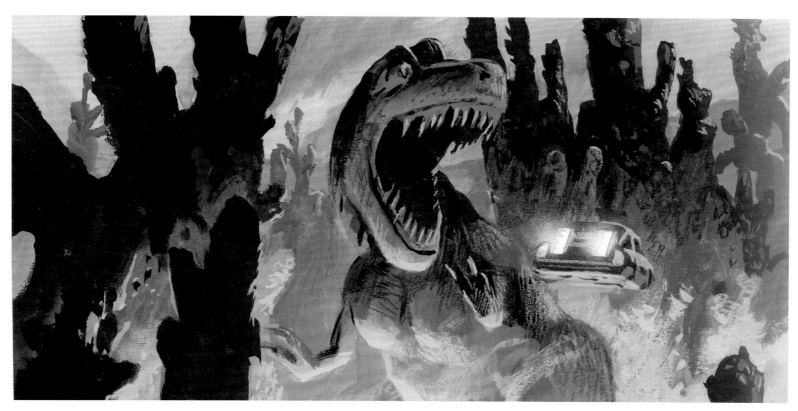

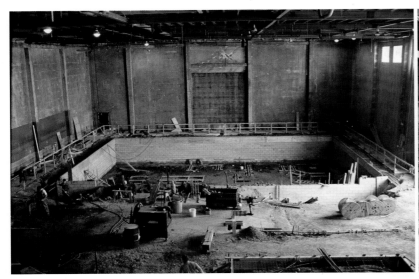

clearly not from the Orlando area or tourists, and they admitted they were from Walt Disney Imagineering. We welcomed them, and they were blown away."

Not only were the Disney people enthusiastic about what had been created, the general public was also in for a treat. "We used to sit out at the exit during the soft opening and watch people come out," Marble recalls. "I saw this ninety-year-old woman come out, jump in the air, and click her heels."

On May 2, 1991, Back to the Future: The Ride had its grand opening in Florida, with Michael J. Fox, Tom

23 June 93

Steven Marble
Universal Studios Hollywood
100 Universal City Plaza
Universal City, CA. 91608

Dear Steven,

Again I want to congratulate you and to thank you for your great work in translating the spirit of "Back To The Future - The Movies" into "Back To The Future - The Ride."

I could not be happier with the end result, which is nothing short of AWESOME.

I look upon "Back to the Future" as one of my children. I raised him the best I could, and then he went away to some college run by a guy named Steven Marble, where who knows what was going to happen to him. But, Great Scott, he graduated with the highest honors, #1 in his class! And everybody in the world is talking about him!

Doc Brown would be proud.

I know I'm proud.

And you should be too.

It truly is The Greatest Ride In The World.

Thank you.

BEST ALWAYS,
Bob Gale

100 UNIVERSAL PLAZA, BUNGALOW 479, UNIVERSAL CITY, CALIFORNIA 91608 · (818) 777-4600

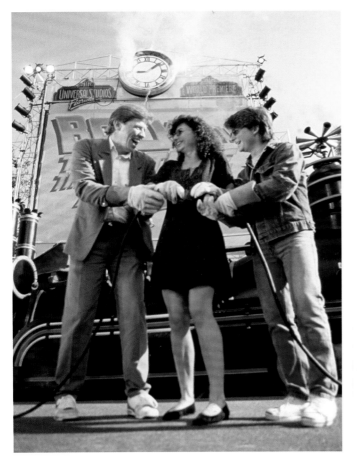

Wilson, Mary Steenburgen, and Robert Zemeckis in attendance and Christopher Lloyd joining the event via satellite. The actors took to the stage in the Jules Verne locomotive used in *Back to the Future Part III*, and the event left the press and park guests exhilarated.

Furthermore, the launch of Back to the Future: The Ride set the Florida park on the track to being the international attraction Universal had hoped for. "For a while, it had the reputation of being the best ride on the planet," states Steven Marble. "It transformed the Florida park to the extent that there were more people going on the ride than had initially entered the park, meaning people went over and over again."

TOP LEFT Interior construction of the Institute of Future Technology at Universal Studios Hollywood.

TOP RIGHT Facility construction manager David Pushkin (left) and project director Steven Marble (right) during the construction of the ride building in Hollywood.

ABOVE A letter from Bob Gale to Steven Marble, congratulating him for his work on Back to the Future: The Ride.

BOTTOM LEFT Tom Wilson, Mary Steenburgen, and Michael J. Fox at the grand opening ceremony in Florida.

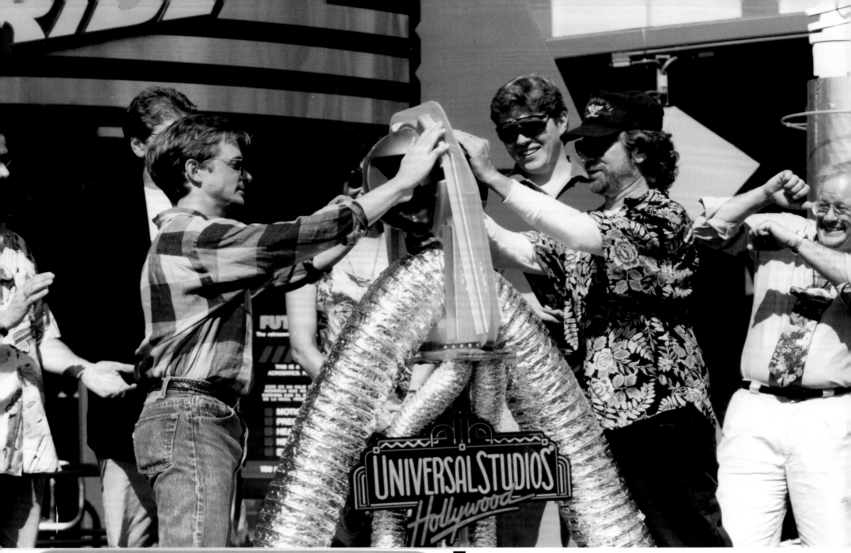

Steven Marble brought in filmmaker David de Vos to expand the preshow, utilizing preexisting "making of" material that ZM Productions had shot for Back to the Future featurettes. In addition, de Vos created a new computer-animated sequence that delivered a 3-D fly-around of the Institute of Future Technology.

On June 12, 1993, Universal Studios Hollywood celebrated the opening of Back to the Future: The Ride, holding a special Back to the Future day. As in Florida, a grand-opening ceremony was held at the studio with appearances by the cast and film-makers. To help take part in the celebration, the studio asked the DeLorean Owners Association if they could supply a few DeLoreans to help promote the event. Although thirty cars were expected, more than a hundred DeLoreans turned up.

The Hollywood version of the ride also proved to be a huge hit, and fans and filmmakers alike were thrilled. "You really are in Back to the Future," said Spielberg. "You're really in the movie. It's not an adventure based on any of the three films; it's almost like *Back to the Future Part IV*. It's a brand-new adventure, and I think you're wrapped in it pretty good for about four minutes."

Immediately after the success of the ride's launch in Florida, Steven Marble was instructed to go back to Los Angeles and begin the process of constructing Back to the Future: The Ride in Hollywood.

While the new building that would house the ride at the Hollywood park was under construction, the team discovered that one of the obstacles they were facing in Florida was that the preshow video was far too short. Response to the ride was so over-whelming that the average queuing time was ninety minutes, but the video was only thirty minutes.

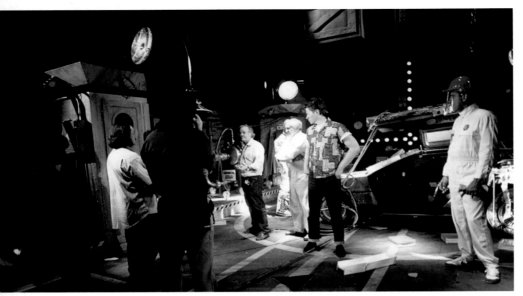

Hollywood. There, visitors could purchase a vast array of Back to the Future–related merchandise, some of it exclusive to the Universal parks. The Hollywood park also continued to expand the brand, opening a restaurant adjacent to the ride, Doc Brown's Fried Chicken: The Finest Chicken of All Time!, along with the Hill Valley Beverage Company counter and Snack to the Future, a stand-alone snack cart.

In March 2001, Universal opened another theme park in Osaka, Japan. Back to the Future: The Ride now had its third incarnation, complete with Doc Brown dubbed in Japanese. Despite this expansion overseas, as the ride entered its first decade, it became clear that the attraction was beginning to run its course in the United States. With no new *Back to the Future* movies in the pipeline and interest in the franchise less than it had been ten years previously, the ride's inevitable retirement was on the horizon.

Nevertheless, the ride proved popular enough that Universal didn't take any immediate action, allowing it to continue operating for an additional six years. On March 30, 2007, sixteen years after it had opened, the original ride in Florida closed its doors, with the Universal Studios Hollywood ride shutting down the following September.

Universal Studios Hollywood announced it would hold a closing ceremony for the ride, dubbed "Back to the Future: The Ride's Final Flight." On August 7, 2007, Christopher Lloyd and Bob Gale started the month-long celebration, standing on a

ABOVE Douglas Trumbull directs Tom Wilson in the final scene of the ride film.

BELOW The miniature set for Hill Valley 2015, was a perfect replica of the working set used for *Back to the Future Part II*.

Despite having not been directly involved with the making of the ride, both Zemeckis and Gale were also pleased with the final outcome. "This story had a really happy ending, because it turned out so great," says Bob Gale. "I was euphoric—it was fantastic! I remember the first time I went on Star Tours thinking I'd seen the messiah, that this was the future of theme park rides. Then Back to the Future outdid it on every level."

With the Back to the Future rides attracting guests by the millions, both parks opened Back to the Future–themed gift shops: Back to the Future: The Store in Florida and the Time Travel Depot in

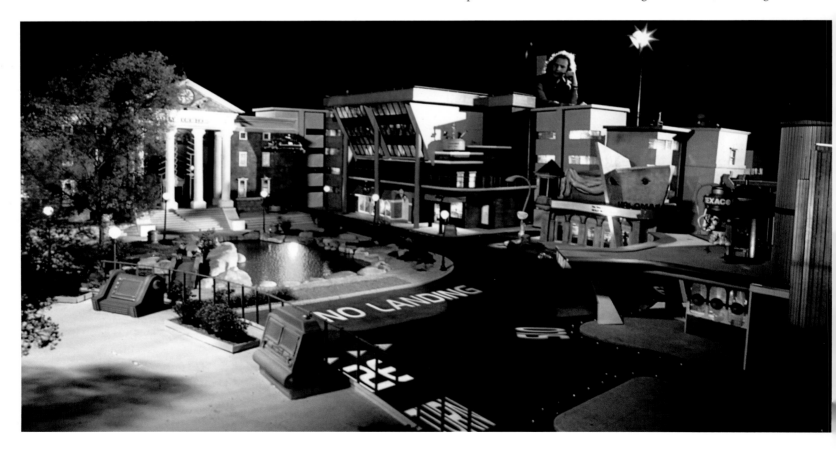

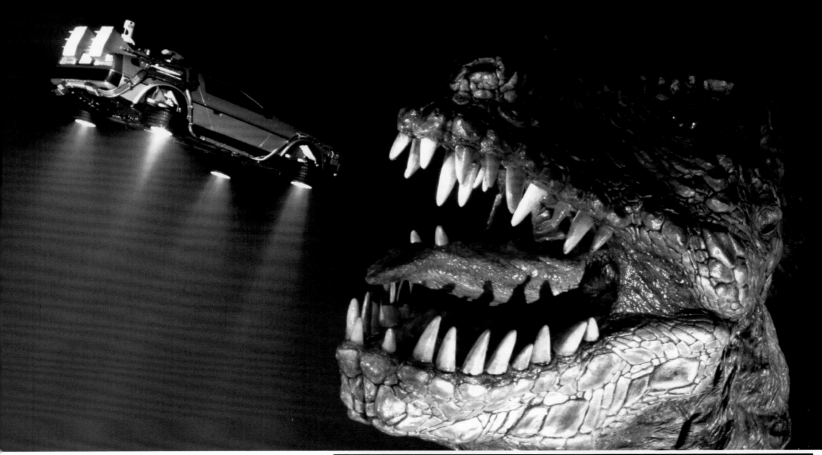

stage designed to look like the iconic clock tower and connecting some familiar electrical cables, which commenced the countdown.

On September 3, 2007, fourteen years and sixty-one million passengers later, Universal Studios Hollywood said goodbye to Back to the Future: The Ride.

Taking its place at both sites would be The Simpsons Ride. However, its creators didn't forget the groundbreaking impact of its predecessor. The preshow queue video included a "Simpsonized" Doc Brown, voiced by Christopher Lloyd, who has lost the Institute of Future Technology in a land deal with Krusty the Clown.

When Universal Home Entertainment reissued the Back to the Future trilogy on DVD in 2009, the studio included not only the main footage created for Back to the Future: The Ride but also the entire preshow queue video. They also included this material on the twenty-fifth anniversary Blu-ray and DVD release in 2010 so that fans could still enjoy the ride, albeit without the motion-control, eight-passenger DeLorean.

Back to the Future: The Ride remains one of the most talked about and memorialized attractions in theme park history. It not only changed the technological scope of what a simulator ride could be, it also set the standard of how great storytelling could drive a theme park ride. "It truly is a fair continuation of the films," says Robert Zemeckis. "It does

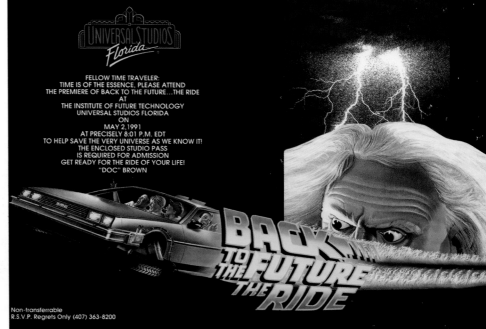

what we were never able to do in the films, in that it actually puts you in the adventure. You get to go on this wonderfully energetic and thrilling ride but also with the characters from the film, and that's what makes it really special."

Although the US versions of the ride are gone, as of June 2015, the ride at Universal Studios Japan is still in operation, including its adjacent Back to the Future–themed gift store.

TOP The DeLorean time machine gets dangerously close to the *Tyrannosaurus rex*.

ABOVE Invitation to the World Premiere of Back to the Future: The Ride at Universal's Florida park.

WHILE BOB GALE was not officially involved in the development of the theme park attraction, there was another Back to the Future project in which Universal was eager to have him participate.

In the fall of 1990, while *Back to the Future Part III* was ending its theatrical run, Universal was gearing up a new venture, Universal Cartoon Studios, with an eye toward creating animated feature films and TV shows. For their first animated endeavor, they proposed a Saturday-morning cartoon series based on *Back to the Future*. Gale was open to the possibility but had two provisos: "One of them was that we would have Christopher Lloyd introduce the episodes as Doc Brown," says Gale. "The other was that we would have science and history content in each episode. My daughter Samantha was two

years old at the time, and, like all parents, I was concerned about what she'd see on TV. I thought we should include a science experiment and it could demonstrate a little science both within the show and afterwards."

Gale's conditions were agreed upon, and CBS signed on for two seasons, a twenty-six-episode commitment. Gale also agreed to serve as executive producer on the series and to oversee the scripts, storyboards, and voice casting. The writer/producer team of John Loy and John Ludin, both of whom had extensive experience in the animation world, were then brought onboard.

Christopher Lloyd's busy filming schedule did not allow him to voice Doc Brown for the animated episodes, but he found three days in which he

BELOW Marty, Einstein, and Doc begin their adventures in animated form.

OPPOSITE Marty and Doc Brown's family, including kids Jules and Verne, as they appeared in the animated show.

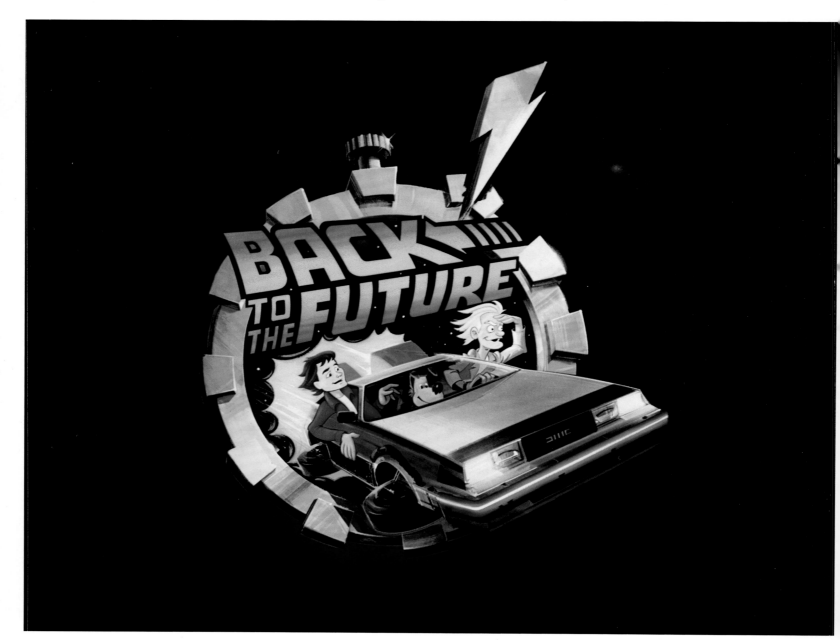

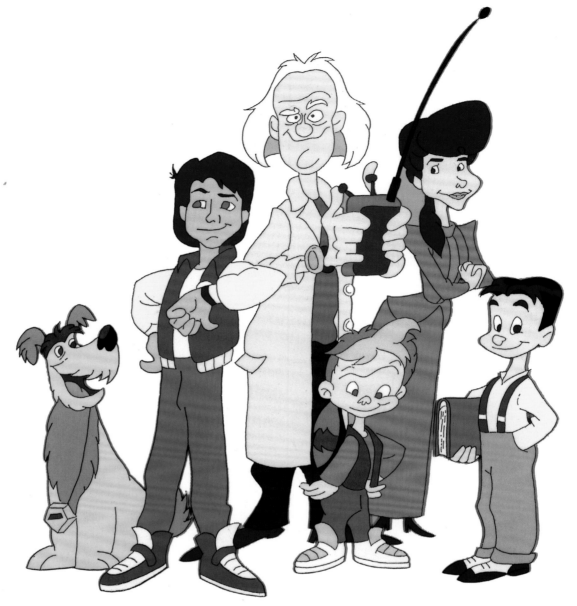

was able to don the wig and lab coat to film the live-action wraparound sequences. Doc's cartoon voice was provided by Dan Castellaneta, known to audiences as the voice of Homer Simpson. Both Tom Wilson and Mary Steenburgen reprised their parts, and, after an extensive search, David Kaufman was hired to voice Marty. Kaufman was so effective that several years later he was asked to voice another role originated by Michael J. Fox, that of Stuart Little in the television version of the movie.

Picking up where the third film left off, in the animated series Doc, Clara, and their sons, Jules and Verne, have moved back to modern-day Hill Valley, living on the farm that Clara called home in 1885. Doc has rebuilt the previously destroyed DeLorean with a number of improvements, and the Jules Verne train is also on hand for family jaunts through time.

Since siblings Jules and Verne Brown were only seen in a brief cameo at the end of *Back to the Future Part III*, they had to be developed as characters for

the series. "We had to explain who Jules and Verne were," says Gale. "Jules took after Doc, and was very scientific. Verne was Dennis the Menace." Marty had moved on from high school to junior college where he still dated Jennifer and occasionally ran into Mr. Strickland. Doc's faithful dog, Einstein, was still part of the family, and, because in cartoons anything can happen, has learned a number of new tricks, such as driving the DeLorean and piloting the train. Biff was still Biff, and, throughout the series, the audience would meet a number of his ancestors, who, of course, turn out to be constant foils to the McFlys.

Bob Gale worked closely with Ludin and Loy and made notes on every script. "My direction to everybody about writing Doc Brown was that Doc always uses a big word when a small one would do," he says. "The writers quickly caught onto the rhythm of how Doc spoke."

The team decided early in the process that due to the number of characters already featured, there

would be no room for George, Lorraine, Dave, or Linda McFly. However, Marty would encounter a number of other McFly ancestors through his adventures.

Following his involvement with Back to the Future: The Ride, Peyton Reed was called on to direct the live-action sequences with Christopher Lloyd. "It was a thrill," says Reed. "This was not just doing behind-the-scenes stuff; it was directing Chris as the Doc Brown character. We would write these sequences and then shoot them very quickly. For me as a director, it was a big leap up—we were shooting on 35mm film. It was a Saturday-morning show, but it was still an official Back to the Future thing." Reed and his ZM Productions partner Mark Cowen also wrote one of the episodes.

The scenes with Christopher Lloyd were shot in the summer of 1991 onstage at Universal Studios in Hollywood. Director Reed and the producers had the set built to look like the lab in the theme park ride, keeping a continuity of sorts. Lloyd addressed his frenzied technobabble dialogue directly to the camera and the viewers at home, but, because of a very tight shooting schedule, he didn't have the luxury of numerous takes. In order to piece together takes that didn't quite match, Reed used a device he had originated for the theme park attraction. He cut in a static glitch, followed by a test pattern featuring a photo of Doc wearing an Indian headdress. A Muzak version of "The Girl from Ipanema" played, and a female voice intoned, "One moment, please. We are experiencing technical difficulties." When Reed cut back to the filmed action, he could use a different take.

Doc Brown required an assistant to demonstrate the experiments at the end of each episode, so John Ludin, who was from Seattle, suggested Bill Nye, who did a local kids' science show in the area. Nye performed the experiments in silence, while Doc narrated.

While most voice-over sessions for animated shows see each actor recording their lines in isolation, for Back to the Future: The Animated Series, the entire cast was gathered and performed the script together. "It was a creative decision to do that," says Gale. "We thought it would improve the performances and give the show extra energy, and it did."

At the end of the first season, CBS agreed to move forward on the second season, but the network's head of children's programming asked for a few changes. "She didn't like the science experiments," says Gale, "so she wanted us to drop that aspect of it. Her other suggestion was to add an alien to the cast of characters. I said absolutely no to both."

ABOVE The test-pattern card featuring Doc Brown was used to smooth the transitions between Christopher Lloyd's various takes.

BELOW Model sheet sketches show the animated Doc Brown in a variety of poses.

OPPOSITE A selection of key frames from *Back to the Future: The Animated Series*.

When it was time to film the live action with Lloyd and Nye for the second season, Peyton Reed had moved on to other opportunities, so Bob Gale happily took his place behind the camera. Due to a reduced budget, all of the sequences were shot in front of a blue screen, with the backgrounds added later.

After the second season, CBS canceled the show, citing low ratings. While it was a disappointment to all involved, the team was proud of what it accomplished in delivering an informative and entertaining series that remained true to the characters and spirit of Back to the Future. "What was very gratifying," offers Bob Gale, "was that we got letters from school teachers all over the country who were really happy that we put those experiments in. Teachers saying, 'I did this in my class because of your show.' Kids would write in about having done the science experiment as well; we loved getting those letters, and I expect we answered most of them, because I always told my assistant, Mary Anne [Lantieri], any chance we get to answer a letter, we should always do it."

INTO THE FUTURE

SINCE COMPLETING THE TRILOGY, Robert Zemeckis and Bob Gale have repeatedly been asked whether they will ever make *Back to the Future Part IV*. Their answer has always been an unequivocal no. The duo remain proud of their work and have resisted suggestions to release the films in 3-D or other digitally altered forms. "These are the movies we made, and we stand by them as they are," says Zemeckis.

That decision hasn't stopped the franchise from flourishing and proving itself to be, in the words of Michael J. Fox, "cross-generational." The ever-growing fan base has helped Back to the Future remain a vital presence, and the films have never slipped from the public imagination.

In the years since the release of *Back to the Future Part III*, a number of factors have helped keep the world of the films alive. With the cessation of Universal's official fan club in 1990, an ardent fan decided to take up the mantle. Stephen Clark founded Back to the Future: The Fan Club to share his love of the trilogy. For many years, Clark published a quarterly fan-club newsletter and, as technology developed, the club morphed into BacktotheFuture.com, a portal to the Back to the Future universe, with up-to-date news covering every aspect of the franchise. Clark's dedication has earned him the blessings of both Zemeckis and Gale.

Back to the Future also gave a much-needed shot in the arm to the image of the beleaguered DeLorean motorcar. With the popularity of the films, many fans began buying the cars and converting them into replicas of the time machine. One such conversion led to some remarkable results. In 2000, fan Oliver Holler was given a dire medical prognosis and decided, alongside his wife Terry, to use whatever quality time he had left to pursue his dream of building a DeLorean time machine.

The Hollers decided to use the completed car to raise money and awareness for The Michael J. Fox Foundation for Parkinson's Research. Traveling throughout all fifty states, as well as Canada and Mexico, the Hollers and their ToTheFuture.org campaign have raised more than a quarter of a million dollars for Parkinson's research. Oliver Holler's own health also improved dramatically in the ensuing years, and he and his wife continue their travels and fund-raising efforts.

Other DeLorean owners have formed regional car clubs and, since 1998, have assembled biannually for the DeLorean Car Show, held in different cities every other June, with appearances by various cast and crew from the trilogy.

In 2011, Nike, which has maintained its strong relationship with Back to the Future over the years, also threw its support behind Fox's foundation. The company manufactured replica versions of the self-lacing shoes worn by Marty in *Back to the Future Part II*. A limited-edition quantity of 1,500 pairs of the "2011 Nike Mag" sneakers were auctioned on eBay, with all proceeds going toward Parkinson's research. To bring awareness to the campaign, several TV and Internet spots were filmed with *Back to the Future* executive producer Frank Marshall directing. Christopher Lloyd reprised his role as Doc, and Donald Fullilove (Mayor Goldie Wilson), comedian Bill Hader, and basketball star Kevin Durant also appeared. The spots were filmed at the Puente Hills Mall and the Nike Store in Santa Monica, with *Back to the Future* cinematographer Dean Cundey also lending his expertise. The auctions raised an estimated $4.7 million.

Back to the Future has also made an impact in other areas. In 2007, the original film was inducted into the National Film Registry, one of twenty-five films that year deemed to be "culturally, historically, or aesthetically significant" and earmarked for preservation by the Library of Congress.

In 2010, software developer Telltale Games recruited Bob Gale to help develop their Back to the Future video game, later bringing in Christopher Lloyd to voice Doc Brown, with Claudia Wells reprising her role as Jennifer. Newcomer A. J. Locascio provided a pitch-perfect performance as Marty, and for the final episode of the five-chapter game, Michael J. Fox made a surprise cameo as the voice of the future Marty McFly and his forefather, William McFly. In February 2011, Telltale Games announced that *Back to the Future: The Game* had become the company's most successful franchise, with the first episode receiving more than one million downloads.

In summer 2014, the continuing popularity of *Back to the Future* was particularly clear in London, England. Since 2007, Fabien Rigall's Secret Cinema had been creating interactive, immersive presentations of a range of classic films for a growing number of moviegoers. In 2014, Rigall announced his most ambitious project yet: *Back to the Future*. The ticket demand was instantaneous and crashed the company's website. Once repaired, 60,000 tickets (at fifty British pounds each) were sold within eight hours. Several performances were added, and all sold out. Rigall re-created the town of Hill Valley at the site of London's Olympic Village, complete with shops, restaurants, and, of course, the iconic courthouse and clock tower. On twenty-one evenings, 3,500 ticket holders arrived at 5:00 p.m. in '50s costume to wander the town and mingle with Hill Valley residents and storekeepers portrayed by actors. Lou's Cafe actually served burgers and milkshakes, and, behind the facade of Hill Valley High, visitors could attend the "Enchantment Under the Sea" dance and boogie to a live band. As darkness fell, attendees

sat in the gigantic town square to watch the film projected onto the courthouse, with live-action elements synchronized to the movie. For example, during the clock tower scene, an actor dressed as Doc zip-lined over the crowd, matching the onscreen action by Christopher Lloyd. And when lightning struck the courthouse in the movie, it triggered a full pyrotechnic display on the replica courthouse.

Bob Gale attended the show on three consecutive nights, dressed as a reporter for the *Hill Valley Telegraph*. Unrecognized by most, he walked the grounds interacting with the other actors and visitors. On more than one occasion, he was congratulated on his fantastic American accent!

Ever since Robert Zemeckis made an offhand comment about hoverboards being a reality, fans have been waiting for the day when technology catches up with the director's fertile imagination. In March 2014, a video hit the Internet that garnered international attention. Arriving in a DeLorean, Christopher Lloyd announced the invention of the world's first working hoverboard, created by HUVrTech. The video featured demonstrations of the fully operational hoverboard by skateboarding legend Tony Hawk, with commentary from rock artist Moby, professional athlete Terrell Owens, and Billy Zane.

The worldwide reactions ranged from excitement and delight to doubt and confusion. Within days, it was revealed the video was the brainchild of the comedy website *Funny Or Die*. Nevertheless, it racked up hundreds of thousands of hits.

Yet, life often imitates art, and in October 2014, Californians Greg and Jill Henderson, fans of the trilogy, demonstrated the Hendo Hoverboard, an actual working hoverboard that uses magnetic levitation over a conductive surface. This hoverboard was not a hoax and has received worldwide press. The boards currently cost $10,000 and are meant to demonstrate a technology that the Hendersons hope can be used to stabilize buildings in earthquakes.

On January 1, 2015, media interest in Back to the Future exploded again as we finally embarked on the once-distant year that Marty and Doc traveled to in *Back to the Future Part II*. Television shows, newspapers, magazines, and websites all dissected Zemeckis and Gale's vision of what was to come, pointing out what they got right (flat-screen televisions, video phone calls, voice-activated controls, high-tech glasses, paying by thumbprint) and what has not yet come to pass (flying cars, the hoverboard, and the Chicago Cubs winning the World Series).

While Zemeckis and Gale steadfastly oppose another sequel or reboot of the films, they have not forsaken the franchise. In January 2014, the two announced that Marty and Doc will ride again in *Back to the Future: The Musical*, tentatively planned to debut in 2017. "Bob Zemeckis and I got to talking one day," says Gale, "and we thought that a musical version of *Back to the Future* just seemed like an obvious concept. Creating a musical version is a way to revisit the story and characters in a different medium. Our hero is an aspiring rock star, so it's natural that he would sing."

Their musical will be based solely on the first film, with music being written by original composer Alan Silvestri. "Fans can be assured it will definitely sound like *Back to the Future*," continues Gale, "and we won't put it up on stage until we're satisfied with it, however long it takes."

With a new comic book, merchandise, and other projects also on the horizon, it's clear that the future of the franchise hasn't been written yet. It's whatever Bob Gale and Robert Zemeckis make it, and, as Doc Brown would say, they're planning to make it a good one.

TO BE CONTINUED....➔

AFTERWORD

IT'S WONDERFULLY APPROPRIATE THAT THIS BOOK is coming out in 2015 on the thirtieth anniversary of the first *Back to the Future* movie—almost as if "it was meant to be," to quote Lorraine McFly. It gives us a chance to compare the future we predicted with the future we actually got.

Bob Gale and I didn't set out to predict the future in *Back to the Future Part II*. We knew we'd fail. We simply set out to make an entertaining sequel to a movie everyone loved, and have fun with the future.

Some of our predictions weren't hard to make. The Cafe 80's, and '80s nostalgia itself was one. Sure, it's a joke (which was a *lot* funnier in 1989), but in the '80s we were nostalgic about the '50s, so it made sense that we'd always be nostalgic about whatever was thirty years ago. In 1988, we knew flat-screen TVs and home videoconferencing were in development. Same for payment and identification by thumbprint and voice-activated lights and appliances. The idea that the town square would become a green space, with the courthouse as a shopping mall, was a way to show the future as a nice place to live. This idea served our story and tone, but it was soundly based on urban redevelopment concepts discussed in 1988.

Some predictions were just jokes that turned out right. Drones? Okay, we're still a few years away from the *USA Today* photography drone or drones that walk our dogs, but that prediction goes in the win column. And those video glasses Marty's kids are wearing at the dinner table? How great is it that so many recent articles about Google Glass or Apple iGlasses or Microsoft HoloLens glasses make reference to our movie?

By the time this book comes out, we'll know if the Cubs made the World Series. If they do, Bob and I will be hailed as visionaries. If they don't, the gag will remain funny. Either way, we win!

With some predictions, we failed spectacularly, although these were first and foremost intended as jokes. Fax machines in every room? Oops. And the pizza hydrator. Not that we expected it—it was just a gag—but I was hoping someone might actually be working on it by now.

We don't have self-adjusting, self-drying, voice-activated jackets yet, but wearable technology is now entering the marketplace. Meanwhile, I'm thankful that kids don't wear their clothes inside out or have bionic implants.

And then there are the hoverboards. Obviously, this sequence was created as the future version of our skateboard chase. I knew from the start every kid would want a hoverboard. What I didn't know was how firmly this idea would implant itself in the world's collective imagination—to the extent that a working version of it now exists! And it's magnetic, just as we imagined it! Here's something that, until 1989, no one had conceived of, no one knew they wanted . . . and now it's becoming a reality! Life indeed imitates art!

Looking back, I can honestly say that, of all my movies, *Back to the Future* is the one I'm most proud of. But maybe not for the reason you'd expect. Of course, every filmmaker dreams of making a movie that's not only successful but passes the test of time and entertains audiences who weren't even born when it was made. Every director wants to make a movie that permeates pop culture so thoroughly that everyone in the world recognizes its characters and imagery.

But my greatest source of pride is that *Back to the Future* is totally original. It wasn't a book or a play or a comic book or a TV show. It wasn't presold, it's not based on a real event, and it's not derivative of anything else. It was born wholly and completely out of my own and Bob Gale's combined imaginations as a *movie*, and it's full of cinematic ideas and moments that wouldn't work as well, if at all, in any other medium.

Back to the Future is a pure movie experience. It's why I always wanted to make movies. And nothing makes me happier than knowing that audiences are still enjoying it and being inspired by it.

Robert Zemeckis

HarperCollins books may be purchased for educational, business, or sales promotional use. For information please e-mail the Special Markets Department at SPsales@harpercollins.com

First published in the United States and Canada in 2015 by
Harper Design
An Imprint of HarperCollins*Publishers*
Tel: (212) 207-7000
Fax: (855) 746-6023
harperdesign@harpercollins.com
www.hc.com

Distributed throughout the United States and Canada by
HarperCollins*Publishers*
195 Broadway
New York, NY 10007

2015 © Universal Studios Licensing LLC

Library of Congress Control Number: 2015942831

ISBN: 978-0-06-241914-9

Unit photography by Ralph Nelson, Jr.

Black-and-white images of Eric Stoltz on pages 44–61 from the collections of the Margaret Herrick library, Academy of Motion Picture Arts and Sciences.

Produced by
INSIGHT EDITIONS

PO Box 3088
San Rafael, CA 94912
www.insighteditions.com

COLOPHON
Publisher: Raoul Goff
Art Director: Christine Kwasnik
Designer: Jon Glick
Executive Editor: Vanessa Lopez
Senior Editor: Chris Prince
Production Editor: Rachel Anderson
Editorial Assistant: Greg Solano

ROOTS of PEACE REPLANTED PAPER
Insight Editions, in association with Roots of Peace, will plant two trees for each tree used in the manufacturing of this book. Roots of Peace is an internationally renowned humanitarian organization dedicated to eradicating land mines worldwide and converting war-torn lands into productive farms and wildlife habitats. Roots of Peace will plant two million fruit and nut trees in Afghanistan and provide farmers there with the skills and support necessary for sustainable land use.

Manufactured in China by Insight Editions

10 9 8 7 6 5 4 3 2 1

AUTHOR ACKNOWLEDGMENTS

There are so many people to thank for their generosity, kindness, and willingness to share their memories in making this book a true celebration of Back to the Future.

I am, and always have been, proud and honored to be a part of the BTTF family. As I've said to Bob Gale on many occasions, "Back to the Future is the gift that keeps on giving . . ." I'm so happy to give back.

Bob is the true godfather of this book. Ten minutes after I told him it was happening, he e-mailed me with a list of people he had already lined up for Randy and me to interview. The access he gave us to everything, from his knowledge to his archives, was unprecedented. And he's been my cheerleader on this project for a very long time. When Bob Gale calls you a "good writer," there is no higher compliment.

Bob Zemeckis and Neil Canton added so very much to this book, as did Steven Spielberg, Kathy Kennedy, and Frank Marshall. My appreciation and gratitude to them all.

The cast members were no less amazing in their contributions. Sincerest thanks to Michael J. Fox, Christopher Lloyd, Lea Thompson, Billy Gibbons, Burton Gilliam, Melora Hardin, Huey Lewis, Ricky Dean Logan, Marc McClure, James Tolkan, Darlene Vogel, Harry Waters Jr., Jeffrey Weissman, Claudia Wells, and Elijah Wood.

The Back to the Future trilogy and ongoing universe would not be what they are today without the incredible talents of those behind the scenes. The same applies to this book. I thank you all: John Bell, Clyde Bryan, Michael Burmeister, Rick Carter, Stephen Clark, Ron Cobb, Charlie Croughwell, Dean Cundey, Ed Eyth, Scott Farrar, Steve Gawley, Cara Giallanza, Todd Hallowell, Scott Harris, Bones Howe, Joanna Johnston, Harry Keramidas, Mark Klastorin, Max Kleven, Marty Kline, Mary Anne Lantieri, Michael Lantieri, Marvin Levy, John Loy, John Ludin, Steven Marble, Les Mayfield, David McGiffert, Marjorie McShirley, Mike Mills, Kenneth Myers, Ralph Nelson Jr., Lawrence Paull, Paul Pav, Kevin Pike, Pamela Eilerson Posey, Andrew Probert, Ken Ralston, Peyton Reed, Michael Scheffe, Artie Schmidt, Walter Scott, Sid Sheinberg, Alan Silvestri, Steve Starkey, Drew Struzan, Wes Takahashi, Judy Taylor, Douglas Trumball, Ed Verreaux, Simon Wells, Cheryl Wheeler-Dixon, and George Zaloom.

No less important are the contributions and support of the following, to whom we express our thanks: Sharon Atamaniuk, Michael Chien, Dale Cohen, Doc Crotzer, Frank DeMartini, David deVos, Matthew Dicker, Samo Gale, Tina Gale, Tinker Hatfield, Terry and Oliver Holler, Kelsey Hornbach, Dan Janison, Ken Kapalowski, Robert Katz, Rita Klastorin, Rob Klein, Justin Lubin, Pam McConnell, Daniel Noah, Mark Parker, Monique Perez, Matthew Richmond, Fabien Rigall, J. W. Rinzler, Tom Silknitter, Michael Singer, Faye Thompson, Nina Tringali, Josh C. Waller, Joe Walser, and Jerry Wertman.

At Universal Pictures: Jamie Braucht, Cindy Chang, Amy Hofto, Roni Lubliner, Kelli Matthews, Darice Murphy, Shahrook Oomer, Jeff Pirtle, and Michael Ribak.

To Robbie Schmidt, Vanessa Lopez, Jon Glick, and Chris Prince at Insight Editions—thank you for your faith, confidence, enthusiasm, and guidance.

Randy, there's no one else I would rather have had in the DeLorean taking this journey with me. Your contributions, knowledge, enthusiasm, and hard work were invaluable.

This book is dedicated to my beloved Ardemis Freeland. You are, you always have been, and you always will be . . . my density.

—Michael Klastorin, 2015